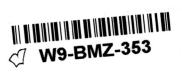

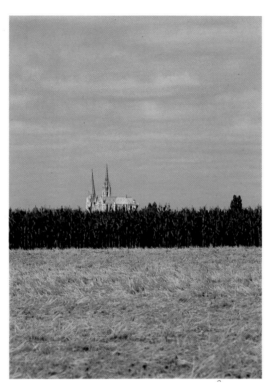

The World of Chartres

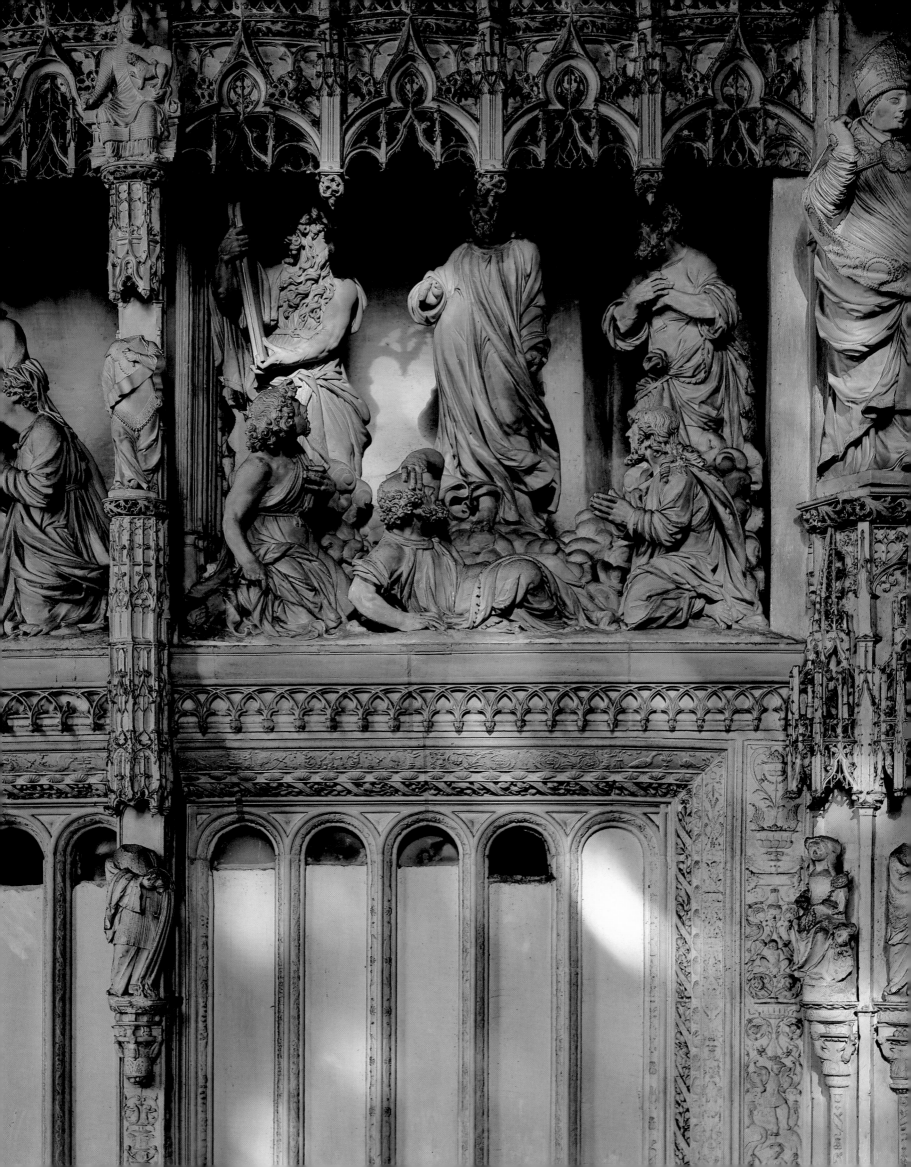

Jean Favier

The World of
CHARTRES

Appendices by
JOHN JAMES *and* YVES FLAMAND

Photography by
JEAN BERNARD

HARRY N. ABRAMS, INC.
Publishers, New York

Illustrations
Page 1
Chartres Cathedral seen from the plan behind the wheat fields
Page 2
Sculpture in the choir tower
Page 3
Interior, triforium
Page 6
Chartres Cathedral seen from above the rooftops of the town, south façade
Page 9
Stained glass of the west façade
Page 11
Detail of p. 12
Page 19
Detail of p. 21
Page 35
Detail of p. 41, at the right
Page 43
Vegetable frieze, column of the north portal
Page 53
Choir vault
Page 85
Detail of the great organ
Page 91
Detail of p. 94
Page 99
Detail of p. 111, right above
Page 113
Detail of p. 114
Page 129
Detail of p. 131, right
Page 135
St Maurice, detail of p. 108
Page 147
Janus, detail of p. 149

Translated from the French by Francisca Garvie

LIBRARY OF CONGRESS CATALOGING-IN-PUBLICATION DATA

Favier, Jean, 1932–
[Univers de Chartres. English]
The world of Chartres / Jean Favier, John James, Yves Flamand;
photographs by Jean Bernard.
p. cm.
Translation of: L'univers de Chartres.
Includes bibliographical references.
ISBN 0–8109–1796–3
1. Cathédrale de Chartres. 2. Chartres (France)—Buildings,
structures, etc. 3. Art and society—France—Chartres. I. James,
John, 1931– . II. Flamand, Yves. III. Bernard, Jean. IV. Title.
NA5551.C5U5513 1990
726'.6'094451—dc20 89–17647
 CIP

Originally published in French under the title *L'Univers de Chartres*
Copyright © 1988 Bordas, Paris
English translation copyright © 1990 Thames and Hudson Ltd., London,
and Harry N. Abrams, Inc., New York
Published in 1990 by Harry N. Abrams, Incorporated, New York

Printed in Italy by G. Canale & C.

Harry N. Abrams, Inc.
100 Fifth Avenue
New York, N.Y. 10011
www.abramsbooks.com

CONTENTS

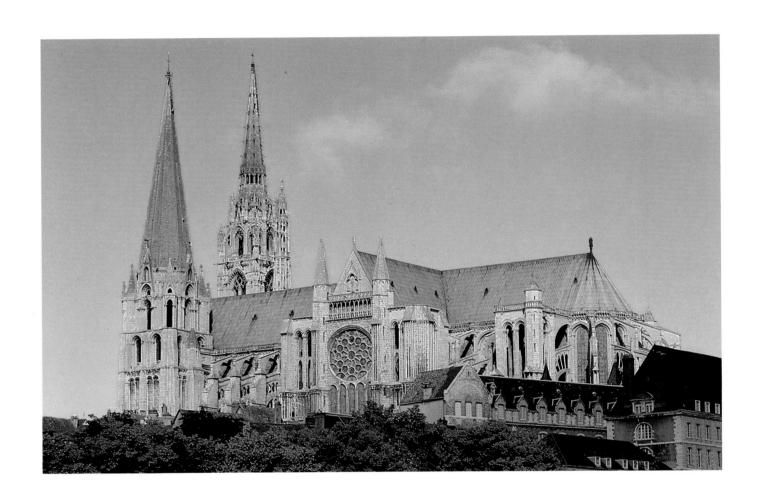

Preface

Why did I write this book? Why Chartres? Why me? Perhaps because over the centuries this cathedral, which has been written about by so many art experts and archaeologists without whom we would know little about its architectural complexity, has attracted a great many historians, but few have actually recorded what they saw.

The historian listens. He only starts writing when he has heard enough, and the reader would be well advised to believe that the historian of the Middle Ages listened just as much as the contemporary historian who can question the protagonists of history. As a dialogue which extends beyond the unreflecting mirror of death, history echoes the thoughts and deeds of the men of the past who have left us charters and letters, accounts and decisions, poems and chronicles. They wrote only what they wanted to write, but they tell us more: what they are, how they lived, how they perceived and understood the world.

Positivist history – the history which advanced our knowledge between the nineteenth and the twentieth century and which would have signed its own death sentence had it regarded as true only what is written – was happy to regard the cathedral as an end in itself. The main thing was that it had been built and all that needed to be known was when and how it was built.

Our contemporaries, accustomed now to taking a larger view of the past, have learned to look at it in a different way, as the synthesis of a moment in history. Like the *Chanson de Roland* or the tales of Joinville, it tells of the men and women among whom it came to be built, who wanted it and made it what it is.

There are perfect cathedrals. As the culmination of the art and doctrine of building they are perhaps also what men wished for. I must admit that they move me less, with their prefect balance, than does Chartres, with its traces of the tentative hands of master builders and its wealth of images – new and used again, single and repeated – which reflect a dynamic process of organization. Some of the stained glass repeats in colour scenes seen in light and shade on the portals. The Passion is depicted in two windows, of different dates and designs. There are as many Annunciations as there were artists eager to express their own vision of that amazing encounter between grace and human freedom.

A cathedral is quite different from a well-defined painting, which the painter can varnish once he has completed it. Because it is alive, the cathedral – and Chartres more than most – is never complete, with its blatantly anachronistic north tower which seems always to be seeking its twin and which would have been condemned by public opinion if people in the sixteenth century had reasoned as we all too often do today.

Chartres is enormously ambitious. What building of our era – including sports stadiums – could contain an entire city at one time? It is a daring concept, in which enjoyment of technical progress goes hand in hand with the pride of parochial patriotism. But ambitious and daring as it is, Chartres remains an utterly human cathedral, with its three south portal doorways that face the town showing the Church of the apostles and the martyrs, the Church of the teaching Christ.

Throughout Chartres, even in the timeless idealism of the Royal Portal, the apparently abstract quality of the large-scale theological compositions is discreetly enhanced by anecdote. Neither the sculptors nor the glassmakers concealed their pleasure or their desire to give pleasure. The Christ in Majesty of the tympanum and the timeless figures of the precursors of the Messiah on the Royal Portal are balanced by the narrative frieze of genre scenes running from one capital to another. The story they tell forms a counterpoint to the requirements of dogma. A similar balance can be found in the ambulatory between the kind of gigantic strip cartoon of the choir wall and the scenes in the large stained-glass windows which the artist, surely with a twinkle in his eye, knew were too high to be visible and yet designed simply because it pleased him to do so!

I shall never forget the first time I discovered Chartres. I saw that same, much-repeated image of the silhouette on the horizon of the corn-fields. And I remember spending the entire afternoon of a late summer

day there, attending a six-hour organ competition, when I experienced the changing colours in space as the hours went by and the light struck the windows one by one, sounding the different notes from Prime to Compline.

But to me this book is above all a dialogue with a living work which bears witness to the world. It bears witness to the faith of Christians and to the trade of the wool-carders, to the procession of saints who mark out the way to Redemption and to the activities which mark out the seasons in the calendar of the portals. It bears witness to hope and fear, history and legend, to those who loved the fertile land and those who gazed enviously towards the rival capital and towards the royal destiny of Saint-Denis. It bears witness to the stone-cutters who portrayed themselves at work to mark their generosity, and to the king of France who displayed his generosity with brightly lit fleurs-de-lis.

In this book, in which the art of the photographer and the science of the architect and archaeologist help us to see, the historian also has a part to play: the part assigned to him by man's endeavours to know what he is by understanding how he has become what he is. It is only those who want to speak who can be understood. Chartres speaks.

Jean FAVIER
Member of the Institute

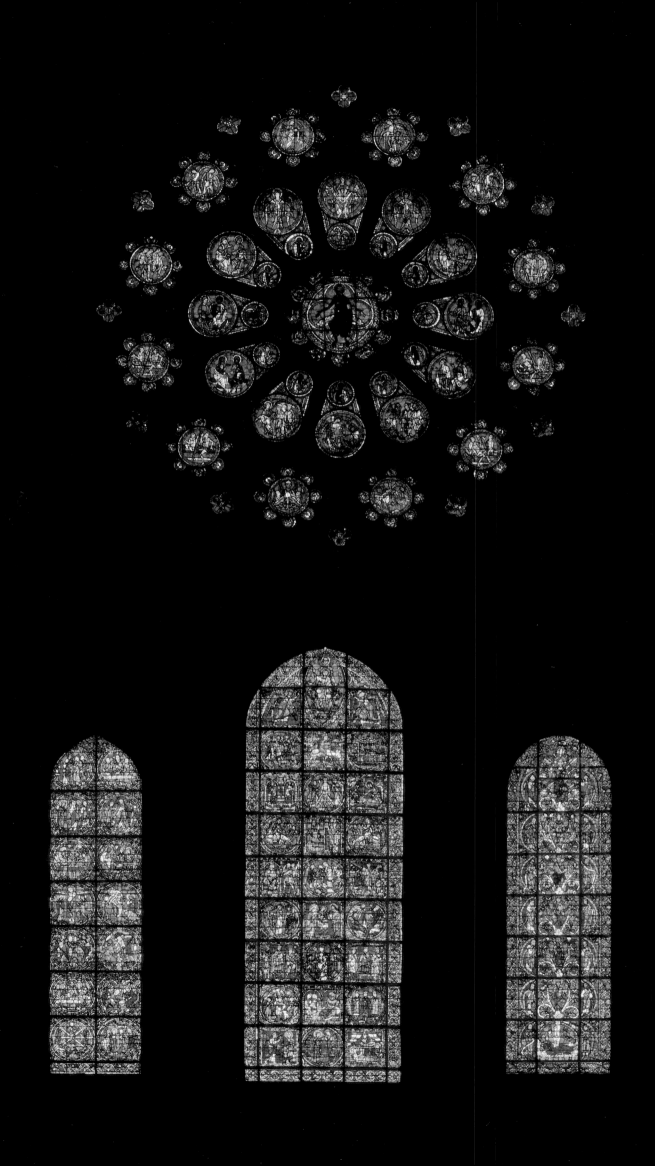

Expansion

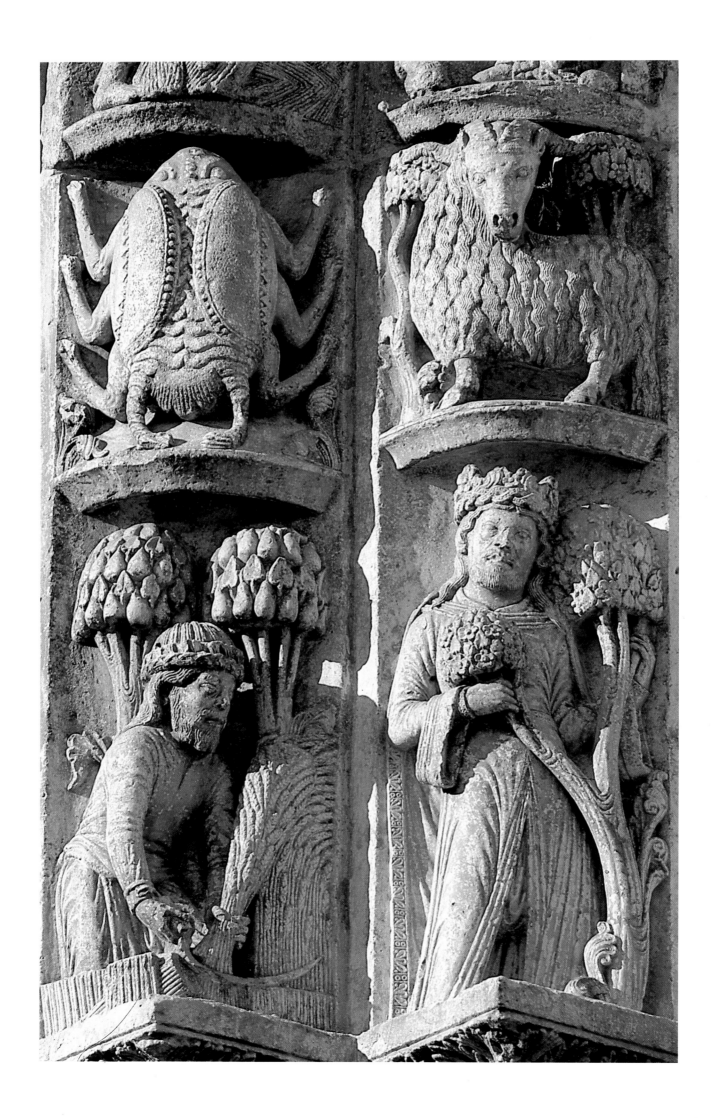

Expansion

The generation born in the year 1000 gave way to new generations who had not experienced such difficult times, epidemics, famine and war. Of course there were still the rich and the poor, periods of calm and times of war, years of sunshine and ill winds. But there were no more great famines like that of 1033 which, as the chroniclers noted, occurred on the millennium of the Passion. The Church's efforts now began to bear fruit in the form of peace: the peace of God which protects the weak, the truce of God which set finite limits to conflict, the crusades which diverted the Christian knights' warlike spirit to more useful ends. After the 1050s, when King Robert the Pious ceded the throne to his son Philip I, when a duke of Normandy called Guillaume became William the Conqueror of England and the whole of northern France saw the sudden flowering of the great movement of municipal emancipation which turned the towns into collective political entities, another movement which had been perceptible here and there for the last twenty or thirty years suddenly transformed the medieval landscape and way of life: man attacked the forest.

This was not the first example of deforestation in history. But it was a long time since peasants had last been seen doing their utmost to enlarge the plot of land which represented their family's livelihood. In fact the family was expanding at the same time as the piece of land. People began to eat better, became more resistant to disease, worked better, produced more: the cycle was closed. More and more mills appeared along the rivers, substituting the force of nature for the strength of man to turn the millstone which ground the grain or crushed the nuts for making oil, mills too which powered the bellows of the forge for making iron tools. And let us not forget the fulling mill which opened the way to the early, modest cloth industry in rural areas.

In this world, which was still extremely rural, the annual cycle was marked out by the work in the field, to the point that the cathedral calendars chose as the symbols of each of the twelve months twelve moments of rural life. On the left portal of the Royal Portal of Chartres and on the right portal of the north transept portal, April — identified by the Ram from the Zodiac — strolls through a flowering countryside, while July bends slightly to cut the harvest of ripe corn with his sickle. Taurus, the Bull of May, accompanies the hunter who is shown setting off with his falcon on his wrist, leading his horse. The fortunes of the king, the revenue of the Church, the life of the peasant, all this depended on the harvest. The simple action of enlarging a

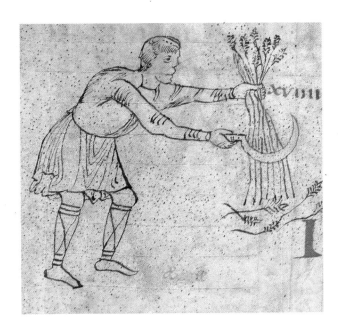

The harvest. It became the symbol of this period of expansion. Families were bigger, better fed and more resistant to disease — a spur to enterprise. The techniques may still have been rudimentary — the stubble was cut high, by sickle, and then ploughed in — but this was the only fertilizer. (11th-century obituary, Bibl. mun. André-Malraux, Chartres.)

The calendar. The year begins in spring. On the right, the young man crowned for the festival walks through a field in flower below the Ram of April. On the left, a peasant is harvesting with his sickle below the Cancer of July. (Voussoir of the left portal of the Royal Portal).

field or lengthening the furrows had repercussions on the structure of political life, on the forms of religious feeling and on artistic expression.

Sooner or later this movement spread throughout Europe. Once the peasant families had a few extra hands, which also meant a few extra mouths to feed, they began to extend the borders of the cultivated clearing which constituted the village plot at that time. Two or three generations later, they no longer wanted to enlarge, only to emigrate. The community allowed its extra hands to leave – the young, the younger sons tempted by the adventure of settling elsewhere, on the plains or in the forests. They founded dependencies, hamlets, some of which were one day to become new parishes. The network of today's French rural communes was more or less determined in the thirteenth century, when men became well aware that they were reaching the limits of agrarian expansion and that they could go no further with deforestation without depriving rural life of an essential element of ecological balance, the forest. For without a forest there is no wood and there can be little stock-farming. It was necessary to build, to close in, to heat. And to feed the pigs.

In the rich limestone plains of the Paris Basin, where a long tradition kept men grouped closely together and the knowledge that water sources were scarce kept them from seeking adventure far from the familiar wells, people felt less need to go far away to clear the ground. It was a long time now since the forest of Beauce had been a real forest, as the neighbouring Perche still was until well into the Middle Ages and as the forest of Yveline was to remain for a long time until belated land clearance turned it into a mere urban forest, the forest of Rambouillet. In the heart of the Beauce country, the fields had taken over from the trees centuries ago. So all the peasant farmers had to do was to lengthen their furrows. That was enough to provide the extra cereals which enabled them to make a little money at the town market. With this they could buy an iron ploughshare to plough the field more deeply. Slowly, the yield increased. On the best soil the peasants learned to combine winter corn – wheat on the very richest soil – with spring corn which, like barley, produced abundant harvests that were fairly safe from frost.

Because people now had something to sell, new activities sprang up in the towns. Eleventh- and in particular twelfth-century society could afford one luxury: to feed people who did not produce food, craftsmen, merchants, soon followed by administrators, students, lawyers, and so forth. It became possible to invent, to build.

Chartres stands at the crossroads of two axes that are rather poorly defined by rivers which are too shallow and often encumbered by the mill-wheels. It was not until the end of the Middle Ages that the need to sell the cereals produced in the Beauce in Paris led to the decision to turn the River Eure into a waterway. But the Eure and the Loir apart, two major roads also explain the political raison d'être and economic value of Chartres' position. One road runs north-south from Dreux to Châteaudun and thence to Rouen, Blois and Tours. The other runs west-east joining the Maine and the Perche to the Paris region. One is the salt and wine road, the other the cattle road. Together they offered a means of politically dominating the neighbouring plains.

Fertile land and ease of communication were all that was needed to make the region of Chartres more populated in the twelfth and thirteenth centuries than ever before. The small peasants had not yet been decimated by agrarian reorganization and mechanization. The population density was

Cutting the vines. At that time vines were grown as far north as Normandy and Picardy. Voussoir of the right bay of the north portal.

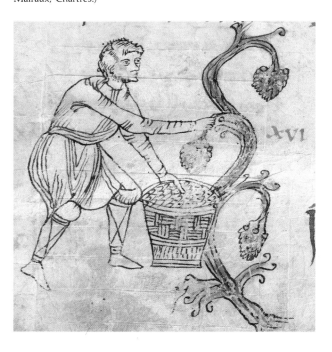

The wine-harvest. The artist had evidently never taken part in a wine-harvest: two hands are needed. (11th-century obituary, Bibl. mun. André-Malraux, Chartres.)

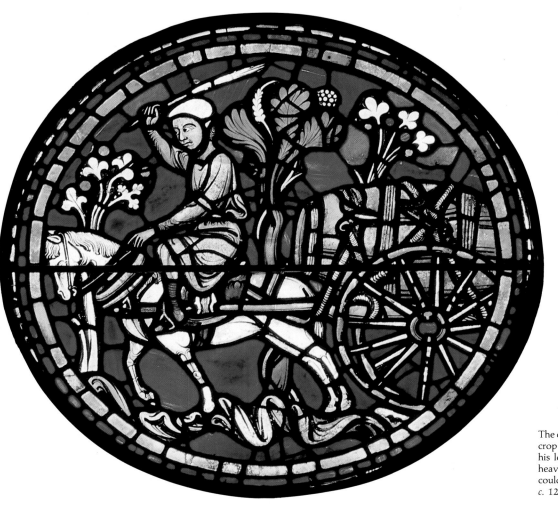

The cart. Transporting the harvest was a heavy task for the peasants. The crop had to be harvested before the rain and the peasant had to bring in his lord's harvest before starting on his own. If the load was not too heavy, he preferred a cart to the heavy four-wheeled waggon which could get bogged down in the mud. (Window of Saint-Lubin, north aisle, c. 1210)

high in the valleys suited to growing vines and fruit, and this encouraged the establishment of village communities and the development of crafts. It was high, too, in the vineyards surrounding Chartres from 1050 onwards, for it needs many, fairly skilled hands to grow wine. Smaller communities also settled initially in the cereal-growing plains which were to gain more importance later with the growth of the Paris consumer market.

At the time when the great cathedrals were built, the Beauce country, with its variety of soils and people, was one of the dynamic areas of northern France; its farmers had anticipated the quarterly crop-rotations of modern agriculture and adopted the techniques of modern agriculture, from the harrow – which improves yield because it covers and protects the seed, as can be seen as early as the eleventh century on the border of Queen Matilda's 'tapestry' – to the pivotal plough invented at the end of the thirteenth century to avoid one-way ploughing when half the furrow is ploughed with the ploughshare raised. In this way the rural world obtained a better return from its investment and work, while the expansion of urban activity was reflected in more capital being invested in agriculture. From the twelfth century, the nobles began to finance farming improvements, and this included the ecclesiastical establishments which attracted the peasants, encouraged land clearance and financed planting.

Farm work. Horses pull better than oxen. The cartload has become even heavier now that the driver sits on the front. This prevents the ox from pulling the coulter and the ploughshare upwards. It is sowing time. On the right, the seed is being covered with a harrow. This is the first representation of a harrow. (Bayeux tapestry, c. 1075.)

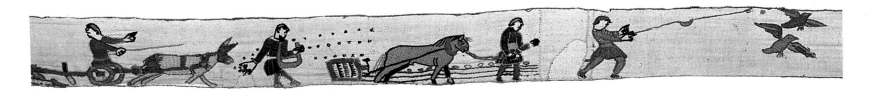

Even in the tenth century, before the year 1000, contracts between nobles and peasants who had applied to clear the land are evidence of rudimentary attempts to restructure the economy in the immediate vicinity of Chartres. A century later, in the 1080s, we see a kind of colonization of the Beauce undertaken at the initiative of some of the nobles, side by side with the first efforts by the peasant communities to gain better control of their environment. In the twelfth century, when the peasants had obtained greater security and were less afraid of their crops being ruined by the passage of knights of the French king, of the count of Chartres or of that terrible nobleman the Sire du Puiset, the Chartres region became one of the most prosperous areas of the Paris Basin. The population increased. Yields improved. Money circulated.

The city of Chartres had become an attraction by then. Peasants from less prosperous areas in the west came there to find work. At the time when the main building of the Gothic cathedral was near completion, the street name rue de la Bretonnerie is evidence of the first organized immigration. Behind the banner of St Malo, the Bretons of Chartres solemnly bore to the site of the cathedral a wagon full of ashlar stones offered by their community.

Others, however, now left to seek their fortune in Paris. Movement is proof of dynamism. And there was movement not only of men, but of ideas, taste and skills. There was no sign here of the closed-in world of a small introspective town.

Chartres expanded. The Gallo-Roman city had long since defined the contours and walls of the late medieval city. The town dating from Carolingian times still occupied the promontory round the cathedral church and its cloister, the château of the counts — already in disrepair at the end of the Middle Ages and finally razed to the ground in the nineteenth century, it was located on the site of the present Place Billard — and, in the south-east, the church of Saint-Aignan. Faced with the threat of Norman incursions during that period, the town actually retrenched, leaving the entire quarter north of the cathedral outside the new wall.

Then, in the twelfth century, a new surrounding wall had to be built, which quadrupled the surface area of the town; it was then, and evidently in part as a result of new trade flows, that the city began to encompass the 'port', which was in fact part of the course of the river Eure, and the lower town which had grown up around this focal point of economic life and around the churches which had hitherto lain outside the walls: Saint-André, Saint-Nicolas, Saint-Hilaire, Saint-Père and Saint-Michel.

In 1020 Bishop Fulbert decided to erect his new cathedral on a considerably expanded plan. A century later, houses had replaced gardens within the city — the gardens having first replaced the vineyards. Everything was being parcelled out. The lower town expanded, the people clustered round Saint-André and Saint-Père. A little later, they began to build near the plain too. It was to cost the bishop one thousand francs to build the section of wall separating the Epars gate and the church of Sainte-Foy in the west.

By the end of the thirteenth century the city had nearly reached the size it was to remain until the dawn of the industrial age. Today its area is still defined by the ramparts which leave part of the medieval wall exposed between the gate of Saint-Jean and the Drouaise gate. Its population was about six to eight thousand, to which we must add one thousand in the suburbs. The population of the modern city is only three times as much.

Peasant warming himself at the fire. It is November on the calendar. (Voussoir of the right bay of the north porch)

Peasant pouring water, wine or milk. In fact, it does not matter which. The sculptor is free to do what he will in the lower parts of the structure which do not form part of the programme planned by the bishops and canons. (Left portal, north transept)

Today that represents a small town. At the end of the Middle Ages, it meant a medium-sized town.

The town was in a difficult position because, although it owed nothing to its proximity to the capital, it suddenly found itself, at the turn of the twelfth and thirteenth century, drawn into the new sphere of influence of the largest metropolis this side of the Alps. From now on the inhabitants of Chartres could no longer forget Paris when they thought of themselves and their city and of the image they endeavoured to give it. Two centuries earlier, Chartres could still easily vie with Paris. But the growing power of the kings widened the gap between the chief county town, which became a dependency of the County of Blois, and the capital chosen by the first Capetians and which Philip Augustus turned into the real political, administrative and legal capital of the kingdom in the latter years of the twelfth century. It is quite consistent that the University of Paris, which became the training ground for many of the higher French officials, was founded at that time.

Henceforth Chartres, the small town of six to eight thousand inhabitants, could never forget that two day's walk away lay a town of one or two hundred thousand inhabitants — the figure it must have reached at the beginning of the fourteenth century — where the real decisions were taken and business was done. No one could ignore such an important consumer market, with its great purchasing power derived from the profits brought in by the influence and pay of administrative and legal services.

For a time Chartres tried to resist the domination of Paris. But it was too late. The die had been cast. Chartres was to remain a small town a short distance from a great one.

It would be hard to understand why the people of Chartres around the year 1200 were so eager to impose their presence if one forgot this new factor of its identity. When Notre-Dame and the great tower of the Louvre were erected, when students throughout France began to desert the cathedral and abbey schools for the universities, whose attraction lay in the variety of courses on offer and the relative freedom of conduct, Chartres realized that there was no longer any question of competing with Paris. Yet it had at least affirmed in stone, on the horizon of the Beauce plains, that it was a great, proud and rich city.

Fortunes of the bourgeoisie

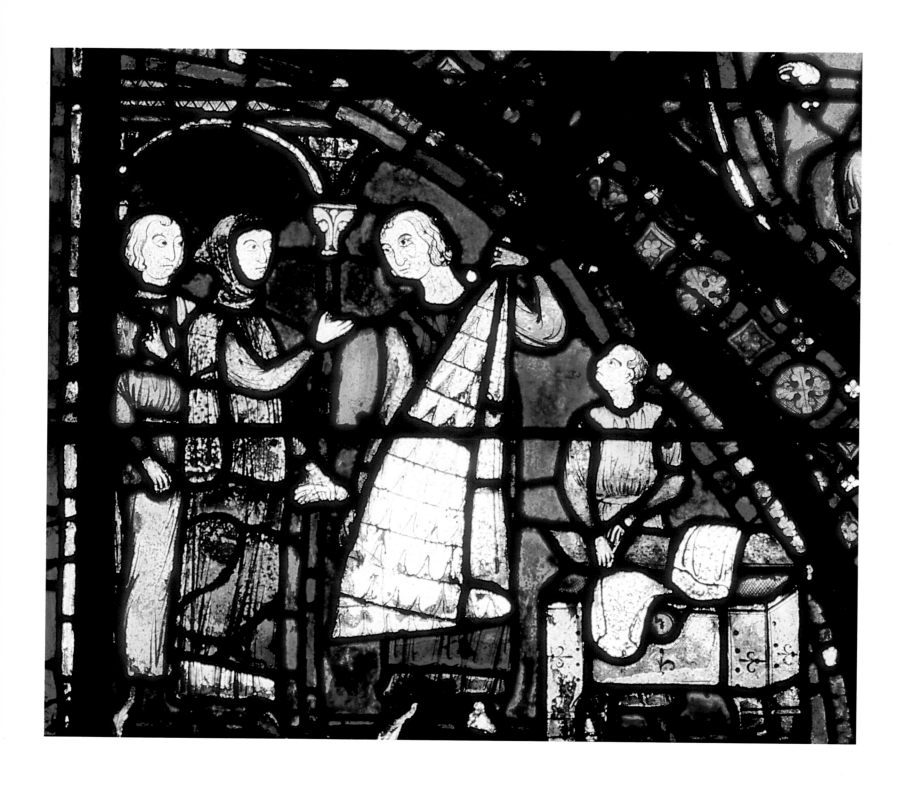

Fortunes of the bourgeoisie

The growing economic strength of the towns was clearly reflected in political relations. The nascent bourgeoisie, organizing themselves to defend their common interests – the interests of their town and of their guild – began to have pretensions about their place in the fabric of society. In the mid-eleventh century, when Chartrain cloth-making was nearing its peak and Chartrain woollen goods were selling throughout France, while the bourgeoisie were taking over the financing and marketing of the finished products of the metal-works established along the rivers near the 'farrieries' of the forest of Senonches, the tradesmen, who were mainly artisans and shopkeepers, began to feel more and more uncomfortable about their marginal situation in the political power structure. Not surprisingly, they dreamed of obtaining an autonomy which would turn the town into a real force in the feudal world.

What some people began to demand aloud, if not with weapon in hand, was to be freed from the direct and always weighty authority of the count or lord, not to be involved in the power struggles between bishops and abbots which had occurred so frequently in history, to sort out their own private legal affairs, which no longer fell within the scope of the traditional feudal land-based system as a result of the new economic trend, and to shoulder their own responsibility for law and order and military defence.

Luckily for the bourgeoisie, their overlords were divided among themselves and could be played off one against the other. As early as 1027, the people of Noyon obtained the bishop's support against the royal chatelain. In 1074, on the other hand, the people of Beauvais obtained the assistance of King Philip I in their dispute with the bishop. Louis VI gained genuine popularity in the towns – especially, it must be added, outside the royal domain – by giving systematic support to the emancipation movement which led to the creation of communes. Philip II Augustus was to reap the benefits of this in July 1214 when the footsoldiers of the communes played such a decisive role on the Bouvines battlefield, later to be praised in a whole body of historical literature; in the eyes of posterity, this episode was the first manifestation of the national unity formed by and for the Capetian king.

Chartres had waited a long time for the communes to become autonomous. The neighbouring towns obtained their autonomy in the twelfth century. Louis I, Count of Blois and Chartres, was not against the idea. Blois obtained its charter in 1196, Châteaudun in 1197. But there was

The draper. In the medieval economy, there was only one industry, woollen drapery. The draper organized and financed the production and was also responsible for supplies and marketing. (Ambulatory window, c. 1210)

Opposite
The furriers. The merchant is offering a piece of squirrel fur to his rich customers, who want to feel it. His assistant is waiting to see if his services are needed. (Ambulatory window, c. 1210)

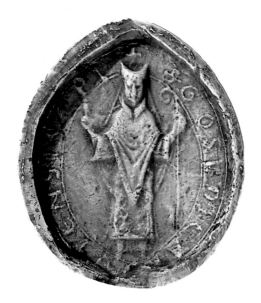

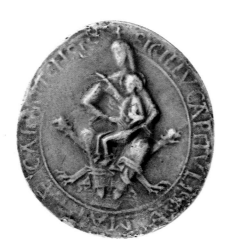

Four Chartrain seals (Archives nationales, Paris). − 1. Goslin de Lèves, Bishop of Chartres from 1149 to 1155. The Royal Portal was built under the pontificate of this grand personage who was related to all the local aristocrats. − 2. The cathedral chapter represents continuity. The bishop passes, the chapter remains. And his seal, depicting the Virgin (dating from 1207), is respected. − 3. The bailiff's court is the administration of the king and his justice. Seal dating from 1443. − 4. The ecclesiastical court administers the bishop's law. The repute of the bishop's seal depends on his influence (seal dating from 1297).

still a blockage in Chartres. In 1195 the Pope authorized the chapter to impose the canonical penalty − in this case censure − on the servants of the church of Chartres if they organized any kind of 'commune, or conspiracy, or rebellion' against it. An uprising in 1210 merely brought anathema on the heads of those who forced the dean of the chapter to seek refuge in the cathedral. They were accused of using a heavy wagon taken from the cathedral site to break down the door of the cloister house where the unfortunate dean's servants had sought shelter. In 1253 a dispute between the chapter and the town provost − about who had jurisdiction over a road near the cloister − degenerated into an uprising: threatened by the bourgeoisie, the canons fled to Mantes, then to Etampes. This time the king, St Louis, found against the bourgeoisie.

It was not until 1297, after the conflict about the amount of taxes payable and about the individual freedoms of the 'citizens, peasants and burghers', that the Count of Chartres − at that time the brother of Philip IV, Charles de Valois − granted the bourgeoisie a charter setting out the obligations of the town towards the count and authorizing them to unite in order to manage their common interests. The people of Chartres soon knew what this was to cost them: 12,000 Tournois francs, that is to say, thirty years of the tax which had been the main source of conflict. But it was more than just a matter of money, it was a question of dignity and freedom. At last the people of Chartres were on an equal footing with the other communes.

This political reality now had to be translated into the urban context. While many towns had long since erected municipal palaces, town halls and bell-towers, the people of Chartres had not aimed so high. The city of Chartres was still dominated by two nearby landmarks: the ducal château and the cathedral with its cloister. Consisting of three roads and encompassing the hospital, the cloister could not even pretend to be a city within a city as it was in many other towns. Some churches, such as Saint-André and the abbey of Saint-Père, created a sense of physical if not political balance. Chartres was neither Bruges with its Palais Communal and its *Saint-Sang*, nor Paris with the Place de Grève and the Maison aux Piliers of the merchant's provosts. The people of Chartres could not express their municipal pride in stone.

Chartres even lacked that symbol of collective bourgeois personality possessed by so many equally or less important towns: a municipal seal. There was the bishop's seal and the bailiff's seal, and especially the chapter's seal, with the effigy of the Virgin on the obverse side and the scene of the salutations of the angels on the reverse. There was no town seal. And there was certainly no seal of the guilds, the trade groups which became one of the political and economic forces of local life in so many towns. In Chartres the guilds looked elsewhere for a means to assert themselves and their prosperity. They were to find their place at the base of the stained-glass windows which they donated to the new cathedral. Showing the typical tools, or the main gestures of their trade, such as the weighing of the apothecary's products in the St Nicholas window on the northern aisle, the artisans and shopkeepers of Chartres regarded the new art of the great stained-glass window as a means of affirming both their own existence and their concern for the common good. One of the prides of any medieval city was its enclosing wall. As we have seen, Chartres had a wall from Byzantine times, extended at the end of the twelfth century by a wall enclosing the suburbs of Saint-Père and Saint-André and even the later parish of Sainte-Foy; this wall even encompassed the course of the river Eure at the foot of

the original city. If the Eure really had been navigable, it would have been a good port, with some development potential. But this was not the case. Although details of the twelfth-century walls were modified on several occasions – in particular with the new fortification of the gates in the sixteenth and seventeenth centuries – the walls themselves never extended beyond the areas enclosed at the time of Philip Augustus and were to remain the main city walls until their destruction in the nineteenth century.

So the people of Chartres had to assert their collective personality elsewhere. At a time when extremely rapid economic growth left enough production capacity free for creating prestige works, many towns directed their energies towards their cathedral.

Since early Christian times, the 'city' had always regarded its main church as a centre of life and a symbol. It was a place of prayer. It was also the site of the main acts of liturgy. And it was a meeting place. Very soon, the cathedral became a symbol of urban identity on the horizon of the town and the surrounding countryside. It was a reminder, if one were needed, that not every urban conglomeration is a 'city'; during these centuries of economic growth, people were not afraid to stress the great age of the political body formed by the city and its chief town since Gallo-Roman times. Official nomenclatures always ranked the 'cities' before recently created towns. Even in the twelfth century, only cities had cathedrals. At least that was the view in the cities, and on the whole it was true.

For a long time the generosity of the faithful made up the bulk of the fortune of the great rural monasteries. Gifts from kings and counts could only take the form of domains, peasants or revenues. The basis of their fortune was land, and the religious foundations remained land-owners *par excellence*. Even the urban churches became wealthy by acquiring rural estates. The best way to found a monastery was to persuade all or some of the local lords to join the place of worship. The time had passed when monasteries were founded at city gates by the early evangelists; with some late exceptions such as the foundations of Duke William and Matilda of Caen, these were the monasteries of Cluny, Conques, Cîteaux, Vézelay and Fontevrault. Saint-Denis lay outside the city, as did Saint-Germain-des-Prés and Sainte-Geneviève.

The economic changes in the twelfth and thirteenth centuries radically changed people's customs. Inherited land began to suffer from the crisis which was affecting all income from land fixed before economic growth gave rise to inflation. Ten *sous* of rent given or bequeathed to a monastery at the time of the first Capetians remained ten *sous*, but the *sou* of the year 1200 was worth one-third of the *sou* in the year 1000. The great abbeys which gave Christianity so many masterpieces of Romanesque art began to pass through difficult times. Some of the people who started renovating their buildings and their abbey churches, inspired by the enthusiastic spirit of expansion, soon had to bring the work to a halt. The lucky chance which has preserved the Romanesque nave of Mont-Saint-Michel, and that of Vézelay too, was in fact simply the inability of the temporal monastic powers to bear the cost of a new building: the construction of the Gothic abbey churches of Mont-Saint-Michel and Vézelay got no further than the choir.

The faithful were beginning to direct their generosity elsewhere. In the 1150s, economic power was no longer concentrated in the large domains but in the towns. The bourgeoisie were happy to give to God or His saints; but they preferred their gifts to be made visible in the town. In the

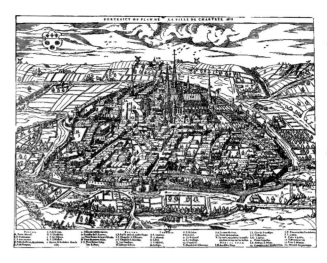

Chartres in the 16th century. Engraving from the *Cosmographie universelle de tout le monde* by Munster and Belleforest (1575). The engraver deliberately exaggerated the difference in size between the cathedral and the other churches. (Bibliothèque nationale, Paris.)

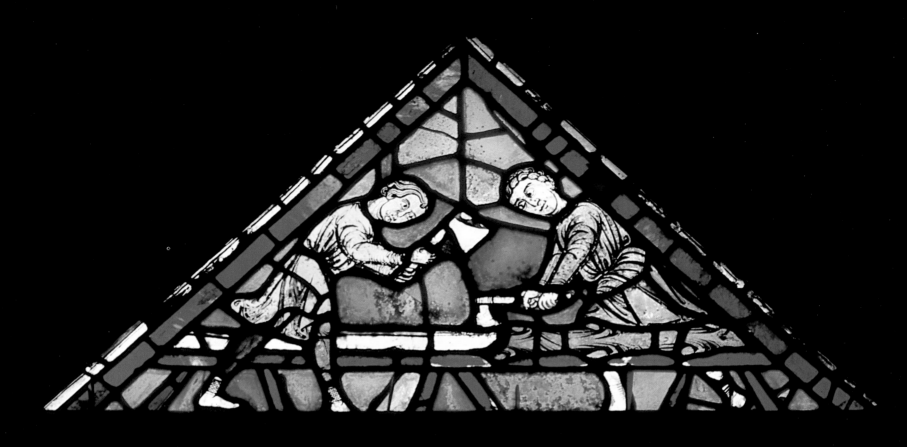
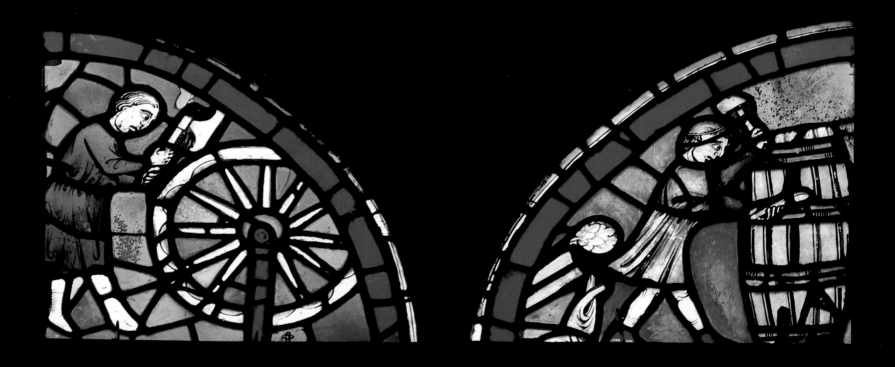

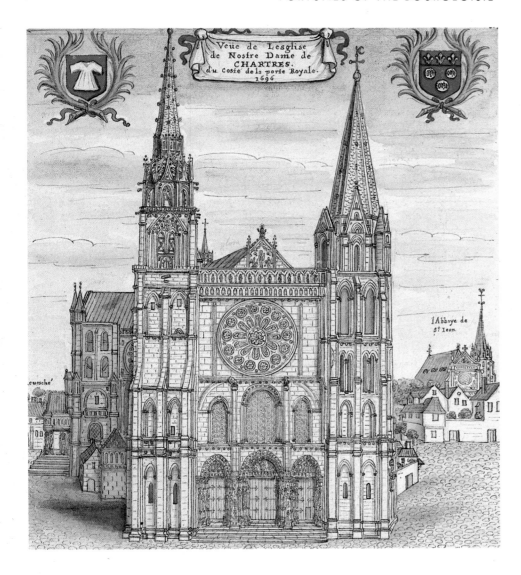

The cathedral in 1696. The north tower has been completed up to the foot of the spire. Engraving by Pierre Ganière (or his father Etienne). (Bibliothèque nationale, Paris.)

thirteenth century the bourgeoisie reserved much of their offerings and legacies for the religious foundations which deliberately chose to establish themselves in the towns and became the focal points of urban religious life: the monasteries of the 'mendicant' orders, the foundations of the Dominicans, Franciscans, Augustines, of 'brothers' who were no longer monks in the original sense of the word and who, far from burying themselves in the country, wanted to open their churches to the general public and preach at every crossroads.

The building of cathedrals formed part of this transfer of gifts and obligations. It was both an act of goodness and a good investment. Now that the townsmen were in control of the public purse-strings and were becoming familiar with the rough competition of the economic market, they were clearly tempted to combine two objectives: to give to the church they could see, and to show what they were able to give. Against the background of towns which inevitably became rivals, the twelfth-century cathedral could be regarded as a work of faith which at the same time enhanced the reputation of the triumphant bourgeoisie.

During the period of expansion, the cathedral chapter of Chartres became one of the biggest landowners of the region. An inventory of its property towards 1300 lists some 3,500 hectares of forest, cornfields and vineyards, bringing the seventy-two canons an average revenue of 5,000 *livres*.

Once they had organized themselves the trades became a political and economic force to be reckoned with. They had their own seal, their guild-hall and their pride, which led them to become patrons of the arts. Of the one hundred and sixteen windows whose donors identified themselves, forty-two were offered by guilds of merchants or artisans. They would offer a window and have themselves represented on it. Here we see the carpenters (above), the cartwrights (below left) and the coopers (below right). (Window from the north aisle, c. 1210)

The rivalry among towns also produced a spirit of emulation that totally defied the caution of earlier times. Naves became wider. The keystones at Laon attained a height of 24 meters, at Soissons 30 meters, at Paris 32 meters. The keystones of Chartres are more than 35 meters high, and more than 36 meters near the west façade. In Amiens they reached 43 meters. One day, at Beauvais, where they reached 48 meters, the whole structure collapsed. This spirit of emulation naturally also affected the height of towers and bell-towers. The bourgeoisie aimed so high that the façade often had to remain unfinished for lack of money to finance such an ambitious scheme. The façade of Chartres, which was nearly completed in the mid-twelfth century, had to wait 350 years for the spire of its second tower which Jean Texier, known as Jean de Beauce, finally began to erect in 1506. The façade of Strasbourg was never completed.

The number of aisles was also increased until there were far more than were needed even for the congregation on feast days. Situated in a town of at most 8,000 inhabitants, the choir of Chartres is surrounded by a double ambulatory and there are aisles even in the transept. And the profusion of portals matches the profusion of aisles and colonnades: the architects of Chartres offered the sculptors no fewer than nine portals on which to display their inventiveness.

The achievement of these bourgeois, both proud and jealous, lay neither in the lines of the vaults nor in the modelling of the statues. Like the bishop and his chapter, the bourgeoisie wanted something and financed it. The craftsmen were responsible for the actual execution of the work of art.

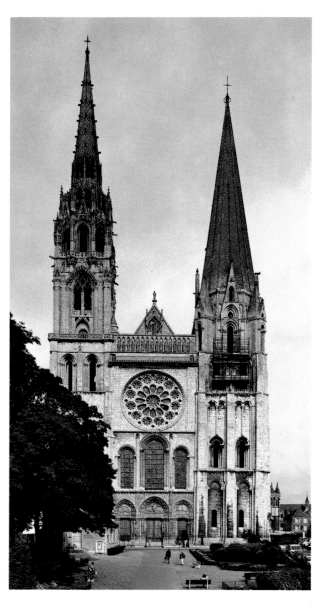

The west façade, with the Royal Portal, as it is now.

Opposite
The labyrinth. Many medieval churches have a labyrinth in the nave floor, signifying pilgrimage towards Jerusalem in this world and the road to Salvation in the next world. A symbol of the Christian way, the labyrinth has never really been used for any religious practices.

A town and its pilgrims

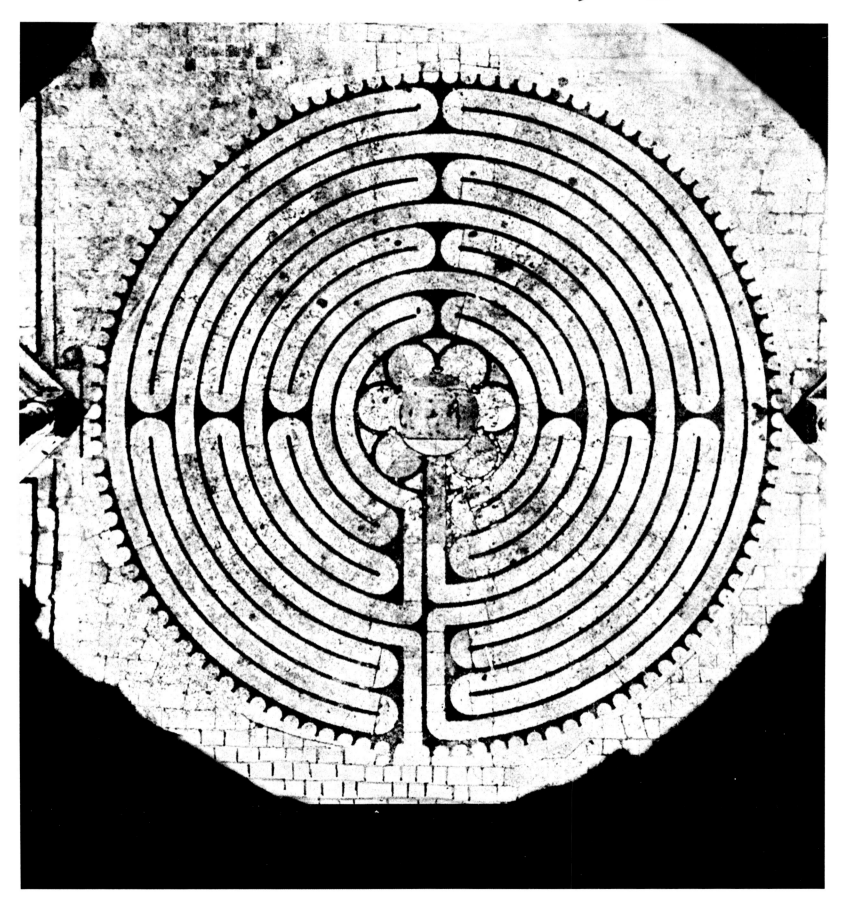

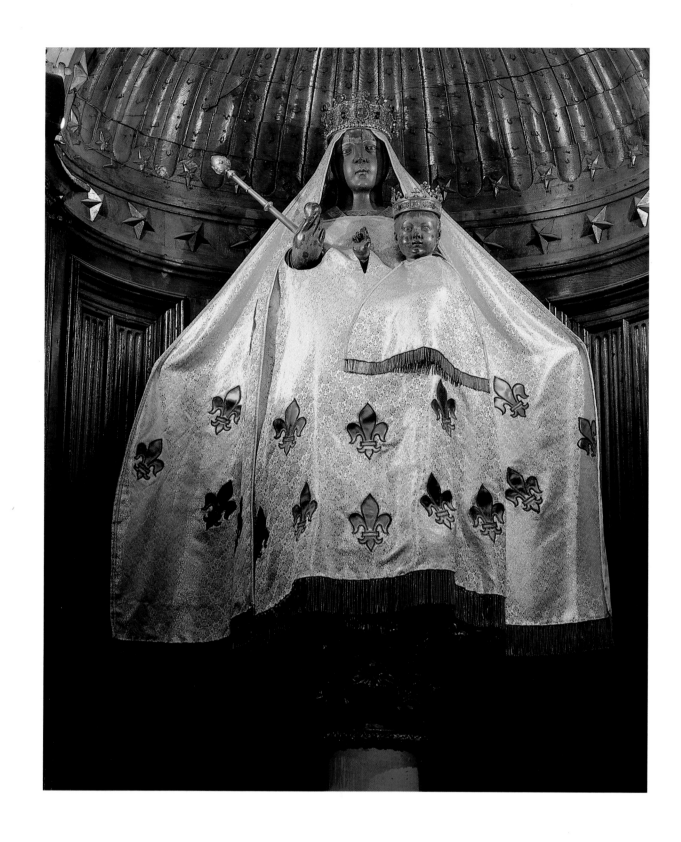

A town and its pilgrims

A capital; a small town perhaps, but a capital. At the dawn of history that is what the Romans called *Autricum*, the city which in the third century attracted one of the most influential peoples of independent Gaul and which was to form a vital element of Roman Gaul. The Carnutes, as this people was called, reached the Seine at the Poissy bend, occupied the eastern part of the Perche and the future Vendômois area and dominated the Gâtinais and northern Sologne. The large villages which were one day to become the towns of Dreux, Nogent-le-Rotrou, Vendôme, Dourdan, Blois and even Orléans all formed part, at one time or another, of the Carnute community.

Of the original town, which in the fourth century took the name of *Carnotum*, Chartres, just as Lutétia took the name of the *Parisii*, virtually nothing remains but a fragment of wall below the cathedral which may or may not have been part of the ancient city wall. A few fragments of an aqueduct and a few sculpted stones have been found; that is all.

By the dawn of the Middle Ages the diocese of Chartres was finally dissociated from the Orléanais province, although it remained a vital factor of political balance for the region between the Seine and the Loire. For a long time to come, Chartres was to escape the growing influence of the young Paris.

When Clovis died in 511, Chartres passed to his son Clodomir, who ruled in Orléans. With the continuous partitions and conflicts between the Merovingians, however, Chartres became a kind of pawn, a frontier town often disputed between the ephemeral 'kingdoms' that made up the kingdom of the Franks. Time after time the town was taken, sacked, set alight. The Normans, in the ninth century, merely worsened the sad effects of this rivalry. And it was outside Chartres, in 911, that Norman troops experienced one of the resounding defeats that led Rollo to accept the compromise of a permanent settlement on the Lower Seine. This was one of the early occasions in the annals of Chartrain history when a miracle occurred: the bishop, faced with the pagan invaders, presented to the people the remarkable relic Charles the Bald had recently offered the city: the Virgin's veil. We shall return to that later.

At this time, the secular organization of the region, which was based on permanent populations, distinguished several districts or *pagi*. By the end of the Merovingian age there were four: Chartres, Etampes, Châteaudun and Blois. There were to be eight in the Carolingian diocese.

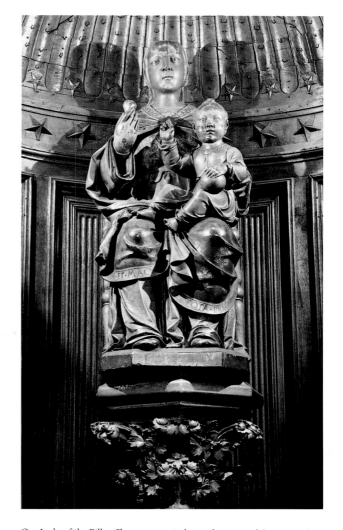

Our Lady of the Pillar. She was a reminder, in the nave, of the main cult in this church, which could not be confined to the crypt towards which the pilgrims were directed. 14th-century statue.

Opposite
The Virgin with the fleurs-de-lis. On feast days, throughout the Christian world, the statues which made the sanctuaries most famous would be decorated. The Virgin of Chartres is, of course, royally adorned.

But as the political world became fragmented and the unity of the empire began to blur, Chartres' horizons narrowed. Sandwiched between the two great powers of the Capetian rulers of Paris and the Normans who held both the Caux and the Cotentin regions, the count of Chartres, a modest administrator of an ancient district of the Carolingian kingdom which had become quasi-independent in the tenth century, found a semblance of power only at those times when he was able to unite Chartres and Châteaudun. The first count known to us by name from the rare extant texts is Thibaut le Tricheur (born 970) who saw Duke Richard of Normandy's army break into his county and sack Chartres.

Chartres was saved by being integrated into a larger principality, one that matched the political stake: from the time of Thibaut le Tricheur, Chartres and Blois came under the same rule, which enabled them to compete with Normandy and with the new power of the Angevins, who were one day to found the Plantagenet state.

For a long time Chartres therefore remained one of the 'marches' of the county of Blois, which became a focal point of the feudal organization of the kingdom of France in the eleventh century when the same territorial prince reigned in Blois, Tours and Champagne. The princes of the Blois-Champagne family directed their ambitions to the Loire and the Cher, the Upper Seine and the Marne – not to the Eure. Chartres was off the beaten track of political activity.

Very soon the town and its little county passed on to collateral branches, to heirs by alliance. In 1286 Philip the Fair bought the county of Chartres from the last of its heirs, the widow of a son of St Louis. By marrying the countess who was both heiress of Champagne and also Queen of Navarre, the king of France finally protected himself against the threat of encirclement that had so often loomed over his ancestors with the episodic alliance between Blois-Champagne and Normandy. Philip the Fair gave Chartres to his brother Charles of Valois, that unhappy and clumsy prince who dreamed of a throne and never managed to become more in the history of France than the son of a king, the brother of a king, the uncle of three kings and, finally, the father of a king, without ever acquiring for himself a single one of the crowns for which he plotted so much. The accession of his son Philip of Valois, who was crowned king of France in 1328 on the death of the last direct Capetian king, changed the destiny of Chartres: in 1346 the county became part of the royal domain.

Raised to the status of duchy by Francis I for his daughter Renée, then given by Louis XIII to his brother Gaston of Orleans and by Louis XIV to the new House of Orleans, the county of Chartres in fact remained in the hands of the king and his officers. Chartres was now merely a small town, in the shadow of the capital.

From the beginning, Chartres owed most of its influence to its sanctuary. The sanctuary of the Carnutes had already attracted the Gauls. The cult of the Virgin, which became established from Merovingian times and probably even before the seventh century, owes nothing to the legend that the Church of Chartres was founded by direct disciples of St Peter and SS Savinien, Potentien and Altin on which medieval iconography laid such store. Modern historiography has changed the chronology somewhat: it does appear that the Church of Chartres, as a public body, was the fruit of the religious peace established by Constantine at the beginning of the fourth century. But other personages, local martyrs like St Cheron and St Piat, seem to have played a more definite role in the foundation of a

Chartres in 1568. This engraving of 1891, published by Bellier de La Chavignerie and based on a painting of 1568, shows the count's castle with its fortifications, dominating the Romanesque chapel of Saint-Vincent. Below, projecting over a row of houses, are vestiges of the late medieval wall. (Bibl. mun. André-Malraux, Chartres.)

Christian community at Chartres. It is difficult to assign them an exact date.

The Virgin preceded Christianity. Even before the birth of Christ, Chartres seems to have had an altar and a statue in honour of the 'parturient Virgin', whom medieval texts call *Virgo paritura*, making this premonitory cult into one of the first miraculous manifestations of the spirituality of Chartres. Israel had its 'prefigures', who are very much in evidence on the cathedral portals. Chartres had its own prophecy about the coming of the Saviour, which was just as significant as the pagan prophecies of the sibyls. Legendary historiography attributes to the founding saints the honour of having persuaded the people of Chartres to dedicate their cult of an unknown Virgin to the Virgin whom they were announcing as the mother of Christ. For the rest, legend does not hesitate to date the foundation of the Church of Chartres to the actual lifetime of the Virgin. And fourteenth-century Chartrains told in all seriousness how their predecessors sent a deputation to Mary offering her the rule of their town. Contemporary historians must at least admit that a tradition has been maintained. The Virgin of the druids gave way to a cult of Mary which has at all times been fundamental to the influence of Chartres.

Certainly, there were a great many relics in the treasury of the medieval cathedral, and certainly the pilgrims gathered there in numbers. The Virgin's 'tunic' is the main relic; it is a piece of silk some five meters long. When Bishop Charles-François de Mérinville had the shrine opened in 1712, it was decided that the word 'tunic' was unsuitable; henceforth it was to be the 'veil' of the Virgin. According to recent expert examination (1927), the cloth may well date from the first century A D.

Chartres was already a famous place of pilgrimage in the ninth century when Charles the Bald donated the precious relic. This further increased its reputation. The Virgin of Chartres was said to cure 'St Anthony's fire', which was no doubt the nervous disease we know as ergotism. A place now had to be found to house the sick. The crypt was used more as a hospital than a place of worship. Pilgrims came from all over Christendom.

The Virgin began to acquire a position in Western devotional life which she had not had in the primitive Church or under its successors in barbarian times. Of course the Virgin was present in all the episodes of the life of Christ, and especially in the 'Infancy of Christ' so often depicted in Romanesque art. Byzantine art reserved a choice place for the effigies of *Theotokos*, the Mother of God, who is represented in majesty on so many mosaics, forming a hieratic throne for the Infant-God whom she is holding up to be worshipped. From the Annunciation to the Flight into Egypt borrowed from the Apocrypha, the Virgin was always present, an essential figure. But she was rarely there for her own sake.

In the cult of the Virgin that began in the twelfth century, especially with the sermons and letters of St Bernard, the Virgin was regarded as incarnating the original spiritual values. Bernard of Clairvaux saw her as the ultimate mediator, continually pleading the cause of the whole human race to her Son. Halfway between the natural and the supernatural, she was seen as God's chosen intermediary. Notwithstanding the Immaculate Conception, on which the men of the twelfth century – including St Bernard – did not dwell, she represented the human condition and she more than anyone was able to understand the frailty of man. The Virgin was the 'sinners' refuge'. Accordingly, all approaches to God were organized around the Virgin Mary and through her. Innumerable miracle plays, more or less written down, expressed in the simple language of the man in the street and

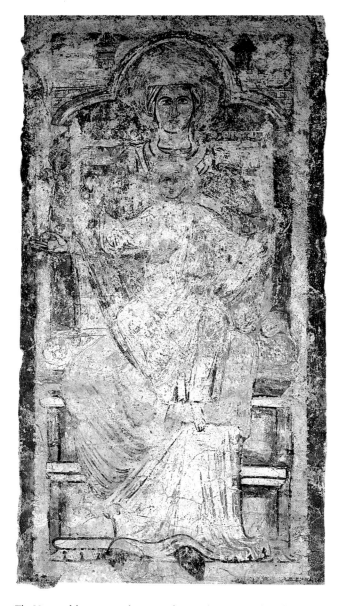

The Virgin of the crypt. 12th-century fresco. This painting dates from the time when St Bernard gave fresh impetus to the cult of the Virgin.

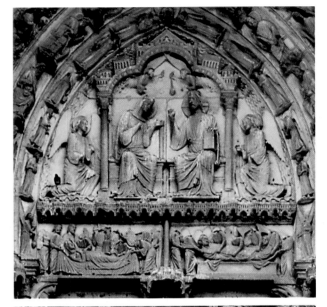

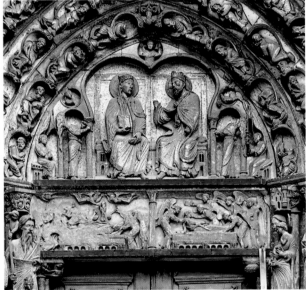

Glorification of the Virgin. Below, the tympanum of the portal of Senlis where this theme appears for the first time (towards 1185) as a coherent image. Above, the tympanum of the central portal of the north transept of Chartres (c. 1215). On the lintel, the Dormition and the Assumption. Above, the Coronation of the Virgin.

Opposite, above
The Jupiter cameo. The Middle Ages took this Roman jewel (1st century), which shows Jupiter in classical pose, to be St John the Evangelist with his allegorical eagle borrowed from the vision of the Apocalypse. Offered to the cathedral by Charles V in 1367, it is now in the Cabinet des médailles of the Bibliothèque nationale, Paris.

Below
St Cheron. The saint is healing a possessed man and making a blind man see. As so often, the saint's miracles – and his gestures, such as the way he touches the blind man's eye – are exactly the same as those which the Gospel attributes to Christ. North ambulatory window, c. 1220.

his trestle theatre the essential idea that there is no sin that cannot be expiated; the intercession of Mary was the sinner's last resort. It was also the first step in the heavenly hierarchy which the sinner could attain by direct entreaty. In this feudal world with its pyramidal structure, where social relations precluded any direct access to the highest authorities, people felt the need for an accessible protectress capable of bearing man's humble supplication to Heaven. 'The Son shall answer the prayers of his Mother', St Bernard wrote, 'and the Father shall answer the prayers of his Son.'

From the mid-twelfth century, St Bernard's enthusiastic cult of the Virgin was to bear fruit throughout the West. The great Gothic cathedrals were dedicated to Our Lady. The counterpart to the terrible Last Judgment with which the Romanesque sculptors adorned their portals, and which we find at Chartres too, dominating the sculpture of the south façade, is the far more human image in the Coronation of the Virgin. It also gives its real meaning to the 'historic' vision of the Incarnation on the north portal. While the Tree of Jesse, as in the window of the façade of Chartres, depicts a symbolic genealogy and affirms the humanity of Christ, the theme of the Glorification of the Virgin, first seen in Senlis around 1185, is intimately associated with human destiny and its supernatural conclusion. The Death and the Assumption of the Virgin form the bases of the higher motif of the Coronation, Mary's entry into the Glory of the Creator.

When the sculptor of the north transept portal of Chartres took up this theme in the early years of the thirteenth century, he still treated it with the utmost simplicity: two kneeling angels frame the double throne, two incense-bearing angels appear above, in a lightly sketched background. Everything is in balance, the angels bearing away the Virgin for her Assumption are the counterpart of the Apostles who surrounded her on her deathbed. This balance was significant. The throne of the Virgin is no lower than that of her Son, and the way she inclines her head to receive the crown in no way suggests submission. The Coronation really associates Mary with the Son of God. We are far from the hierarchic visions of Romanesque art, which was still under the influence of the East and especially of Byzantium. Very soon, the 'Litanies of the Virgin' were to make Mary the 'Mother of God', as reflected in the hymn *Regina Caeli*, Queen of Heaven, which rather forgets the Creator. The Virgin was beginning to assume an exceptional place in the Western Christian mind.

It hardly needs saying that this emergence of the Virgin as the central figure of Christian religion greatly enhanced the reputation of those sanctuaries where she already represented the spiritual point of reference. This trend turned Chartres into an outstanding site of pilgrimage, matched only by the St James of Santiago de Compostela, the Mary Magdalen of Vézelay and the Archangel of Mont-Saint-Michel. As the sanctuary of the Virgin, Chartres Cathedral became the main site of worship for pilgrims seeking grace.

At the time of the great crusades, Chartres therefore became one of the chief places of pilgrimage in the Western world. The next century, the popes favoured it with special indulgences. The feasts of the Assumption and of the Birth of the Virgin (on 15 August and 8 September) were annual highpoints. Several kings of France came to them, as did a king of England, princes and prelates, as well as a number of honest citizens and ordinary peasants. St Louis came on foot and offered a rose window. Charles V decorated the Veil of the Virgin with an antique cameo, now in the Louvre;

because it depicted Jupiter with his eagle, it was regarded as St John with his eagle. Louis XI paid for a precious tabernacle to protect the miraculous statue.

To enable the faithful to approach near the shrine and the statue of the Virgin, which were displayed above the main altar, a wide ambulatory was built round the cathedral choir. The sixteenth century was to resolve the problem of the circulation of visitors less elegantly: it enclosed the shrine in a 'treasury' inaccessible to the ordinary pilgrim and placed a replica of the miraculous statue at the transept crossing, in front of the rood-screen.

New objects of worship had been added to the original ones. By the end of the Middle Ages, the statue in the crypt — the 'Black Virgin' — had become the object of a cult separate from the one which drew the pilgrims to the main altar. And by the eleventh century, if not even in Carolingian times, a miraculous well in the crypt, into which the bodies of the first martyrs were supposed to have been thrown, had also become a devotional object. This was the well of the 'Saints-Forts'.

The saints specific to Chartres also formed part of the attraction of the sanctuary. St Piat and St Cheron worked miracles too and the pilgrims came for them as well.

The pilgrims to Chartres also became involved to some extent in the large-scale building work carried out in the twelfth and thirteenth centuries

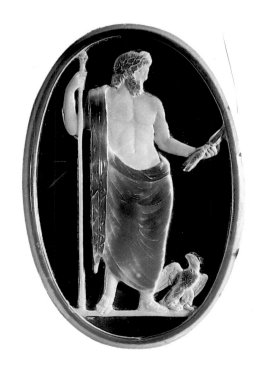

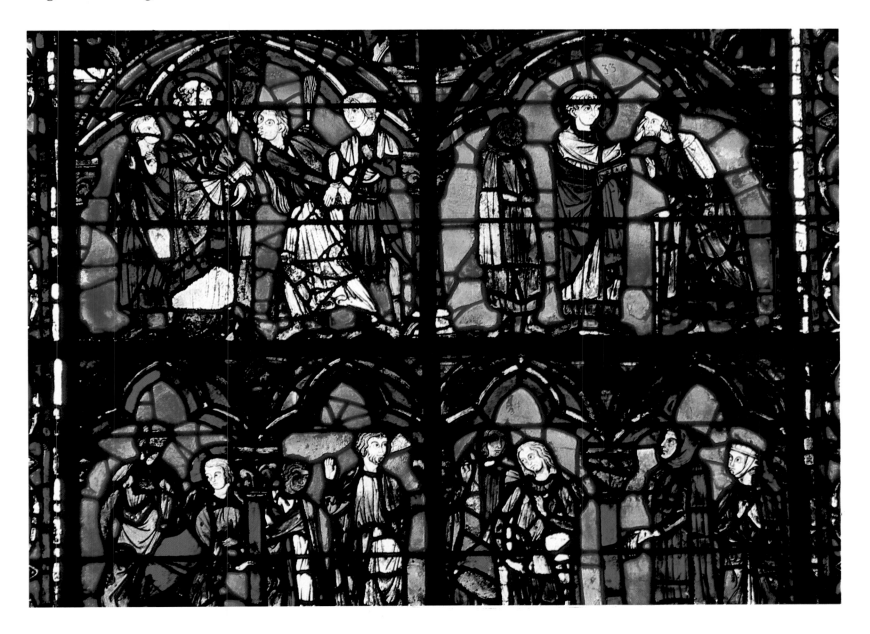

to create the present cathedral. The generosity of the faithful largely financed the building, and many of the pilgrims lent a hand with less specialized work. The confession, the offerings, but also the carriage of stones and wood, all this formed part of the religious ceremony. The sixteenth-century embellishments, from the north tower to the choir screen, were also due in large part to the influx of pilgrims and their contributions.

Pilgrimage came under threat in more recent times. The Revolution put an end to it. And when the Christians from the Paris region took the road to Chartres at the time of the Second Empire, it was in a quite different spirit. On his own initiative and in a moment of distress, Charles Péguy brought in students from the capital. In 1912, he was surrounded by only a few friends. There were fifteen students in 1935, six thousand in 1950, twenty thousand in 1962. No one mentioned the 'Saints-Forts' any more and no one expected more miracles. Pilgrimage, with its profound penitential significance, had now became mainly a demonstration of faith.

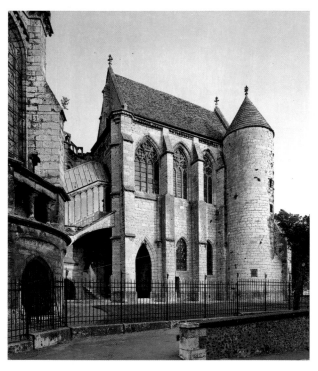

Saint-Piat Chapel. Built outside the cathedral towards 1330 and flanked by two towers used as the chapter's prison and for the archives, in the 1350s it was connected with the main building by a stairway.

Intellectual activity

Intellectual activity

Chartres very quickly established itself as an intellectual centre. With the rise of urban society, the episcopal schools began to compete with the abbey schools, and eleventh-century society learned to pay attention to what was said and written at Chartres.

Of course the West had never forgotten that the cities were the centres of intellectual life in Roman times, or the role which the first evangelists had played in them. Tours and Orléans, Metz and Auxerre had had their own schools, rapidly organized round the bishop and his clergy. But the predominantly rural life of barbarian times – with many of the more dynamic aristocracy withdrawing to their large estates – had made the fortune of the schools established within the major monasteries. From the ninth century on, the life of the mind – which meant art as much as intellect – was represented far more solidly by the schools of Bec-Hellouin, Corbie and Fleury-sur-Loire than by what remained of the schools around the cathedrals of Toul, Rheims and Limoges. Even in Paris, teaching and thinking long remained the prerogative of Saint-Victor and Sainte-Geneviève, outside the cathedral precincts, rather than of the cathedral and its cloister in the Cité.

The growth of the urban economy, of production and in particular of trade after the year 1000 put an end to this situation. And it should be remembered that for a time this change also spelled victory for the secular clergy of the cathedrals and the parishes over the secular clergy of the monasteries and the priories. The flourishing of the mendicant orders – Franciscans, Dominicans, Augustins and Carmelities – restored order in the thirteenth century by reinstating the regular clergy as the spiritual counterbalance of the territorial hierarchy of the dioceses and parishes, a role hitherto played by the monastic orders, especially the Benedictines and Cistercians.

Chartres assumed an extremely important place among the schools opened in the shadow of the cathedrals. There was a long scholarly tradition in the heart of the Beauce country. From the fifth century, at the time of Clovis, bishops such as Flavius and Solenne were regarded as great thinkers. In the next century, one Chartrain was so proud of having followed the teachings of a schoolmaster named Chermir that he had this inscribed on his tomb as a title to fame. Master Béthaire, a near contemporary of Dagobert, stopped teaching only when he became bishop of Chartres.

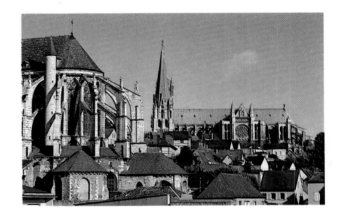

View of Chartres. In the foreground, the Gothic chevet of Saint-Aignan (16th century).

Fulbert, Bishop of Chartres from 1006 to 1028. He was both one of the great thinkers of the 11th century and one of the most energetic architects of Chartres. Here he is shown teaching the faithful. The pastoral crook has not yet become the jewelled crosier of the next period. The bishop can be recognized by the straight stole he wears – as opposed to the crossed-over style worn by priests – under his chasuble. The 11th-century obituary states that Fulbert was a pastor to his flock for fifty-four years and ten months (11th-century obituary, Bibl. mun. André-Malraux, Chartres.)

In Carolingian times, many clerics came to Chartres to study the liberal arts, i.e. theology or medicine. Richer, the chronicler of Hugh Capet, was one of the medical students who owed their knowledge to the school of Chartres in the tenth century.

Then there was Fulbert, an Italian. He studied mathematics in Rheims under one of the most remarkable men of his time, a man who was to become pope in AD 1000 after being the architect of Hugh Capet's accession to the throne in France: the professor of theology Gerbert of Aurillac. Fulbert arrived in Chartres shortly before the year 1000, when his master had left France, never to return. At the time, Gerbert was archbishop of Ravenna. Fulbert was a schoolmaster of Chartres. In 1006 he became bishop. A skilful practitioner of the liberal arts which are the road to knowledge and expression, he was also a lucid and exact analyst of his times, and it was not surprising that princes corresponded with him and chose him as their confidant and advisor.

Clerics came from all over France to hear him teach. He had pupils from Paris, Normandy, Aquitaine and Picardy. King Henry I's doctor said he owed his knowledge to Fulbert's teachings. Students also came from Liège, Besançon and even Cologne. Adelman of Liège, who was master of the episcopal school of Liège and then bishop of Brescia, dedicated his *Alphabetic rhythm of contemporary famous men*, a dictionary of proper names that was a worthy attempt at writing history in the style of Plutarch, to the memory of his master Fulbert. Other students admired the bishop of Chartres' dialectical skill and his reputation for dogmatic accuracy. In one of the great theological disputes of the mid-eleventh century, which ended with the scholar Berengar of Tours being declared a heretic partly because he treated the real presence of Christ in the Eucharist as an intellectual symbol rather than a material presence, both sides equally referred to Fulbert's doctrinal teachings and his exegesis of the Scriptures.

We know that at that period the princes were not afraid to consider the problems of this world: to this we owe the first systematic consideration of the legal and political effects of the vassal-lord contract. In a letter, which has rightly become famous among historians, written in reply to William V, Duke of Aquitaine, in 1020, the Bishop of Chartres defined the rights and duties of lord and vassal under that contract – a contract entered into freely between two men – which formed the basis of feudal society.

After Fulbert (died 1028), Chartres experienced another peak of intellectual activity under a bishop who was a famous master of canonical law: St Yves of Chartres, not to be confused with the Breton advocate and saint who was one day to become the patron saint of advocates. The quarter of a century (1090–1115) during which Yves reigned over the Church of Chartres and its school was marked by considerable progress in legal studies, which came in the nick of time; for this was the period when the growing complexity of social structures and the administrative machinery of the princes and the towns revealed a clear need for the services of lawyers and legal advisers. The school of Chartres became a seminary for administrators.

The period after Bishop Yves saw the development of what we would call philosophy. The schoolmaster of Chartres at that time was the grammarian Bernard, who taught from 1114 and who, as chancellor of the Church of Chartres, presided over the school until his death in 1124. Bernard tackled the same fundamental problems that an Italian, Thomas Aquinas, was to try to resolve in Paris in the next century: the problems of

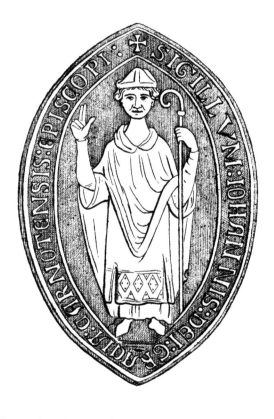

John of Salisbury, Bishop of Chartres from 1176 to 1180 and one of the scholastic masters of the 12th century. He was bishop for only four years and his seal is known only from this drawing by Paul Gillard, executed in the 19th century after an anonymous 18th-century drawing. (Bibl. mun. André-Malraux, Chartres.)

the relationship between Platonic idealism and Aristotelian rationalism. Bernard of Chartres believed it was possible to take an intellectual approach to the Revelation. He taught that one could go further along this road than the Church Fathers.

In the early twelfth century, at a time when teachers began to argue about doctrine throughout the West and masters and students travelled from town to town, it was still the 'liberal arts' which made the reputation of an intellectual centre. The liberal arts meant, first and foremost, the 'three channels' of intelligence and expression, those fields of learning used to analyse and disseminate thought: grammar, or the art of saying exactly what one wants to say; rhetoric, or the art of making oneself understood; dialectics, or the art of persuasion. Then there were the 'four ways' of knowing the world: arithmetic, or the science of numbers and analysis; geometry, or the science of space and how to master it; astronomy, or the science of mechanisms apprehended by observation as much as by reflection; and music, or the science of universal harmony.

We owe the treatise on the seven liberal arts, entitled the *Heptateuch*, to a master of the school of Chartres called Thierry, who may have been Bernard's brother. This treatise, with its selection of quotable texts, gives us an extremely clear idea of the basic teaching and points of reference used towards the middle of the twelfth century. Of course it contained a few ideas taken from the late Greeks and from the Arabs in the limited field of astronomy: much was made of the *Astronomical Tables* drawn up by Ptolemy in the second century A D. And we must not forget the foundations of geometry laid down by Euclid. But these exceptions aside, nearly everything came from ancient Latin sources, which had been reduced to a few classical 'authorities' like Cicero. So it is not surprising to find Euclid and Cicero beside the allegories of geometry and rhetoric on the voussoirs of the Royal Portal.

In fact, this culture was sustained mainly by certain late manuals without which the high Middle Ages would have been ignorant of the bulk of the thinking of antiquity. The foremost of these were the *Grammar* by Donatus and the one by Priscian, who became so confused that the visitor hesitates whether the figure on the Royal Portal representing the liberal art of Grammar, shown writing at his desk beside Pythagoras, is Donatus or Priscian. Students read the *Dialectics* by Porphyrus and by Aristotle, but in the abbreviated and convenient version produced by Boethius for the less exacting contemporaries of Clovis the Frank and Theodoric the Ostrogoth.

Thierry of Chartres, who taught in Paris for a while and returned to Chartres in 1150 to head the cathedral school, was a stern and austere man who regarded scholarship primarily as a means of spiritual progress and not as the royal road to honour and fortune. He missed no opportunity to remind students who were a little overeager to graduate without bothering too much about knowledge that the true scholar is modest. We are, he would tell them, 'dwarfs sitting on the shoulders of giants, that is to say the ancients'. If you look a little closer, he would add, there is no reason not to be proud of that. Without the ancients, we would be nothing. This preaching of intellectual humility underlay scholastic thinking and its foundation, the *authority* of the Scriptures, the Fathers and the Ancients.

The image of dwarfs perched on the shoulders of giants made such an impression that it is found again fifty years later on the windows of the southern façade of the new cathedral: on both sides of the Virgin with Child – it is worth making this comparison in a cathedral which so abundantly

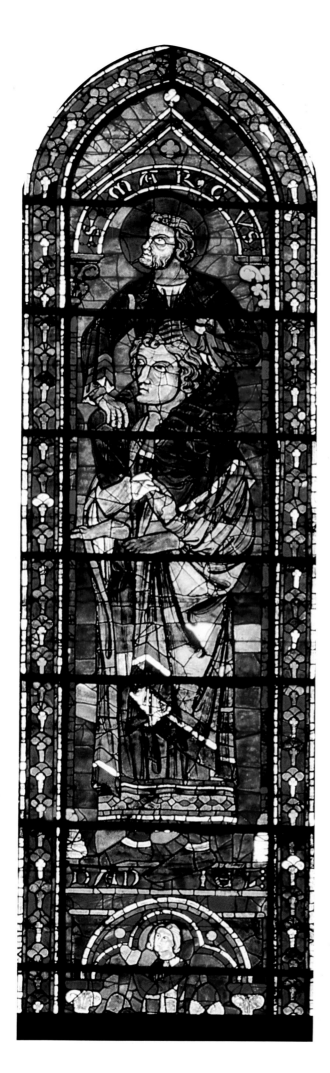

portrays the theme of the human genealogy of Christ and the completion of the Old Testament by the New — four large windows show St Luke on Jeremiah's shoulders, St Matthew on Isaiah's, St John on Ezekiel's and St Mark on Daniel's. Surely this is reminiscent of the lion of St Mark and the lions in the den Daniel was thrown into. Surely there is a connection between Ezekiel's fantastic vision, with the four symbolic animals, his announcement of the misfortunes of Israel — the sword, famine and pestilence — and the curse of the Lord, and the apocalyptic vision of St John in Patmos, which is equally symbolic and terrifying. We can also compare the beginning of the Book of Jeremiah, who was ordained a prophet while still in the belly of his mother, with the first chapters of St Luke, describing the annunciation by the Angel and the Virgin's visit to her cousin Elizabeth. Mary's *Magnificat* — 'for he that is mighty hath done to me great things' — echoes Jehovah's prediction as related by Ezekiel: 'I have this day set thee over the nations and the kingdoms.' As for St Matthew, with his human genealogy of the Saviour, he follows directly in the line of Isaiah, who describes and explains the vision of the Tree of Jesse.

Medieval man was familiar with these parallels, this reasoning, these images. He did not always consider the details. But he entirely grasped the meaning, which is the continuity of human destiny, in other words the path of Redemption.

In his teaching at the episcopal school of Chartres, Bishop Thierry also gave new vogue to the idea often put forward in Christian antiquity of the parallelism between the two Testaments. According to Thierry of Chartres, one of the certain ways to understand the Scriptures was to seek in antiquity the 'prefigurations' of Christ, episodes which foretold the Redemption, to identify symbols anticipating the New Testament, and in particular the sacraments. The school of Chartres pursued this task with a fervour which was reflected once again by the introduction of elements of this parallelism into Chartrain iconography. All the 'prefigurations' of Christ — from Isaac's sacrifice to the priest-king Melchizedek's offerings can be seen in concordance both on the cathedral porches and in the teachings of Master Thierry.

As an intellectual centre, the school of Chartres reached its peak in the 1150s when the Royal Portal was begun. The masters of Chartres were among those who discovered in the Arabic literature of Spain and the Maghreb many aspects of antique thought still unknown at that date. The first victim of this search for a rational road to faith was a former master of Chartres who became bishop of Poitiers, Gilbert de la Porrée, whose doctrine was condemned in 1148. Others were to follow, until the advent of the first Thomists.

There was Aristotle the logician, passed down to the Middle Ages as part of the Greco-Latin legacy of the Roman world, whose face appears in the voussoirs of the Royal Portal as the main representative of dialectics. Then there was the Aristotle of literary legend, the Aristotle of the *Lay*, which shows us the great thinker dominated by his senses and agreeing to carry his mistress publicly on his back in order to please her. Many iconographers, from Romanesque to Gothic times, have left us their pictorial version of this contradiction between man's reason and his senses. But now there was also Aristotle the philosopher, the proponent of a moderate rationalism which Siger of Brabant, Albertus Magnus and, above all, Thomas Aquinas, tried a hundred years later to harmonize with the story of the Revelation.

The school of Chartres at that time was above the vain quarrels of the logicians. During the twelfth century, when the increased knowledge of Greek and Arabic authors opened up new vistas of scientific thought, the intellectuals preferred the 'arts' of the knowledge of material things. Notwithstanding the views of the traditionalists – of whom there were many in Paris – who disapproved of this new interest in the elements, in nature and the universe, the masters of Chartres endeavoured to understand man and the world. A few years later, on the right portal of the south transept, Solomon appeared as the doctor of ancient wisdom, the Biblical master of the secrets of knowledge.

The humanism of Chartres tended towards rational research into and investigation of a universe which was no longer only the Creation. Man began to be integrated in nature just as, in the thirteenth century, he was to become integrated in a natural 'state' which may have been the will of God but was certainly not ordered by the Church. These masters of Chartres rejected the classical view of human nature as a mere moment in Creation:

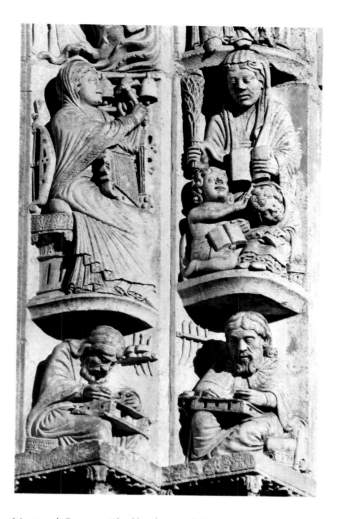

Music and Grammar. The liberal arts, which are the foundations of knowledge and expression, were still very popular subjects among 12th-century artists. But the philosophers of antiquity were only names to them. Music can be distinguished by the harp and the little bells, but the philosophers are not differentiated at all and are shown simply as writers, wise old men sitting at their desks with sharpened pens. Pythagoras and perhaps the grammarian Donatus. (Right voussoir of the right portal of the Royal Portal.) On the left, Aristotle. (Left voussoir.)

Opposite
The Moderns on the shoulders of the Ancients. St Mark, carried by the prophet Daniel. Philosophic speculation and the weight of its authority are quite justified if the arguments are based on revealed truths. (Large window on the south façade, *c.* 1229).

instead, man was the object of the Creation. God created the world for man and for human reason.

In the end, the intellectual baggage of the Middle Ages came full circle. It is to another bishop of Chartres, Bishop John of Salisbury, that we owe the *Polycraticon* in which fifteen generations of students were to find the apt quotation, the texts they needed to know, the images they needed to develop. The bishop who reigned at Chartres from 1176 to 1180, at the height of the new art we call Gothic, was certainly one of the masters who 'fixed' the course of medieval thought, as the authors of the *Roman de la Rose* were to do some years later. After that time, medieval thought was to find it very difficult to gain fresh impetus without departing from its basic doctrines. In the middle of the fifteenth century, all the quotations used by that reluctant student François Villon were still culled from John of Salisbury's *Polycraticon*. It is, therefore, hardly surprising that Villon's genius had nothing to do with anything he learned at school. By the end of the twelfth century, the dynamism which had made Chartres such a great intellectual centre had begun to bear its final fruit. Afterwards, men were to seek other things, but elsewhere.

The cathedrals

The cathedrals

Over the centuries, one cathedral has succeeded another in the heart of the area called the cloister and which corresponds to the central third of the Gallo-Roman villa. The cloister was a town within a town. In the middle of the thirteenth century, the wealth of the seventy-two canons provoked such hostility among the people, who had been taxed again and again to pay for the building of the cathedral, that the cloister had to be closed to protect the canons from possible riots.

The first cathedral was no doubt built during the religious peace brought about by Constantine at the beginning of the fourth century. Nothing remains of it. The monumental church complex presumably comprised two places of worship, which were also cathedrals, that is to say two bishop's sees: the church of Notre-Dame on the site of the present cathedral choir, and the church of SS Sergius and Bacchus – destroyed at the beginning of the eighteenth century, though not by the Revolution – to the north, both presumably separated by the baptistery, a detached building in accordance with ancient usage, of which we still find a few examples in France, for instance in Fréjus and in Poitiers. This complex was completed by a bishop's palace on the site of the classical palace which stands there today and a hospital for the sick situated south of the present façade.

After being damaged to some extent by Duke Hunald of Aquitaine's army in 743, the cathedral of Notre-Dame was soon restored without many changes. That is when a 'residential' complex with houses, a refectory and a cellar were added. This was the cloister, which was designed to foster the communal life of the cathedral chapter which Charlemagne's reforms had made into the basis of religious life within the diocese.

The cathedral was restored again after the town was sacked by the Normans in 858. 'St Lubin's vault' in the crypt, below the apse of the present cathedral, presumably formed part of the Carolingian building; it is a fairly large structure, basically consisting of a barrel-vaulted passage curving round a central mass of masonry no doubt intended for the tomb of one of the founding saints.

A fire ravaged the Carolingian cathedral in 962. It was restored as well as possible. Yet another fire, in September 1020, destroyed it completely.

At that time the ambitious and influential Fulbert, advisor and tutor to princes, was bishop of Chartres. He wanted a cathedral worthy of his status and worthy of becoming an increasingly important place of pilgrimage. Most of the present crypt dates from this Romanesque structure –

Entrance to the Carolingian church. The lower parts still survive, in the existing crypt.

Base of a pillar, dating from around 1215. The mouldings still show the high relief of the 12th century but the groove between them is deeper; in the 13th century this was to lead to a new effect of shadow at the foot of columns. (Pillar in the ambulatory.)

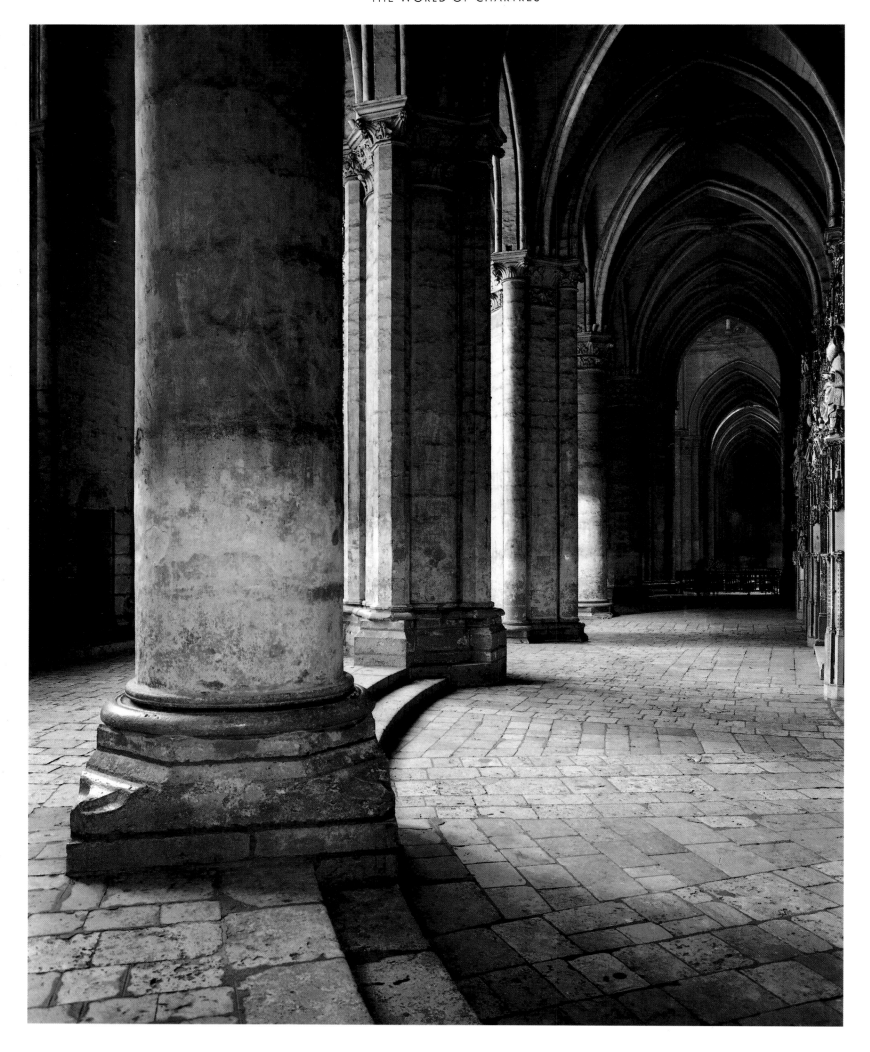

Crypt. The clergy wanted to hold their services in peace and moved the pilgrims – who could be noisy – to a special area large enough to contain the crowds who flocked in on feast days.

Fulbert's cathedral. The top drawing is a reconstruction by André de Mici (published by Denisart on the basis of old documents, in particular the picture in the obituary referred to on p. 37). The lower drawing is based on archaeological research carried out by René Merlet (1893). Note the rather unrealistic view of the complex of the choir and chevet chapels in the first drawing. (Bibl. mun. André-Malraux, Chartres.)

completed soon after Fulbert's death – which struck his contemporaries by its large scale. The upper church was 105 meters long, 34 meters wide.

Fulbert and his architect, a layman called Berenger, built the choir and the ambulatory of his cathedral on a grand scale – anticipating the Gothic edifice of the next century – so that it could accommodate the crowds of pilgrims eager to view the shrine and the statue of the Virgin. External niches further enlarged the ambulatory and made it possible to display the important treasure of relics the cathedral had acquired in Carolingian times. In the Gothic period, these niches were to become the radiating chapels of the chevet.

And it was to enable the faithful to file past the relics without crowding into the upper church, devoted mainly to the celebration of the liturgical offices, that the relative importance of the crypt and the church were determined at that time. The pilgrims were restless. They had travelled far. Their arrival was not always discreet. The bishop and the canons certainly wanted to attract large numbers of faithful from all over the Christian world. But at the same time they wanted peace and quiet to chant the terce and celebrate mass.

Fulbert's cathedral fell prey to another fire in 1030. At that time it still had a timber roof. Presumably it was during the rebuilding of the parts that had collapsed that the master mason Berenger enlarged the chevet, with its choir and ambulatory, so that it could contain the crowds of pilgrims who appeared several times a year and could satisfy the needs of daily worship in a cathedral with a large clergy and congregation. Berenger also took the bold step – an innovation in Chartres – of vaulting the upper church. It was well done. The new cathedral was consecrated in 1037. Fulbert never saw it; he had died nine years earlier.

The era of pilgrimage to Chartres reached its peak now. So the bishops of the late eleventh and early twelfth centuries decided to enlarge their cathedral. They added a sort of transept to the crypt and an entrance to it

Opposite
Ambulatory. This wide passage round the choir was designed to give easier access to pilgrims wanting to venerate the relics on the altar. It soon became a factor of structural balance, an extension of the aisles.

Ambulatory. The choir wall begun in 1514 by the master mason Jean Texier known as Jean de Beauce (d. 1529) encloses and isolates the space reserved to the canons while at the same time providing a lesson in the Holy Scriptures visible to the pilgrims. Jean de Beauce and his successors (until the 18th century) employed the leading sculptors of their day to carry out these forty scenes from the Life of the Virgin and the story of Christ.

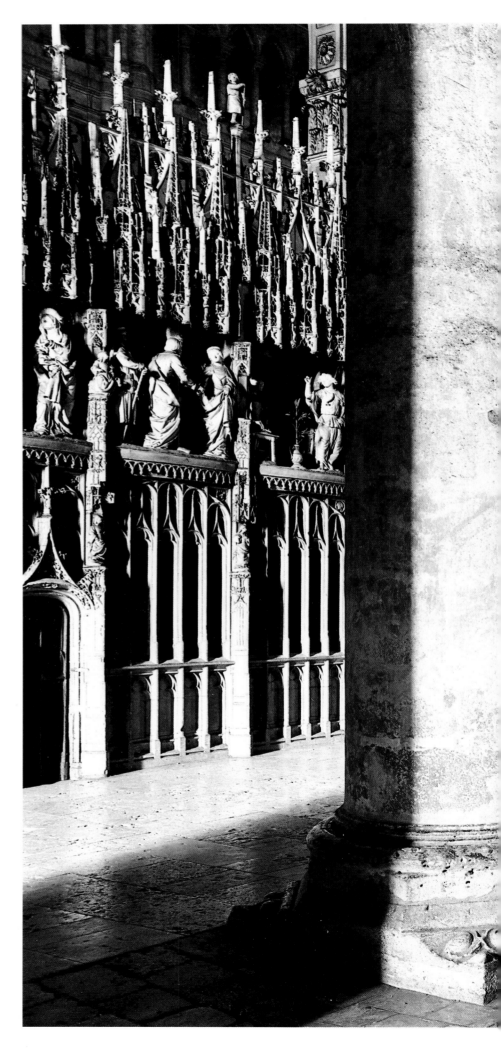

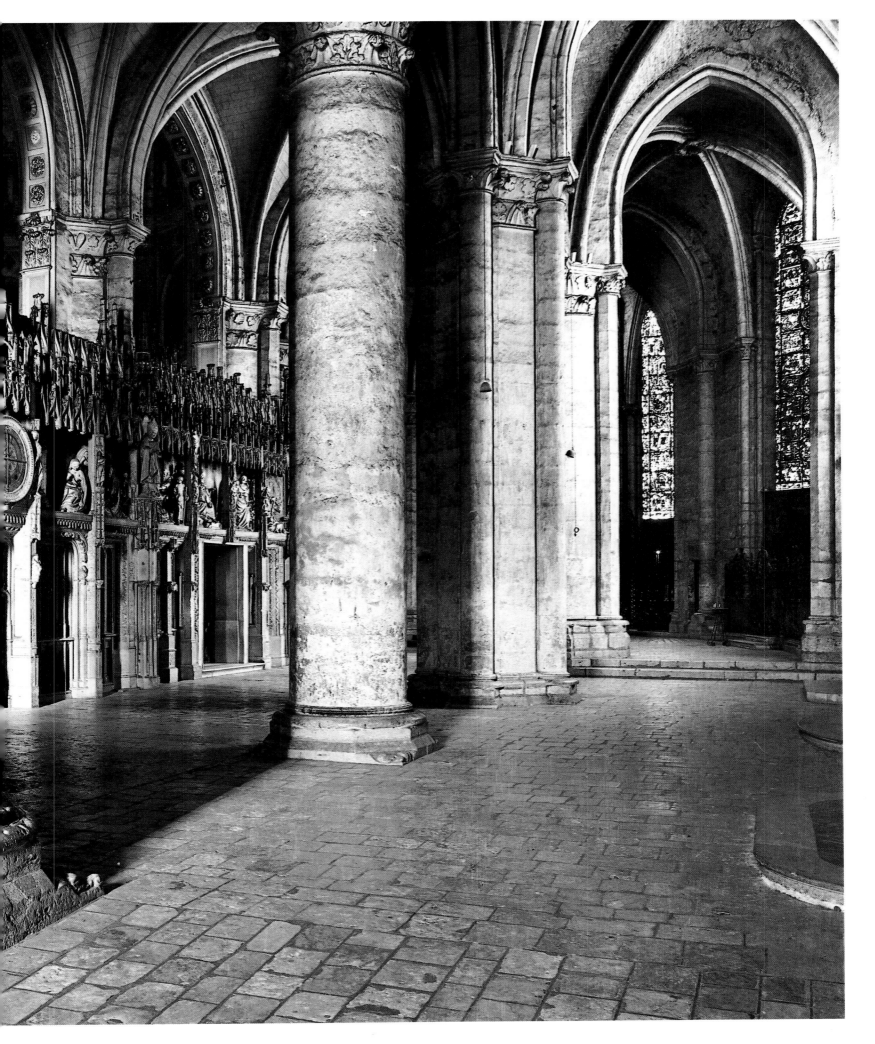

Frieze of foliage. Note the concern of the Romanesque and early Gothic sculptors to fill the entire frame. But this foliage is stylized and is still far removed from the naturalism of the flamboyant period. (North portal.)

above the aisles, so that the noise of the pilgrims would not disturb the service.

This meant that pilgrims wanting to see the well of the Saints-Forts left the upper church as soon as they had entered by the west portal, and services could proceed in the choir and the nave without hindrance. The access to the nave was also altered by the construction of a porch — perhaps as early as the eleventh century — in front of the nave, a kind of vestibule six meters long which set the external façade some meters behind the present façade. The portal had a tribune on the upper level, opening onto the nave. It was surmounted by a tower. The whole complex was destroyed by fire in 1134.

That is when the cathedral was given its new façade. Two towers were built in front of the porch. The southern one was completed rapidly, in a rigorously vertical form that was underlined by the play of monumental buttresses and high bays of decreasing size, separated by light cornices. That is the façade we still see. The north tower, although started first, was not completed until the sixteenth century.

For a while, then, the towers were detached in front of the façade made up of the porch. They were attached when the porch was integrated into the church and a west wall was built at the level of the towers. Here, in 1145, a monumental portal was built, one that is exceptionally important, as much for its size — three doorways — as for the iconographic programme of its sculpted decoration: it is known as the Royal Portal.

The crypt was extended beneath the towers so that the pilgrims could reach it directly without entering the upper church.

The thirteenth century completed the twelfth-century façade by rearranging the upper part to include the three Romanesque windows that still survive, and crowning them with a rose window, below a gallery of kings whose figures recall the human genealogy of Christ.

In this town, in which most of the houses were built of wood, fires broke out frequently. As in 1134, the town burnt down again in 1178 and yet again in 1188. In 1194 the cathedral was damaged once again, severely this time. The fire raged for three days. The lead from the roof flowed onto the paving stones. The Holy Tunic was only saved in the nick of time. Apart from the crypt, only the two west towers were spared. They were kept.

Chartres' fortunes had reached their height and France under Philip Augustus no longer built as it had done fifty years earlier under the young Louis VII. The time of restoration and repair was past.

People wanted an up-to-date cathedral on a par with the spiritual influence of the Virgin of Chartres. Bishop Renaud de Mouçon and his architects kept only the recent façade with its Royal Portal and its south tower — fortunately — and decided to embark on a masterpiece of the new art, an art combining a new spirit and new techniques, which we call Gothic.

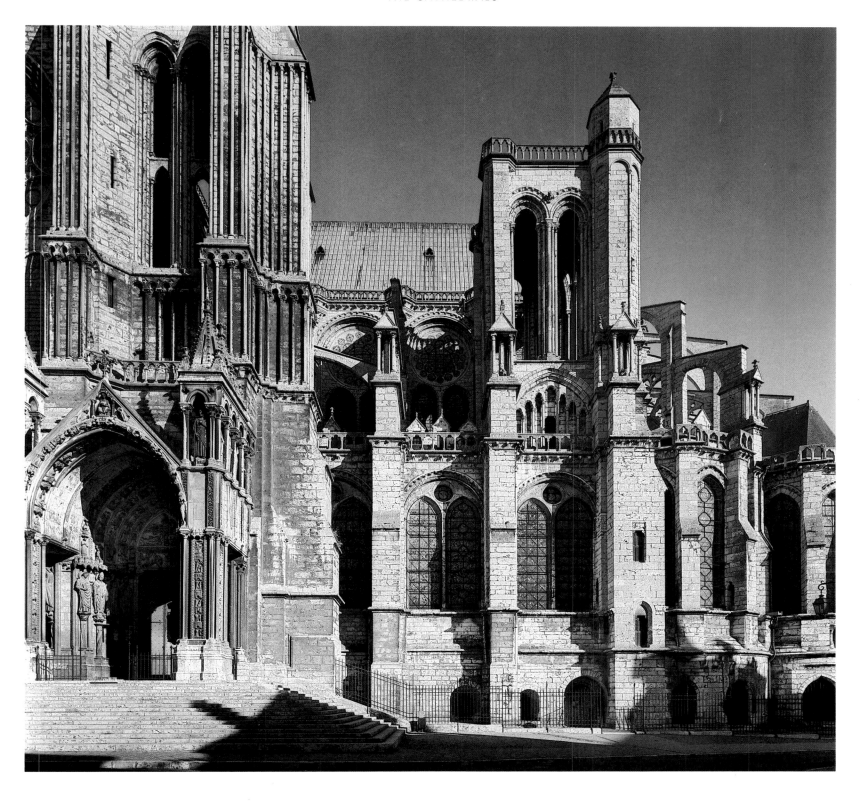

The chevet, from the south. Note the strength of the brick courses, in preparation for the many towers designed to make the cathedral stand out in the urban landscape and to ensure its general stability.

Light and space

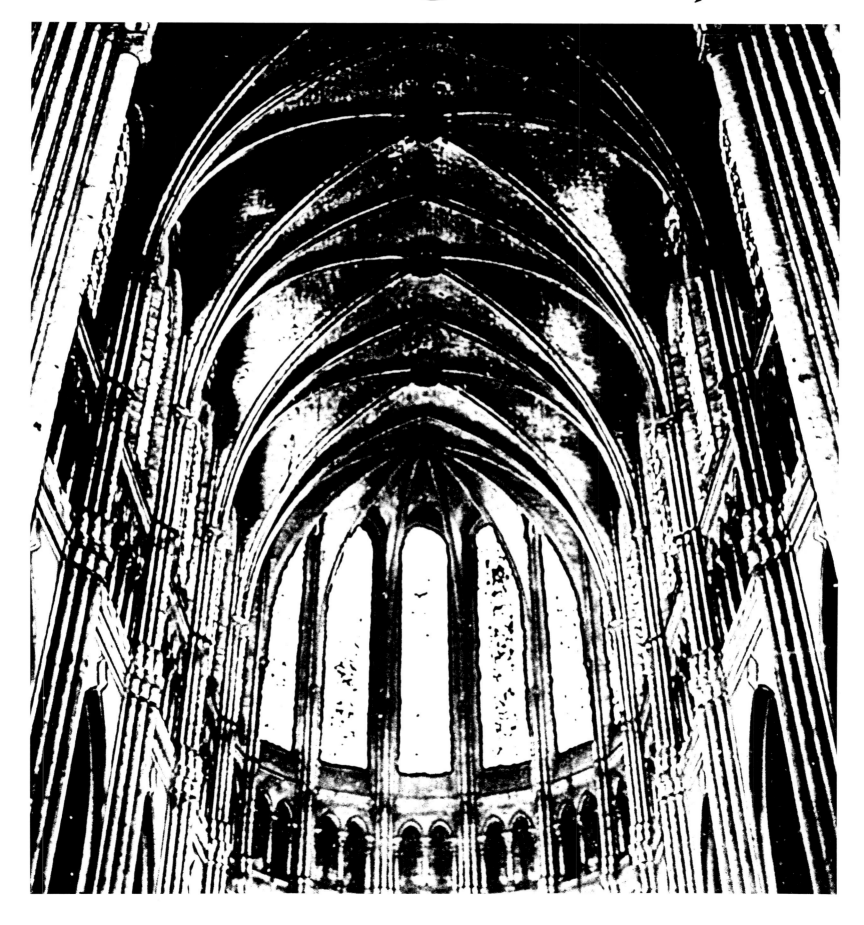

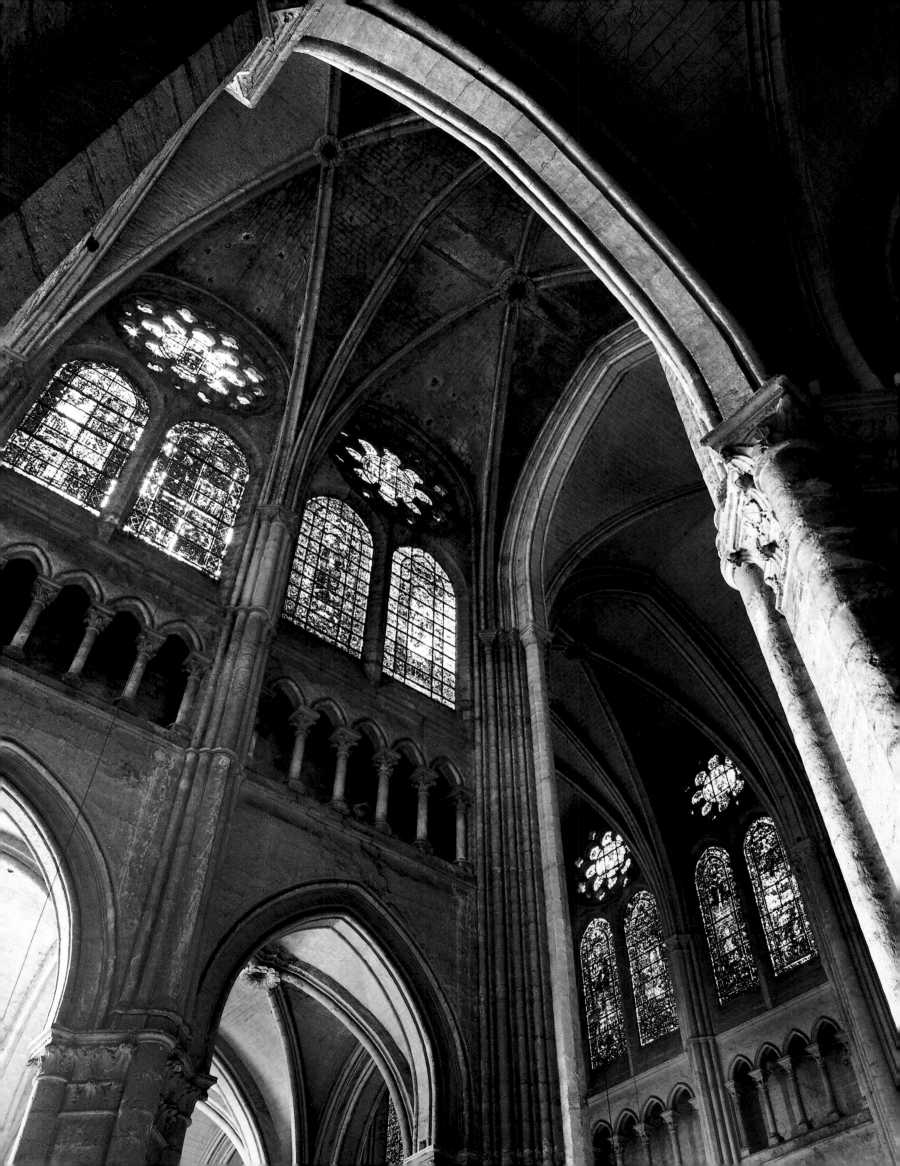

Light and space

The West began to think big. Horizons grew wider on land and at sea. Growth seemed the norm. So the master masons and those who commissioned them set out quite happily on another adventure, one that in fact echoed antiquity: the conquest of architectural space. The desire to accommodate a greater number of the faithful and pilgrims, to make manifest the new financial wealth and technical audacity in and through stone, to affirm the political power of the princes and the towns, and also to make the neighbours jealous were some of the motives which, after the year 1000, led to the trend towards larger naves, more numerous bays, the development of apses, the thrust of towers.

The means of achieving these audacities — what it all came down to in the end — was the arch. The West had never forgotten it and was quite adept at using the vault, that is, the arch which extends all the way across the building. Charlemagne's architects made much use of it in Aix-la-Chapelle, drawing their inspiration from Byzantine models known in the East or simply from Ravenna. In most cases, as when the old cathedral of Chartres was restored after the Norman sacking of the town in 858, the vault could only cover narrow naves, low and narrow passages, often subterranean, crypts in facts, which are expected to be heavy and solid and where a balance is easy to achieve because they are underground. In the cathedral Bishop Fulbert rebuilt after the fire of 1020, only the crypt was vaulted: the upper church had a simple timber roof. No mason would dare to build a vault 34 meters wide!

In the eleventh century, however, it was realized more and more widely that systematic vaulting is more solid and secure than a simple wooden roof. And besides, it was the fashion. Now a church that made do with a wooden roof would be embarrassing both to the clients and to the builders.

The problem was weight. The arch and the vault press against the walls. With a vault pure and simple, the springings of the arches would push outward and the wall would collapse. So, paradoxically, the vault was made even heavier. The heavier the vault, the thicker the walls, the more rigid the structure seemed likely to be. External buttresses were used to counter the thrust. All this worked, but became very confused. To lighten the wall by piercing it with windows would seriously endanger its balance. Weight reduced the lateral thrusts, but at what a price!

It was tempting to concentrate the thrust at a few specific points. For a

Vault of Fulbert's crypt. The 11th-century architects were already adept at drawing perfectly three-dimensional arches and groined vaults.

The conquest of space. The rib vaults on a rectangular ground plan made it possible to widen the nave without spacing out the springings too widely. The large windows let in the light. For this generation, the triforium remained an architectural necessity transformed into a decorative element.

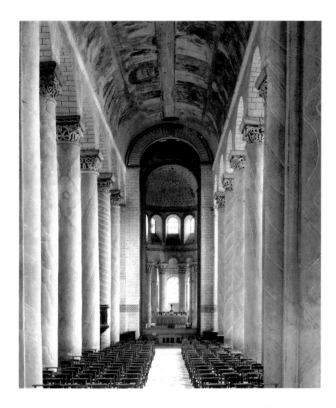

Barrel vault. Barrel vaults, like this one at Saint-Savin-sur-Gartempe (*c.* 1100), provided a continuous space for large-scale painted compositions.

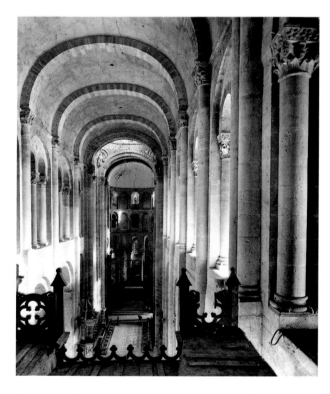

Transverse-ribbed barrel vault. In order to strengthen the vault it was decided, as here at Conques (*c.* 1075), to support it at intervals by carefully profiled ribs.

Opposite
The nave. At that date no one had yet dared to make a vaulted space so wide. The rectangular bays create a strong sense of unity by the rows of identical pillars. Strong capitals separate the pillars from the bundles of ribs extending the transverse and diagonal vault ribs down towards the ground.

while the architects experimented with spanning a few arches from one side to another under a barrel vault. This barrel vault on transverse ribs – as at Sainte-Foy in Conques and at Compostella – made the whole structure firmer. Transverse ribs began to frame the bays in the nave and were immediately seized on by the fresco painters as surrounds for the paintings which were taking over from the continuous decoration allowed by the simple barrel vault. But the question of the vault was still very much there. Between the transverse ribs, its thrust was as strong as ever. At best the transverse ribs could only absorb part of the load of the timber, descending perpendicular to the main rafters.

The first step forward was to make real use of the bay: from one transverse rib to another, two barrel vaults crossed, one parallel, one perpendicular to the walls. This formed the groined vault known even in Rome, for example in the Basilica of Constantine, facing the Forum. Its construction required a keen eye for measurement and design, and accurate cutting of the angular stones which make up the groins at the intersection of the two vaults. But in fact it takes the thrust to the four corners of the bay. This thrust is fairly strong at these corners, but it can simply be buttressed where it is strongest. Between the springings of the groined vault, the wall can be lightened, the windows enlarged. In the Rhineland, in Burgundy and Normandy, a few of the masterpieces of Romanesque art owe their size and their light to this system. This is true of the light of Vézelay and that of Tournus, with its rib-vaulted aisles.

The structure holds together because of the weight, which prevents any excessive audacity. The two vaults which play each other off in each bay need perfectly dressed ashlars. As in the old days of the barrel vault, each stone helps form the arch and of course the solidity of an arch depends on the perfect dressing of each stone. The thrust, which always tends to press outward and therefore towards the collapse of the structure, can be directed. It can certainly not be reduced.

Towards the beginning of the twelfth century innovative architects tried out a new system. For the arch, they adopted a design already tested by a few Romanesque architects: the 'broken' arch, which does away with the central third of the traditional arch, in other words with the stones resting on empty space and whose weight forced apart the side stones which were laid closer to the walls or pillars. At the same time, the architects learned their first lessons from experiments undertaken even before 1100 on a few sites in England and Normandy.

The idea was simple: to span two diagonal arches crossing each other under the groined vault, as a precaution – to lighten the weight of the vault – rather than as a bold innovation. That was the beginning of the pointed arch. At first, it merely increased the weight of the vault and the risk that this extra thrust would push out the corners of the bay.

The really bold innovation, which was to make northern French architecture so inventive and original, was to invert the parts played respectively by the pointed arch and the vault. In the 1150s it was the pointed arch that kept the structure rigid. More delicate ribs, perfectly traced, support four triangular compartments, four lightweight 'mini-vaults', like veils of stone whose lesser weight and thrust reduce the risk of collapse. They could not exist in the void. What ensures that the whole remains rigid in spite of the expanses covered is the pointed arches.

Now that the structure was lighter, it could be made higher too, and not just wider. To buttress the heavy groined vaults of Romanesque

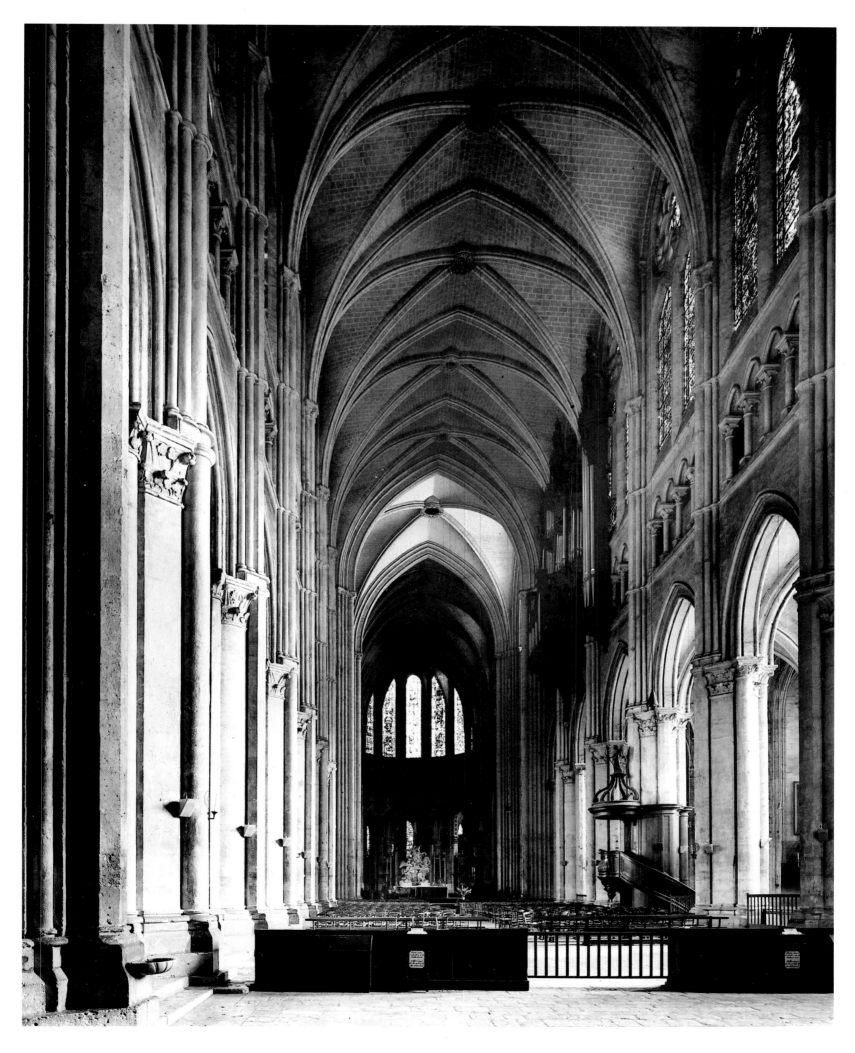

architecture assumed a whole system of secondary internal vaults and external buttresses. The stability of the building was based on a pyramidal design which, at the cost of considerable weight, brought the thrust back to the vertical and as low as possible.

These are still the structures of the first generation of that purely French art which the neo-classical age tried to mock by calling it 'Gothic'. The main vaults are still shouldered by tiers of lateral vaults. At the springing of the ribs, external buttresses absorb the final thrust against the external wall.

The central nave became higher. But it did not become much lighter. In Laon, as in Noyon and Paris, the vaults and the floors of the aisles and the tribune gallery screen the sparse light filtering through the windows of the outer walls even more. And in the nave, the covered aisles are matched by a high windowless space: on one side of the wall is the roof, on the other an arcade, the triforium, whose sequence of arches strengthens the stability of a structure which in fact consists of arches, but whose main and purely ornamental function is to occupy the space that inevitably exists at the base of the upper windows. The great churches of this first Gothic generation whose masterpieces, aside from Notre-Dame in Paris, are the cathedrals of Laon, Noyon and Soissons, are most notable for their four-storey internal elevation – the great nave arcades, tribune gallery, triforium and clerestory windows – one storey of which seems to consist purely of light.

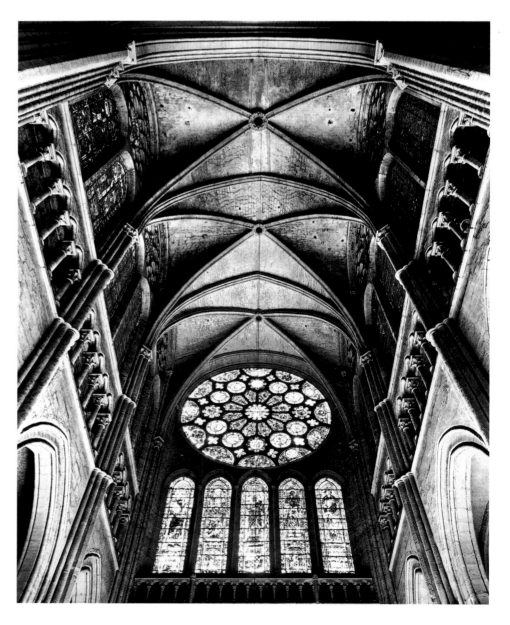

South transept. The wall has become lighter, lending itself to bold new techniques such as this wall of glass formed by the windows and rose on the south façade of the cathedral. The structure of the rose is still very solid, with a large number of rigid arcs and circles pressing against one another (c. 1230).

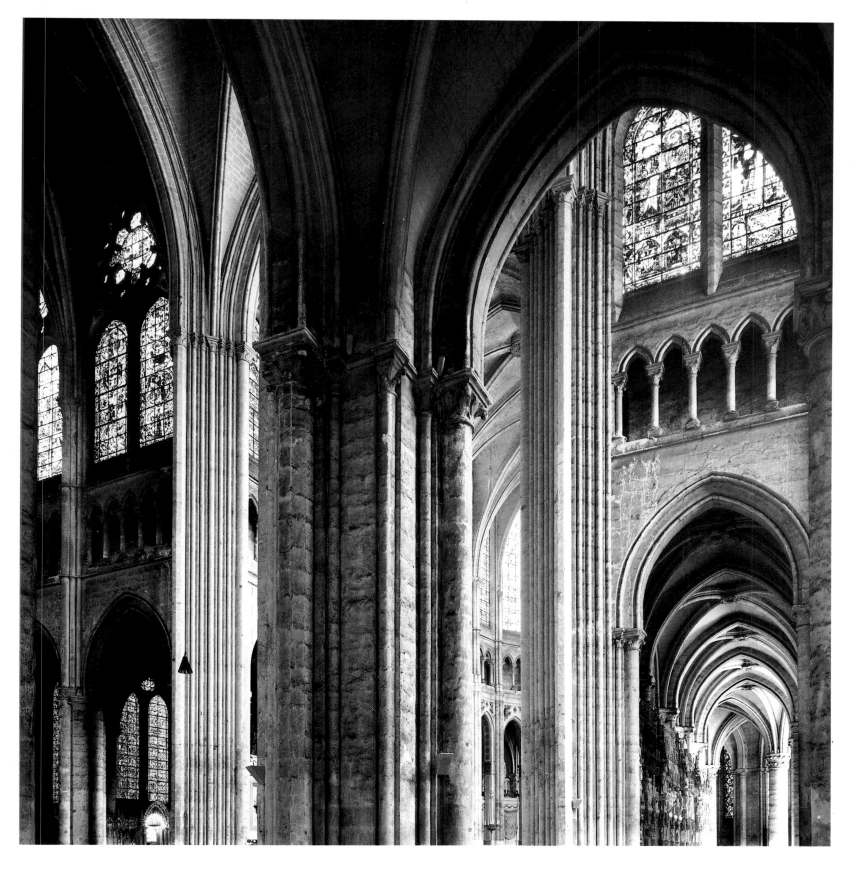

After the fire of 1194 when Chartres Cathedral began to be rebuilt, a new Gothic generation was emerging. Fifteen years earlier the architects had found out how to direct the thrust to the foot of the highest vaults instead of lower down and to compensate for this by constructing heavy buttresses at the base. Once the pointed arch concentrated the thrust at specific points, at the springing of the bays, the contrary thrust to prevent the vaults from collapsing sideways could well be needed only at those precise points, instead of all along the wall. After the pointed arch came the flying buttress.

Transept crossing. Two perpendicular aisles cross here. The pillars no longer take any thrust but the load is extremely heavy. The size of the pillars is clearly a response to the cumulative weight of the springings.

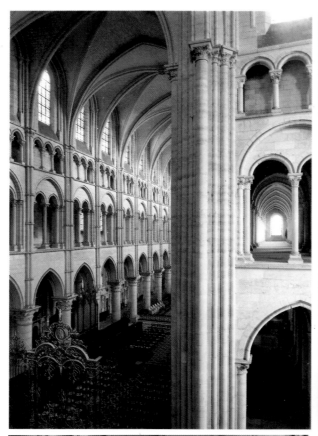

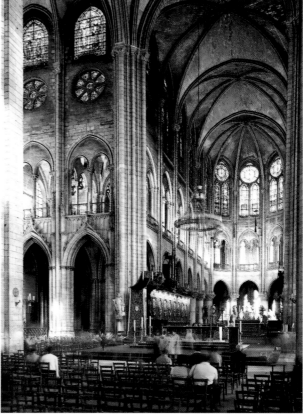

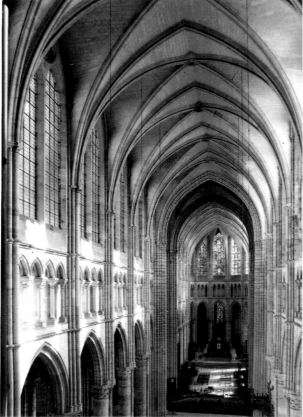

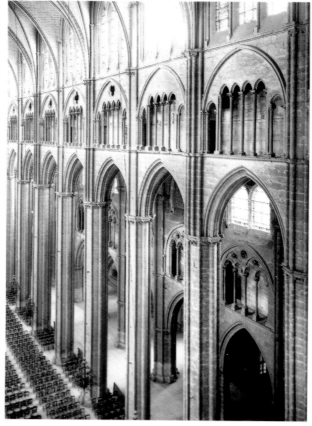

The conquest of light. At Laon (above left) the balance still depends on a pyramid of vaults. At Paris too (above right), there are still four storeys (in the reconstruction by Viollet-le-Duc of the two bays near the crossing) and a tribune, which is a high gallery over the aisle. At Soissons (below left), the gallery has disappeared and the flying buttress reigns triumphant. At Bourges (below right), the four aisles and the nave form a unified area of light.

Opposite
The nave of Chartres. At the end, the west façade with its rose. The solid masonry is still a sign of timidity. The wall is still very much in evidence.

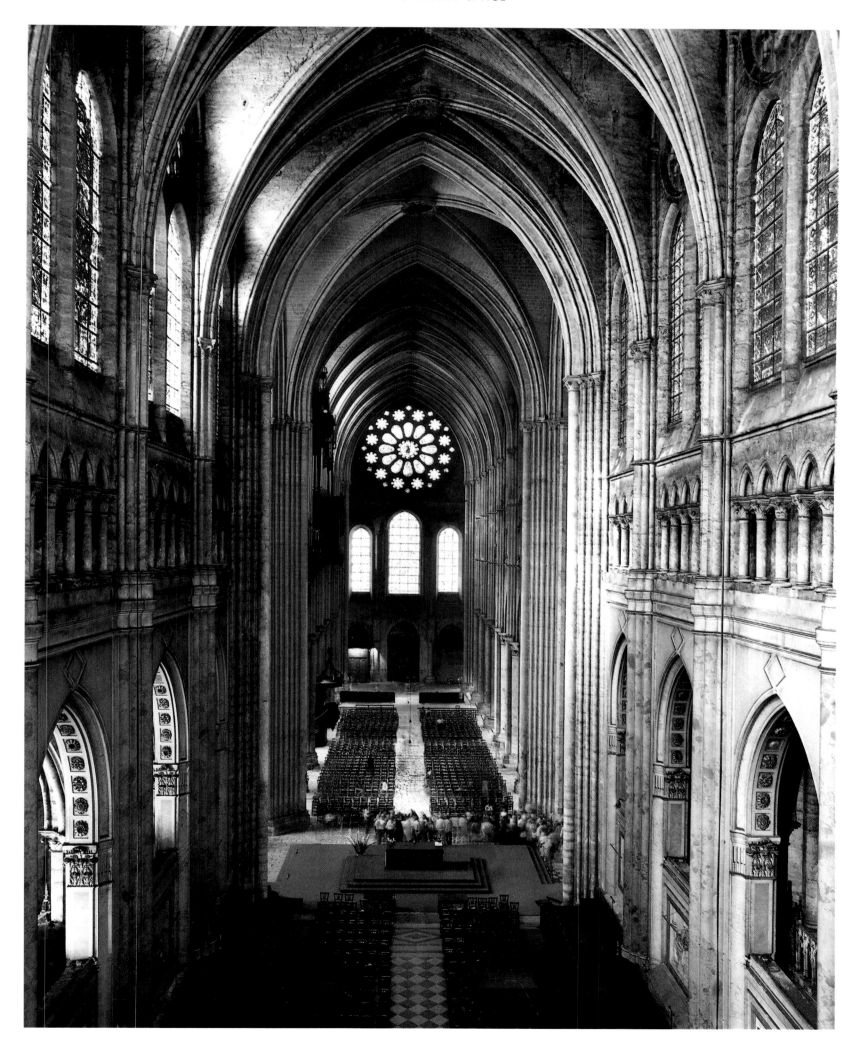

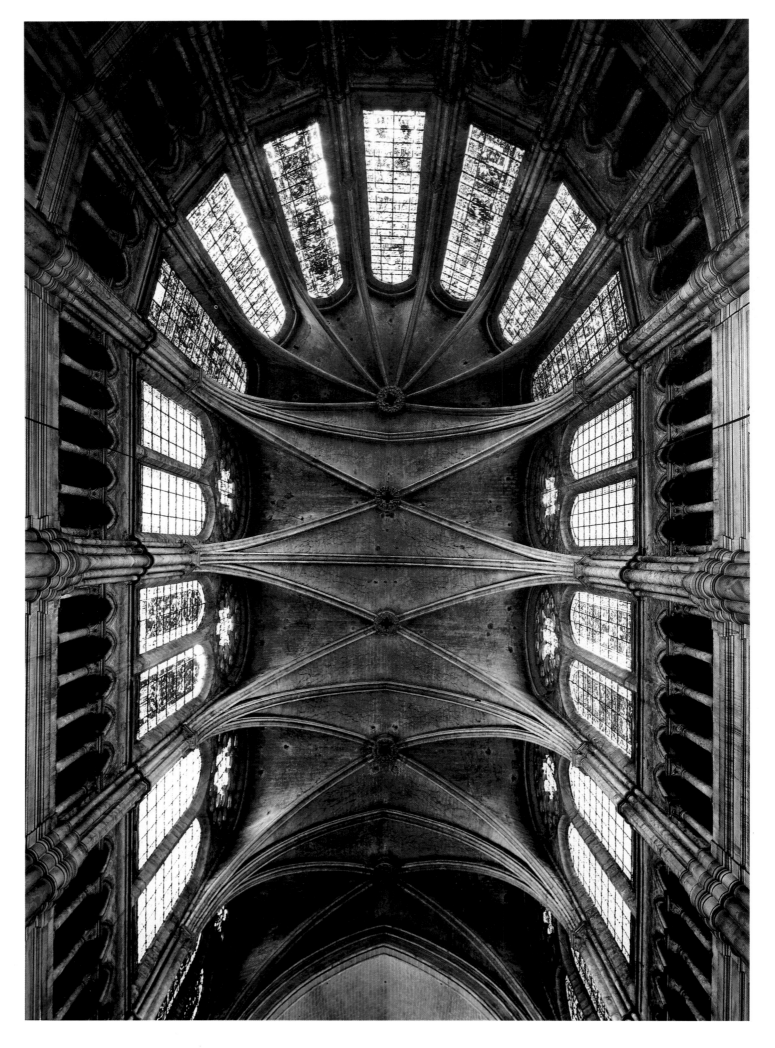

It was important to know where to apply this thrust. In about 1214, when the architect of Chartres buttressed the first ribbed vaults of the new cathedral on the sides of the nave, he was still groping for the answer. He attached a complex device, stiffened by two superimposed arches, to the wall at a height of five meters. He was obviously a prudent man. And yet, it soon became apparent that the wall moved above these flying buttresses, which were evidently placed too low. A third arch, an awkward addition, was added to raise the level of support of the buttress system.

Towards 1216, when another master mason constructed the apse vaults, he showed a very sure hand in applying thin and slender flying buttresses to the base of the thrusts. This was still not the single arch, but this precision produced a feeling of greater lightness, as it had done under the vault where the ribs became increasingly light. The heavy diagonal arches of the 1100s gave way to fine ribbing, and the carefully calculated construction of the thirteenth-century pointed arches, whose mouldings enhance the play of light and shade, made them sufficiently rigid.

At the same time, the vault changed. With the Romanesque groined vault as with the pointed-arch vault, the square bay restricted the size of the aisles. The first consequence of any attempt to enlarge it was to space out the springings along the walls, and therefore to increase the load on each of them. The twelfth century introduced vaults with six compartments: an extra arch helped ease the load. This 'sexpartite' vault, which can be seen in the cathedrals of Laon and Notre-Dame in Paris, alternates thick piers supporting the diagonal and transverse ribs which separate the bays along the aisles, with thinner ones that support only the intermediate ribs. Both in Laon and in Paris the builders created an illusion of equality between the thick, unequally loaded columns, whose thrust is reflected in the aisles in compound piers of unequal resistance.

The next generation, who made the vaults even lighter, dared to embark in the 1200s on what was to be the definitive design of the Gothic vault: the rectangular bay on the 'barlong' plan. The nave was enlarged — it was 16.40 meters wide in Chartres — without spacing the springings along the aisles too far apart. The alignment of the piers — whose profile now continues down to the ground with their colonnettes that continue the ribbing of the vault — acquired the regularity that gives such a strong sense of unity to the naves of Chartres, Rheims and Amiens. The architect of Chartres made sure this regularity did not mean uniformity: where the great arcades open onto the aisles, he built a row of alternating square piers with circular colonettes and circular piers with polygonal colonettes. The nuance is barely perceptible, but it does give a certain rhythm to the main play of light, i.e. the vertical light, and interrupts the monotony of the long nave without impairing the unity of the structure.

Thanks to these colonettes and mouldings, the internal decoration has become architectural. There is no sign now of the sculpted capitals of people and stories, such as those which enliven the naves of Autun, Vézelay, Saulieu and Aulnay-de-Saintonge. The capital reverted to being a simple architectural element, decorated only with ornamental foliage which slowly became more naturalistic. That was all. The size of the vaulted space was underlined by the play of light and shade which changes hourly along the ribs and the rising columns, barely linked by the lightweight capitals with their foliage ornament. The real decoration now is light.

The era which saw the construction of the nave and aisles of Chartres was certainly a time of victory, sudden and rapid victory over the obscurity

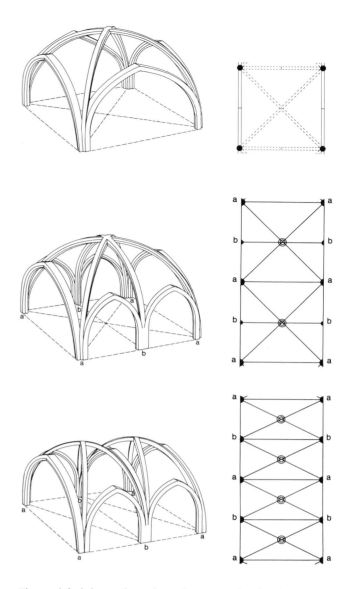

The search for balance. Above, the quadripartite vault. When the nave is enlarged, the springings are spaced further apart: the building therefore becomes fragile. In the centre, the sexpartite vault; the points of support **a** take on a greater load than the points of support **b**. Below, the vault on a rectangular plan, where all the points of support **a** and **b** take on the same load. On the right, the rectangular 'barlong' plan.

Choir vault. The upper parts of the structure are pure illumination, forming a wall of light for the master glazier. There is no room left now for the fresco, which has given way to the stained-glass window.

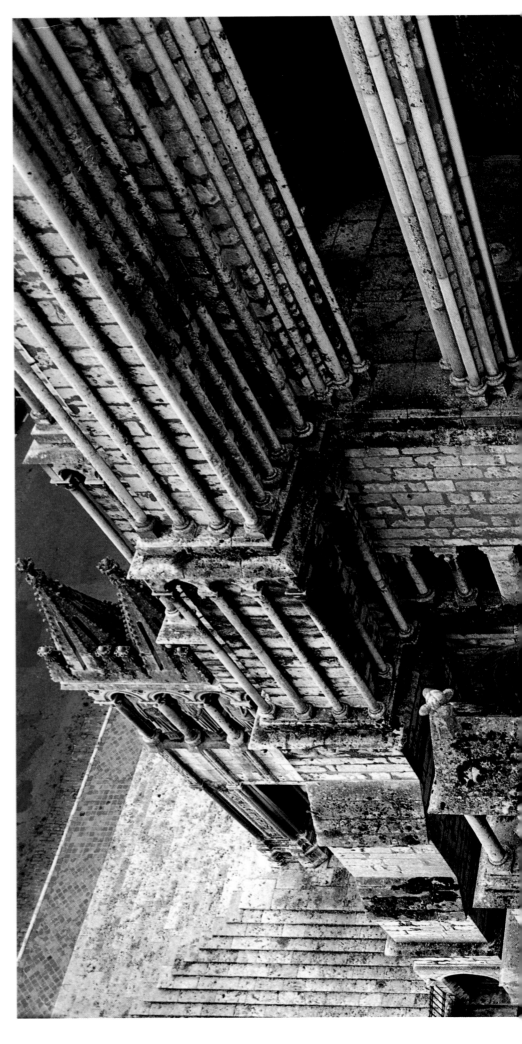

Pages 64–69
The flying buttress. The idea was clear-cut from the outset: to ground the thrust at the foot of the vaults. But there was much hesitation. Several tiers of flyers, an outer flyer shouldering the inner ones – the architect was still cautious.

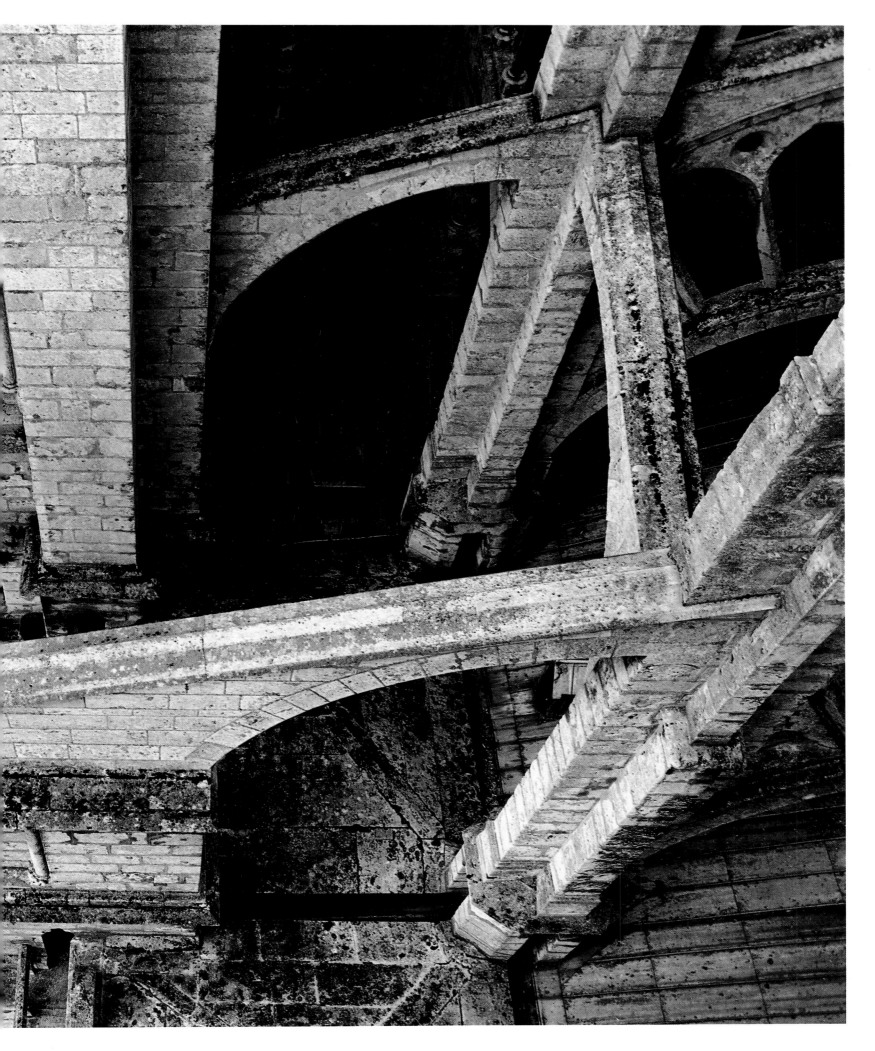

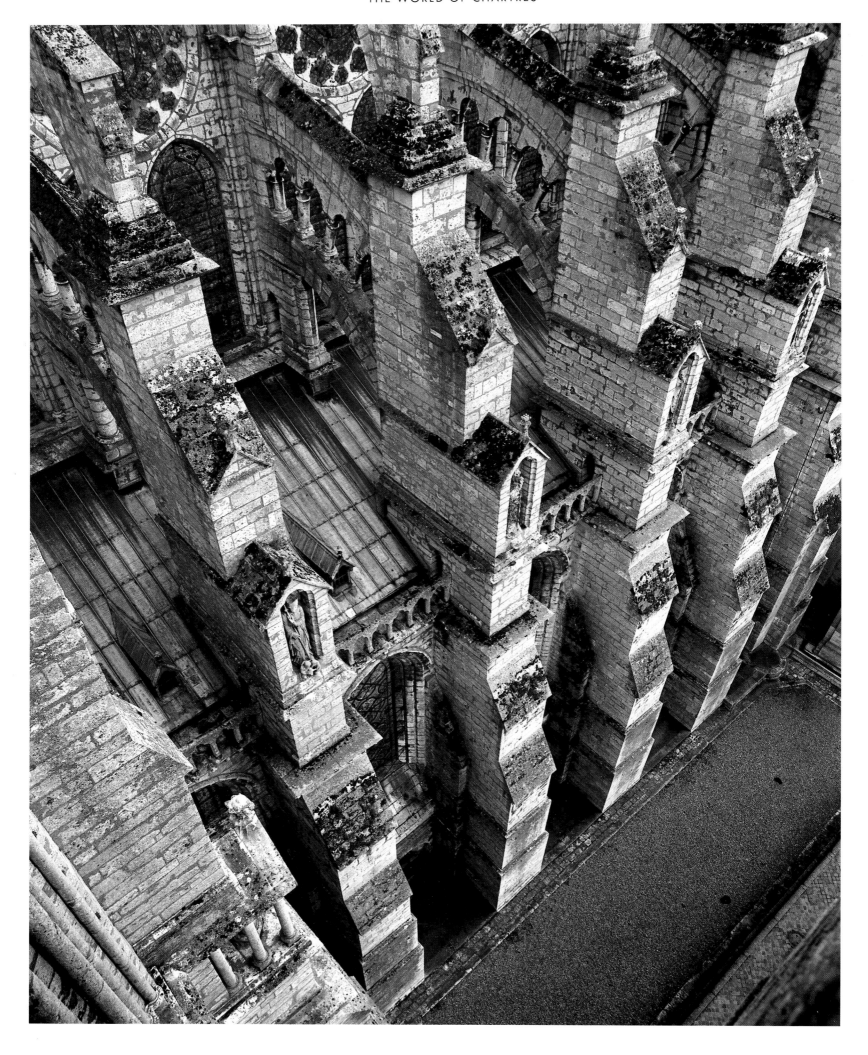

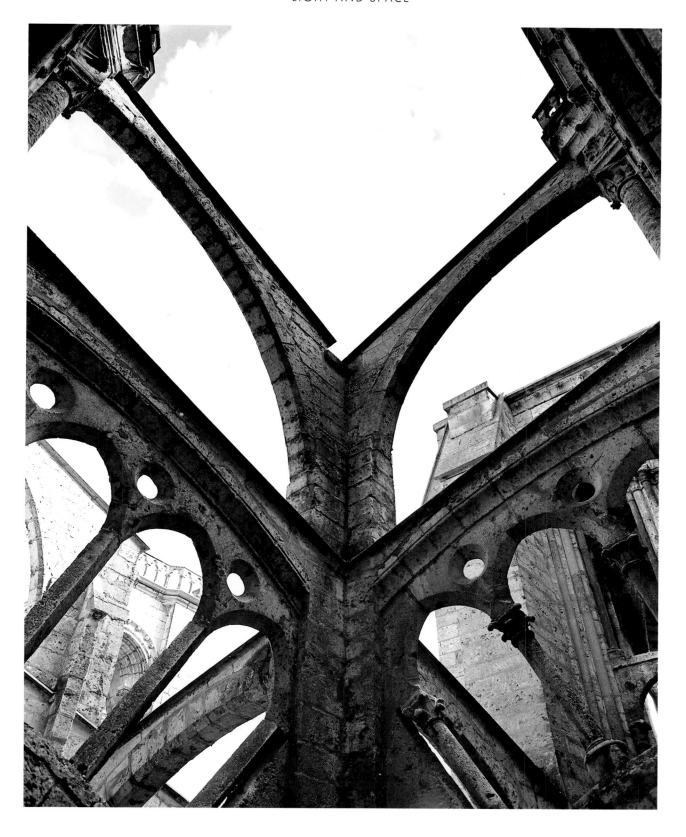

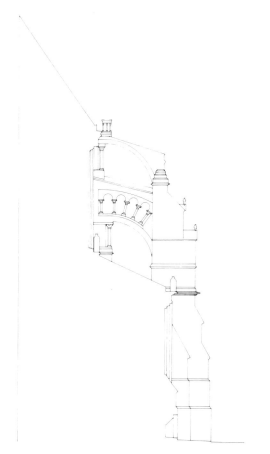

Diagram of a flying arch

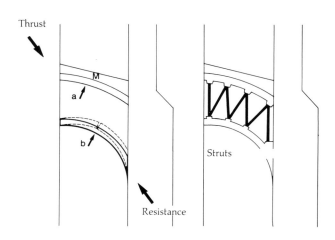

Thrust

M

a

b

Struts

Resistance

Under the combined effects of the thrust of the vaults and the resistance of the buttresses, the archstones of the flyer might have a tendency to rise. The mass M holds down the upthrust **a** in the upper arch. But the section of the lower arch could not by itself ensure that the force of compression passes through the central tierce-point and there was the danger of its rising through the effect of component **b**. So the little arcades often act as structs.

Opposite page
The transept crossing. The master mason exploits the network of ribs to create light and shade effects. There is no need here for plasterwork. Gothic art is based not on austerity but on logic.

sought by the Romantics who thought they understood the ideals of the Middle Ages. In fact, it was all a question of technique. And the invasion of light which paved the way for the stained-glass window was due to three purely architectural advances.

The first was to do away with the tribune gallery above the aisles. Once there were flying buttresses to take the main thrust, there was no longer any need for these superimposed vaults which consolidated the building but also acted as extra screens. The aisles now rose uninterrupted, allowing the light from the external windows to enter through the 14-meter high arcades into the heart of the cathedral.

The second was the arch embedded in the wall of the ribbed vault of the bay. This 'formeret' rib, which emphasized the join between vault and wall, is more than just an elegant piece of design. It lightens the wall. It makes it easier to pierce it with windows. Once again, light wins the day.

The third advance was achieved by stages. The flying buttress may not have been invented for that purpose, but it did have the added advantage of discharging the rainwater that collected on the roof. Until then, and at Chartres this was still the case, the water from the nave roof flowed down to the simple slope of the aisle roof. It would have been foolish to give the aisle a roof with two slopes, for that would only concentrate the water into a gutter with no outlet. The two-pitched roof became practical only when the flying buttress created a down gutter. This made it possible to open up the blind triforium wall, decorated at Chartres by the fivefold and almost continuous blind arches — designed, once again, to lighten the rhythm of the bays and to bring out the continuity of the nave. The triforium survived a while longer, but in the form of a storey of windows, a new storey between the high windows opening onto the nave at the foot of the vaults and the low windows casting light onto the aisles. One day, the windows and the triforium were to be combined in a single level of very high windows.

That had not yet happened at the time when the high vaults of Chartres were built. However, the windows had already begun to play the star role in the iconographical decoration of the interior.

The walls enclosing the architectural space perpendicular to the nave and the two arms of the transept support only a very light thrust, easily absorbed by the weight of the massive masonry carrying or about to carry the towers. And these curiously attenuated walls — which therefore cast only slight shadows on the windows — provided a choice site for the iridescent light of the rose windows.

On the west side, around 1140 when the builders were not yet quite so daring, the wall of the renovated façade of Fulbert's old cathedral was still perfectly visible. But the three enormous windows, which were to be crowned in the early thirteenth century by a rose window with strongly moulded tracery, already reflect the new importance of glass. The rose window was, and was to remain, a complex of opposing arches, playing each other off one against the other and giving the wall of glass the necessary architectural rigidity. Even though the master mason played safe and restricted the size of the central rose by surrounding it with twelve little roses, he still extended the area of stained glass to the limits of the support the vault could give to the wall.

Another generation had come and gone. The architects believed everything was possible. On the façades of the transept, which was to be fitted with towers like the west façade, the structure remained as rigorous as

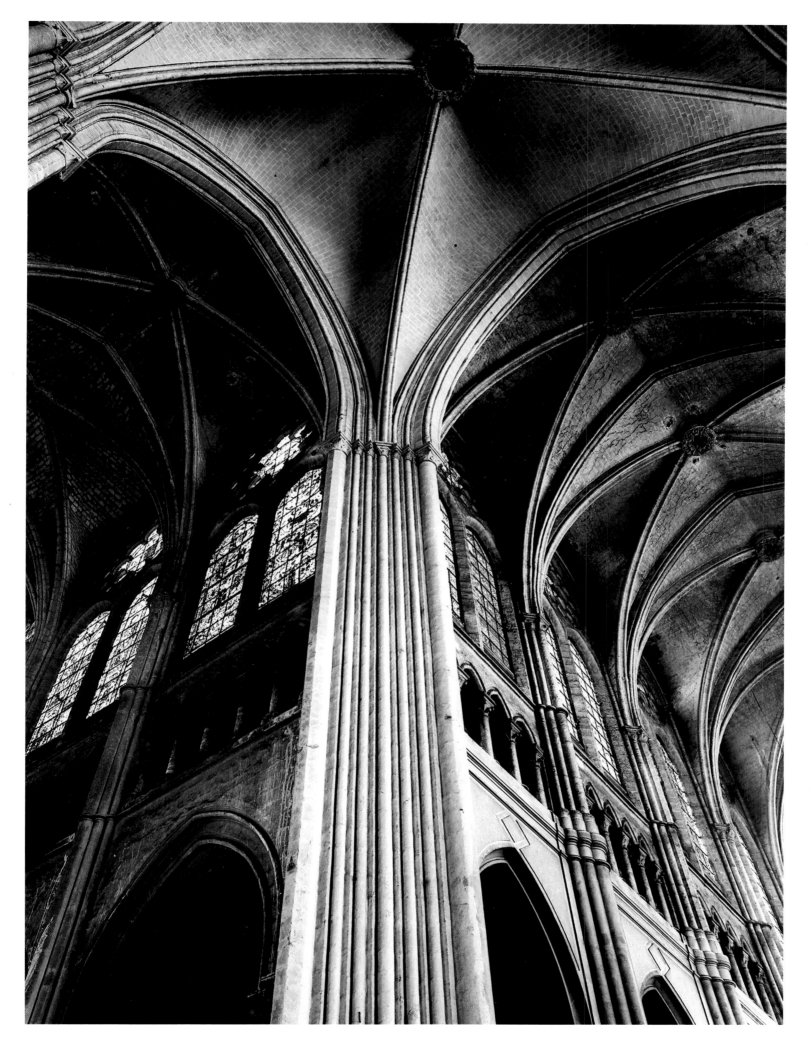

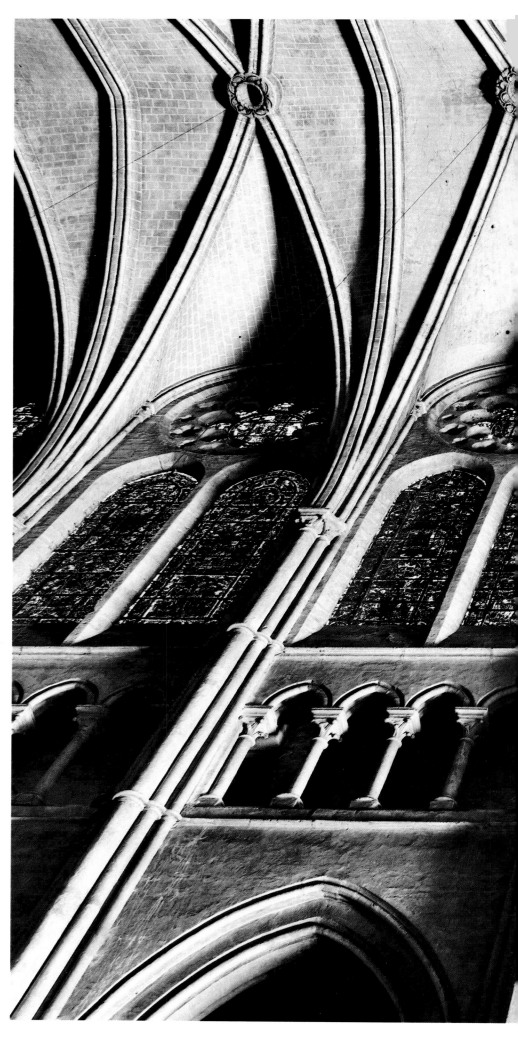

The nave. Three-storey elevation. The arch is everywhere, spanning and defining the spaces.

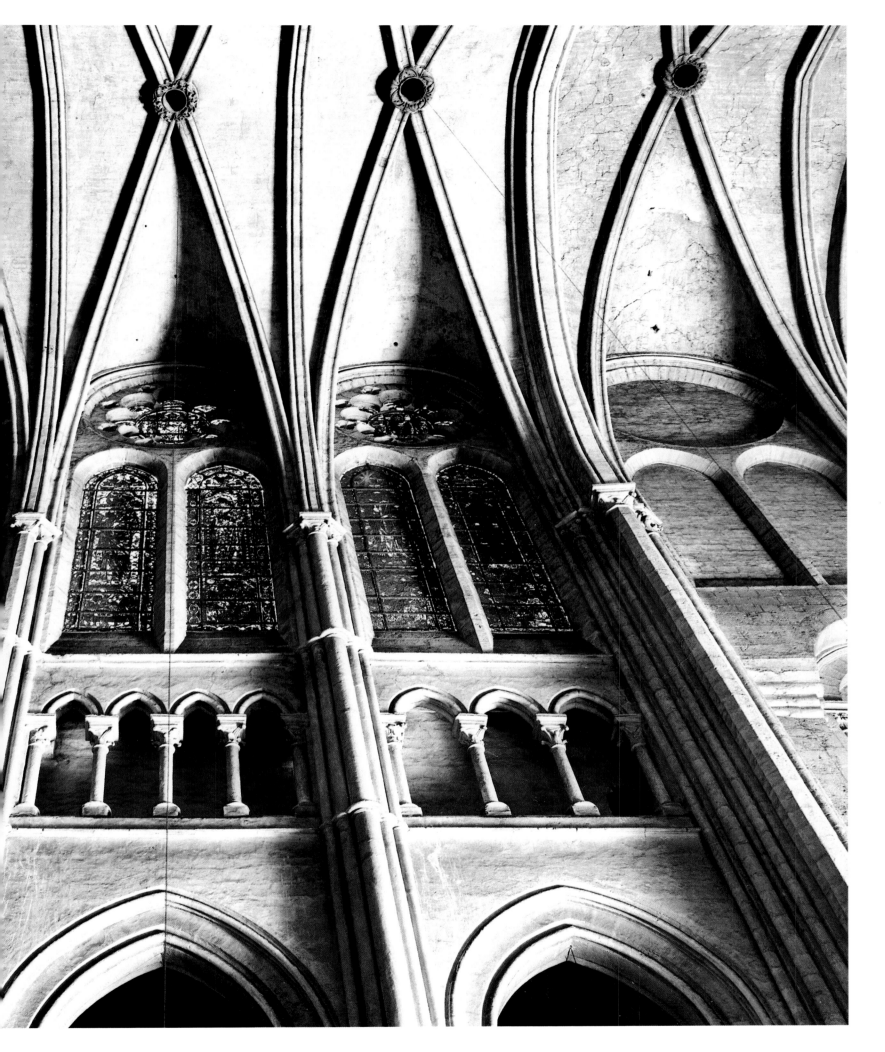

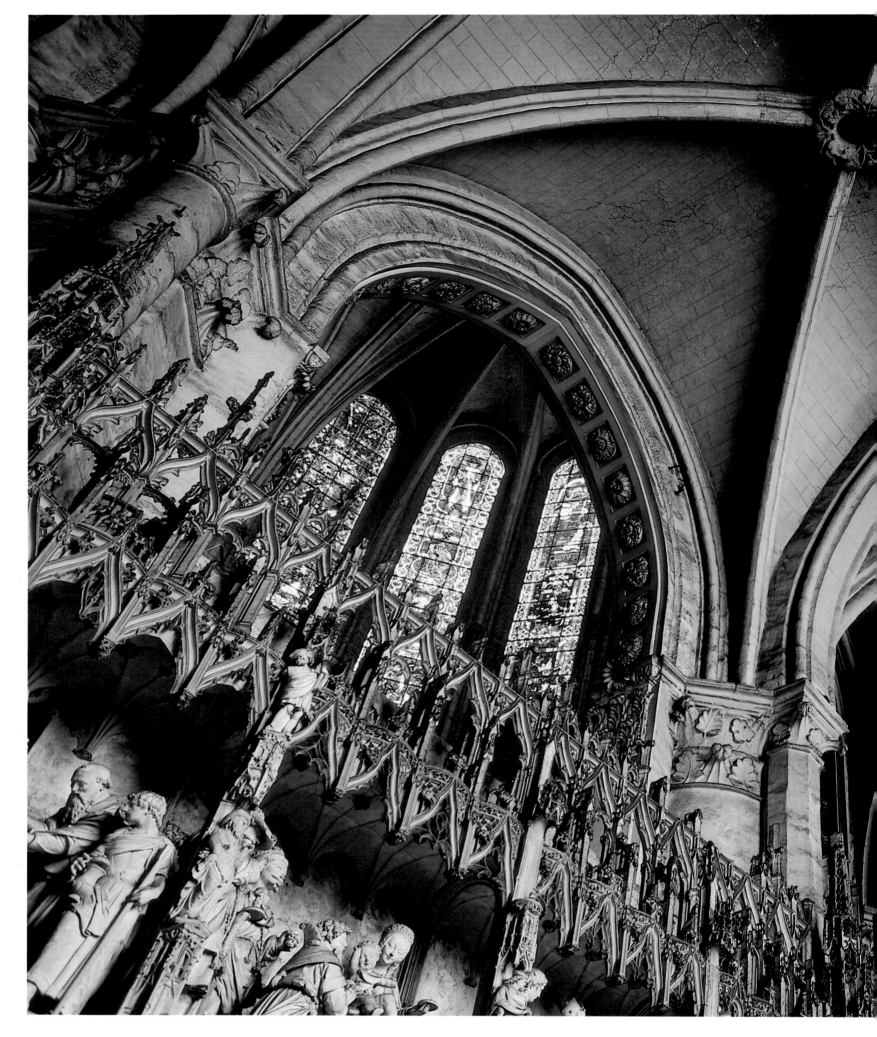

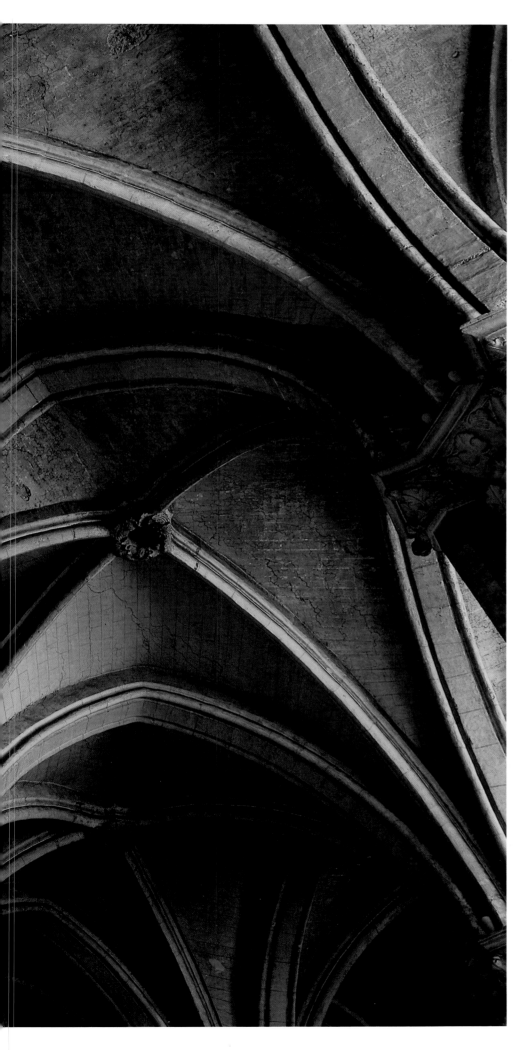

The north ambulatory. The unified internal space sought by the 13th-century architect did not interest the canons who ordered the choir to be closed in the 16th. The choir was to be a private place. The Council of Trent condemned this rather unpastoral attitude.

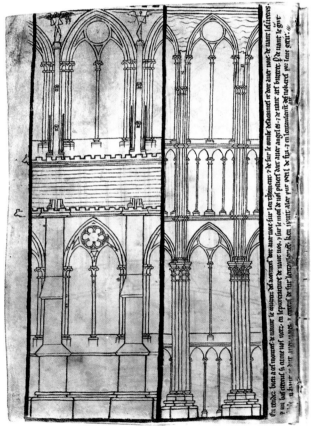

Album of Villard de Honnecourt (early 13th century). The architect, who witnessed the erection of the great Gothic cathedrals, took constant notes, drew sketches, absorbed ideas. Above, drawings of Rheims. (Bibliothèque nationale, Paris.)

ever, but arches radiating from slender colonettes take the place of a wall. In about 1229 the south façade still had two massive masonry spandrels separating the rose window offered by the Dreux family from the lancet windows showing the Evangelists perched on the shoulders of the prophets. In the north, five years later, the wall was gone and even the spandrels had given way to stained glass on which the fleur-de-lis of France and the castles of Castile indicate the patronage of St Louis and his mother Blanche of Castile. From the lancet windows – decorated with effigies of the precursors of Christ – to the rose window, the upper façade is all glass, and the careful arrangement of little roses around the large one makes way for the luminous explosion of a whole constellation of medallions. The stone becomes invisible. Colour takes over from the play of shade.

Elsewhere too, in the enclosure formed by the lower walls of the aisles and their chapels and the high walls of the nave, the transept and the choir, the structure becomes lighter. Two bay windows and a rose make up the high windows of one bay. Separate windows, their glass strengthened by iron bars, open onto the aisles and the chapels. The same framework which restricts the iconographic decoration helps to balance the structural masses.

There was, thus, a movement towards a different distribution of the areas intended for preaching the faith and those reserved for the lesson in history which the medieval church embodied. Barrel vaults seemed to lend themselves well to frescoes, like the almost totally windowless walls of the Romanesque church. Examples of that art are found at Saint-Savin-sur-Gartempe in the Poitou, Vicq-en-Berry and Berzé-la-Ville in Burgundy. For a long time the groined vault and the first pointed arches, which broke up the surface of the vault, were responsible for the popularity of those dark skies studded with gold stars. The introduction of windows relegated the frescoes to marginal images on the lower walls. With the irruption of light, the window came into its own, occupying more than 2500 square meters of vertical surface.

The stained-glass makers of Chartres knew how to exploit light. The morning sun is not the same as the evening sun and the north windows, gently illuminated, especially at night, by the imperceptible slant of the axis towards the south-west and north-east, create different plays of colour from the midday light. The great variety of opportunity fuelled experimentation, invention. At one point, towards the mid-twelfth century, during an early campaign of stained glass which has given us the three large windows of the west façade, experiments were made with very pale blues, sky blues which have gone down in history as 'Chartres blue' and which, by reducing the value of the dominant colours and paradoxically using white as the colour of light, create an overall sense of harmony.

This same blue was used around 1180 by the author of the central panels of the stained glass known as Notre-Dame de la Belle Verrière. Future generations of glass-makers admired these works so much that they decided to insert the three western windows into the new façade – though not without 'restoring' them – where they lit up the first bays which the heavy mass of the towers could otherwise have made rather dark, and to position the Belle Verrière in the ambulatory south of the choir.

Very soon, the influx of light into the enormous spaces of the Gothic cathedral radically changed the glass-makers' techniques. The Romantics, always on the search for historical puzzles, invented the lost secret of the twelfth-century blue glass. In fact, the master glaziers may quite simply have found that the bright afternoon light would not really show up very

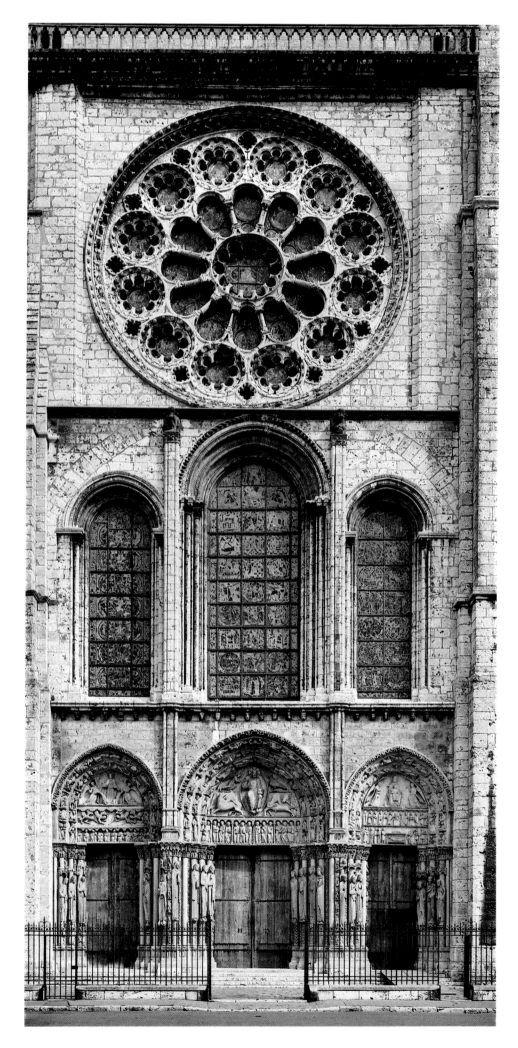

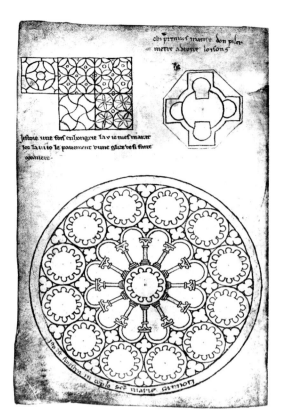

The west façade. The three portals of the Royal Portal, the three large 12th-century windows and the rose added a century later, at the time of the first great innovations. Villard de Honnecourt reproduced the tracery with extreme precision. (Bibliothèque nationale, Paris.)

Page 78
South façade rose (*c.* 1230). Glass has taken over, but the builders still did not dare to connect the large windows with the rose. From left to right: Isaiah, Daniel, Ezekiel and Jeremiah carrying on their backs the Evangelists Matthew, Mark, John and Luke, who have come to bear witness to the accomplishment of the Scriptures, not their abolition.

Page 79
North façade rose (*c.* 1235). The final innovation. Little windows with the arms of France and of Castile – Louis IX and his mother Blanche – lighten the lower spandrels. The colours are less sustained than in the south rose because the light is less bright here. From left to right: Melchizedek and his censer, David and his lyre, St Anne carrying the infant Virgin, Solomon and his sceptre, Aaron and his flowering rod. They are all named so that there can be no mistake.

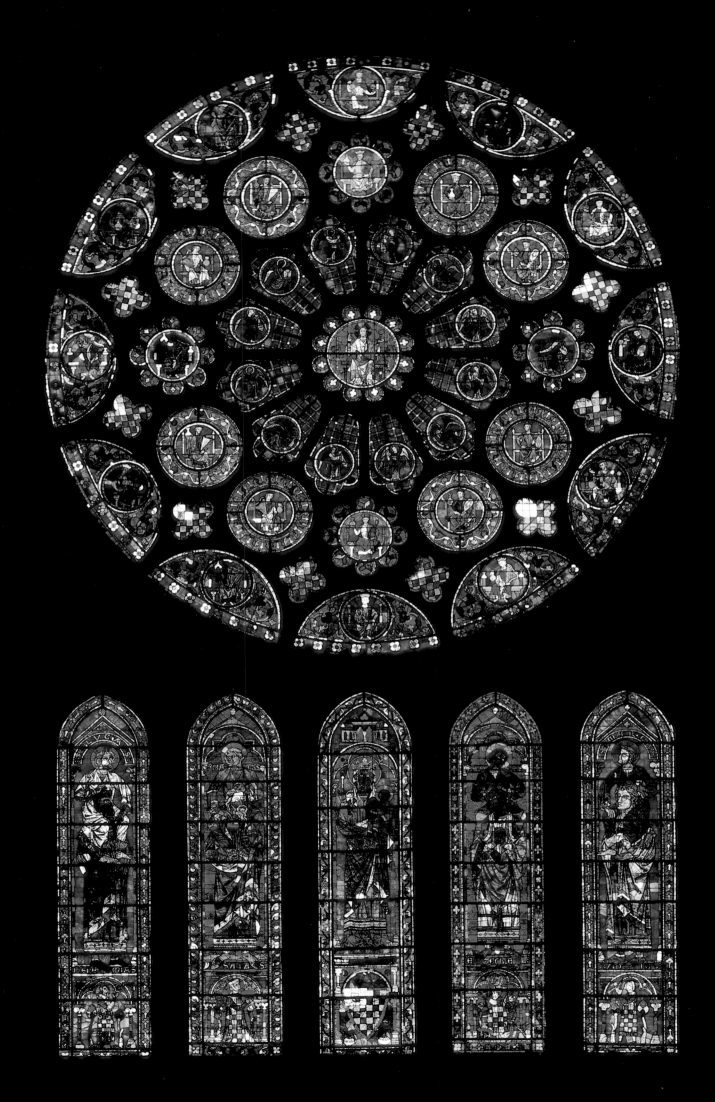

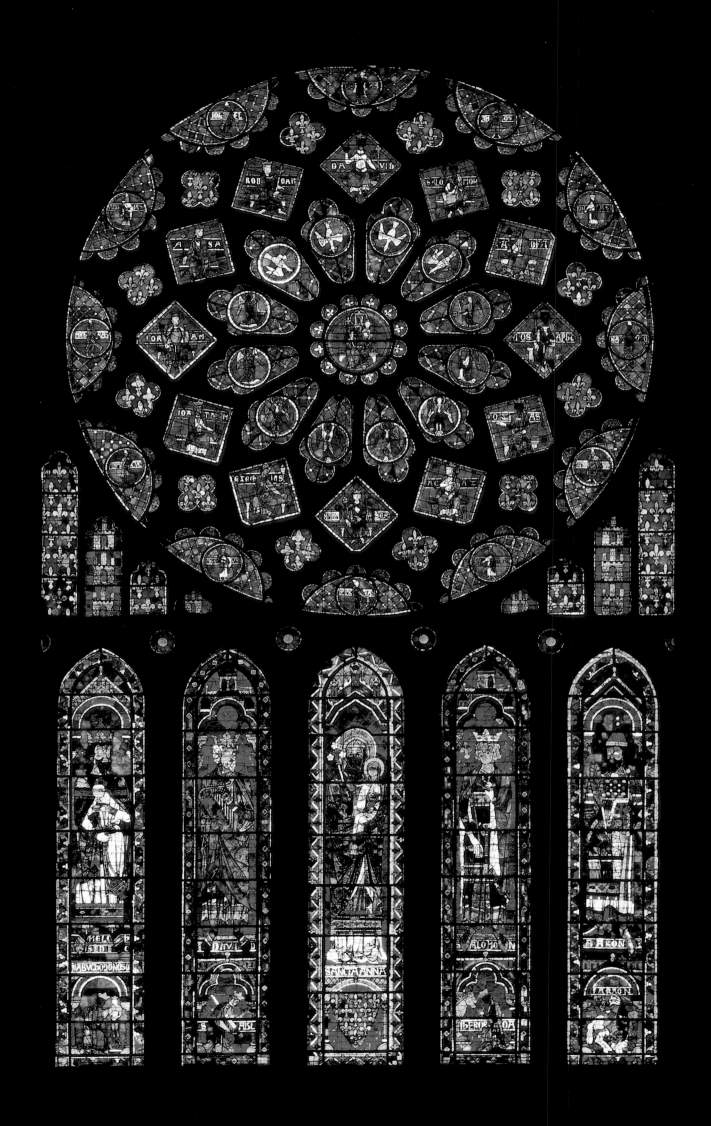

pale blues if they were used too extensively. The strong light of the Ile de France called rather for the balanced use of saturated blues and reds, creating a general sense of harmony through the whole range of violets, which characterizes thirteenth-century stained glass.

With the subtle combining of sunlight and glass that makes up the art of stained glass in the early thirteenth century, a certain technique — glass coloured in the mass, set in lead and rendered rigid by its iron frames, with a grisaille pattern that accentuated the play of shade and defined the details of faces already framed by the pure black of the lead — was adapted to a particular environment in which it was sometimes legible, sometimes not. The light of the Beauce and the Ile de France, long considered too weak to allow the mosaics with their gold background to sparkle as they did in Italy, actually seemed too strong for the soft reds and blues which were and would remain the basic colours of stained glass. The fourteenth-century glaziers only used incandescent yellow in their palette to underline, to highlight, to accentuate the play of light. They also used it abundantly to add a little warmth to the grisaille.

The workshop of Chartres was at the head of this search for a new art that matched the skies of France. Neither Paris, nor Rouen nor Bourges could ignore the teachings of Chartres. And the glazier who, exceptionally, signed one of the ambulatory windows in Rouen was happy to give his references: 'Clement, glazier of Chartres, made it'. In the 1220s, that was sufficient introduction for a new artist on the cathedral site.

Around 1220, when the last flying buttresses were erected to ensure the equilibrium of the last vaults of Chartres, it looked as if everything had been said and every problem solved. In Amiens and in Bourges, the architects achieved greater height and width. The nave of Chartres only reaches 36 meters at its highest point. While the pyramidal balance of Romanesque architecture is still visible in Noyon, Sens and Paris beside the technical innovations of Gothic art, Chartres achieved the perfection that results from the total mastery of bold innovation. Leaving aside the isolated masterpiece of the Sainte-Chapelle, Chartres Cathedral says everything and, like Amiens and Bourges a little later, represents the apogee of this architectural system. More was to be added. It was to become more complicated, as when the masters of the flamboyant style created their star-shaped tracery. But architecture was not to invent any new structures for dominating space until the advent of reinforced concrete.

The transept crossing. Outside are flying buttresses, inside are the arches — with their slightly broken profile which increases their resistance — of the terrifying main vault that keeps the whole structure rigid.

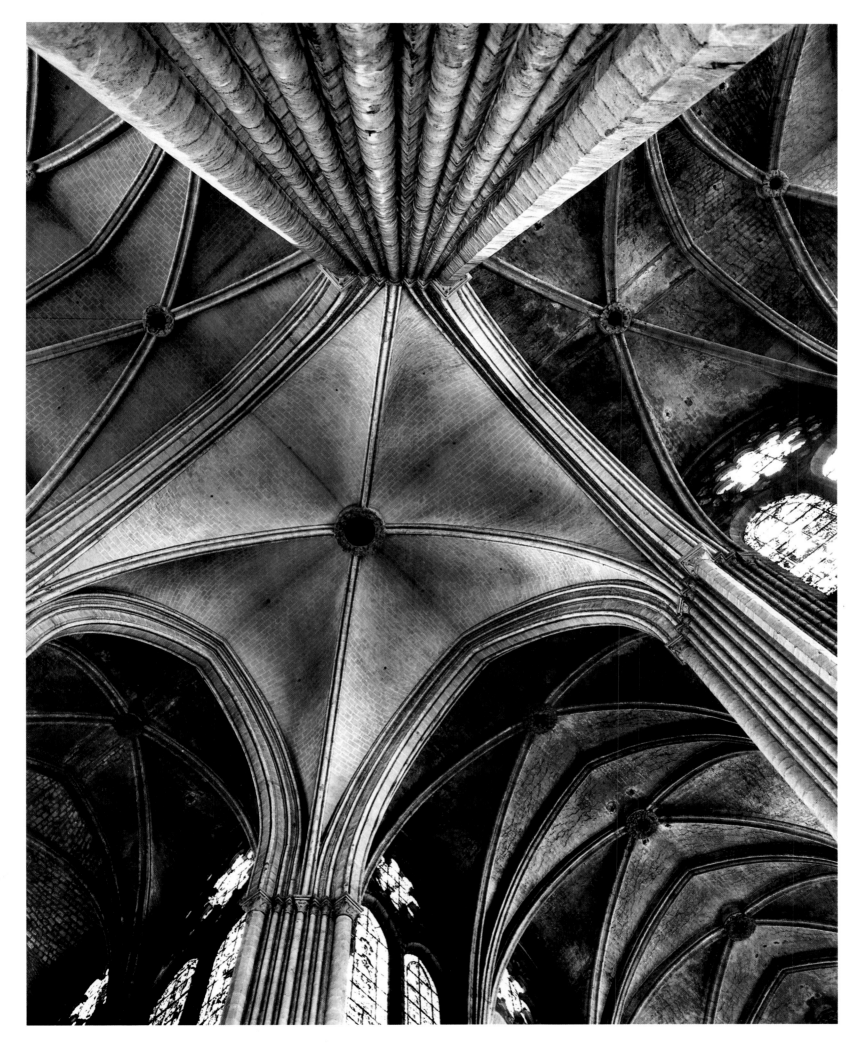

This is where any certainty about balance ends. Unlike the side walls, the large end wall closing off the south arm of the transept is not shouldered by flying buttresses. At one time, there were plans to frame it with thick towers, like the western façade wall. The masons confined themselves to the lower storey. The proof was there: the 'barlong' vault exerts its main thrust sideways. The time had come for the great roses.

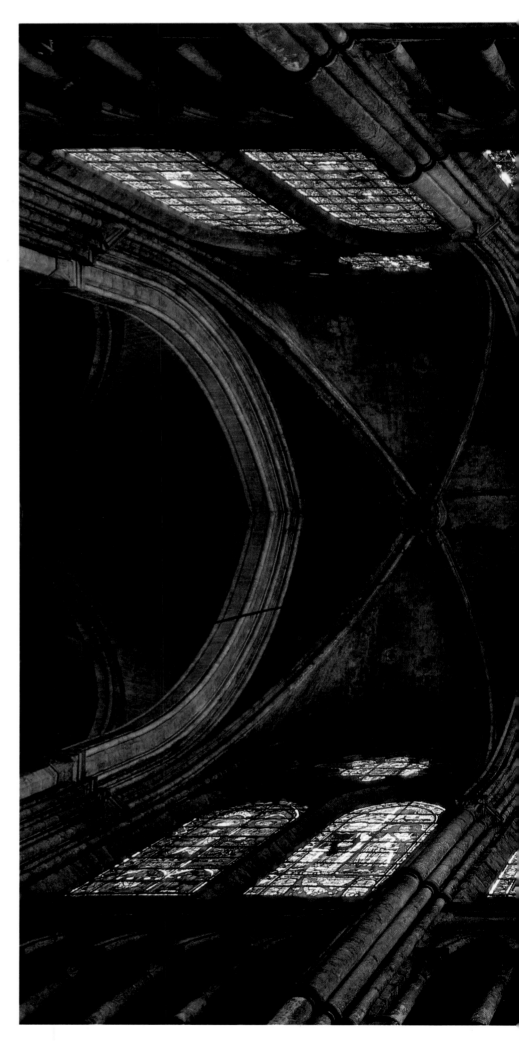

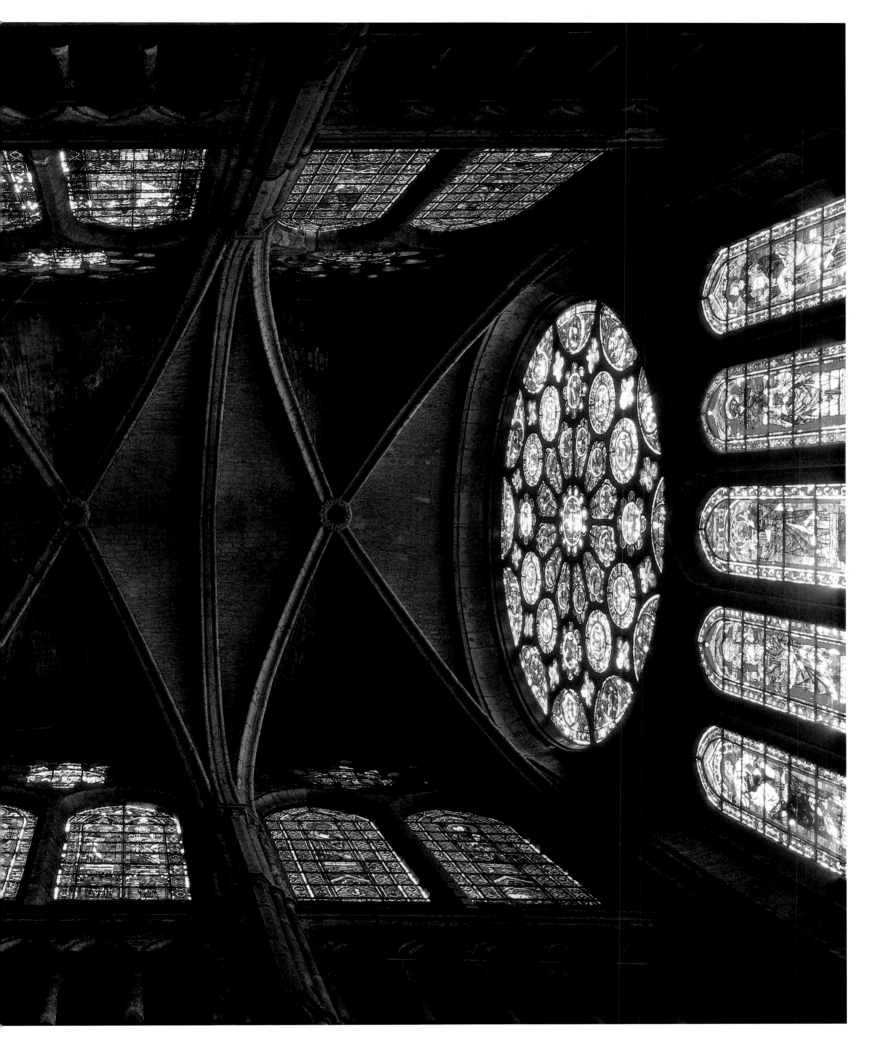

The great organ

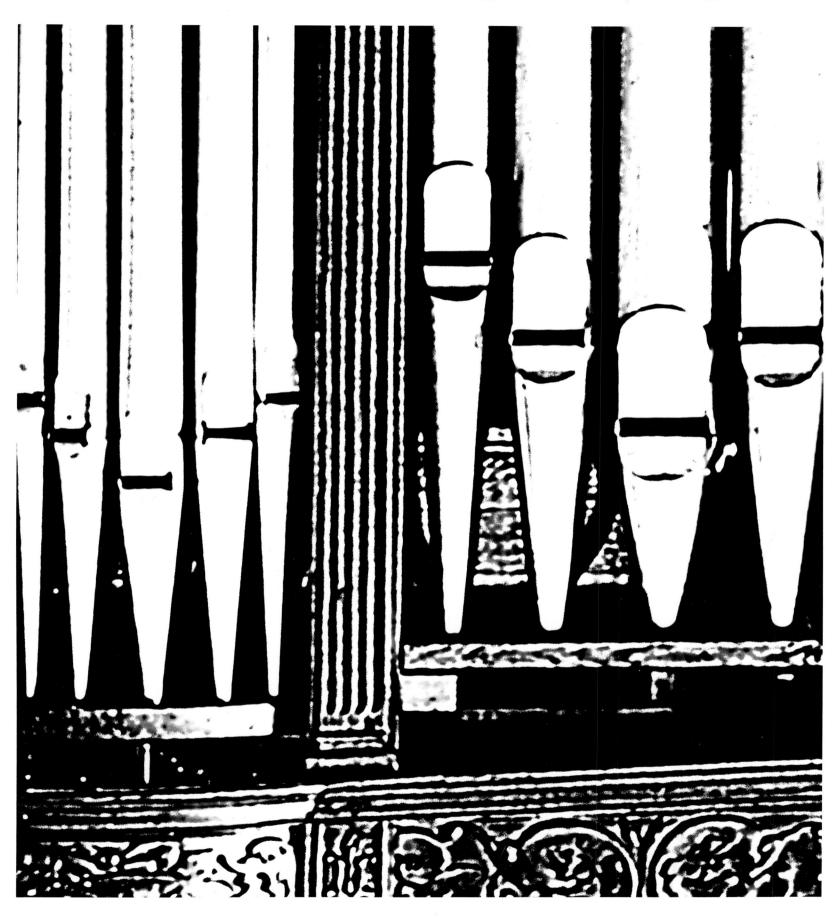

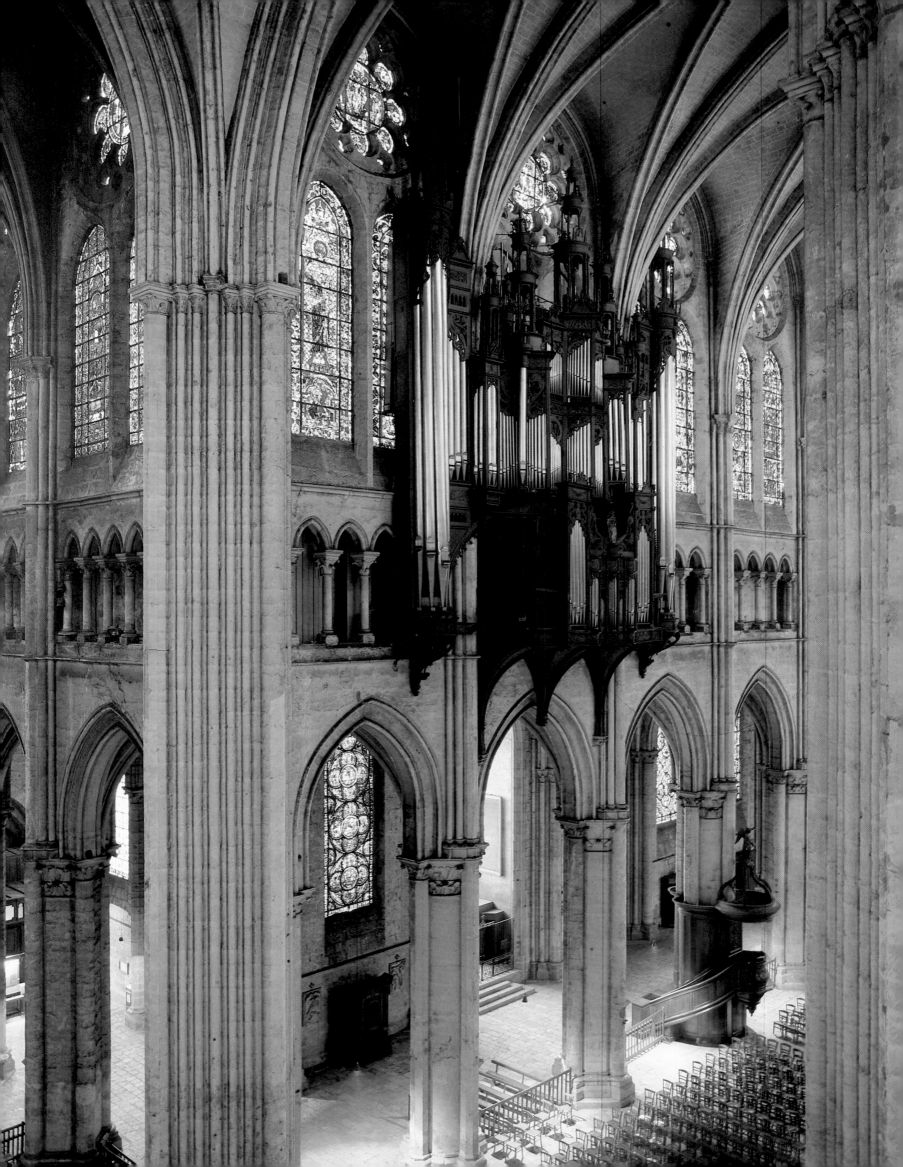

The great organ

Well before the fifteenth century, Chartres had its own organ, a small instrument situated on the floor beside the lectern in front of which the choristers stood. It was still a choir organ in the sixeenth century, restricted to the function it had in the Middle Ages of supporting and accompanying the choristers' voices, playing in unison with the simple melody of the Gregorian chant or plainsong.

The second half of the fifteenth century brought a change in religious music. In addition to plainsong, and often replacing it, we increasingly find polyphonies, in which two or more melodies run parallel, combining the various themes and creating that subtle dialogue between parts, now differentiated, that was eventually to lead to counterpoint. In the court of Burgundy, Gilles Binchois and Guillaume du Fay sought to marry freedom of invention with theoretic and practical attempts to create a balance between the parts. At Chartres, from 1455, the chapel master Jean le Teinturier — he called himself Tinctoris in the Latin fashion of the time — wrote no fewer than twelve treatises on composition, illustrating his theories with the masses and motets commissioned throughout the year for the needs of the service.

In the next generation, the Fleming Antoine Brumel, chapel master from 1483, wrote most of his religious works for four voices. Like his contemporary Josquin des Prés, Brumel went to Italy to refine his polyphonic art. He died there in 1510, at the court of the duke of Ferrara.

With the emergence of this new vocal music, the organ acquired new status. It was no longer an accompanying instrument but became one of the parts of the polyphony. It now had to make the original quality of its sound effects heard, vary them and adapt them to the general effect required. Soon it seemed that the organ could also be a soloist. The time had come to enable it to produce a purely instrumental polyphony.

An early, beautifully proportioned instrument was started in 1475 by an organ builder called Gombault Rougerie. It corresponds more or less to the central parts of the organ we see today, which still retains the flamboyant panelling of the Gothic organ-chest. This organ, which Antoine Brumel presumably first decided to incorporate in the cathedral's liturgical life, was a powerful instrument. It had a wealth of harmonics and was already capable of different registrations: each note corresponded to fifty pipes, used as the player wished. Six years later, when two notes were added at the top of the scale, they each had one hundred and fifty pipes!

The great organ. The windows of the west façade are essential for lighting up the first bays of the vault, darkened by the heavy masonry of the towers. Wisely, the organ was placed against the triforium wall, a position frequently used for choir organs.

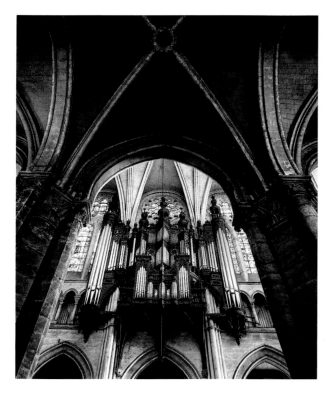

The great organ. From the 16th century on, organs were the size we know now. The instrument was modified at later dates simply in order to adapt it to the kind of music to be played and to the accoustics of the building.

To sustain the harmony and ensure the operation of the stops, the organ builder decided to add six enormous tin pipes, six 'horns', which sound at the bottom of the scale and reverberate from the vaults. These horns are fitted outside the main instrument, in two lateral turrets which still look basically the same, after being recarved in the sixteenth century.

But powerful as it was, the Gothic organ could not play a dialogue with itself. It was possible to vary the timbre from one piece of music to another or even during the execution of a piece, but it was not possible to characterize and distinguish two parts by changes of timbre. This was remedied in 1542, when the whole instrument was adapted by the organ builder Filleul, assisted by two cabinetmakers, Foubert and Bély. Not only did Filleul add stops – especially for the reeds, trumpets, cornets and others – and replace the heavy horns by stops more closely in harmony with the whole, he also introduced a great innovation, the second keyboard with its own stops whose pipes were positioned in a small organ-chest situated behind the player's bench, called the rear choir-organ.

The Renaissance had profoundly marked the work of the two cabinetmakers. With a flamboyance that still owed much to the Baroque style of Late Gothic and which links the organ-chest of Chartres more closely with the roof of Chambord than with the ribbed vault, they produced a wealth of balustrades, turrets, pinnacles and candelabras. With its decorative scheme that reflects a rather unadulterated Renaissance style, and even though the central parts of the Gothic organ and its formidable lateral turrets were kept, this organ-chest of 1542 is one of the most remarkable, and best preserved, examples of instrument-making in sixteenth-century France.

The seventeenth and eighteenth centuries embarked on several restoration and renovation campaigns, which did not actually change the Renaissance organ very much. At the beginning of Louis XIV's reign, another attempt was made to extend the range of sound. Etienne Enocq, who was to work with Robert Clicquot ten years later on the first designs for the organ of the royal chapel at Versailles, restored the organ of Chartres from 1666. His son-in-law Henri Lesclop renovated it at the end of the century.

The organ was much played and became worn. In 1736 Jean Regnault had to modernize the bellows and took the opportunity to add more stops, especially the reed-stops so popular in classical organ music.

In 1742 François-Henri Clicquot decided that the organ was still not right; so many stops had been added that it was out of balance. There were many good-quality stops, but some were too loud, others inaudible, and new reed-stops were needed: the high notes of the bugle 'do not sound two days in succession'. The keys did not all have the same resistance and it was difficult for the organist to avoid jerky sounds. In short, the mechanism had been restored, but the pipes needed looking at. Nothing had yet been done when the Revolution broke out.

So the fire in 1836 which interrupted the career of the classical organ merely condemned to silence an instrument that was already tired. Unfortunately the organ builder Gadault had neither the means nor the ambition to do anything about it. The organ which was inaugurated in 1846 and to some degree restored twenty years later was a very mediocre one, in terms of the number and variety of stops – especially pipe-stops – and the range of the keyboards. The restoration undertaken by the Abbey brothers from 1881 to 1884 gave the cathedral an instrument that was

The great organ. Detail of the organ-chest. Here, in the 16th century, the search for balance and the borrowings from the decorative grammar of antiquity combine with memories of the Baroque luxuriance of the flamboyant period.

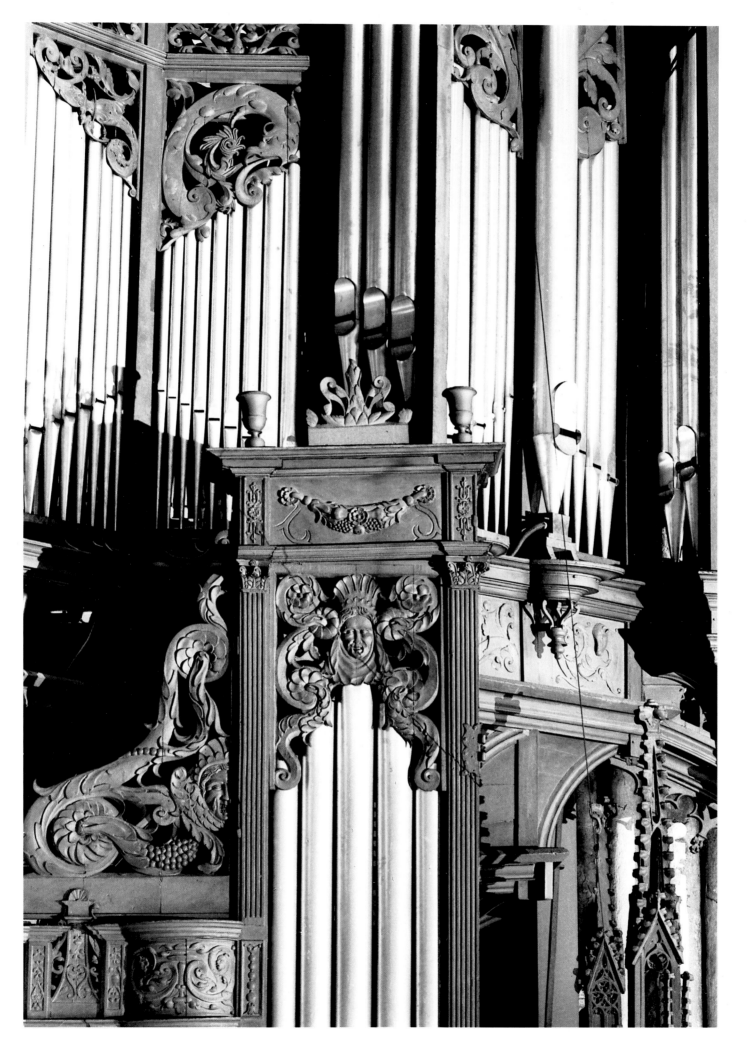

barely acceptable, with three keyboards for playing contemporary works, by Camille Saint-Saens perhaps, or César Franck. Then came Guschenritter. In 1911 this organ builder finally gave Chartres an instrument in keeping with its nave and aisles and its tradition. Each of the manual keyboards acquired another octave and thirty-nine stops were added, which made it possible to play the entire range of ancient and modern music. The instrument now had great potential and it was to improve Chartres' image until after the Second World War.

Then, once again, the much-played organ became tired. Pierre Firmin-Didot led the campaign to renovate it on the basis of new technical advances and the rediscoveries of organology. And so, in 1971, it became a great instrument again thanks to the organ builder Gonzalès, with sixty-seven stops distributed over four manual keyboards and one pedal-board. Now the cathedral became a centre of musical life with concerts and competitions of interpretation and improvisation, and appearances by the most famous musicians.

Perhaps the most astonishing fact is that after so many mishaps and such long periods of mediocrity, we are fortunate enough to hear the organ of Chartres still play some of the stops loved by Clicquot, in an organ-chest which is basically the same as it was in the sixteenth century.

The image

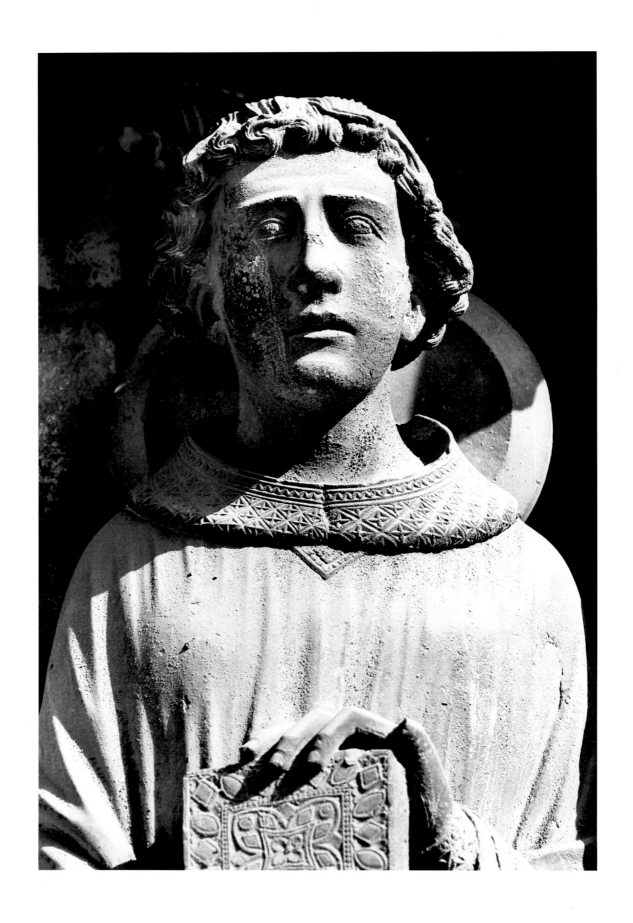

The image

The image has always been the best means of making something understood. From the often complex visions of the Revelation to the often difficult foundations of morality, it was by rendering ideas through the reality of the human face or the colour of an anecdote that the teachers — schoolmasters and religious teachers — defined their thought and argued their theories. Plato did just that when he invented the dialogues between Socrates and his slave. And Christ, inventing the people and situations of his parables, was doing the same when He gave Charity the form of the Good Samaritan willing to spend time and money on a traveller beaten up by bandits. From Aesop to Florian, not forgetting La Fontaine, the fable-writers of all times have created figurative images — often including animal allegories — to demonstrate or refute examples of social conduct.

Just as every individual has several facets, so the anecdote can be read in several ways. Each reader takes from it what he sees, and La Fontaine was well aware that the story of Perrette and his pot of milk would encourage the average reader to take elementary precautions, while leading the investor tempted by maritime and colonial adventures to be careful in his speculations. To the provincial reader the old man planting seeds looks like his neighbour, while to those familiar with the gardens of Versailles he looks like the Sun King.

Faced with congregations whose knowledge of the truths of the Gospel varied, the medieval preacher could not have done without this form of argument. Delving into the certainties of history, or what he believed to be so, and into the storehouses of legend and miracle, he borrowed more than he invented. Leaving aside the history of the recent past, which could not pretend to be authoritative, he drew from the inexhaustible anecdotal treasury of ancient history and its symbolic heroes, from the Bible with its prophets and patriarchs whose names alone are an allusion to the message of the Bible, from ecclesiastical history with its saints who could act as models of the virtues expected of the Christian for every occasion.

In this way a whole body of references was built up, whose very mention showed the trend of the sermon. They formed an undisputed basis for the dialectical exegesis which both explained and applied them. The Tree of Jesse was at the same time an image, immediately perceptible to the simplest mind, of Christ's essential humanity, and the basis of all the sermons about God's original intention for mankind to be saved by the advent of he who was to call himself the Son of Man. The branches of the

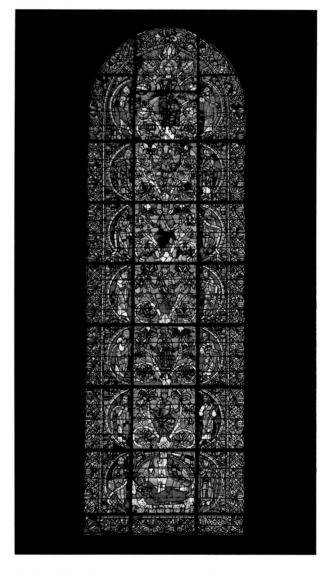

The Tree of Jesse. With the entry of a degree of humanism into theology, the masters of the iconographic programme began to underline the human genealogy of Christ by recalling Isaiah's vision. Window of the west façade (*c.* 1150).

Opposite
St Vincent. The deacon and martyr carries the book that symbolizes the right of deacons to read and comment on the Gospel. (Right portal, south transept.)

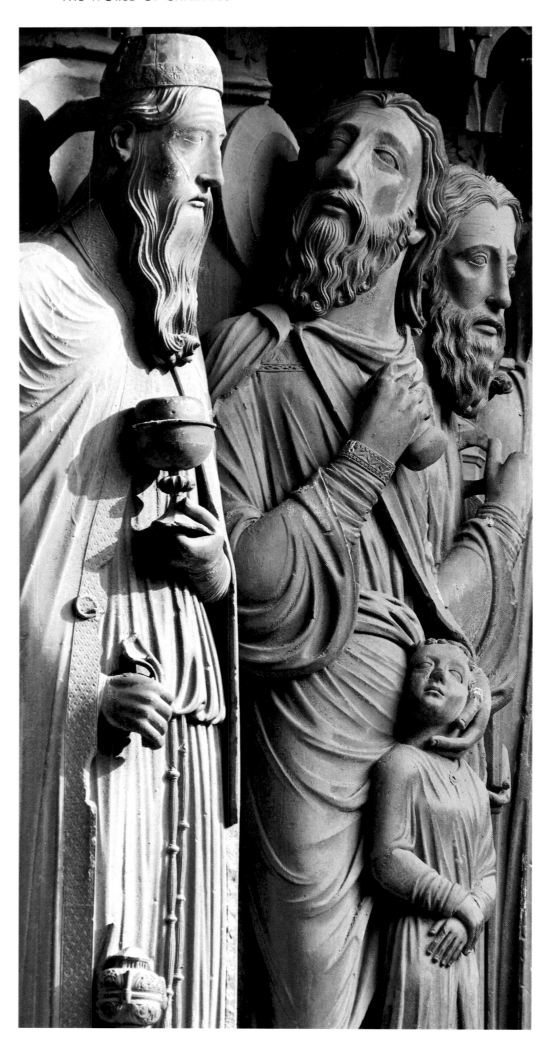

Melchizedek, Abraham and Isaac, Moses. After the Royal Portal, the statues began to emerge from their columns and adopt more animated poses and expressions. Anecdote began to take over from the ideal. The priest Melchizedek is carrying the censer and cup of wine. Abraham is preparing to sacrifice his son Isaac. At the patriarch's feet lies the ram which will eventually be sacrificed: the whole story is told here. (Central portal, north transept, c. 1215.

Opposite
Isaiah. What is important here is the opened scroll on which his main prophesy was written: a Virgin will bear a child. (Right-hand statue of the central portal, north transept.)

94

tree which Isaiah sees coming from 'Jesse's stock', the father of David, represent humanity as a whole. They form the historical framework for the human birth of the Saviour foretold by the prophet. The Messiah is not the divine avatar imagined by so many Eastern religions. He actually walked among men, not apart from them.

The Tree of Jesse which the masters of Chartres showed twice in succession on the west façade of their cathedral, with its figures dressed in purple and dark green emerging on each level – meaning each generation – from the branches of light springing from the sleeping Jesse, recalled everything the sermons had preached. Such points of reference encourage memory. But the Tree of Jesse also helps situate the Biblical figures who represent stages leading to the human birth of Christ, figures needed for other developments of the story who occupy a specific genealogical place.

The 'kings' of Israel represented on the façades of so many cathedrals and which the masters of Chartres wanted to show in two 'galleries', one on the west façade, the other on the façade of the south transept, are simply juxtaposed figures; the harp carried by one and the baton by the other are intended purely for their formal differentiation. Some modern art historians have wrongly interpreted them as kings of the royal dynasty of Clovis and Charlemagne. The gallery of kings in Paris owed its destruction by Revolutionary vandals to that error. The same confusion arose at Chartres where the twenty statues of kings on the north porch were deliberately destroyed because they were seen as representations of the French monarchy. The Tree of Jesse gave their true meaning, which was the continuity in the story of the Incarnation, to these kings whose *raison d'être* in medieval iconography lay not in history but in theology.

The catalogue of references is vast. But it had to be used wisely. The art of the preacher lay not in finding new references but in drawing lessons from existing ones and exploiting the speaking image to the utmost in order to uncover its full meaning.

The first meaning, at first sight or first hearing, was historical. It was inherent in the story itself, or the figure itself, with all that was known about its place in time, i.e. in the journey towards the Redemption and in the Redemption itself. Like the image-maker, the preacher was well aware that what the congregation liked best was to be told a story: they only listened to the actual spiritual message if the protagonists and stories were interesting, identifiable, intelligible.

In this sense, Melchizedek can be seen as the priest-king of Salem who met Abraham on his way back from his victory over the infidel. Blessing Abraham, Melchizedek offers him bread and wine. And in return Abraham, not to be outdone, offers a tenth of his worldly possessions, which means his caravan. Five lines in Genesis, that is all. But they formed part of a system of references and in the twelfth century everyone knew who the 'grand priest' Melchizedek was, with his conical cap and often wearing priestly robes.

They were equally familiar with the sacrifice of Isaac. God asked Abraham to sacrifice his only son. Abraham rose early, took his ass and his son Isaac with him, and cut firewood for the holocaust. Just as he was about to kill his son, an angel appeared and stopped Abraham. A ram replaced the child on the improvised sacrificial altar. It was a good story, full of suspense.

Job, for his part, was shown as the rich man of the land of Uz, 'the greatest of all the sons of the Orient', with his seven sons and three daughters, seven thousand sheep, three thousand camels and five hundred yoke of oxen, the

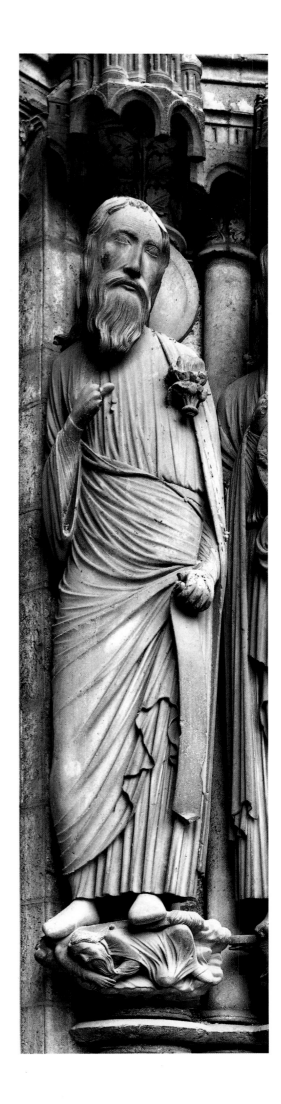

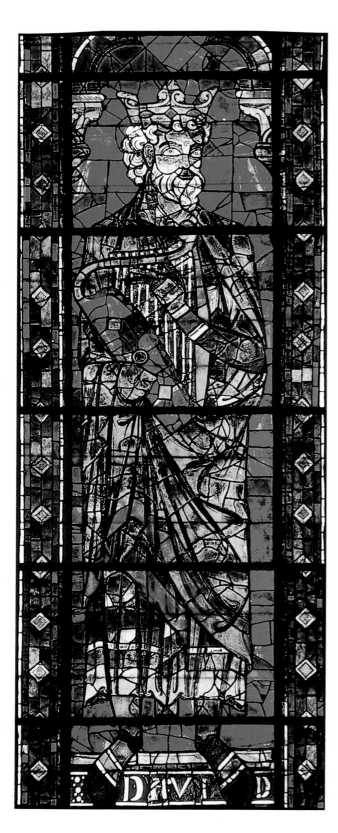

David. He is shown here as the author of the Psalms as much as the king of Israel. The royal crown and the poet's lyre underline his dual role in the historic legacy of the Old Testament. Kings David and Solomon surround St Anne, mother of the Virgin, with the priests Melchizedek and Aaron. These windows, offered by the young St Louis and his mother Blanche of Castile, perfectly portray the political realities of the difficult alliance between the Capetian king and the Church. (Window of the north façade, *c.* 1235.)

'righteous' man on whose head misfortune suddenly falls, the death of his family, ruin and disease. He is the hero of the colourful scenes showing his friends, who used to feast with him, standing beside him, full of consternation, not knowing how to express their sympathy except by crying and speaking. Job himself is seen almost naked on his dung heap – an image that has almost become proverbial.

The second meaning the commentators tried to discover in the anecdote or portrait was the moral one. The teaching must be translatable into individual and social behaviour. Melchizedek quite naturally introduces the theme of praise of hospitality, sharing. He stands for the respect due the clergy, like the respect of Abraham for the priest king. The sacrifice of the patriarch, who was willing to slay his only son, stands for abnegation, obedience, the willingness to discard all rational thought in total submission to God. It is also trust in a God who is terrible to His enemies but full of goodness towards His faithful, since in the end He spares the father and the son. And by his example Job preaches detachment from the things of this world and submission to the will of God.

All these themes could be developed in the sermon, which was underpinned by the images which helped the congregation remember the model. The Word becomes form here. Abstract ideas and conduct difficult to accept as such were presented in the form given to them by image-makers capable of representing the firewood for the sacrificial burnt offering, the robes of the Biblical priest and the leprosy of poor Job.

There is also a meaning which Christian thinkers never ceased seeking and trying to explain in an exegesis deliberately linked to the Gospel: Christ did not come to abolish the old Law but to accomplish it. That is the allegorical meaning, suggesting a global theology of Creation. Everything has been foretold, everything will be done. The world is still looking towards and drawing inspiration from the mystery of Golgotha.

In this sense Melchizedek is the incarnation of the eternal priesthood. The faithful recognized his statue by his liturgical instruments: the ciborium of consecrated bread, the censer of hospitality. The bread and wine he offers in welcome also represent the Alliance, the Eucharist. The offering of the bread and the wine changes the face of the world. They are at the heart of the alliance of God with men. Melchizedek's offering is the offertory of the Mass.

The sacrifice of Isaac, the sacrifice of the Son, is of course the sacrifice of the Calvary. From the time of original sin, God wanted the blood of His Son shed for the salvation of man. But it was also to be the last blood. The Almighty stops the sacrificial knife. A new law takes the place of the old.

As for Job, he is the renunciation imposed by the priesthood. All those who abandon their family and give up their wealth to follow Christ are simply following the example of the righteous man: God gave them to me, God has taken them back. He is also the hope of consolation in this world, this 'vale of tears', and the trust in a final reward. God rendered to Job twice as much wealth as he lost. He gave him another seven sons and three daughters. And Job saw his sons and his son's sons up to the fourth generation. The symbol of submission is also that of everlasting joy. Above the dunghill scene, on the north portal of Chartres, we see God watching over his servant Job.

No one interpretation precludes others, and the Job episode has even been seen as an illustration of Christ outraged by the sinners and heretics, or even by the Aristotelians!

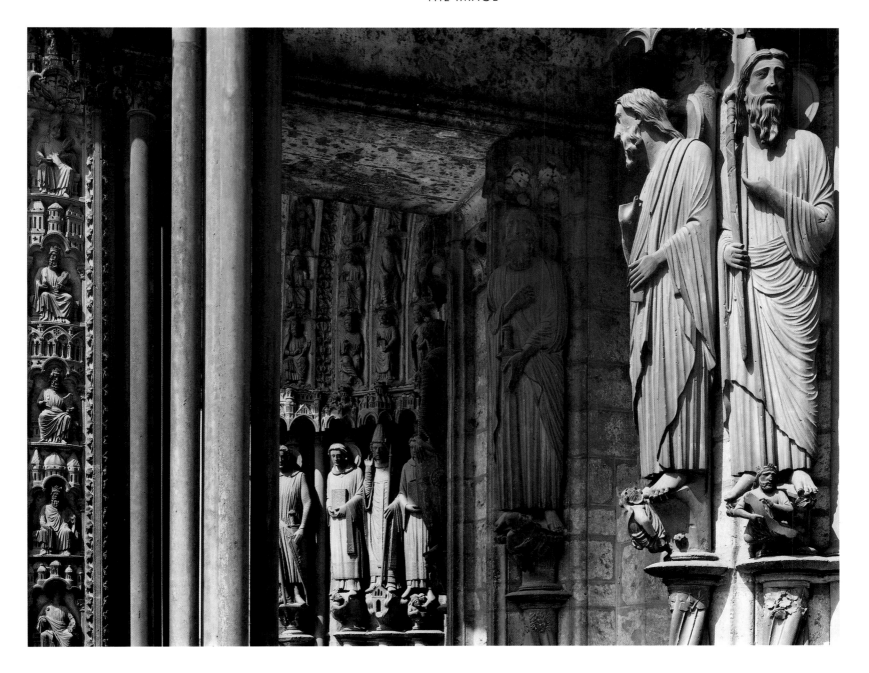

The south transept portal (c. 1206). The statues to the left of the left portal (at the back) are: SS Theodore, Stephen, Clement (with the papal tiara) and Lawrence. The deacons Stephen and Lawrence are carrying the Gospel. This is the primitive Church, the martyred Church. In the foreground, the Apostles of the central portal.

Images mean decoration. That is where the theologians were at odds with one another. Was it necessary, in order to instruct the people, to do so through an art whose aesthetic ambitions, however much directed towards the glory of God, still turned man's eyes elsewhere and diverted elsewhere the wealth he could have put to better purpose? We are far away now from the 'iconographical dispute' which darkened the skies of Byzantium in the eighth and ninth centuries. The twelfth-century West was more moderate in its transports and more secure in its faith, and was not as afraid as the eighth-century East that the worship of images might turn Christianity into paganism using the Gospel as its camouflage. No one worried that the iconographical decoration of the churches and liturgical manuscripts might lead to a form of idolatry that submerged the faith in a single and immaterial God. When St Bernard, Abbot of Clairvaux, and Abbot Suger of the abbey of St Denis made the whole of Latin Christianity reverberate with their dispute, their arguments no longer related to dogma but to morality.

How could one speak of Evangelical poverty, St Bernard asked, when the stone church was such a manifestation of wealth? How could the faithful pray and think only of God when their attention was distracted by a decor

in which the world and human society took precedence over the spiritual aspect? The Abbot of Clairvaux told his new disciples: leave your temporal bodies at the door. Only the spirit may enter here.

Clairvaux was remote from the world, Saint-Denis three leagues from the capital. Suger wanted to speak to the people and not just to the monks dedicated to meditation. Preaching in an isolated valley was not the same as preaching among the crowds of a noisy city.

For Suger, decoration and images quite simply signified the splendour of God and the splendour due to god. They rendered perceptible the Perfection which is God's first attribute. And Gothic art, with its explosion of light, appeared a means of making the Light of the Creator perceptible to the senses. The high vaults and great stained-glass windows, the shining liturgical gold plate and the monumental statues in the embrasures of the portals all have but one purpose: to show the greatness of God.

Iconography

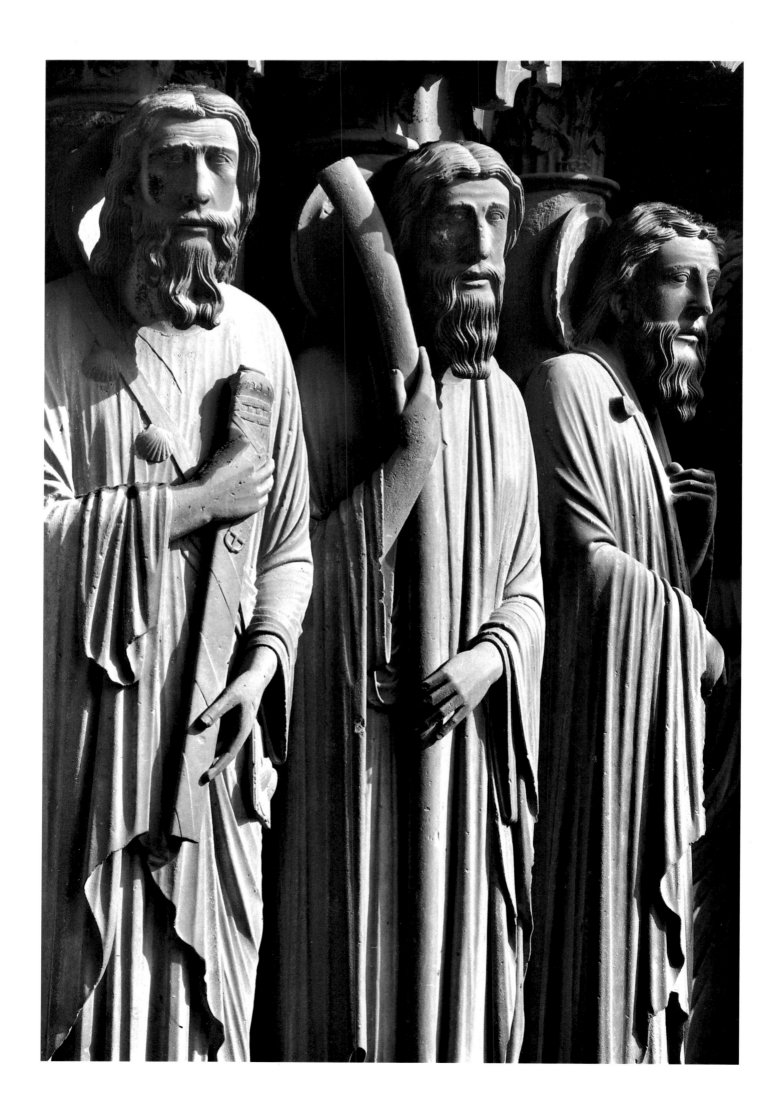

Iconography

According to Suger, to decorate a church was a work of piety. According to St Bernard, it ran counter to the expression of the two fundamental virtues, humility and renunciation of the world. 'Of what use is the gold in their churches to the poor of Christ?' And the Abbot of Clairvaux condemned the vain pride of the new art: 'the excessive height of the chapels, their disproportionate length, their superfluous width, the sumptuous ornament and the very curious paintings which attract the eye and are thus an obstacle to devotion.'

He launched several severe attacks against bishops who 'try to excite the piety of the common people by material ornaments because they cannot do so by spiritual ones.'

Towards 1125, when the Abbot of Clairvaux wrote those lines in a treatise intended purely to refute the new sacred art and reform religious conduct, the bishops of Chartres had but one idea in their minds: to enlarge and embellish their cathedral. The thunderings of the reformer certainly did not slow down the introduction of new techniques or the development of decorative programmes. The glory of God won the day over evangelical poverty. So did the glory of the town.

In earlier times people had found different means of expressing their faith and piety in art, such as the Carolingian manuscripts with their full-page miniatures and their ivory-plated bindings, or the reliquaries, chalices and patens wrought in gold and enamel. Everyone knew the statues covered in jewels offered by rich pilgrims, like Sainte-Foy in Conques. The miraculous statue of Chartres, now lost, was one of those works which transmuted into an at times rather exaggerated work of art a generosity born purely of the desire to give to God.

But the manuscripts were not accessible to just anyone, the chalices were kept far from the people and the pilgrims had little chance to pause on their way past the shrine. Whatever Suger thought, there was no lack of faith; but all this decoration was designed to underline the importance of a particular cult, the fame of a particular relic, the antiquity of a place of pilgrimage. Neither the sacred vessel nor the illuminated manuscripts competed with the sermon. And the bishops were inclined to shrug their shoulders when a Cistercian monk reminded them that the primary arguments for converting the masses are those of the spirit. The Abbot of Clairvaux, in the view of the Bishop of Chartres, had only a vague idea of what it was like to deal with a crowd of coopers and cloth-dyers. Images designed to express the rational bases of popular faith now began to fill all the empty pages the new 'Gothic'

The Apostles. There is little anecdote here. Each Apostle bears the emblem that identifies him. The faces are still anonymous. St James the Greater can be recognized by his shell, St James the Less by the club with which he was killed, Bartholomew by the knife with which he was flayed. (Statues to the right of the central portal, south transept, c. 1206.)

The north transept portal (*c.* 1215). This is the portal of the New Alliance, of the Old Testament completed by the New. Patriarchs and prophets announce and prefigure the Redemption. From left to right: the Nativity, the Glorification of the Virgin, Job and Solomon.

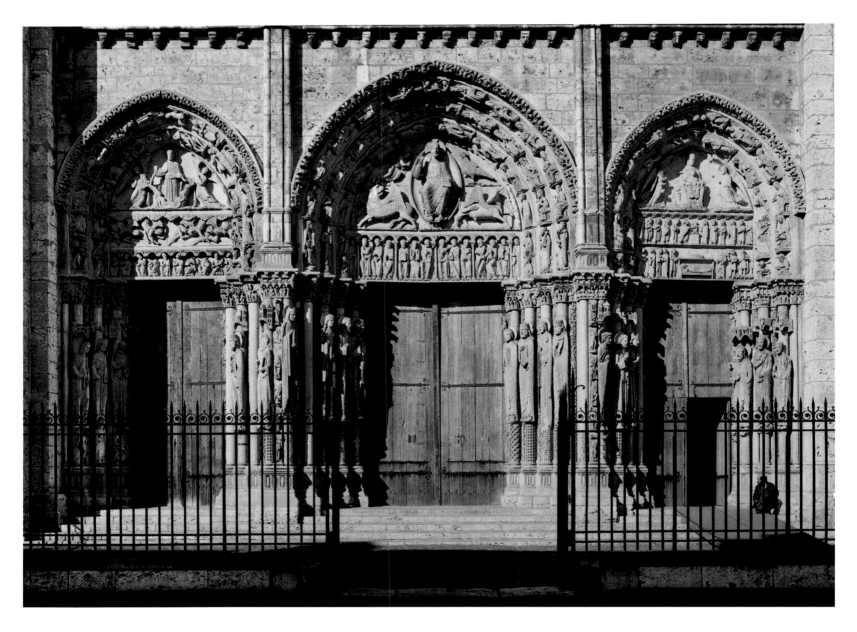

Royal Portal (*c.* 1140). This is the portal of Glory, of God manifesting Himself to man. From left to right: the Ascension, Christ in Majesty, the Virgin and the Infancy of Christ.

The south transept portal (*c.* 1206). This is the portal of the Church Militant and the Last Judgment. Martyrs and saints, shown interceding and healing, frame the Last Judgment portal.

102

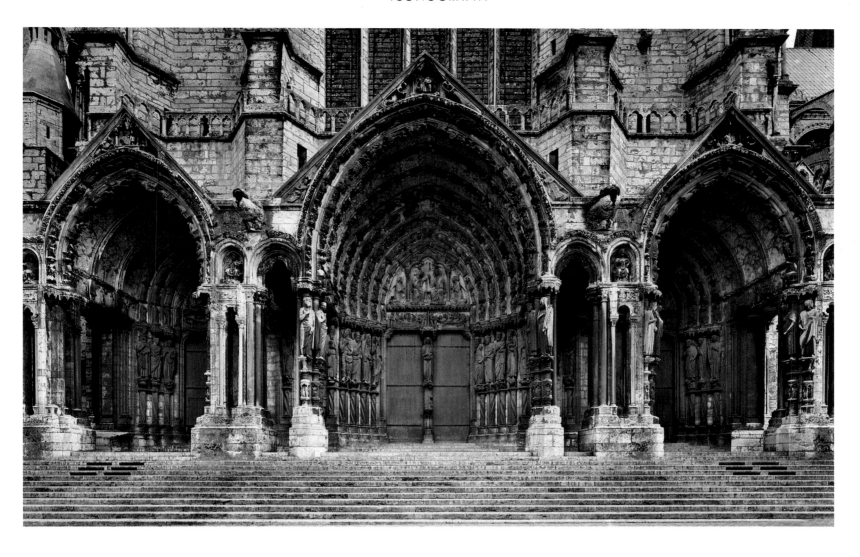

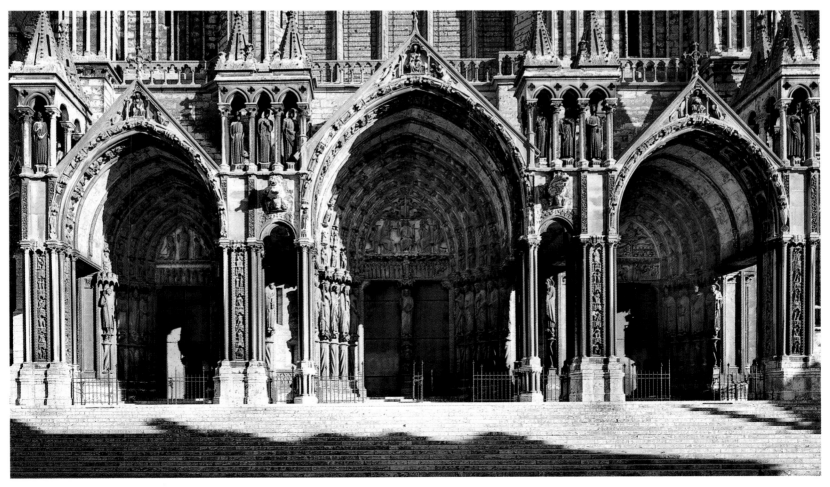

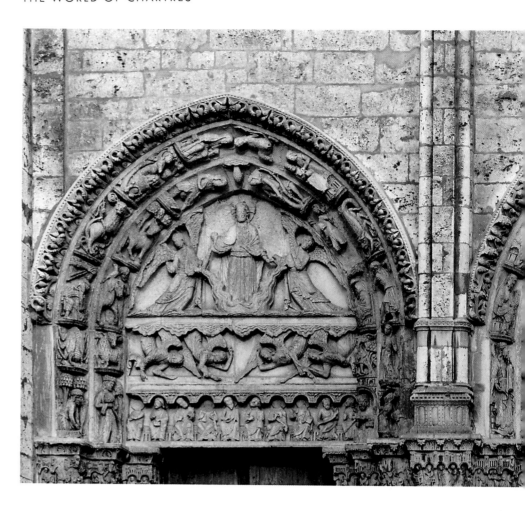

art could offer, in place of the Romanesque vaults with their low capitals and austere walls. Very soon, towards the mid-twelfth century, there was no turning back and no one was to dispute this approach until the end of the Middle Ages. Sculpted figures were now arranged around the great portals opening onto the nave and the transepts: there are three portals at Senlis, five at Paris. There are nine at Chartres and each unfolds a story, illustrates a moment of the Redemption. The tympana are a series of historical compositions presenting narrative scenes side by side and in superimposed registers. Little figures give a running commentary in the voussoirs around the tympanum. And large statues, on the embrasures of the portal, further define the narrative by relating the main figures to the truths of the faith which they preach or symbolize.

The Royal Portal, on the west, preaches the greatness of God and tells of the Redemption, the redemption of the human race by the will of God. But the joyful spirit of the High Middle Ages – before the often rather morbid Baroque of the difficult times which came in the fourteenth century, bringing war, famine and the plague – preferred images of life to those of death, and victory to defeat. Christ on the Cross is remarkable by its absence from the iconography of the portals of Chartres. He can be found in the stained glass, first on the western façade, then in the northern aisle and in a high transept window. On the Royal Portal, the Passion is shown only in small scenes on the capitals which tell the story of the life of Christ in a frieze running from one portal to the next.

Similarly, far more emphasis is put on the picturesque quality of the events from the Gospel than on the dramatic representation of Christ dying for the sins of man. The Passion is shown not as the calvary of Golgotha, it is St Peter cutting off the ear of the grand priest's servant, the kiss of Judas

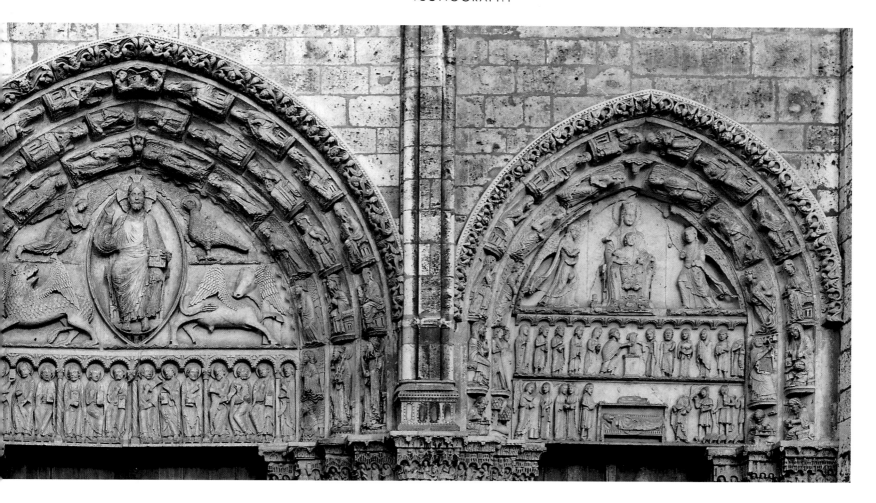

The Royal Portal (c. 1140). The portrayal of Christ in Majesty has a hieratic quality — Apostles on the left, scenes from the Infancy on the right — that is underlined by the little figures on the voussoirs. The picturesque is confined to the frieze on the capitals running the length of the façade, above the large statue-columns.

and the arrest in the Garden of Gethsemane, the ass and the palm branches of the entry into Jerusalem, the deposition of a Christ with folded hands by his pious disciples.

In the main, the Royal Portal represents triumph. Christ is seen in Majesty, with his apostles, on the main portal, surrounded by the angels and wise elders of the Apocalypse. The Virgin is also shown in Majesty, on the right portal, while the scenes from the Infancy of Christ below recall His 'historical' role in the Incarnation, not the sufferings of the Passion. This is not yet the era of the *Pietà* and of Our Lady of the Seven Sorrows which the artists of the late Middle Ages liked to show. The left portal shows the moment of glory following the Resurrection: the Ascension of Christ — although some exegetists see it as the Creation. Parallel to the Christ in Majesty, this is the living Christ ascending to the Kingdom of the Father.

The three north transept portals are devoted to the Incarnation. From the 'prefigures' of Christ to the Coronation of the Virgin, via the Nativity, they tell the human story, annotated by the Biblical stories anticipating the advent of the Saviour, with the most beautiful part reserved to the sufferings of Job, the prophet who awaits his final justification.

The south transept portals show the Communion of Saints, whose merits could procure the salvation of the faithful. The Last Judgment is depicted as a manifestation of this unity of the Church around its saints, not as the end in itself of God's anger. And the chosen are shown in the bosom of Abraham. The Old Testament is completed by the New.

In spite of the succession of different workshops and the diversity of styles, the nine portals as a whole form an orderly and coherent composition of the paths of Redemption. The Old Testament and the New form a balance, as do the just of the Ancient Alliance and the elect of the

The Good Samaritan. Morality is taught by example and the scenes and anecdotes on the windows recall the exhortations from the pulpit. The subject lends itself to realism: the traveller who has been beaten up and left naked (above, right). But the artist skilfully combines teaching by parable – the parable of the Good Samaritan – with teaching by example – the miracles of Christ. (South aisle windows, c. 1210.)

Below, right
The Kiss of Judas. In a society which exalted the concept of fidelity that lay at the very basis of feudal structure, as illustrated so often by the *Chansons de geste,* few stories demonstrated man's sinfulness as well as Judas' betrayal. (Window of the Passion, north aisle, c. 1210.)

Communion of Saints. The man we know as the 'Master of the Royal Portal', who was probably responsible for the Christ in Majesty and the large statue-columns on the left of the central portal of the Royal Portal, certainly determined the general scheme of the sculpted ornament and oversaw the first works in the 1140s. His successors showed the same concern for coherent teaching by image.

Another empty page had become free for narrative and lent itself well to continuous decoration telling a coherent story. It was the choir wall – blind because it was designed to enclose and disproportionately long as a result of the extension of the choir – which, with the jubé or choir-screen, encloses the choir, and which was well lit on the outside by the row of lower windows. At the beginning of the sixteenth century, when it was decided to complete the iconographical programme without touching the façades, all that remained to do was to replace the earlier wall by a vast band of sculpture; this was the choir wall erected from 1514 by Jean Texier, known as Jean de Beauce, the same man who had just erected the north tower on the façade that had been waiting for more than three centuries. Most of it still survives, in spite of the demolition of the jubé which closed off the choir

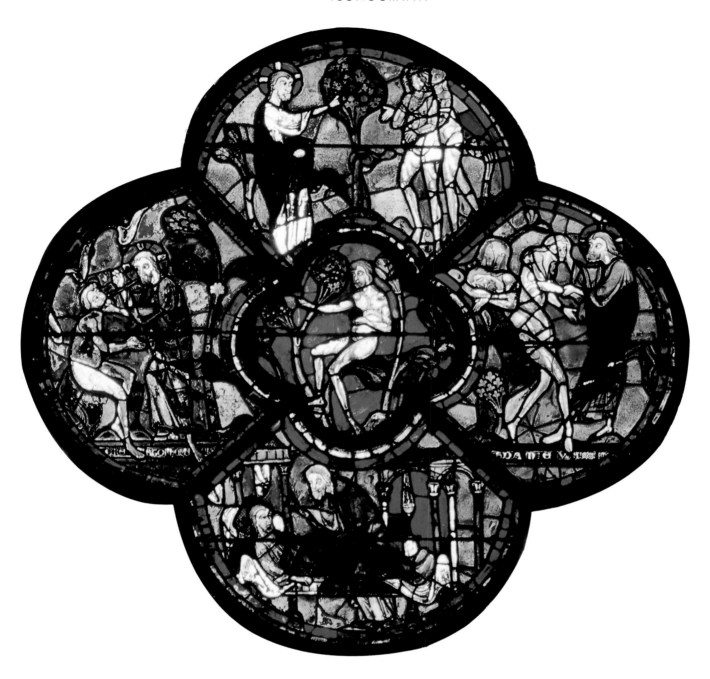

opposite the nave in an ostensible isolation which the Council of Trent was to condemn in the mid-sixteenth century.

And then there is the glass. Like the portals, the windows can be used to compose a variety of pictures. They follow the portals in preaching a series of sermons that alternate historical episodes with allegories and which mingle the Scriptures with legend, without forgetting the picturesque aspects of daily life. With their pattern of medallions set in iron to strengthen it against the winds, the glass of the large windows offered the perfect setting for series of scenes from the Bible. They depict the miracles of Christ, but also those of the saints. The stations of the Cross are shown, as are dramatic episodes from the lives of the martyrs. Even though here and there we might happen upon a tall effigy of Christ, the prophets or the saints, more important are the superimposed generations of the Tree of Jesse, the twenty-four round and square scenes of the Infancy of Christ, the fourteen scenes leading from the Transfiguration to the Risen Christ appearing to the disciples at Emmaus, the dozens of episodes at the base of the tower which tell the story of Noah and of St John, or in the apse telling the story of Charlemagne.

St Theodore. He is dressed as a knight of the time of Philip Augustus, in a coat of mail with the cowl down, carrying a lance and a long sword. (Left statue on the right portal of the south transept, c. 1206.)

Royal Portal. The identity of these Old Testament figures is uncertain. The statues are still quite closely attached to their columns. This idealized portrayal is reflected in their rigidity, scarcely attenuated by the folds of drapery, and their frontal pose, with their hands in front of them, creating an appearance of immobility. The tight folds and low-relief modelling only vaguely indicate the lines of the body. The eye is drawn to the head. The artist wanted to situate these men in the context of the Redemption, not show their role in history or their personality. (Statues to the right of the central portal, c. 1140.)

Let us make no mistake. If he remembered what he had been told in the sermon, the faithful who crossed the portals in the throng of pilgrims might recognize the grand priest Melchizedek by the censer and ciborium he is holding rather than by the round cap he is wearing of an imaginary Biblical priest. He would probably recognize Abraham and the child Isaac. He would certainly identify the two statues of the Virgin and Elizabeth in the scene of the Visitation, familiar to Christians singing the Magnificat. And the lintel of the Portal of the Virgin on the Royal Portal would be comprehensible to anyone who paid any attention to the priest's sermon, with its 'cartoon strip' of the Infancy, identified on the left by the angel of the Annunciation, on the right by the shepherds and their flock. The remainder falls into place easily, around the central scenes of the Nativity, with the Virgin in her bed and the Child in His manger, and with the Presentation at the Temple of the Child, now much older, and set on a real pedestal by His parents like a statue. It is more doubtful whether the same faithful passing through the portal would realize that the traveller wearing laced boots, his feet on his ass, is the prophet Balaam, that the apostle with the club is St James the Less — not the saint of Compostella — and that the superb horseman on the south transept portal, with his coat of mail and his lance, is in fact the great St Theodore, a soldier in the Roman army of the east martyred in the late third century for having set fire to a temple of the mother goddess Cybele, an image the Gothic sculptor has obviously borrowed from Byzantine ivories, if not from memories of travels to Venice or Sicily.

In any case, the assiduous visitor or occasional pilgrim did not have binoculars. What we can see today was often hidden from them because they could not see the upper areas and their decoration properly. At a height of thirty meters, the figures of the Infancy of Christ on the central window of the western façade — figures 50 to 80 centimeters high — were and still are impossible to distinguish by anyone standing on the floor of the nave. In the twelfth century, the faithful may have been able to appreciate the lower scenes on the windows around them, especially those where the guilds had themselves portrayed to show that they had financed the decoration; but basically they were more aware of the outpouring of faith represented by this gigantic sermon in images than of the details of the arguments embodied by the figures on the voussoirs of the portals and the medallions of the windows.

Decoration is not explanation; it is designed to strike the beholder, to remind. In fact it is not the vital factor, and in this sense St Bernard was right: it is not by being shown scenes of little figures in blue or red that the faithful will be persuaded of the necessity of the three theological virtues of faith, hope and charity. But Suger — and the bishops of Chartres who thought his way — continued to preach that the faithful would also be spiritually elevated by the beauty of the building and that there was no reason not to bring the truths of religion home to them by two or three different means.

In the final analysis, the priest on the pulpit, the actors on the stage of the bourgeois theatre and the image-makers on their medallions all taught the same lesson. The *Miracles* and the first *Mysteries* that were presented in the church square found their echo on the tympana of the cathedral. The marvellous story of Deacon Theophilus saved by the Virgin in spite of his denial is told both on the portals and on stage. And the Creation of the world can be expressed as well in stained glass as in plays about the life of Adam.

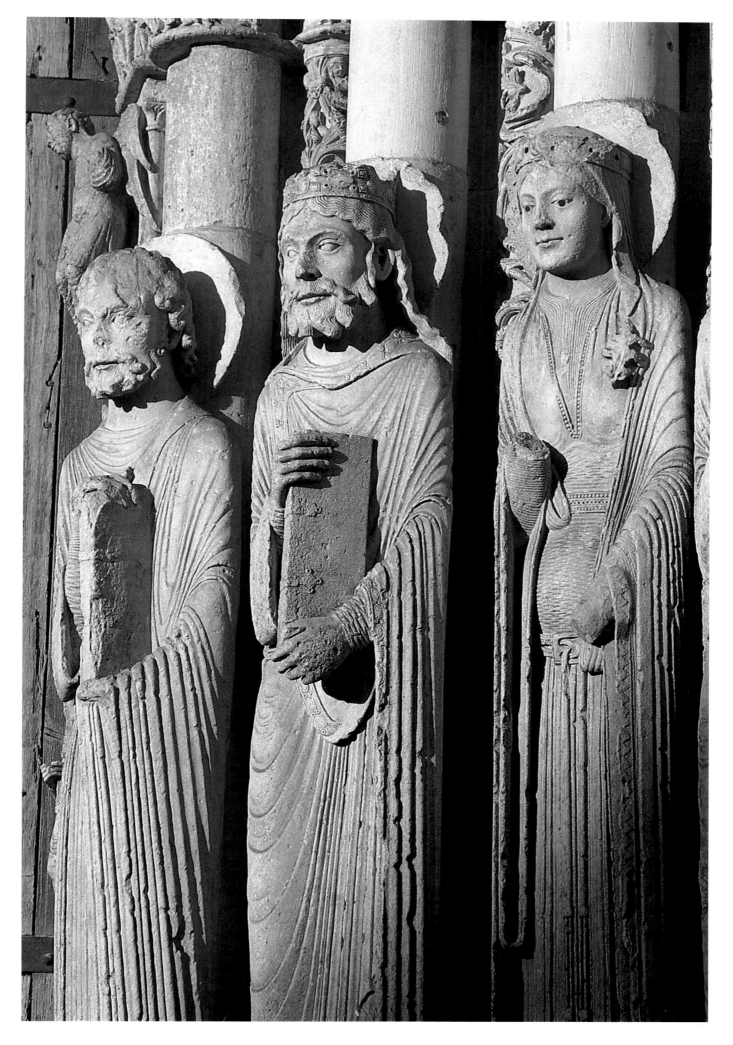

Statues in the central bay of the north porch (*c.* 1215). Perhaps Jesse and his wife. With the approach of the 13th century, the faces become more expressive. The man is more important than the idea. The artist does not hesitate to show contemporary fashion, as in the woman's headdress, a starched linen cap.

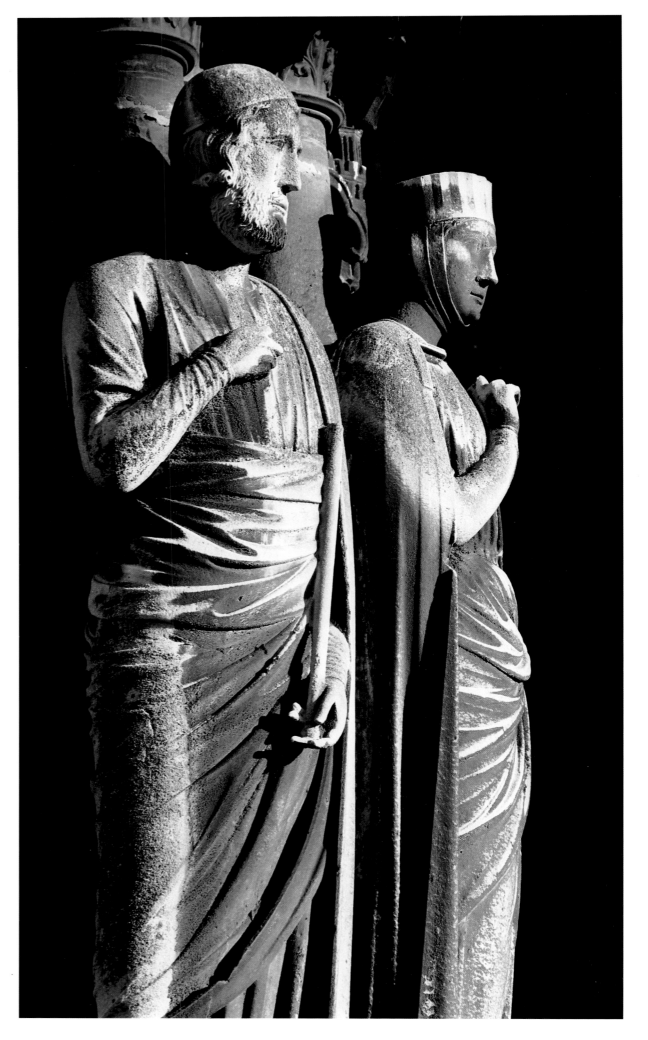

Right
Small figures at the foot of the large statues. The artist gave rein to his sense of fantasy and animation in these works which are secondary to the main composition. There are no constraints here and the aim is not to instruct, even though the crowned figure (above) being trampled by the large statue of St Piat is his persecutor Rictius Barrus. In fact, the artist's aim is to distract, to show his skills. (South transept portal, *c.* 1206.)

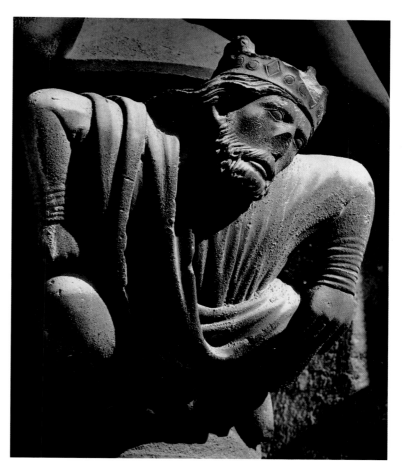

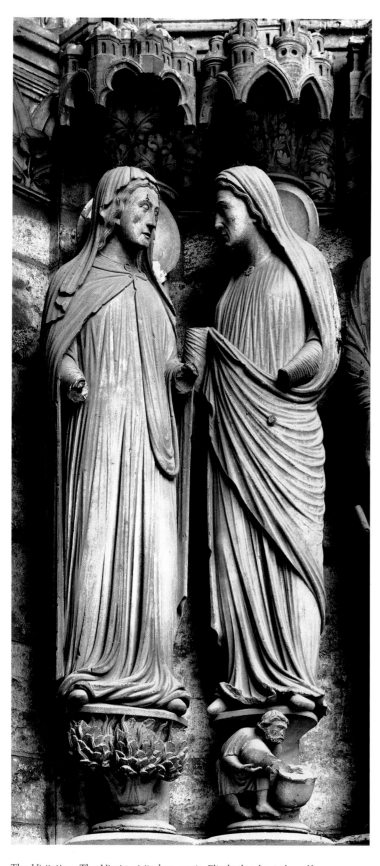

The Visitation. The Virgin visits her cousin Elizabeth who is herself pregnant with the future John the Baptist. These faces already show some emotion and the artist manages to suggest the difference in ages. (Statues to the right of the left portal of the north transept, *c.* 1215.)

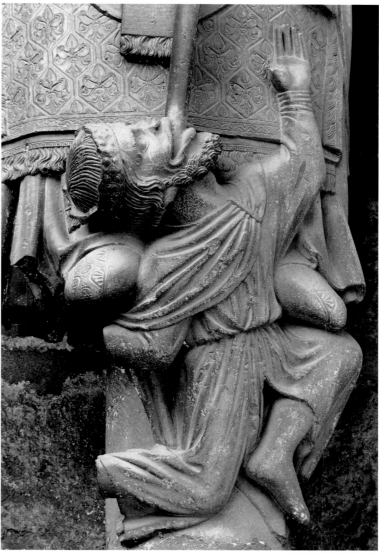

111

As for the *Lives* of the Saints, which formed a vital part of medieval literature and openly reflected parochial pride, whether diocesan or municipal, the general public would be unable to read them or remember the details simply by hearing the commentaries on these texts during the sermon. So the faithful could only get to know them through the episodes selected by the artist for his bas-relief or stained glass. These images derived from texts, but the public would not know that and would simply relate the stories depicted in the decoration to those told by the bishop or priest in his sermon. They refer to the same saint, the same miracles, teach the same lesson, the same practical morality.

So the lesson taught is the same, and the image helps teach it. Anything not fully understood could be explained in a sermon or a miracle play. Examples and comparisons from the same Holy Bible inspired the sermon from the pulpit, the play on the stage or the scene on the wall or window. Painted or sculpted, figures and anecdotes were designed to strike the beholder, to render the spoken word more memorable. The cathedral was a whole, but it was also a living whole with its liturgy, its teachings and the kind of para-liturgy that was normally staged in the church square and led to the mystery plays. Here the image is more than mere illustration, it is a way — and evidently an enduring one — of presenting the Christian points of reference.

The sculptors differed in their views about the need to create a sense of direct contact between the faithful and the image. Those responsible for the great statue-columns of the Royal Portal, and especially the 'Master of Chartres' to whom we mainly owe the Biblical figures on the left embrasure of the central portal and the tympanum of Christ in Majesty, concentrated on the essential idea of the figure they depicted, reflected in the face rather than the pose.

Drawing on the Platonic teachings of Bernard of Chartres for their art, these sculptors were interested only in the essence of the figure. There is no sign of realism in the faces, nor in the draperies which conceal the lines of the body. There is nothing picturesque in the absolutely symmetrical composition of the scenes of the Infancy on the right portal: the shepherds and their flock are reduced to their essential function, which is their place in the manifestation of the Incarnation.

In contrast to this serene idealism, the author of the figures on the voussoirs gave the philosophers seated at their writing desks expressive faces and differentiated personalities, as he did for the elders of the Apocalypse singing the glory of the Lamb. He aimed at effect, in the play of the drapery, in the movement of the body and in the variety of facial expression.

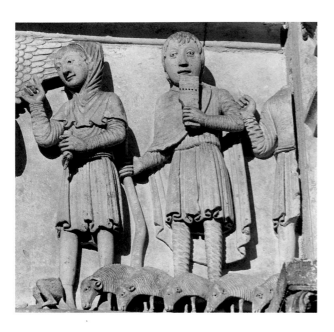

The Annunciation to the Shepherds. There is little evidence of the picturesque in the well-balanced scenes of the Royal Portal. The shepherds play their part – i.e. to tell the world the news – in the mystery of the Incarnation and the sheep are there only to identify the shepherds. (Royal Portal, lintel of the left portal, *c.* 1140.)

God

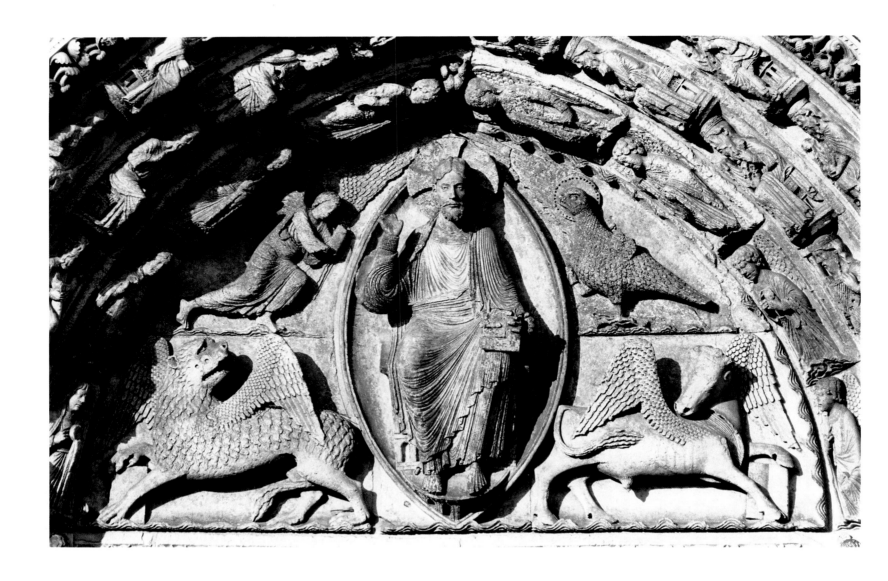

God

At the heart of any manifestation of the essential truths lie the three fundamental mysteries: God, the Incarnation and the Redemption. In most Gothic cathedrals all three are represented in the decoration of the main portals and again inside on the windows. At Chartres, with its nine portals distributed over three façades, the masters had great scope for their work.

The Royal Portal, which opens onto the nave, is devoted to the triumphal themes of the greatness of God. The Saviour is shown in Majesty on the central portal, flanked by the four symbolic figures who surround the Father in His glory in the *Apocalypse* of St John and who, representing the Tradition of the four Evangelists, introduce the different approaches to the essence of God.

The winged figure above, on Christ's right, is none other than St Matthew, one of Christ's first disciples whose Gospel opens with an astonishing human genealogy, beginning with Abraham who 'begat Isaac' and ending with . . . Joseph, 'the husband of Mary, of whom was born Jesus.' It is made quite clear here that the agency of the Holy Spirit reduced Joseph's paternal role to little or nothing. But the Gospel of St Matthew anchors Christ firmly in the human race, gives him ancestors in accordance with the Law and assigns him a place in the chronology of man's collective destiny, i.e. in the road to Redemption.

Facing him, on Christ's right, is the eagle, in other words St John. It is the eagle of the dazzling vision of the *Apocalypse*, the apostle who came face to face with the glory of God, as the eagle can look at the sun without blinking — according to an ancient legend already told by Pliny.

The ox and the lion complete the picture. The ox, a sacrificial animal under Ancient Law, is St Luke, the evangelist who lays most stress on the sacrifice of the Calvary as replacing the old sacrifices of a world awaiting the Incarnation. The lion is St Mark, whose Gospel begins with the sermon of the man crying in the desert like a roaring lion, the last of the prophets, John the Baptist.

Dominating the twelve apostles on the lintel, the Christ in Majesty of this Royal Portal is at the centre of the gigantic lesson taught by the nine portals. It is worth noting that God the Father is absent from this composition. Religion became more humanized in the twelfth century. It assigned to the Son of man a status which other periods — and the *Apocalypse* and the prophets — had reserved to the Creator.

The Creation of the world, the first work of God the Father, is shown in Chartres only as a preliminary chapter of history: the sole *raison d'être* of the

The Son of Man. At the top of the tree, in the scrolls unfurling at the termination of a human genealogy which extends from Jesse to the Virgin, we see Christ surrounded by the seven doves who here represent the gifts of the Holy Spirit. (Left window of the west façade, *c.* 1150.)

Opposite
Christ in Majesty. This is the masterpiece of the artist known as the Master of Chartres, who carved this tympanum and several of the large statues, directed the other sculptors and gave unity to the programme and its execution. Christ in Glory is surrounded, in the voussoirs, by the choir of angels and elders of the Apocalypse and flanked by the four winged symbols of the Apostles who announced the message of the Gospel. It is a Christ deliberately free of any indication of the historical aspect of the Redemption. He does not exist in time, forms no part of mankind. God is He that is, He that reigns. (Royal Portal, central portal, *c.* 1140.)

Old Testament was to herald the New. That is the significance of the patriarchs who prefigured the Saviour and the prophets who predicted him, rather than the scenes, so familiar to Romanesque artists, of the Creation of heaven and earth, the trees and the animals, man and women.

In the iconographical programme of Chartres, Genesis is shown only on the outer voussoirs of the north porch, in a few admirably animated scenes whose rather secondary positioning clearly reflects the modest role assigned to the creation of day and night or the division of the waters under the firmament from the waters above the firmament in the story of the Redemption. At best we find a moral anecdote told on one of the windows of the left aisle, the history of Noah, of the Flood in which the sinners drowned – the glass-maker even shows us the construction of the boat – and of the drunkenness of Noah, when he discovers which of his sons have retained respect for him.

The artists were no theologians. Their dogma matched their understanding. We see no more of the Holy Spirit than of God the Father, except perhaps in the ambiguous form of the dove perched on the shoulder of St Gregory who inspires him with the sounds of the Gregorian chant. The artist wanted solid images. The Christian humanism of the twelfth century reduced the mystery of the Holy Trinity to a simple formula. We are far here from the scenes of the Spirit spreading its rays above the Father and the Son found on so many Byzantine mosaics created by far more subtle artists than the honest sculptors of Chartres. These latter believed quite firmly in the Holy Trinity when they sang the *Credo* and made the sign of the Cross, but they did not see it. For them Christ alone was the face of God. It is Christ we find in the form of the 'doctor', i.e. exercising the spiritual power, on the tympanum of the Royal Portal and on the pier of the southern façade. As in Amiens, we see the 'Beau Dieu' at Chartres, Christ as doctor of his Church, watching over his flock on the façade facing the town.

The christological composition on the Royal Portal, echoed by that of the three large windows on the west façade, follows on from the two themes chosen for the lateral portals. On the right, the Virgin, she too in Majesty, dominates the traditional scenes of the Infancy of Christ. The Annunciation, the Visitation, the Nativity, the Annunciation to the Shepherds, the Adoration of the Magi, the Presentation at the Temple, all these scenes introduce the faithful to the mystery of God through the mystery of the Incarnation and present the Virgin in her dual role: her historical role as Mother of God – a hieratic figure holding the Child on her knees as on a throne – and her theological role of intercessor, familiar now to the pilgrims who have come so often. We find the Virgin depicted for her own sake on the north portal. But here, on the main façade, she is present only because of the place God assigned her in the Redemption: she is there for the Saviour.

The Divine Mystery is completed on the left portal by the Ascension. The cycle is complete. God has become Man, the Son of God has returned to the dwelling of the Father. He is borne away from the realm of men by a cloud which the sculptor perceives as an enveloping wave between two angels. The apostles are still there. We are far from the genre scenes showing Christ's followers struck dumb by the sight of the risen Christ whom they expected to keep with them from now on, rising up in a cloud. Here, shown in hieratic frontal attitudes, the apostles represent the Church that endures forever, after Christ has been lost from sight.

The scenes of the Infancy of Christ occupy a vital place in the teaching of

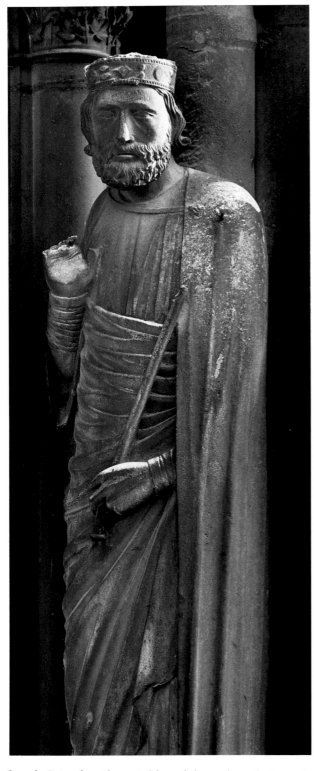

Samuel. (Statue from the central bay of the north porch, late 12th century.)

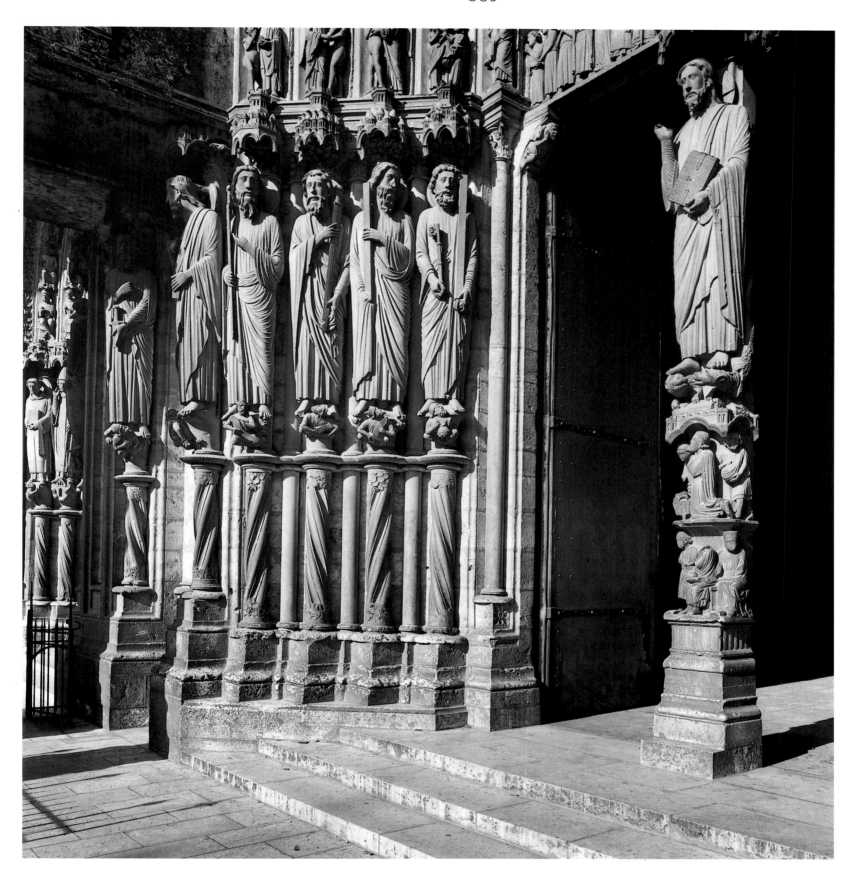

The Church. St Peter, recognizable by his keys, is the first of the Apostles, shown to the right of the teaching Christ, a humanized Christ facing the town. The Apostles can be identified by the instrument of their torture that each carries. Each has his own human destiny. (Central portal, south transept, *c.* 1206.)

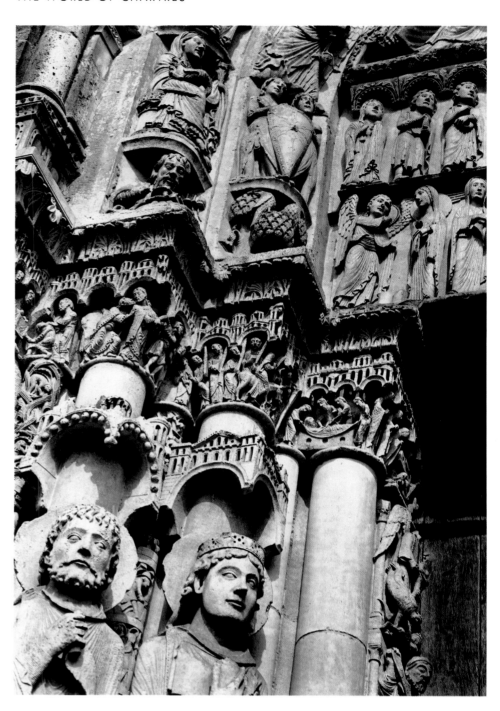

The story of the Redemption, told by the frieze. Anecdote is paramount here, instructing and echoing the teachings of the Gospel. Right, the Washing of the Feet on Maundy Thursday, the Kiss of Judas, the Entry into Jerusalem on Palm Sunday, and the Entombment. The historical sequence is rather confused. (Right portal of the Royal Portal, c. 1140.)

The Washing of the Feet. This is the scene that occurred on the eve of the Passion and which the bishop repeats every Maundy Thursday by washing the feet of twelve of the poor. For the faithful, this was real history. (Right portal of the Royal Portal.)

the Salvation through the Incarnation. The artist tried to make it quite plain that Christ did not just pretend to become man. The picturesque quality of the scenes certainly had some bearing on their popularity, and the sculptor depicts them sharply and forcefully – for instance the dramatic scene of the Massacre of the Innocents – all along the unusual capitals separating the large statues from the tympana and their voussoirs. Here the Gospel is combined with all the Apocrypha with which the early Christians fanned their devotion. For it was the Gospels of the Virgin and of the Infancy of Christ – which were in fact Syriac, Aramaic and Arabic texts of late antiquity – which gave to Christian tradition the ass and the ox of the Nativity and the ass carrying the Virgin and Child led by Joseph in the Flight into Egypt. All these historical accompaniments, pure inventions, that were required by the devotion of the first Christians and their need for picturesque anecdote on a human scale, were already present in the eleventh-century frescoes of the cave churches of Cappadocia. They could be seen on the capitals of Autun and Saulieu and Vézelay. They appear on all the façades of Chartres.

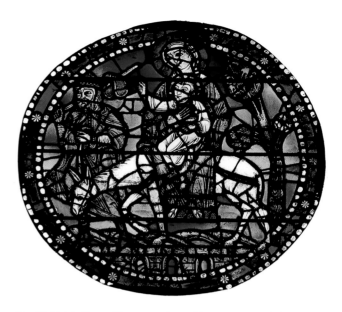

The Flight into Egypt. This scene, derived from an apocryphal Gospel, fits easily into the story of the Infancy of Christ. From the time of the first crusades, when everyone was talking about Egypt, the scene of the Holy Family and their ass became very popular. (Central window of the west façade, *c.* 1140.)

The Gospel forms the main basis for the frieze of the life of Jesus that runs along the capitals of the Royal Portal in a continuous sequence of linked scenes and repeated figures. This is not the ideal composition of the Infancy of Christ we see on the right portal. And perhaps it cannot even be called a composition. The historical sequence is often wrong. The Washing of the Feet of Maundy Thursday is shown beside the apparition of the Risen Christ to the pilgrims of Emmaus. The double composition of the Entry into Jerusalem amid a crowd waving palms and the Arrest of Christ – with the admirable scene of the Kiss of Judas – sits oddly between the scenes of the reaction of St Peter cutting the ear of the grand priest's servant and the Deposition of Christ, even to those who do not remember all the details leading up to the Passion. The logic of Holy Week is rather confused. What remains, for the image-maker and the faithful, is a living story whose specifically human quality forms a counterpoint to the majesty of the great figures enthroned on the tympana.

The divine plan is shown elsewhere. It is the principle behind the systematic and much repeated representation of the prophets and 'prefigures' of Christ, whose role in the Old Testament was regarded by the entire scholastic age as a commentary preceding the Redemption. The premise of the Redemption existed from the very moment of original sin, scarcely hinted at in the iconography of Chartres.

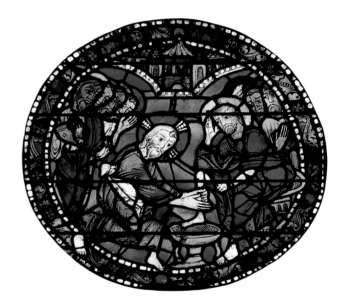

The Washing of the Feet. This scene was *de rigueur* in any story of the Passion, such as the scenes of the large 12th-century windows. (Left window of the west façade, *c.* 1140.)

Among the great sculptures of the Royal Portal, the statue-columns whose expressive grandeur and deep significance are enhanced by a technique which confines them to their vertical support, the faithful could recognize the Queen of Sheba whose alliance with Solomon foretells the New Alliance of God with all peoples, and not just the chosen people. They could identify by their long scrolls, which originally had painted texts on them, the prophets they were to see again nearly a century later in the luminous splendour of the great transept windows, carrying on their shoulders the Evangelists whose good tidings complete the Old Testament without impairing it. They could see Isaiah, foretelling the Salvation through the rod out of the stem of David, i.e. of Jesse, a Salvation offered to all the nations finally assembled round a new Jerusalem. Then there was Jeremiah, telling of the misfortunes of Israel and its regeneration. Ezekiel suggests his already apocalyptic visions of the end of time and the last day. As for Daniel, his trials in the den of lions are considered a prophetic

anticipation of the Passion of Christ.

On the embrasures of the portals, and of the porches in front of the north and south transept portals where the variety of poses – due in part to the variety of workshops and artists from very different origins – is nevertheless still dominated by the great lessons in idealism and inner peace taught by the 'Master of the Royal Portal', the visitor can easily identify the symbolic figures of the Redemption and the New Alliance. On the north transept portal, for instance, he can see the figure of the priest Melchizedek with his long emaciated face, carrying his censer and his offerings of bread and wine which he will exchange for Abraham's possessions: the clergy was no less likely to forget this first justification of the tithe the lay world had to pay the Church than the fact that it also prefigured the sacrifice of the Eucharist.

The picturesque aspect is not always dismissed, but it is always relegated to a secondary position; it is a means of identification, an aid to memory, not a distraction. The popularity Balaam enjoyed among artists and preachers, who always showed him standing on his ass, owes much to the singular quality of the famous dialogue between the prophet who wants to travel in peace and the ass who can see the Angel of the Lord barring the road. The theologians interpreted this as the confrontation between man and God, the eternal combat of grace which is illustrated elsewhere – including by Delacroix on the walls of Saint-Sulpice in Paris – by the battle between Jacob and the Angel. The ordinary people saw in it mainly the surprising story of an obstinate ass who starts sermonizing. As a result, they did not forget the story of Balaam. Similarly, the praise of wisdom illustrated by the story of Solomon, who threatens to cut in half the child disputed by the two putative mothers, is in many ways merely the pithy story of a skilful judge who manages to settle a quarrel. The faithful knew the meaning of quarrels between neighbours. So they were not likely to forget this story.

The vision of Isaiah summarizes the whole concept. The tree growing from Jesse represents in itself the entire pattern of the Redemption. Before even appearing on the voussoirs of the north portal, it began to occupy a vital place in the cathedral, when the Tree of Jesse window, with its splendid harmony of blue, was set in the façade of the nave.

The Palm Branches. Once again, the faithful can relate this scene to the liturgy of Palm Sunday, which describes the procession of people carrying palm branches. (Right portal of Royal Portal, *c*. 1140.)

Opposite
The Old Testament on the threshold of the cathedral. The woman in the middle may be the Queen of Sheba, who led the pagan world to the Alliance of God. The sculptor – the Master of Chartres himself – is not interested in identifying the ancient world that leads to the Gospel. Painted texts sufficed here. The pose of these statues, still almost embedded in their columns, expresses the divine mystery, and nothing else. (Central portal of the Royal Portal, *c*. 1140.)

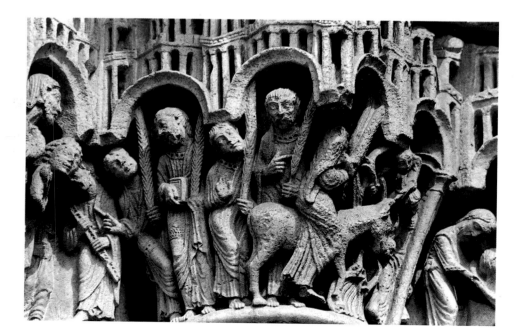

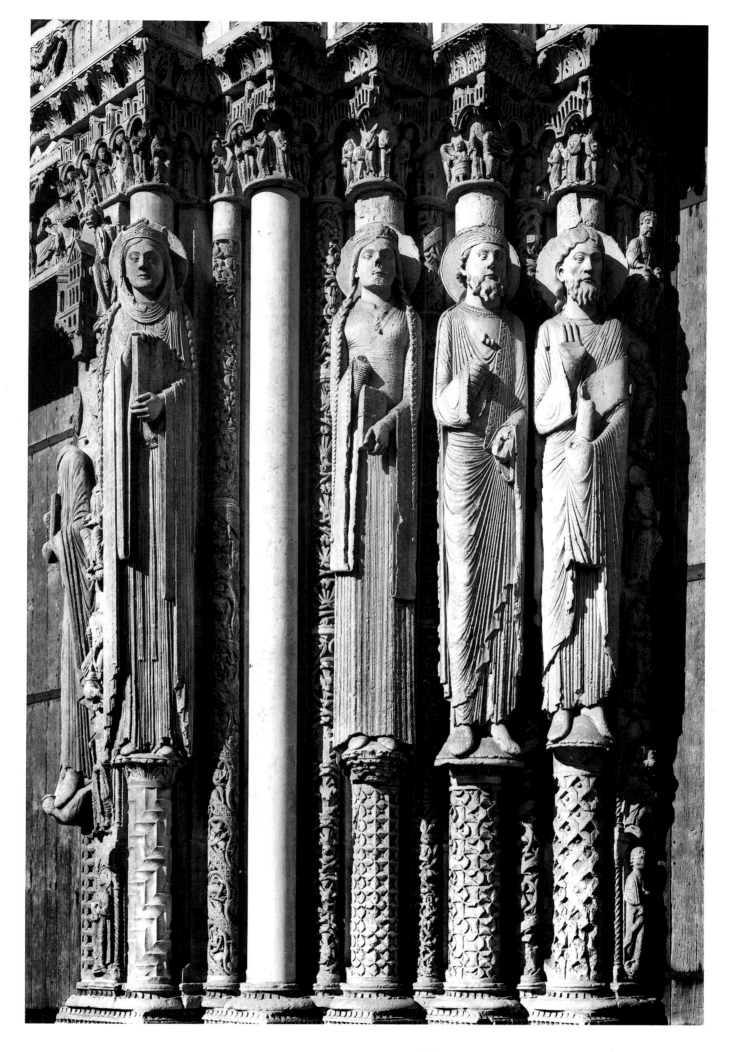

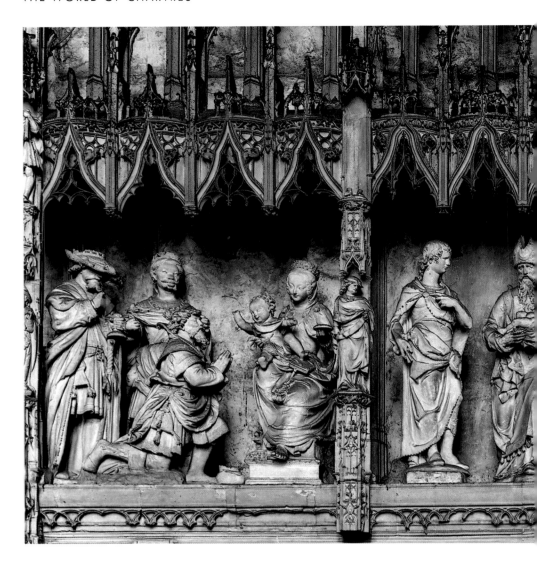

The rest followed automatically, the Passion completing the Incarnation. Although virtually absent from the sculpted decoration, except on the small capitals of the Royal Portal, the Passion forms the counterpart of the Tree of Jesse in the great wall of light on the western façade. Of course, the average pilgrim would not have been able to distinguish all these scenes, nor those of the Infancy of Christ on the central window. The positioning is highly significant, but not very effective. Perhaps this remote position had some bearing on the decision at the beginning of the sixteenth century to construct a choir wall which, thanks to the talent of Jean de Beauce, presents a continuous frieze of forty scenes containing some two hundred figures, situated almost at the height of a man, telling the story of the Incarnation beginning with the Annunciation by the Angel to Joachim and the Birth of the Virgin and ending with the apparitions of the Risen Christ. Considering the effort involved, there must have been a strong sense of need to teach a legible iconographic lesson.

Beyond the Ascension, which completes the terrestrial destiny of the Man-God, there still remained the essential moment, the Salvation. Two great visions represent it: the Last Judgment facing the full midday sun on the central tympanum of the south façade, and the Apocalypse, which with its choir of angels and elders with crowns carrying musical instruments, on the central voussoirs of the Royal Portal, forms a real aureole for the Christ in Majesty.

In both cases, the Gothic master has followed a long tradition, illustrated again and again on the portals and vaults of the Romanesque churches. But

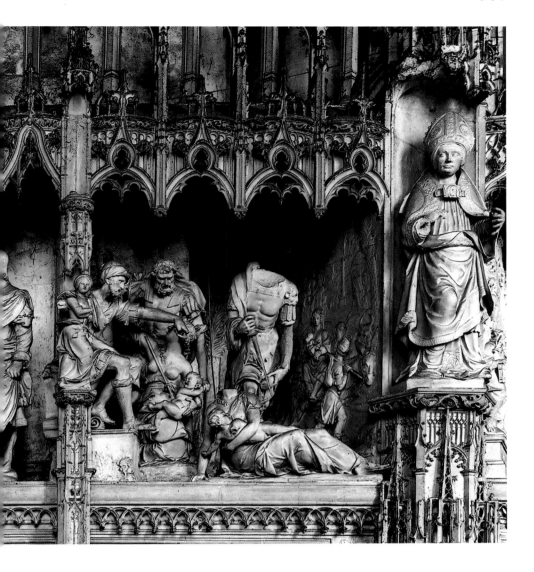

Iconography within eye's reach. The Magi, the Presentation in the Temple, the Massacre of the Innocents, from a sequence of sculpted scenes in the ambulatory. Choir wall. The scene on the left is anonymous (before 1540). The two others are by the Orléans master, François Marchand (1542).

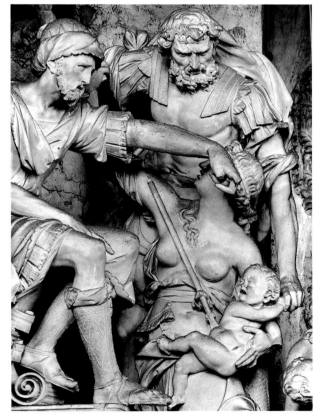

he has left behind the confusion of the huge Romanesque compositions, with their unintelligible scenes and otherworldly figures.

The Romanesque sculptors and painters rarely took the risk of representing the Apocalypse, barring a few fantastic images where the figures and symbols were drawn from the last book of the New Testament. Even in the fourteenth century, when the Apocalypse gained a certain popularity, it was shown only as a series of miniatures or wall-hangings in which no artist even tried to give an overall view of the book of St John.

The Romanesque sculptors and painters did, however, create a number of global visions of the Last Judgment: the angels sounding the trumpet, the dead rising everywhere from their graves, the saints and the righteous forming a procession to the right of the supreme Judge, the Virgin trying to help the sinner, beside the angel holding the great scales for weighing souls and, at the summit, Christ the Judge. This vision lends itself to the picturesque, realistic treatment of the settling of social accounts: the usurer is sent to hell with his purse round his neck, the lewd woman's breasts and the glutton's tongue are torn off with pincers.

The Last Judgment of Chartres is a serene one. Here we are a long way from Romanesque naturalism. The south tympanum discards the usual concept of a God – once again it is the Son – as the judge of the living and the dead, retaining only the image of justice suggested by a Christ with outstretched arms. The Virgin is there too, praying for humanity. There is nothing tragic about the scene, nothing Baroque; nor is there in the double scene on the lintel showing the elect in a sort of chanting choir and the

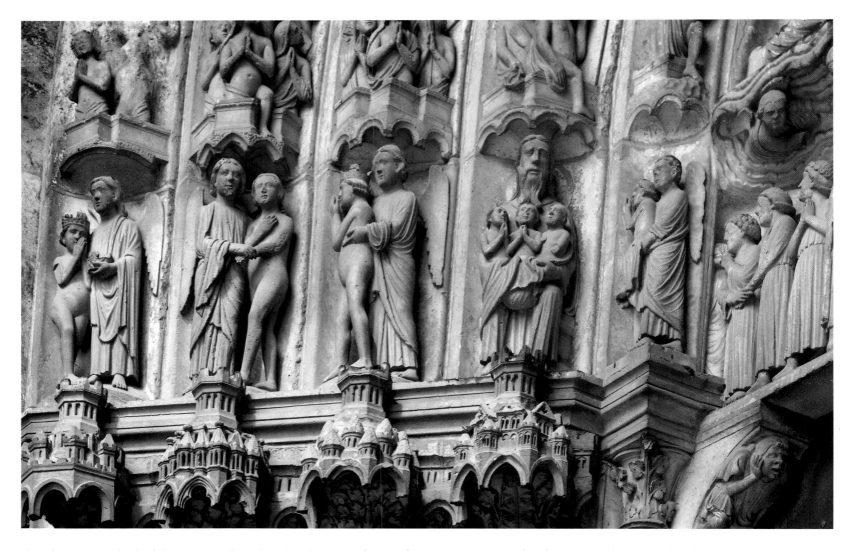

The Judgment. On each side of the tympanum where Christ the Judge presides over the final destiny of the chosen and the sinners, felicity and damnation show their myriad faces. To the right of Christ (left in our picture) we see the souls welcomed to Paradise where Abraham takes them to his bosom. Opposite are the damned, with clothing that reflects their social status. The devils are calculated to be frightening. Here the picturesque, the Baroque even, impinge on the serenity of the actual Judgment scene.

damned in a procession leading into the mouth of Leviathan. There is nothing here to remind of the anguish of the damned or of the weighing of the souls which occupied such an important place on Romanesque tympana.

There was still the notion of equality before the judgment, which was to become transformed after the disasters that struck the late Middle Ages, after the Black Death, into a dance of death of all the different social types. On the portal of Chartres, the king, the bishop, the lady, the monk and the burghers proceed peacefully to hell, while the chosen sing the glory of God but without going into transports. The humanization of religion, visible in the faces the artist gives to Christ and his saints, and in particular to the Virgin-Mother, is also reflected in a very moderate portrayal of death and the judgment. There is no naturalism here, and it was not to flourish again until the flamboyant period.

The favourite themes of Romanesque Judgments do, however, appear on the voussoirs, that is to say, in small genre scenes. The Baroque inventiveness of the early twelfth-century masters — of Conques, Autun and Vézelay — is repeated here, in the carnivorous devil with his human-faced belly, carrying over his shoulder, upside down, her beautiful hair falling to the ground, the lewd woman the Romanesque sculptors were so eager to point to, or in the other devil who, tongue between his teeth, is leading into hell a usurer who is still devotedly clutching his enormous moneybag.

Yet there is nothing immoderate in this vision of the Last Day. The Baroque is kept in check. The overall composition of the Last Judgment is

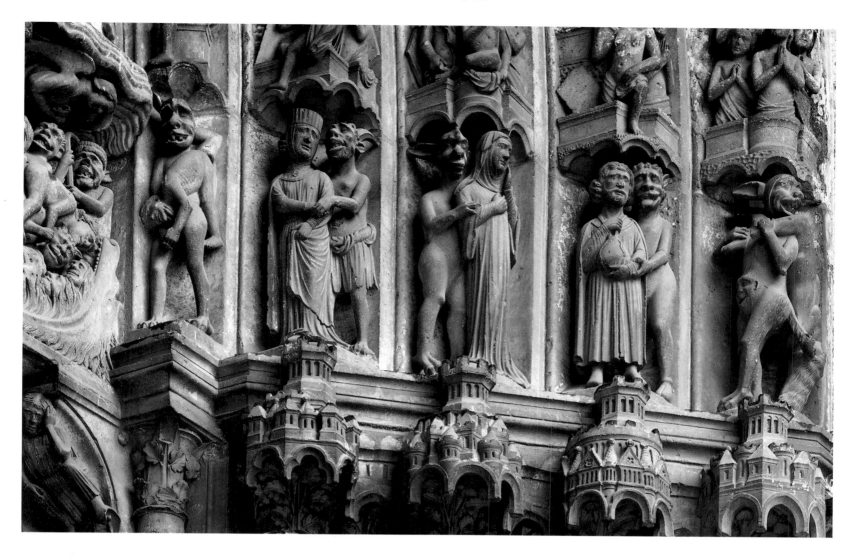

marked by the same atmosphere of serenity, so typical of Chartres, that also imbues the Ascension of Christ and the Glorification of the Virgin. And it is in the same spirit of serenity that the saints take the elect under their protection, the demons prepare to devour the damned, Abraham embraces the righteous men. The dead are emerging from their graves, but not in the skilfully composed disorder created by the sculptors of the preceding age. Everyone is in his rightful place, a place doubly defined by social status, shown by the clothing and the hair, and by the gravity of the sin, which can be measured by the aggressiveness of the demons.

At a time when the function of judge was becoming a vital part of the duties of the lord, and specially of the king, divine justice was no longer pictured in its Baroque context of tattered corpses and the screams of the

The Elect and the Damned. The Romanesque sculptor of the portal of Sainte-Foy of Conques (c. 1125) made sacrifices to realism. The Resurrection of the Dead is an animated scene, the devils are terrible, the reception in Paradise warm, and the devil shovels the damned into the mouth of Leviathan.

125

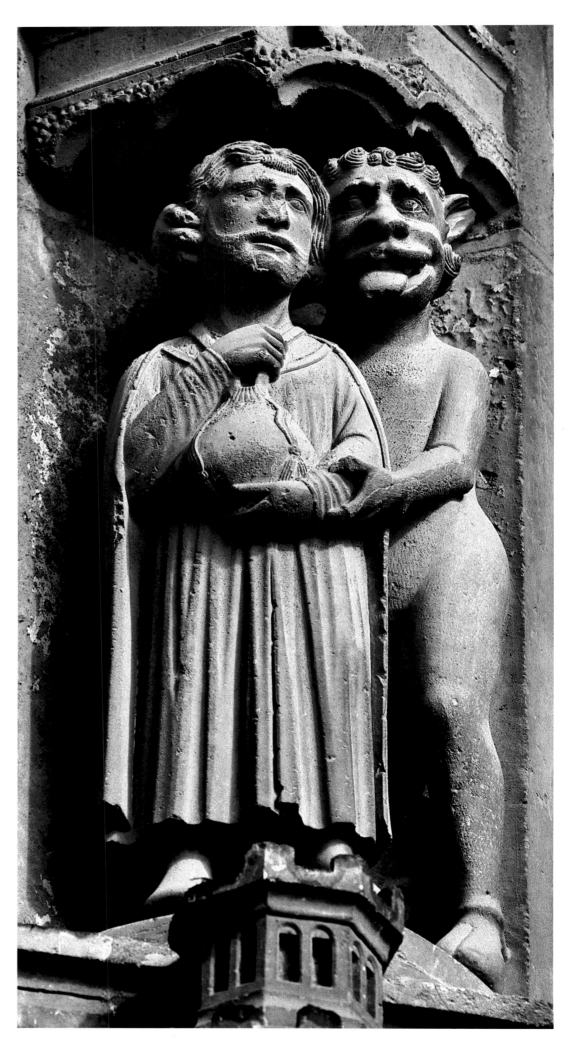

The Damned. At Chartres, the picturesque is relegated to the voussoirs. The miser wears his bag of gold round his neck and the demon carrying the wanton woman upside down himself has a stomach with a human face. But the damnation scene as a whole is a balanced one, suggesting justice and not revenge.

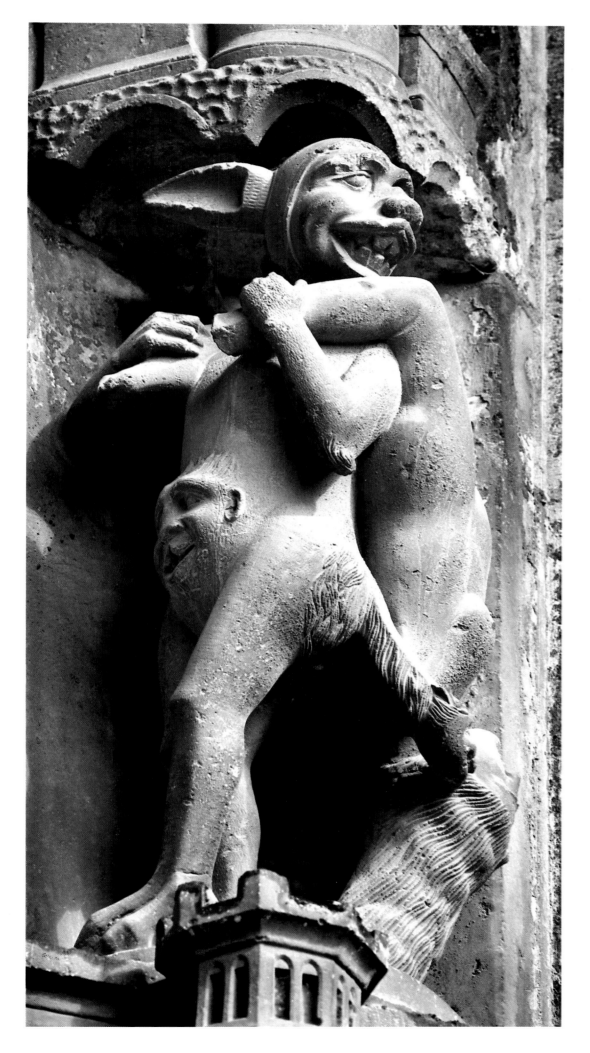

damned. The well-known episode of St Louis calmly passing judgment on a summer's night under the refreshing shade of an oak tree simply meant that the royal judge was attributed with the same nature which the sculptor gave to Christ the Judge in the 1200s. Justice was no longer a question of drama, more of order.

Christ the Judge. Above the teaching Christ the Doctor, on the door jamb, we see the Supreme Judge, but without the apparatus of judgment and accounting of the Romanesque Judgments. The Virgin and St John are intercessors there, not participants in the Judgment. (Central portal, south transept, *c.* 1206.)

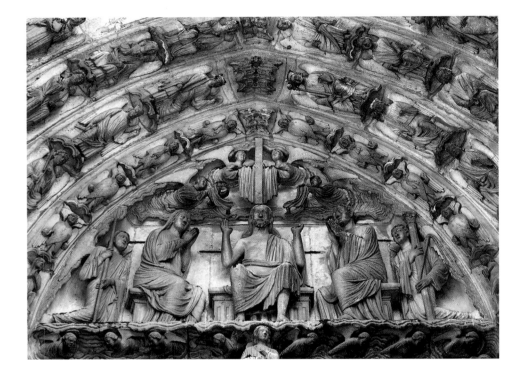

The Virgin

The Virgin

Dogma is faith. The Incarnation and the Redempton lie at the heart of all Christian teaching. It is there, above all, that the mystery of the relationship between God and the world is to be found. But man is aware of the incommensurable nature of this relationship and calls on intercessors who can give him his place in the Redemption, even if he feels unable on his own to attract divine attention to his wretchedness in this 'vale of tears', as it is termed in the *Salve regina*.

The cathedral builders, their minds formed by ten generations whose place in the world was based on the direct relationship between the vassal or tenant and overlord, were not ready to accept a direct approach to the God they called Lord. 'My man's man is not my man', was an adage of feudal law. No one tried to overstep the hierarchical ties of vassalage. Not until the progress in common law of the thirteenth and particularly the fourteenth century could anyone conceive of a sovereign power extending equally to all and equally accessible to all.

In the feudal society which was still proposing its own intellectual blueprints to the twelfth-century world, it was not possible to approach the ruler, that is to say, the lord of lords, except through the immediate overlord. The world of Chartres was not yet ready to address God rather than his saints.

The choir-screen. This screen, made in the 13th century to close off the nave end of the choir, was destroyed in the 18th century by a clergy eager to modernize while at the same time belatedly obeying the instructions of the Council of Trent. A few fragments remain, including this delicately expressive Nativity now conserved in the Saint-Piat chapel.

Left
The Virgin in Glory. This is the upper part of the window devoted to the life of Christ which was put back into the Gothic cathedral in the 13th century. Only slightly later than the Saint-Denis glass which Goslin de Lèves, Bishop of Chartres, had admired when the abbey was consecrated in 1144, this window was to remain the largest ever made for some time. (West façade, *c.* 1140.)

Opposite page
Notre-Dame-de-la-Belle Verrière. The only 12th-century window, apart from the large western windows, which the 13th-century master considered worth re-using. No doubt it had already become famous. The oldest part, with its 'Chartres blue', dates from the 1180s. The remainder, added to make the glass fit the window frame, is of the same date as the glass created for the new cathedral (*c.* 1215–20). The Virgin's head was restored in the 19th century.

The Life of the Virgin. Mary presented at the Temple, the Marriage of the Virgin, the Annunciation. These three scenes are by anonymous artists who presumably began their work under Jean de Beauce. (Choir wall, south side, between 1525 and 1540.)

In the first rank of saints stands the Virgin. She is alone because she was foretold by the prophets. Church tradition relates the text of the *Proverbs*, 'I was set up from everlasting', to her. And the words of Solomon, 'When there were no depths, I was brought forth,' are applied to the Immaculate Conception. From everlasting times, Mary is by nature different from the ordinary saints, who are neither women nor men. She is also alone because she is the 'Mother of God', even if this phrase is theologically inaccurate. And she is alone because she was 'blessed among women' at a time when women were rarely exalted and when the rather considerable proportion of the faithful who were women needed to offer their devotion to the Virgin Mary as the saint *par excellence*.

Mary is everywhere in Chartres. As patron saint of the Cathedral she is shown at the summit of the Infancy window, which gives a detailed picture of the life of the Virgin from the Annunciation. In the twelfth-century window which was moved south of the choir in the thirteenth century, she is 'Notre-Dame-de-la-Belle-Verrière', Our Lady of the Beautiful Window, an extraordinary figure in Majesty – like the Virgin of the Royal Portal – whose pale blues and purples stand out against the bright red ground, further enhanced, since a thirteenth-century addition, by surrounding angels on a saturated blue ground. There is one significant detail: the dove of the Holy Ghost appears above the Virgin and the rays of divine inspiration are directed towards her. There is no doubt that Mary has partly taken the place of Christ at Chartres.

The Majesty on the central portal of the north transept is quite different; here we find, above a Virgin and Child which is much less hieratic than on the Royal Portal, an iconographical programme that is typically Gothic and already appeared a few years earlier on the portal of Senlis Cathedral. Here the Virgin exists in a time which is not historical time, within a supernatural essence assigned to her by Church tradition and which makes her first among all creatures.

This 'Senlis theme', which was to find its place on all the 'portals of the Virgin' of Gothic times, deliberately disregarded the evangelical stories of the Infancy of Christ. It concentrated on the final glorification which assigns the Mother of God her place in the paths of Redemption. Two terrestrial scenes are shown on the lintel under the tympanum: the death of the Virgin – what is called the Dormition – and her ascent to heaven, which is in fact the Assumption. Mary thus escapes the common destiny of mankind. She is not only first among the saints. She also fulfils the prophesy of Jesus son of Sirach, who promised glory and immortality to Wisdom, which was very soon identified with Mary – as shown by the texts chosen for the old service of the Nativity of the Virgin.

So the thirteenth-century masters quite naturally culminated the theological story of the Mother of God with a terrestrial vision of glory and an eschatological view of the Redemption: the Coronation of the Virgin, in which the entire tympanum is taken up with a very simple scene of the final meeting of the Virgin and her divine Son. We have moved far beyond the evangelical view of the story of Mary the mother of Jesus, from the Annunciation to the Nativity. The Coronation forms a counterpart to the Judgment. It paves the way to it.

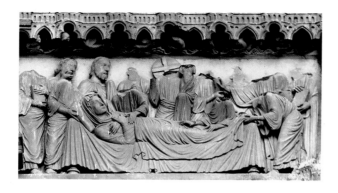

The Dormition of the Virgin. The risen Christ and the Apostles witness the death of the Virgin, awaiting the Assumption. (Tympanum of the central portal, north transept, c. 1215.)

The Incarnation. This is the all-important moment in the Life of the Virgin, when she finds her place in the divine plan. Below, the Annunciation, the Visitation, the Nativity of Christ, The Annunciation to the Shepherds. Above, the Presentation at the Temple, or the manifestation of Christ to the world. (Tympanum of the right portal of the Royal Portal.)

The Communion of Saints

The Communion of Saints

The Virgin stands apart. The saints, however, are in the Church. They play their part in the battles of the Church Militant, the Church that suffers, that bears the consequences of original sin. The Virgin embodies all the perfection of a creature conceived without sin. The saints are sinners who triumphed over evil but were not unaware of it. As such, they play a dual liturgical role: they are models who are not beyond human comprehension and they are intercessors. This brings us to an idea dear to a society profoundly marked by the direct ties of the feudal world: it is not possible to miss out any steps on the ladder. Rather than addressing God directly, each individual should find a protector within his reach who can intercede with the Supreme Judge. The iconography of the saints never fails to point to the former weakness of these chosen saints of the Last Judgment: their weakness helps them understand human nature and watch over man.

Because he was aware of the complex nature of the saints, medieval man was also convinced that no one can do everything. The lives of the saints displayed such wide divergences in their approach to perfection that it seemed useful to translate these differences by attributing to each chosen saint a specific aid which he could give to his followers. That is how popular devotion, encouraged by official preaching, came to define the 'auxiliary' saints, each offering his own type of aid to suffering humanity and type of intercession with God.

So each social group found its own patron saint. Each trade sought its counterpart in Paradise, a saint who would understand its members and take special care of them. In their moment of suffering, the sick addressed their prayers to a saint who had undergone similar trials, to a saint whose life offered special advice to those facing a particular kind of tribulation here on earth. This was a perfect social structure at a time when everyone had his due place for all eternity, his part in the divine plan, on the basis of his position in the earthly Jerusalem.

A manifestation of humility as much as of confidence, this distribution of tasks within Paradise simply reflected the same immense need for protection which the system of vassalage expressed on earth. Until the revival of legal studies and the discovery of the political systems of the ancient world re-established the concept of the State as implying the relative equality of the individual before the State and in particular before the law, medieval man had to negotiate his protection in exchange for his

St Peter. It is no chance that Christ the Doctor is surrounded by his Apostles in the centre of the south portal. Sent to evangelize the nations, the Apostles look towards the new society, the town (c. 1206.)

St George. The Apostles represent the beginning. The Church Militant was the continuation. The knight saint, St George, looking like a crusader, stands beside the bishop saint, St Denis, the priest saint St Piat and the deacon saint, St Vincent, again facing the town. (Left portal, south transept.)

St Piat, St Avit. They were the bringers of Good Tidings, of the Gospel. The cathedral had relics of them. This St Avit, with the pastoral staff but no mitre, is not the bishop of Vienna but the abbot of Saint-Mesmin, near Orléans, a contemporary of Clovis.

Opposite
St Philip. (Central portal, south transept.)

loyalty. He approached his eternal destiny in the same way: he needed a protector and an intercessor within his reach.

So the world of Chartres is peopled with saints who served as models and stories of saints which served as arguments. Of course there are also universal saints — above all, the Apostles. They share one vital function with the prophets: they form part of the procession of glory of the Saviour. They form an indissociable whole. They are expected to be there. But nothing specific is expected of them. They can be identified by their attributes, like St Peter's keys or St Andrew's X-shaped cross. They are necessary but not sufficient. The Church Fathers, the great pontiffs, the doctors are there too, in the form of St Clement, St Gregory, St Jerome. Together they form the basis of the Communion of Saints, the participation of suffering humanity in the merits of the martyrs and confessors of the faith.

Naturally, the saints of whom the church had the honour to possess relics were assigned a special place. The cult of relics, born of a practical synthesis between the ancient cult of the dead and the Christian desire to approach the best intercessors in the other world, led to constant discoveries of important relics and to the appearance of more and more local relics. Chartres is proudest of all of the 'Virgin's Tunic', but it also venerates more specifically Chartrain figures, whose statues on the portals echo their shrines in the treasury: St Piat, St Avit, St Lubin, St Cheron.

First and foremost, the saints are expected to set an example of faith. They are the 'confessors of the faith', the 'martyrs to the faith'. It is easy to understand the popularity of the first of them, St Stephen, the faithful Apostle whom the Church finally described, on the basis of history and hierarchy, as 'first deacon' and 'first martyr'. As the first to suffer for his faith, St Stephen is found in every iconographic programme. But painters and sculptors also found him particularly interesting simply because a stoning was a spectacular scene and the martyrdom of St Stephen could be an interesting composition. On the lintel of the left portal of the south transept of Chartres, we see scenes from the arrest and martyrdom of St Stephen, in which the raised arms of the stone-throwers standing over the praying saint clearly express their violence and hatred.

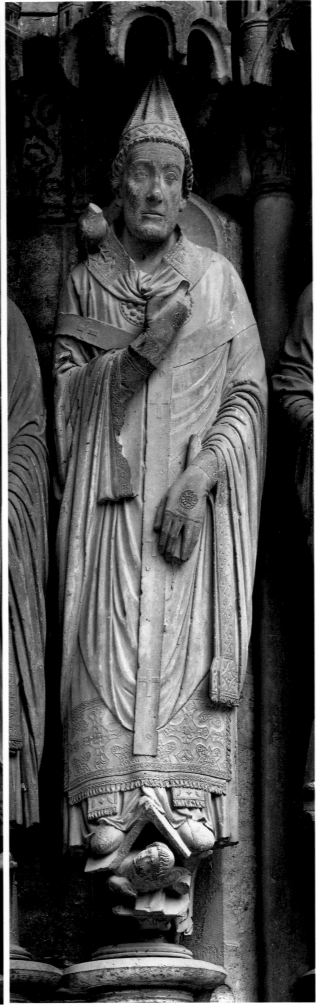

Opposite, left to right
St Martin, the saint who as a young soldier gave a beggar half his cloak, is shown on the tympanum as the archbishop of Tours. The sculptor is not interested in the anecdotal as much as in the missionary saint's position in the Church. (Right portal, south transept.)

St Gregory. The dove on his shoulder whispers the sacred chant which bears his name into the saint's ear. (Right portal, south transept.)

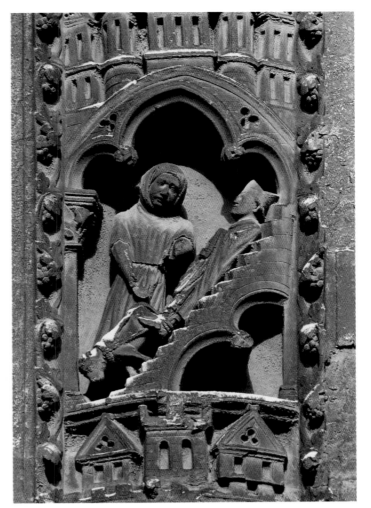

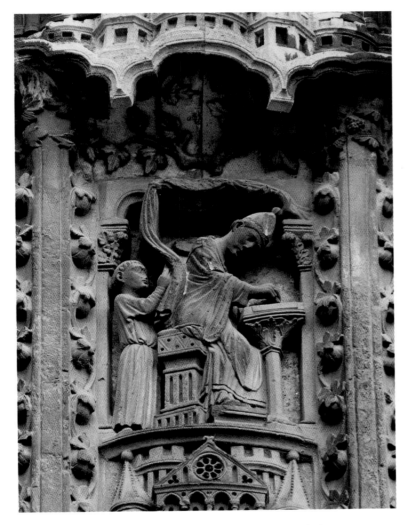

St Gregory. Here the message of the statue is completed by an anecdotal scene. The pope, wearing his tiara, is writing or composing. (Forward pier, right bay of south porch, *c.* 1230.)

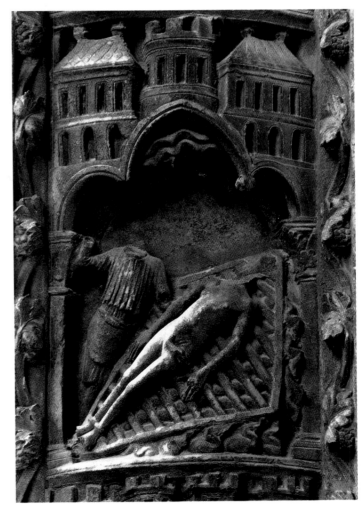

Above right
St Sernin on the steps of the Capitol. Dragged by the feet by a bull, the first bishop of Toulouse (3rd century) was to break his skull on the steps. (Left bay of south porch.)

Below right
St Lawrence on the grid. From the earliest days of Christian art, the martyrdom of the Roman deacon has tempted the hand of many artists. (Left bay of south porch.)

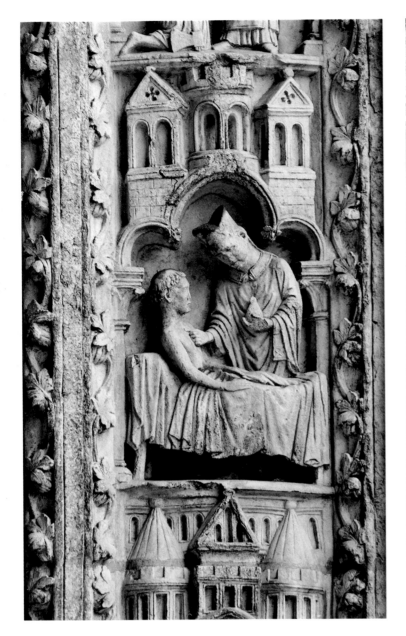

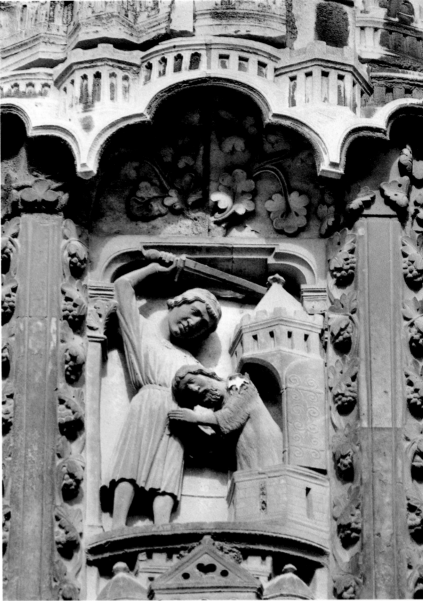

St Lubin gives the last Sacrament to St Caletric. (Forward pier, right bay of south porch.)

Right
The Martyrdom of St Denis. The scene is subtle: the executioner has raised his sword, but the head is already half severed. (Left bay of south porch.)

St Lawrence is seen nearby, on the right-hand pier. The Spanish deacon martyred in Rome during the persecutions of the third century, and identified among all the martyrs by his death on a grid, also sets an example of the triumph of faith over death. But we must remember that these saints are not there just for their own sake. One is shown healing the sick by his touch. Other sick people flock to their tombs.

The saints are certainly acting here as intercessors, protectors, healers. The Communion of Saints is not just the sharing of spiritual merits with a view to the eternal salvation of mankind; it is also the influence the saints have on Him, Who alone can do everything, an influence placed at the disposal of man for the satisfaction of his temporal needs: health and life. At a time when doctors made speeches in Latin but did not touch the sick, and the main remedies were the apothecary's salves or the barber's bleedings, religion gave the patient some hope of a cure. Like Christ in the Gospel, the saints often appear as miracle-workers in their *Lives*. By curing the sick, they could gain the attention of the well.

The evangelical message, and its implications for mankind, is formulated at a quite different level in the Beatitudes, those sayings so difficult to translate into the real world and into plastic form. Many artists gave up all idea of showing them other than in the form of the teaching Christ. On the

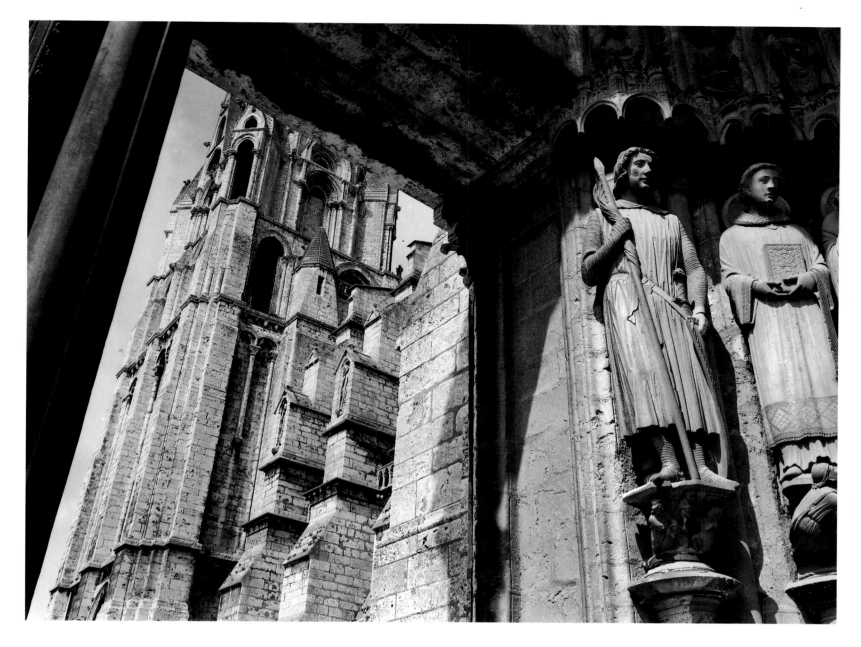

large central portal of the southern and northern transepts of Chartres, two sculptors took the risk, avoiding any pretext to adopt an expressionist approach.

Here, as with the great prophets and apostles, the image is nothing without the teaching that is based on it and which it calls to mind. The Beatitudes, seated beside the prophets, are figures whose smiling serenity certainly evokes beatitude but who remain silent about how to achieve it. The poor in spirit, those who hunger and thirst for justice, the pure in heart and those who mourn are no easier to identify than the prophets beside them. And at least the prophets carry scrolls on which are written the words which recall their best-known sayings. The Beatitudes have nothing like that. These happy faces say no more about beatitude than can be said from the pulpit.

With the Gospel of St Matthew, sung in Latin but commented in French at the grand mass of All Saints, and with the Beatitudes, we have, however, reached the very heart of the medieval preoccupation with teaching. In twelfth- and thirteenth-century Chartres, neither the clerics nor the laymen seriously considered becoming martyrs for their faith. The Cathars, far away, went to those lengths, as did a few heretics unwilling to compromise. But the average good Christian, whether in Chartres, Amiens or Paris, was

View onto the south tower. In the foreground, the statues of St Theodore and St Stephen. The vast porch in front of the north and south transept portals shelters both the statues and the faithful, who can look at their leisure. The porches were also an opportunity to create an iconographic programme that reinforced and annotated the statement of essential truths represented by the tympana and the large statues.

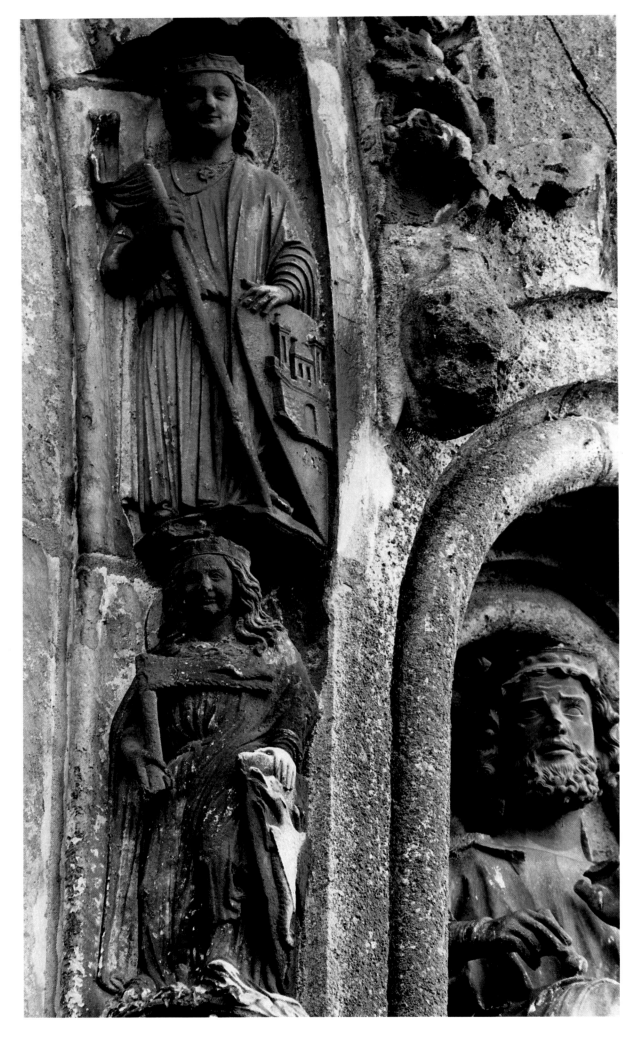

sustained by the consensus and quite simply did what his priest told him, for he did not feel threatened by stoning or quartering. He sang in good faith about wanting to give his life for Christ. In fact, as he knew full well, the question did not arise.

No doubt it did arise at the time of the first crusades when the desire to free the holy places and the acceptance of suffering on the road and death in battle were still mingled with a desire to travel to new places and total ignorance of the geographical, political and climatic realities. The companions of Peter the Hermit, Walter the Penniless and Godfrey of Bouillon were certainly prepared to die for the faith. The notary and baker passing under the vault of the Beatitudes to hear Sunday mass were prepared to shed their blood in spirit only. But they were sure to have been strongly moved by the moral teaching and its social implications, underlined in the thirteenth century by the new religious orders, the 'mendicant' orders of the Dominicans and Franciscans.

The entire iconography of this theme was therefore aimed at the exaltation of Christian virtues, by combining picturesque scenes of matchless heroism with the far more useful lesson of the conduct of the just in circumstances which the faithful encountered in their own life, family and work. It is one thing to list virtues and vices and erect effigies in the form of emblem-bearing female figures or women warriors in the good fight against evil. It is another to offer to the curious eyes of the faithful who are entering the left portal of the north transept – and who know by heart the great and extremely intelligible scenes of the Nativity on the tympanum – a reminder of that utterly simple parable of the foolish virgins whose lamps have gone out and the wise virgins who have enough oil. The wise virgins were therefore worthy of appearing in the procession of Christ. This is the theological teaching of the coming of the Bridegroom, that is to say Christ. The Christian must remember that he must be ready at all times. It is also a moral and practical lesson about a prudent approach to the fleeting moment and its immediate temptations. To keep something in reserve can mean many things.

The Beatitudes. There is no sign of expression or anecdote here; the idea is paramount. (Left bay of north porch, *c.* 1220.)

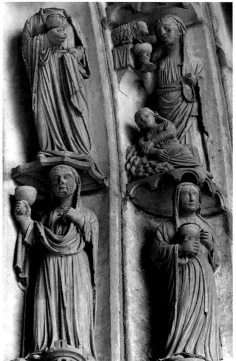
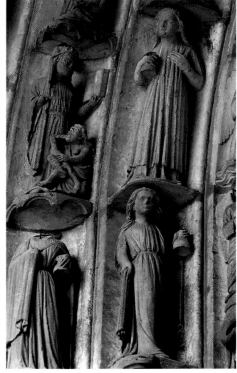

The Wise and the Foolish Virgins. The wise virgins' lamps are lit, the others have used up all their oil. But the lesson is in the procession, not the individual story. Once again, the emphasis is on the symbolic presence of these figures, and not on narrative. (Voussoirs of the left portal, north transept, *c.* 1215.)

But anecdotal scenes are also included to attract the eye of the faithful who tire so quickly of sermons set on an ideal plane. The virtues who accompany the wise virgins are a series of genre scenes, which lead the passerby to question himself, and which are to the image what the narrative story – the parable of the Gospel – quite naturally is to oral preaching. Faith is seen here as a woman holding out a chalice – the mass – towards a sacrificed lamb from which flows the blood of the Redemption. The faith of the Christian is quickened by the Eucharistic sacrifice. And it is easy to recognize the woman with the bandaged eyes, collapsed at the feet of Faith, as the fatal darkness of paganism, idolatry, disbelief.

The Church and the Synagogue. The main difference lies not in the pose – one figure is standing, holding the chalice, the other is prostrate – but in the bandaged eyes which signified the Jews' inability to see the Redemption. The Synagogue is blind. The church teachers enjoyed embroidering on this theme. (Left portal, north transept, c. 1220.)

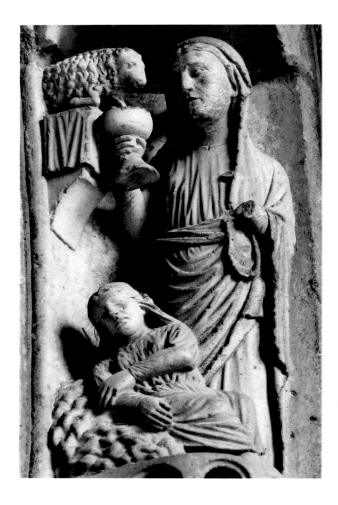

146

The world

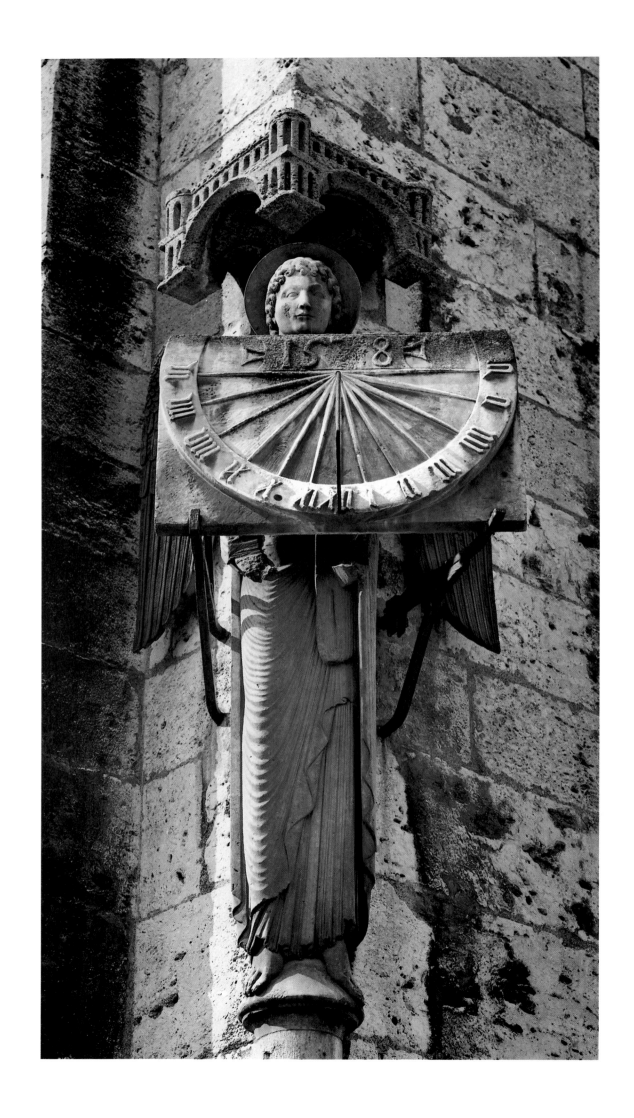

The world

All this is part of life, not just of doctrine or dogma. The porches which introduce the faithful to these profound truths clearly establish the presence of the secular world within the world of the cathedral, and the logic of a vision of the world based on the Christian virtues. They show time passing, measured by the calendar of human activities. They also show the society of men, with their tasks and trades.

On the Royal Portal, the cycle of the months is ambiguous, starting from the sign of Cancer with the July harvest (outside) and the Ram with the first flowers of April contemplated by a figure itself crowned with flowers in honour of spring (inside). Subsequently, the sculptor became more disciplined in his imagery. On the north portal voussoirs, which again depict a combination of the Signs of the Zodiac and the seasonal activities, the calendar which begins below on the left opens with the month of January. In their everyday life people did not always follow the inconvenient customs of the royal chancellery which had moved the beginning of the year to Easter. According to the faithful of Chartres, January was the turning point between the past and the future year: the little two-faced figure borrowed directly from antiquity and its god Janus tells even the simplest-minded that the year has ended. Higher up, February is hooded and warms his naked feet by a fire. At the side, winter is shown as an old man, Capricorn as a kind of monster coiling its long tail and Aquarius, no longer regarded as Ganymede abducted by Jupiter or as the father of Actaeon who was torn apart by his own hounds, appears simply as a young man pouring from his pitcher, the water-bearer.

The shift from a year beginning in spring to a year beginning in the heart of winter also implies a change in Chartres society. In the space of half a century, the attitude to urban life had changed. In the mid-twelfth century, the sculptor at work in the heart of the city who wanted to depict the months could only use the language of the peasant. But a long time had passed since the burghers of Chartres last devoted the month of November to killing and salting their pigs. In town, pork was bought in shops. But representative types are tenacious, and the town had not forgotten the annual cycle that opens with spring seeds, burgeoning buds and flowering cherries. Situated between the two sowing times, the long mid-winter nights did not seem like a beginning.

Fifty years later, rural life no longer imposed its rhythms on the course of town life. The images were still borrowed from the outstanding symbol of

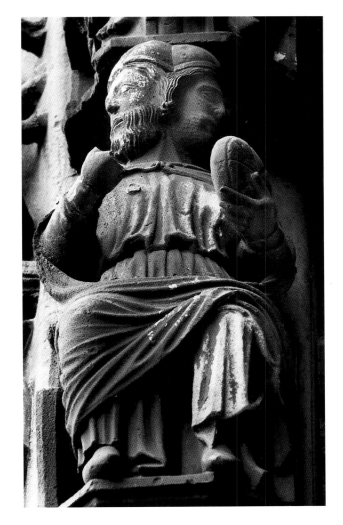

January. The cycle of rural life begins with the spring buds. In urban society, however, with its economy of artisans and merchants, the winter solstice came back into its own. The days begin to lengthen. A new year begins. The old symbol of the two-faced Janus came back into use, with its one face looking back at the old year and one forward to the new. (Right bay of the north porch, c. 1220.)

The Angel with the Dial. The first public clocks appeared in the towns in the 14th century (but this dial is dated 1578). It is a symbol. The angel carrying the time stands for a truth which the theologians are constantly preaching: time belongs to God. Time is of God. (South façade.)

Ass playing a hurdy-gurdy. The sculptor is entitled to give rein to his imagination and to amuse himself, on the sidelines. (South façade.)

November. The peasant kills his pig. The rural cycle still wins the day on the Royal Portal (c. 1140.)

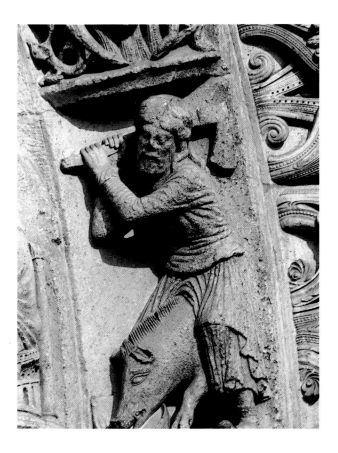

the passage of time, the cycle of seasonal labours. But the commencement of the urban year was no longer dependent on the first buds.

It was in professional life that town and country came together. On the portals of the Incarnation, the world of man does not appear only in the form of the humanity of Christ. The carders, the spinners, all these figures in whom the visitor could see or recognize himself or his neighbours, accompany a representation of the Beatitudes that is even more idealized than those on the south transept portal. The faithful knew what it meant: this world of religion which they were entering, where the virtues and mysteries had assumed a human face, was their world. It showed them Faith and the Lamb of God. But it also showed them the man with cold feet and the woman's work tools.

Now the faithful were ready to take in the lesson of the saints. History offered a vast choice of saints, but preference was given to well-known ones, because they changed the face of the earth or quite simply because they played a part in local society or because the church owned a piece of their bone or clothing which added to the wealth of its treasury and its fame as a place of pilgrimage. The people of Chartres considered it quite normal for an ambulatory window to record the life and miracles of St Cheron, a young patrician who lived in Chartres in the fifth century and became known for refusing to marry, the better to serve God. St Cheron performed many miracles, healed a woman possessed of the devil, restored a blind man's sight and saved the life of a carter crushed under his overturned cart. He died a martyr. The miracles continued and even the son of King Clotaire was cured after a pilgrimage to his grave.

Neither the image nor the word is very fastidious about the authenticity of the anecdotes, and legend which admits to being such competes here with a history that was itself often based on the legends disseminated by the *Lives of the Saints*, if not by the medieval chronicles of the *Chansons de geste*. There is some confusion between the different lives. Cheron healing the blind man borrows the particular gesture made by Christ — he touches the man's eyes with a finger wetted with saliva — and after his martyrdom he carries his severed head in his hands, like St Denis of Paris, till he reaches the place, designated for devotional purposes by a miraculous fountain, where the faithful were to erect an abbey over his tomb. This abbey was to bear his name and to remain very active until the wars of religion. The borrowings are plain to see. The medieval inhabitants of Chartres considered it quite normal for a local saint to behave like a saint from Paris.

No artist could fail to depict these familiar scenes which everyone could identify with ease but which also remained the solid bases of religious teaching. St Martin — a proud horseman — seen sharing his cloak with a poor man on one of the south portals is clearly an example of charity, like St Nicholas beside him, shown dropping his bag of money from the window into a house where a father unable to give his daughters a dowry lies dying. The moral of the tale appears above, with St Martin's vision of Christ wearing half his cloak and the sick crowding round the tomb of the archbishop St Nicholas.

Repetition by no means weakens the moral of the tale, on the contrary. The stone-cutters of Chartres who sculpted the scenes from the life of St Cheron on the south portal decided to offer the cathedral a window depicting the healing of the carter, not forgetting to show the real cause of the accident: a demon sitting on the cart wheel. As for the haberdashers and apothecaries, who had themselves represented below their window in the

characteristic attitude of their trade, weighing their products on the scales, they were happy to offer the faithful the contemplation of a series of scenes, on the left aisle, borrowed from the edifying life of their patron saint.

It is not surprising to find the wisdom of Solomon here, or the submission of Job, or the incredulity of St Thomas – duly lectured by Christ for wanting to touch the stigmata of the Passion to convince himself of the Resurrection – or the heroism of the martyrs who founded the great churches of France: St Remi, St Germanus of Auxerre and St Savinien of Chartres.

And so we also find Charlemagne, in a story of twelve episodes directly borrowed from the *Chansons de geste* or more specifically from the *Geste du roi*, the chronicle of the king, depicted on one of the main windows of the ambulatory, just behind the choir. He could be the hero of the battle for the faith, the crusader before his time, always at war with the pagans of Germania and the Saracens of Spain; in short, he resembles Philip Augustus' marshal who died at the siege of Acre, Aubry Clément, Lord of Mez, the crusader in the long blue robes shown on one of the high south transept windows, who receives from St Denis the oriflamme preserved in the royal abbey, which is borne before the Capetian king in the battles for the faith.

But in fact the Charlemagne on the window donated by the furriers of Chartres is very much the emperor of legend, accompanied by his cavalcade and his nephew Roland who can split a rock with a single blow of his sword Durandal, a Roland who sounds his horn in all those cathedrals where the ivory horn preserved in the treasury is, inevitably, known as Roland's hunting horn. The Charlemagne of Chartres is the one of popular fame and

The world of labour. The women are working the wool, carding and combing it. (Left bay of north porch, *c.* 1220.)

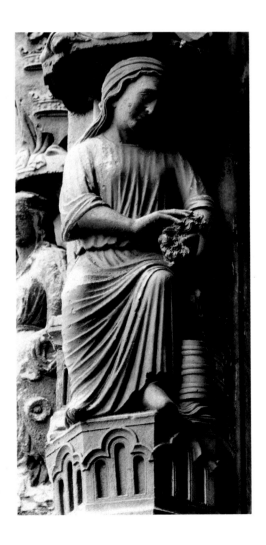 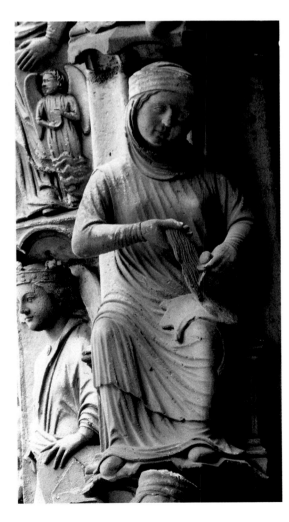 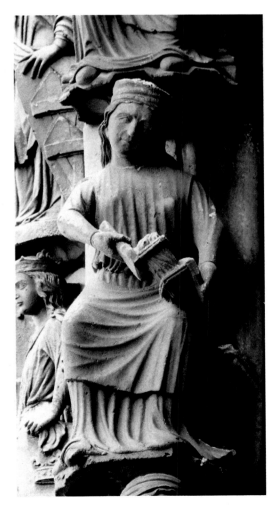

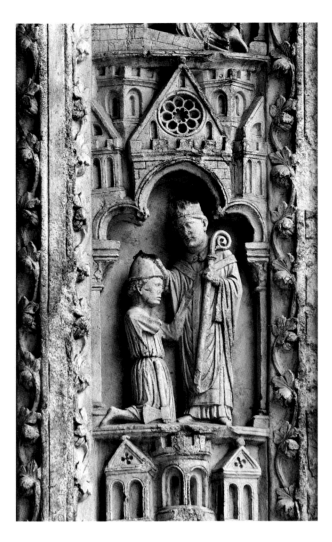

St Martin blessing the man who had tried to strike him. (Forward pier, right bay of south porch.)

what was most admired about this scourge of the Saracens was not that he sought sanctity by fighting for the faith but that he killed so many enemies single-handed.

As for Archbishop Thomas Becket, murdered in Canterbury Cathedral in 1170 by the over-zealous servants of the Plantagenet King Henry II, his portrayal in the 1220s on the window of one of the ambulatory chapels must have been for reasons of flattery. Although he became a martyr by his death, Becket was never the object of any form of cult in France. But Philip Augustus was still king of France in 1220 and it was only a few years since he had destroyed the continental power of the Plantagenets. To recall the murder of Becket was to exalt a prelate whom history had placed on the Capetian side, for reasons which had nothing to do with religion. The blood of the martyr underlines the justness of the king of France's cause. Fifteen years later, Blanche of Castile and St Louis presented Chartres with the north façade windows. It had been made quite clear to them that Chartres was a Capetian cathedral.

With the oriflamme that Philip Augustus had borne before him to Bouvines in 1214, with Charlemagne whose last descendant, Isabella of Hainaut, he married, with Thomas Becket whom he avenged by inflicting a series of defeats on the Plantagenets which virtually eliminated them from French soil, the political pretensions of Chartres become quite plain. During the period of about 1220–30, when these three windows were constructed, Chartres saw itself as a rival to the great royal churches of the Parisian area. And on the windows of Chartres, the arms of France are depicted three times – this is the earliest preserved record – with their colours: a blue ground with a scattering of gold fleurs-de-lis. Chartres wanted to be a royal cathedral and wanted everyone to know it.

The situation was still fluid at that time and the Capetian king had not yet settled on the final places of royal worship: Rheims for the coronation, Notre-Dame of Paris for his glorification, Saint-Denis for his tomb. Rheims Cathedral was the only one to owe its importance to history, but that history was only a one-day wonder. For the rest, the decision was still open. And it was no chance that Clovis appears at Chartres, on the right-hand pier of the south portal, as a right Christian king kneeling before St Remi.

For the past three centuries, St Denis, the traditional necropolis of the Merovingian and Carolingian kings, had been facing a competition due to circumstances – the death of kings – and to rivalries, clearly reflected by the fact that in the twelfth century so many princes gave preference to the new order of the Cistercians and to their monasteries built far from the 'world', over the traditional Benedictine abbeys whose spiritual influence was weaker. No Carolingian was buried in St Denis after the ephemeral Carloman who died in 884. His successors chose their final place of rest at Saint-Corneille of Compiègne and Saint-Remi of Rheims.

The kings of the new dynasty, who were masters of the Abbey of Saint-Denis, restored it to its position as royal burial place after 987. But they did not assure it a monopoly. Hugh Capet is buried at Saint-Denis, but he had his eldest son buried at Compiègne. Robert the Pious and Queen Constance of Arles are at Saint-Denis, as is their son Henry I who died in 1060. But Philip I (died 1108) deliberately chose to have his tomb at Saint-Benoît-sur-Loire, at a time when the status of Paris as the capital seemed to be at risk: the centre of the royal domain was shifting southwards. Robert the Pious had given some thought to settling on the Loire. Philip I spoke openly of making Orléans his capital. Everything was still possible.

Louis VI returned to Saint-Denis, for himself and for his eldest son who died before him. But towards the middle of the twelfth century Louis VII decided, for his part, to look elsewhere. This pious and austere king preferred the Cistercians. At his wish, he was buried in the abbey he had founded near Melun, at Barbeau. And on two occasions, in 1130 and in 1150, the king of France convened his assembly of nobles at Chartres. Several *Chansons de geste* composed at that time bear witness to Chartres' aspirations to compete with the capital.

Under Philip Augustus, Paris returned to favour. The Louvre was built, perhaps representing both the fortress — with its treasury, archives and prison — and the symbol of the centralization of the monarchy. The main part of Notre-Dame, begun in 1163, was completed in 1196, the western façade in 1210. All that remained were the north and south façades, which had to wait another half century. In 1186 Philip Augustus had his protégé buried there, the young Geoffrey Plantagenet, who died in Paris in the midst of a rebellion against his father Henry II, King of England and Duke of Normandy. He also chose this site for the tomb of Queen Isabella of Hainaut, then of their eldest daughter and finally of their grandson, the eldest son of the future Louis VIII. Meanwhile, he also tried to obey the last wishes of his mother, Adèle of Champagne, who wanted to be buried at Barbeau; but the monks there were so hostile that the queen's body was eventually buried in another Cistercian abbey, at Pontigny.

At the time when the new Cathedral of Chartres was nearing completion, the situation was confused, to say the least. Saint-Denis no longer had any kind of monopoly. Paris had not yet won through. The iconographical programme of Chartres — although not its style, which is more humanized — was too obviously inspired by Saint-Denis not to suggest a desire for succession. The west windows of Chartres echo the choir windows of Saint-Denis, just as the Royal Portal and the great statues on the north transept portal recall the statues of the façade of Saint-Denis.

For the last fifty years all the towns of the region had been competing for their cathedrals. The ground plans were expanded far beyond the area needed to receive the faithful, the naves became ever longer and the vaults ever higher. Notre-Dame of Paris lay at the heart of the capital, which is what Paris had finally become, but it was apparent to everyone that its architecture had become dated. By 1200, the stylistic decisions of the masters of Notre-Dame, which in fact heralded the late Gothic style, had already turned the cathedral into an old-fashioned building, with its four storeys and sexpartite vaults, and its sparse light, of which the bay reconstructed by Viollet-le-Duc still gives us some idea.

Many royal cemeteries existed by then. Blanche of Castile and St Louis began to add to the list. Of St Louis' brothers, the eldest is buried at Notre-Dame of Paris, the next two at Poissy, while Philip-Dagobert who died in 1234 is buried at Royaumont. His children were buried there too, and Queen Blanche joined them in 1252. But Capetian France had still not chosen its main sanctuary, its spiritual centre.

It could no longer be Saint-Denis, which St Louis had made the official necropolis of the kings — and only the kings — when he rearranged the positioning of the tombs in order to mark the profound unity of the French royalty over and above the succession of dynasties. Yet St Louis never went to Saint-Denis to worship or to celebrate the great moments of his reign. It could not be Notre-Dame, an old-fashioned cathedral which was not famous for any particular cult or for attracting crowds of pilgrims.

The oriflamme. St Denis – an obvious allusion to the royal status of the abbey of Saint-Denis which contained the sacred symbol of the defence of the faith – is handing the oriflamme to a knight who is traditionally regarded as the marshal of Philip Augustus who died in the crusades. (Window on the east side of the south transept.)

Charlemagne. The Emperor was regarded as defender of the faith, ally of the Church and restorer of Christian royalty. He was a legendary figure, and was considered a saint. Immediately below, Charlemagne and his knights. Below, Roland splits the rock and sounds his horn, the ivory horn found in the treasuries of so many churches that aspire to illustrious origins. (Ambulatory window, c. 1225.)

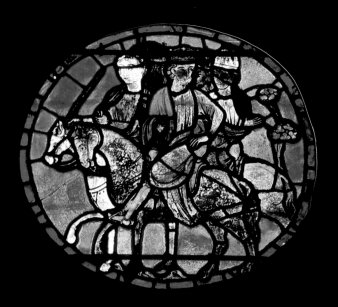

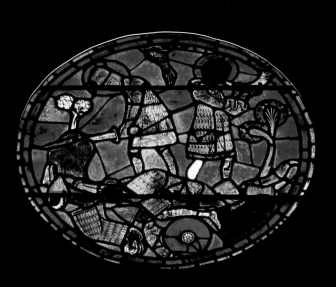

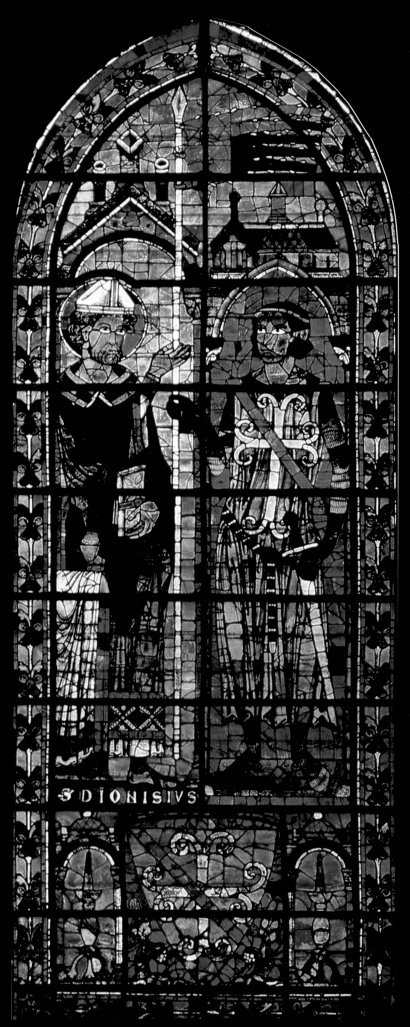

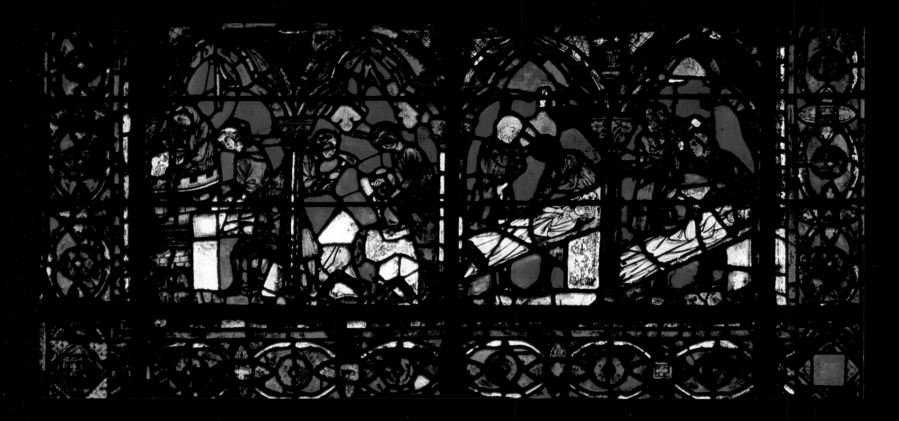

The stone-cutters. They built the cathedral, but they also offered a window of their own, showing the life of St Cheron. At the foot of the window they are shown cutting the statue that is to be placed on the south portal out of the stone. (Ambulatory window, c. 1225.)

France and Castile. The fleurs-de-lis and the castles of Castile. The young king Louis IX and the regent Blanche of Castile. The great windows of the north rose proclaim the names of the donors. Chartres is a royal cathedral. But there are others too.

Chartres had some chance of taking over from Tours, whose chapel of Saint-Martin was no longer drawing in the visitors. Its great architectural programme, its wealth of decoration, its importance as a place of pilgrimage, the fame of its relics, all this combined to make the cathedral on the Beauce plains one of the sanctuaries of the Capetian world, a world centred politically around Paris but in which there was no reason — nor was there any foreign example to follow — to equate the political and religious centres.

St Louis was to show how highly he esteemed the sanctuary of Chartres. The great northern rose window is the evidence. But he also donated two rose windows to Notre-Dame of Paris and it was in the entirely new Sainte-Chapelle in the heart of the capital that he was to place the most remarkable relic ever received by the Christian West: the Crown of Thorns. The oriflamme remained at Saint-Denis. The period of great rivalry was over now. The royal cathedral, the cathedral of feast days and gatherings, of the *Te Deum*, was to be Notre-Dame of Paris.

And Chartres, within its precincts which still did not measure up to its ambitions, was to remain the cathedral at the end of the pilgrims' road.

Appendices

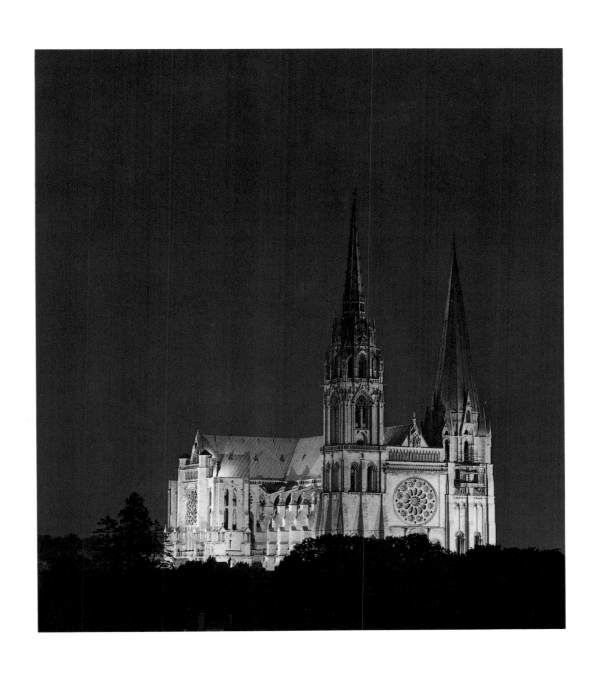

Plan of the windows

The windows of Chartres cover a surface of more than 2,000 square metres. Most of them were made between 1210 and 1240.

Story of the Prodigal Son

Story of Noah, p. 24 *Story of St Lubin*, p. 15 *Story of St Eustace* *Story of Joseph* *Story of St Nicholas* *The Redemption*

Genealogy of Christ, 12th-C. (Tree of Jesse), p. 93, 115

The Life of Christ, 12th-C.
From the Annunciation to the Entry into Jerusalem, p. 119, 131

The tall figures of saints, prophets and Apostles appear in the double lancet windows crowned by a rose in the clerestory.

Story of the Passion and the Resurrection, 12th-C., p. 107 below, 119 below

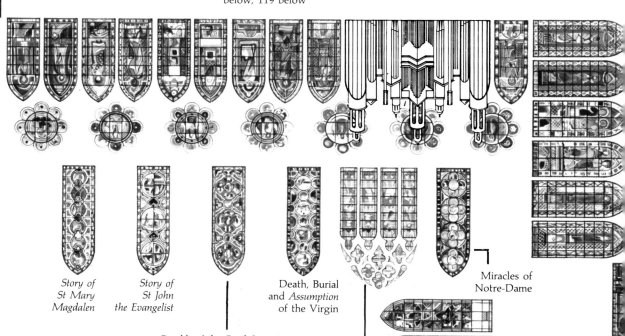

West rose, p. 9
The Last Judgment
In the centre, Christ tortured, surrounded by angels and the four beasts of the Apocalypse. Above, Abraham and the chosen. Below, the Weighing of Souls. To the left and right, the twelve Apostles.

Story of St Mary Magdalen *Story of St John the Evangelist* Death, Burial and *Assumption* of the Virgin Miracles of Notre-Dame

Parable of the Good Samaritan, p. 106, 107.
The Creation, the Fall and the Redemption of Man

15th-C. windows of the Vendôme Chapel, showing Louis of Bourbon, his wife and other members of the royal family, with their patron saints and their coats of arms.

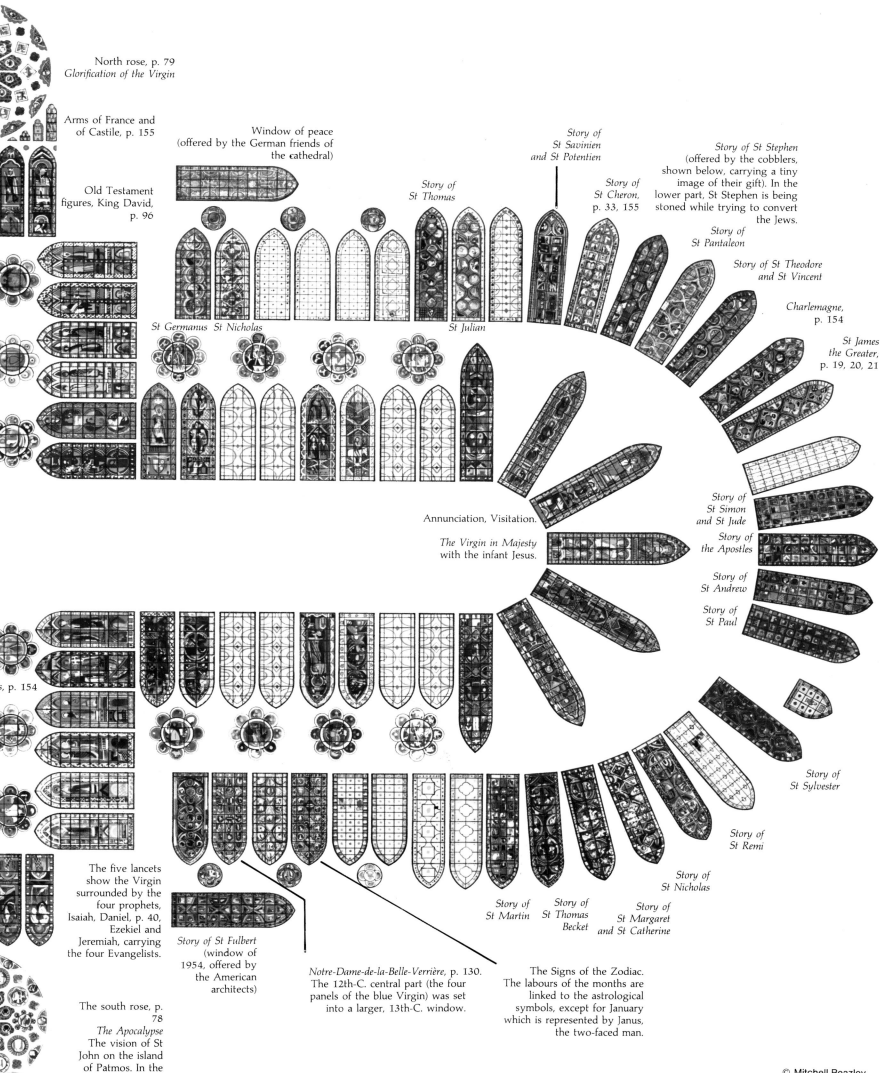

North rose, p. 79
Glorification of the Virgin

Arms of France and
of Castile, p. 155

Old Testament
figures, King David,
p. 96

St Germanus St Nicholas

Window of peace
(offered by the German friends of
the cathedral)

*Story of
St Thomas*

St Julian

*Story of
St Savinien
and St Potentien*

*Story of
St Cheron,
p. 33, 155*

Story of St Stephen
(offered by the cobblers,
shown below, carrying a tiny
image of their gift). In the
lower part, St Stephen is being
stoned while trying to convert
the Jews.

*Story of
St Pantaleon*

*Story of St Theodore
and St Vincent*

*Charlemagne,
p. 154*

*St James
the Greater,
p. 19, 20, 21*

Annunciation, Visitation.

The Virgin in Majesty
with the infant Jesus.

*Story of
St Simon
and St Jude*

*Story of
the Apostles*

*Story of
St Andrew*

*Story of
St Paul*

's, p. 154

*Story of
St Sylvester*

*Story of
St Remi*

*Story of
St Nicholas*

The five lancets
show the Virgin
surrounded by the
four prophets,
Isaiah, Daniel, p. 40,
Ezekiel and
Jeremiah, carrying
the four Evangelists.

Story of St Fulbert
(window of
1954, offered by
the American
architects)

Notre-Dame-de-la-Belle-Verrière, p. 130.
The 12th-C. central part (the four
panels of the blue Virgin) was set
into a larger, 13th-C. window.

*Story of
St Martin*

*Story of
St Thomas
Becket*

*Story of
St Margaret
and St Catherine*

The Signs of the Zodiac.
The labours of the months are
linked to the astrological
symbols, except for January
which is represented by Janus,
the two-faced man.

The south rose, p.
78
The Apocalypse
The vision of St
John on the island
of Patmos. In the
centre, Christ

Chronology

There have been at least five cathedrals on this site, each replacing an earlier smaller building that had been destroyed by war or fire. It was called the 'Church of Saint Mary' in the eighth century, and in **876** Charlemagne's grandson, Charles the Bald, gifted the Virgin's great relic, the *Sancta Camisia*, to the cathedral. This veil is now housed in the cathedral treasury, and is believed to be the one that Mary wore when she gave birth to Christ.

This relic was probably given to the cathedral at the consecration of the church which was rebuilt after the cathedral had been destroyed by the Danes in **858**. There was another fire in **962**, and a more devastating conflagration in **1020**, after which Bishop Fulbert reconstructed the whole building. The present crypt, which is still the largest in France, remains from that period (p. 47).

Bishop Fulbert established Chartres as one of the leading teaching schools in Europe. Great scholars were attracted to the Chapter, including Thierry of Chartres, William of Conches and the Englishman John of Salisbury. These men were at the forefront of the intense intellectual rethinking that we call the twelfth-century 'renaissance'.

In **1134** another fire damaged the town, and perhaps part of the cathedral. The north tower was started immediately afterwards, along with the subterranean parts of the southern tower. When the north had reached the third story the south tower was continued, and the sculpture of the Royal Portal installed with it, probably just before **1140**. It was once thought that this sculpture was intended for another place and moved here, but recent investigation has shown that all three doors and the magnificent figures around them were created for their present situation. The two towers were then completed fairly quickly and, between them, a chapel constructed to Saint Michael (traces of the vaults and the shafts which supported them are still visible in the western two bays). The glass in the three lancets over the portals which once illuminated this chapel were installed in about **1150**. The south spire, 103 meters high, was completed in **1165** (p. 26).

Finally, on 10 June **1194**, a disastrous fire destroyed nearly the whole of Fulbert's cathedral. The choir and nave had to be rebuilt, though the western towers and the Royal Portal were incorporated in the new works, as well as the old crypt: which shows that the present cathedral is no longer than the earlier one. The south porch was installed by **1206**, and by **1215** the north porch had been completed and the western rose installed. The high vaults were erected in the **1220**s, the canons moved into their new stalls in **1221**, and the transept roses over the next two decades.

Each arm of the transept was originally meant to support two towers, two more were to flank the choir, and there was to have been a central lantern over the crossing. The latter was eliminated in **1221**, and the crossing vaulted over. Work continued in a desultory fashion on the six additional towers for some decades, until it was decided to leave them incomplete, and the cathedral was dedicated in **1260** by King Louis.

Little has been done to the cathedral since then. In **1323** the Chapter constructed, at the eastern end of the choir, a new meeting house for itself with the Chapel of Saint Piat above that. This is today the cathedral treasury. A small chapel was placed between the buttresses of the south nave for the Count of Vendôme after **1417**. At the same time the small organ that had been built in the nave aisle was moved up into the triforium where it still is, though some time in the sixteenth century it was decided to take it down and place it on a raised platform at the western end of the building. To this end some of the interior shafts in the western bay were removed and plans made to rebuild the organ there. It was fortunate that this decision was reversed, and instead the old organ was replaced with the new one we know today.

In **1506** lightning destroyed the north spire, which was rebuilt by Jehan de Beauce 113 meters high. He took seven years to carve the intricate and delicate stonework on this tower, and erect it. He afterwards continued working on the cathedral, and began the monumental screen around the choir stalls, which work was not completed until the beginning of the eighteenth century (pp. 122–23, 132–33).

In **1757** the *jubé*, or screen between the inner choir and the nave, was torn down, and the present stalls built. Some of the magnificent sculpture from this screen was found buried underneath the paving, and was removed to the treasury (fig. 1). At the same time some of the stained glass was removed and replaced with *grisaille*, or grey glass, so that the canons could read their missals more easily. Then in **1836** the original lead and timber roof, known as the forest, was burnt out and replaced with copper sheeting on cast iron supports (fig. 2).

The cathedral has been fortunate in being spared the damage suffered by so many during the Wars of Religion and the Revolution, though the lead roof had been removed to make bullets and the Directorate had threatened to blow the building up as its upkeep, without a roof, had become too onerous. All the glass was removed just before the Germans invaded France in **1939**, and was cleaned after the War and replaced. Since then the fabric has been lovingly tendered and repaired in the most scrupulous fashion to retain its original character and beauty.

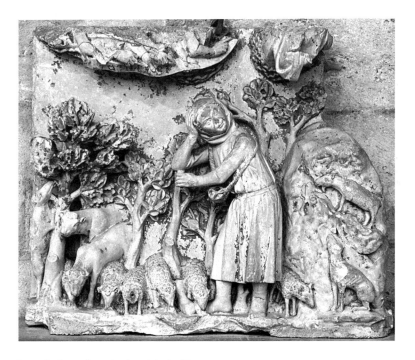

Fig. 1 Sculpture from the demolished *jubé*.

Fig. 2 Framework and roofing seen from the interior.

The men of Chartres: visionaries and craftsmen

Too many of the great cathedrals have been destroyed by fire, desecrated by restorers and bigots, and their glass and sculpture wantonly hacked out. Anger, calamity and stupidity have taken all too great a toll. We are fortunate still to have at Chartres an almost untouched thirteenth-century cathedral, with the most marvellous assembly of images in Europe, a collection of stained glass without equal in the world and, in total, an enduring encyclopedia of Christian thought.

The cathedral built after the first fire was almost as large as the present building, and at the time the second largest church in Europe, the first being Saint Peter's in Rome. Remnants still embedded in the towers suggest that it was three storeys, with a middle gallery, and that it was almost as high as the rose windows in today's clerestory. An immense building indeed. The crypt from this campaign still exists.

During one terrible night in 1194 a disastrous fire raged through the town of Chartres, laying waste most of the houses and shops, and destroying much of its ancient cathedral. As the smoke abated only the western spires remained above the charred and tattered walls. A desolate picture! Surmounting their despair the townsfolk and the clergy decided, in the most positive way, that the fire had been a sign from the Virgin herself, an injunction to rebuild Her House in the most marvellous manner possible.

For this they invited an architect from the region to the north-east of Paris, a talented man who had worked for the Cistercians and the Benedictine monks, as well as at the cathedral of Laon.[1] He seems to have been a seriously philosophic man, skilled as a mason and with a considerable understanding of the Christian theology of his day.[2] We do not know his name, for all the documents have been lost, but we have identified him in sufficient places to gain some idea of his standing and capacities. Lacking a documented name, we have called this genius 'Scarlet'.[3]

A dozen years earlier he had begun the apse in the huge Cistercian Abbey of Longpont. This austere order imposed strict limitations on the masons who worked for them; but it seems that Scarlet may have influenced his patrons, for the plan of Longpont was unusual for the 1180s.[4] Instead of the usual flat eastern end, Longpont has an ambulatory with seven chapels not unlike the plan Scarlet prepared for Chartres a little later.[5]

In spite of the constant coming and going of these different teams[6] of men nearly the whole of the cathedral was completed in thirty short years. These building teams were large, perhaps consisting of 300 men, of which over fifty would have been skilled masons and the key men in charge of the organization.[7] This number could not have been left idle while the clergy waited for donations. Once the coffers were empty they would have left the site in a body, and found other employment. When enough money had been collected[8] to allow the church to re-engage masons, the last group were probably working at some other site, and a fresh team had to be found. This impermanency was normal, and everyone expected it.

There were also technical considerations, like the slow setting lime mortar, that could force the builders to leave. Even in the Royal works, where there were ample funds, builders were put off while the mortar set in arches or over the vaults. At the Sainte-Chapelle in Paris there may have been as many as five changes to crews for just these technical reasons.[9] Changes in masters were expected by both the owners and the masters themselves. As will be seen, their methods of design were evolved to cope with this situation, and to ensure that enough unity would be maintained between the work of one mason and his successor to prevent the design becoming totally chaotic.

This was a time of extraordinary building activity across the limestone region we call the Paris Basin.[10] Over 2,700 churches, chapels and cathedrals were built in this small area during the one century that separated the choir of Saint-Denis from the Sainte-Chapelle. Over 90 percent of all the early Gothic churches are found in the Paris Basin because it was here, and practically nowhere else, that the revolution in architecture was occurring.

A recent analysis of the costs of this ecclesiastic work calculated by region showed that the quantity of building in the north around Soissons and Laon was greatest in the 1170s and 1180s, while in the Ile-de-France construction peaked around 1220.[11] While the Soissonais was abubble with great works the Parisis was relatively dormant. It was here, therefore, that huge construction teams were assembled and trained. After 1190, as work declined in the north-east, these skilled men, complete with their foremen and other key people, would have been looking for more distant projects — and Chartres was one of them. And this is why most of the other work executed by the contractors who constructed Chartres is to be found to the north of Paris between Creil and Rheims.

Fig. 3 Cistercian abbey of Longpont: ruins of the transept and nave.

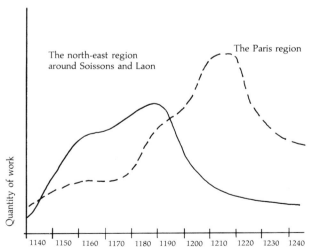

Fig. 4 Quantitative graph of works carried out in the north-east area of the Paris Basin and in the Ile-de-France between 1140 and 1240.

THE NINE MASTERS

Research has shown that there were nine groups, or teams of masons, each under the control of one master mason, with their attendant quarriers, apprentices and so on. These teams, which may have numbered as many as three hundred men, seem to have arrived on the site as a group, and left together: the carving styles change at the same time as the architectural details.

The unusual aspect of the medieval building process, which applies to the smallest church as much as to the greatest cathedral, was that these teams seldom stayed on the site for very long. One might work for a few months, the next for a couple of years, in an ever changing sequence that lasted throughout the many decades needed to construct the cathedral.

The first master we have named Scarlet, since we did not know his name; he began work just after the fire in 1194. The second was Bronze and the third Olive, working around 1196. Probably in 1200 Scarlet returned to set out the south porch and the labyrinth. Olive returned some ten years later to redesign the clerestory windows, and the team we call Bronze worked nine times on the site between the fire and the completion of the main vaults.

For over thirty years the masters changed almost every year. The cause was probably money: they did not have the sophisticated funding techniques we possess, but relied on cash, and when there was money the hand work could be pushed on apace – but when there was none the builders had no choice but to pack up and find work elsewhere. And this they did. Olive, for example, worked mainly along the Marne river, and at Rheims and Soissons, and on only three occasions moved out of this region to work at Chartres. Most of the work by the Bronze team is to be found in the hilly district between the Aisne and Laon, though his characteristic style is to be found as far away as Mantes-la-Jolie, as well as at Chartres.

It is by their style that we recognize them. This most exciting aspect of modern research is identifying the hitherto anonymous architects of the Middle Ages by what we might call the thumb print of each person. Every master had a unique approach to his profession, with his own way of creating the profiles and of arranging them into elements like windows and doors. Though there were changes with the passing years, each master's personal style tended to remain distinctly his during his lifetime.

There are still many gaps in our knowledge, but it is becoming increasingly clear that the extraordinary architectural inventions manifested during the century around 1200 stemmed from the creative endeavours of a few dozen men who travelled across great distances with their workmen. They gained an intimate understanding of their fellows by constantly being asked to continue with buildings which had been reared by others, yet every one of them maintained a strong, often idiosyncratic, manner of working that identifies him as clearly as the lines on our hands will identify us.

TEAMS OF MASONS

BRONZE	1195	Began transepts	1217	Nave clerestory roses	
	1198	Set out the transept doorways	1222	Nave roof	
	1201	Sanctuary windows begun	1225	Choir vaults completed	
	1205	Choir aisle vaults	1230	North towers begun	
	1208	Choir triforium begun, south porch complete	1238	Southern towers completed	
COBALT	1203	Nave aisle vaults	1212	Nave buttresses begun	
	1207	Apse chapel aisle vaults	1219	Nave vaults begun	
GREEN	1228	North transept triforium completed	1235	South transept vaults	
	1231	Eastern towers almost complete	1241	North transept vaulted	
JADE	1221	Southern towers started	1226	Continues work on transepts	
OLIVE	1197	Began *pilier cantonne* and crossing piers	1223	Nave vaults completed	
	1210	Continued work on triforia	1240	North transept roofed	
RED	1213	Choir outer buttresses begun			
ROSE	1196	Continued walls and footings			
	1204	South porch lintels	1224	Crossing vaults and roof to choir	
	1214	Nave clerestory capitals	1229	South rose installed	
RUBY	1199	Nave walls to window sills	1216	Nave flyers under way	
	1202	Nave arcade arches	1220	Choir vaults begun	
	1206	Started nave triforium	1227	First transept vaults	
	1211	Nave clerestory set out	1233	North rose installed	
SCARLET	1194	Set out the cathedral, the first plan	1215	Western rose started, north porch complete	
	1200	Began south porch piers, set out labyrinth	1218	Choir flyers under way	
	1209	South transept triforium			

The evolution of the Gothic style

This essay is based on the detailed and often exciting research conducted by many people over the past twenty years, which has greatly enriched our understanding of the period and has exposed a time that was much more complex – and interesting – than was once thought. Ideas in art do not move in simple progression, and the interface between the changing aspects is often so hard to define that historians understandably make things simpler in order to be comprehensible. Yet we must face this complexity if we are to understand the richness of one of the most creative periods in human history.

The simple definition of Gothic that satisfied us two generations ago will no longer suffice. The decisive features of Gothic architecture were not the pointed arch, nor great height, nor the cross-ribbed vault. Ribs had been invented in England in 1100 and the builders in the areas of France ruled by the English handled rib vaults with a skill and a delicacy that were unsurpassed by their Parisian contemporaries. The height of the great Abbey church of Cluny, started in 1088, is almost that of Chartres – and its arcade arches were all pointed. In contrast, for forty years after Chartres was started, nearly every church built around Paris was low and squat, with tiny clerestories.

Except for four key inventions and the thinning of the shafts and ribs, Gothic was derived from a fresh view of structure that bypassed the decorative experiments of the previous fifty years. These four inventions were

* the flying buttress used at Sens about 1160;[12]
* the wide window that replaced the wall, first used at Chartres about 1200[13]
* the tall clerestory from Orbais around 1200,[14] and
* tracery, evolved at Essomes and Rheims around 1215.[15]

The ways these ideas were woven into tradition is a complex story, and not fully understood, but it seems there were four threads. Firstly, the flying buttress was taken up by Ile-de-France builders who were interested in light-weight construction, for with it they could make the walls even thinner and taller. This gradually evolved into a totally new type of structure, unheard of in masonry construction anywhere in the world before this date: the skeletal frame.

Secondly, around 1180 the north-eastern builders inserted a continuous triforium into the elevation of the Benedictine monastery of Saint-Vincent, and shortly afterwards in the abbey at Braine.[16] This seems to have stimulated them to go higher, as can be seen in Longpont and in the Soissons choir begun shortly afterwards.[17] One of the most important moments seems to have come when the northern builders saw the potential in the skeletal structures being developed in the Parisis to combine the flying buttress with the triforium. This was first achieved at Soissons, and then at Chartres, and was the supreme moment of medieval architecture.[18] From this and the *pilier cantonné* came the classic cathedral form, which is why Chartres has been called the Parthenon of France (Fig. 6).

This continuous triforium forms an articulated hollow that appears to pass behind the slender vaulting shafts like an unbroken cord, so all loads appear to flow past or through it. It ties the building together in the horizontal plane, raising the centre of gravity and anchoring it in the air, so to speak. The concept is subtle, and depends for its effect on the most carefully balanced detailing that emphasizes the vertical by reminding us that the horizontal still exists, even at that level.[19] The aisles were considered more than a passageway, but were symbolic of man and all mundane existence, while the clerestory was symbolic of the spiritual realm. The dark aisle was the material universe while the clerestory with its enormous translucent glass walls was the Tabernacle of the Heavenly Jerusalem. In Chartres the aisle arcade and the clerestory are almost equal in height, so the triforium is like an intermediate zone between these two equal powers. It is interesting that this architectural concept was being evolved just at the time that theologians were developing the idea of a separate Purgatorial state that separated Heaven from Earth.

This was not the only key concept to have come from the Benedictine monasteries of the north. Other Benedictine abbeys located to the east of Paris made fundamental contributions to the new Gothic style. At Orbais they created the tall clerestory around 1200, and at Essomes tracery less than fifteen years later.[20]

It may have been the flying buttress that stimulated a builder from the Marne to dramatically heighten the clerestory windows in the Abbey of

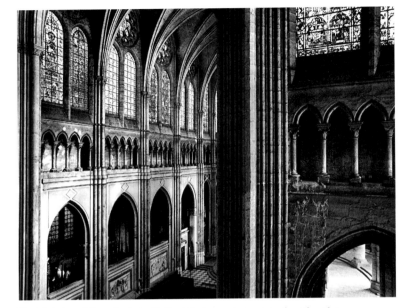

Fig 5 Interior of the cathedral with the triforium and view into the side aisles.

Fig. 6 The north rose in the north façade on which one can see the *en délit* shafts.

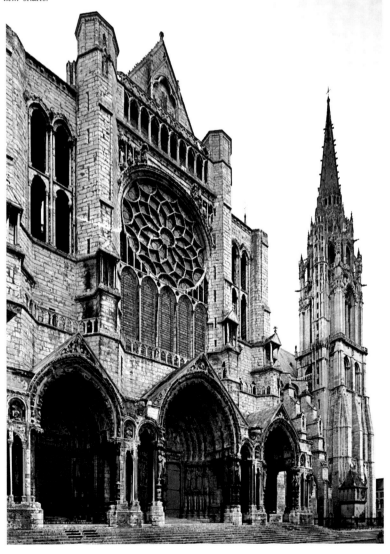

Orbais. He moved the capitals upwards, or if you prefer, shifted the sills downwards, to make the upper storey as tall as the aisles. The vault was suspended between the windows, floating on a bed of light. The tall clerestories found at Chartres and Soissons were started shortly afterwards.[21]

This extended the glass zone underneath the capital, as if slicing the vaults from their supports over a shimmering glass cage. The light of God occupying the full width of the walls left almost nothing of the structure, and that which remained looked less and less material as the splendour of the illumination dominated the interior. This made the windows so wondrous that bar tracery was a natural outcome; though, except for the north rose, it was invented too late to be used at Chartres (Fig. 6).

The double window with surmounting rose had been developed in the Oise valley to the north of Paris where the frames were simple splays, while along the Marne the frames were articulated with shafts. From the former came the windows at Chartres, and from the latter was developed tracery. In the darkness of Chartres the stained glass produces such a glare that the edges of the stone under the vaults seems to dissolve.

It was not the role of Paris to make these inventions, but to weld them into a single statement after they had been perfected elsewhere. It was when these different streams were conjoined at Saint-Germain-en-Laye and the Sainte-Chapelle that Rayonnant was born and exported from France after 1240. Prior to this, few Parisian churches had made much of the lofty exhilaration found in contemporary churches being built only a few miles to the north, the east and the south of it.[22]

The classic greatness of Chartres

Chartres is considered the most perfect cathedral ever created, for the balance of its parts and its supreme simplicity. However, none of the elements used there are, taken singly, unique. What has made Chartres such a special place is the scale of the interior, the perfect proportions, the stained glass and sculpture, and the uncompromising use of the latest ideas in the most direct manner. Chartres is architecturally very simple. There is virtually no decoration besides the string-courses, the capitals and torus moulds. There are just columns and arches, and between them plain walls or space – little else. Whether we look at the aisle arcades, the triforium and clerestory, or the vaults themselves, all we find are variations on the same theme: arches supported on shafts.

The shafts supporting the vaults are so thin that few would have believed they actually did carry the vaults. As they were not carved with the masonry of the wall, but were laid as separate vertical *en delit* stones, a shadow was cast between them and the wall which made the shafts independent of the structure.[23] They look as if they were hanging down like rope rather than pushing up. The ribs and their shafts were made so lightweight they resemble cloth, with cords hanging from them, pretending to be stone but in real vision the Tabernacle of God. It is a space dedicated to the illusion that its upper parts are not of this world (Fig. 7).

The abbeys seem to have been looking for ways to make the upper storeys a replica of paradise floating like the ultimate promise above the monks' heads: so that the upper parts of the church, above the triforium, actually and in truth were the Heavenly Jerusalem. This concept may have played the fundamental role in creating the new style. As the Abbot of Saint Remi, Pierre de Celle, wrote, 'where should one treat of the Tabernacle of Moses, if not in the tabernacle itself'. The tabernacle was imagined to look like a sumptuously decorated parasol tent, for Isaiah had written that 'He established heaven as a vaulted chamber, and stretched it out as a tent'. From inside the light coming through the skin, especially when made from richly woven or painted material, would have glowed like stained glass. This may have inspired the invention of painted glass which recreated this translucence in more permanent materials. Similarly the development of the rib may have been helped by its similarities to the curved lines on the under-surfaces of the tent. The concept was audacious.[24]

The most important step taken at Chartres was to combine these hanging shafts with a new idea, the *pilier cantonné*, which combined the drum piers then so popular in the Paris area,[25] with the four shafts under the arcade arches and the vaults. This pier may have been invented at Chartres. The effect of combining drum with shafts was to integrate the aisle piers, and the

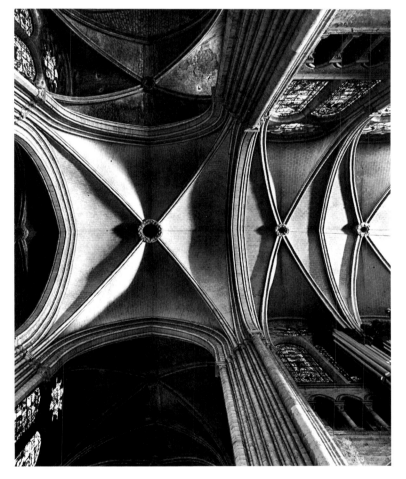

Fig. 7 High vaults with the colonnettes quite visible.

165

foundations under them, with the hanging tassels from the vaults, without actually joining them (Fig. 8). Like the horizontal of the triforium which did not interfere with the vertical thrust of shafts and clerestory while still enhancing the horizontality of the space, these piers created a balance to the hovering vaults, seeming to peg them down without hindering their etheriality.

The significance of the new Gothic form

The earliest medieval church was a protective place. The plainness of the enclosing walls and vaults, and their cool tranquillity suggested a changelessness and timelessness that induced feelings of peace. It was a citadel of faith, designed to feel like a fortress and a refuge.

From the inside of Chartres, the aisle windows seem small, leaving large areas of dark and strong walls – a powerful image of protection – and the *piliers cantonnés* are palpably huge, and in the next storey, the triforium is already lighter in feeling than the lowest zone, while the wide areas of glass in the clerestory make this part the lightest of all. The effect is twofold. First, the apparent vertical movement of the shafts creates a vortex or lateral spatial flow *through* the wall. This sideways motion is no longer contained and liberates us from a sense of enclosure, so we are free to move inward and outward as well as up and down. Second, unlike most Romanesque buildings with interiors that are bounded and predictable, we feel an apparent elimination of the mass and the dematerialization of the stone itself.

Externally, the upper walls in Romanesque buildings form a barrier between the House of God and our world. We are outside, the House is inside. But at Chartres the flying buttresses form a lofty cage around the perimeter that screens the clerestory and hides the walls so the precise outline of the most symbolically spiritual part of the building cannot be defined. This is aesthetically and structurally an utterly new concept (Fig. 9).

It has been pointed out that the steeply sloping flyers at Bourges are far more cost-effective than those at Chartres because they are unusually steep and take the loads to the ground as directly as possible.[26] They look like the gigantic stays of a tent, pulled down to earth and unmistakably structural.

In contrast, examine Chartres from the east: the flyers seem to rise above the edge of the roof like gigantic elbows thrust up and outwards (Fig. 10). They do not appear to be stabilizing the walls so much as dangling them. They are like great fingers holding the church from their tips: the fingers of God suspending the dematerialized and glazed splendour of His City, vibrating just above the heads of the faithful.[27]

Inside, the stained glass has a similar effect. It makes the interior as dark as moonlight, which imposes a sense of unreality on what we see, and like the flyers it disguises the solidity of the interior. It appears weightless, as if made from some other substance than stone. Medieval people knew the building was made of stone, for they saw it built. But they believed that on consecration God became immanent in the church and transmuted its base materials into the immateriality of the tabernacle. Both the flyers on the outside and the thin *en delit* shafts suspended from the vaults on the inside helped the distortions of light to create this illusion.

The clerestory windows at Chartres are unique, for the rose at the top occupies the full width of the bay (Fig. 12). Elsewhere at that time the rose was smaller, in what became the classic Gothic solution, leaving space so that the arch over the window could be pointed. The rounder fuller rhythm gives Chartres a less vertical feeling than it might have had, though in compensation these huge eyes draw our attention upwards into the vaults and tend to hold us there with a memorable certitude.

These roses are the work of the team under the master called Bronze, and were a favourite motif of his. He had used them in many places such as the transepts of Saint-Martin in Laon, and in the cloister of the nearby cathedral.[28] He always designed them in an eight-lobed arrangement, rather than the twelve lobes found in the great rose windows, and inserted small quatrefoil openings between the lobes and the outer frame.

However, there is evidence that there had been a number of earlier proposals for the clerestory, and that these were changed as different masters took over and the client's ideas were altered. We should not think of the design of a Gothic cathedral as a fixed concept immovably approved by the Church before construction began. Though some sort of general plan, or even a model, would have been prepared at the beginning, it was being

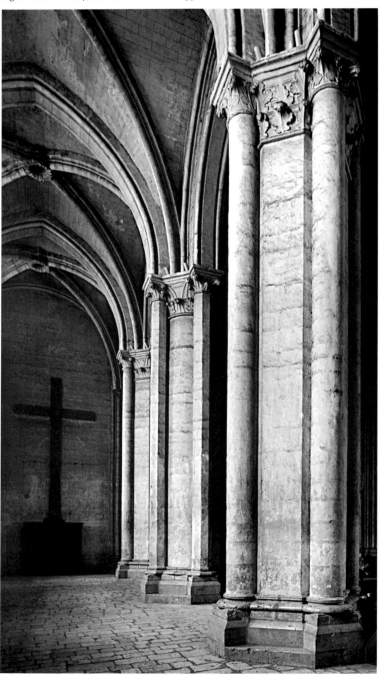

Fig. 8 View of the *piliers cantonnés* (see also pp. 57 and 86).

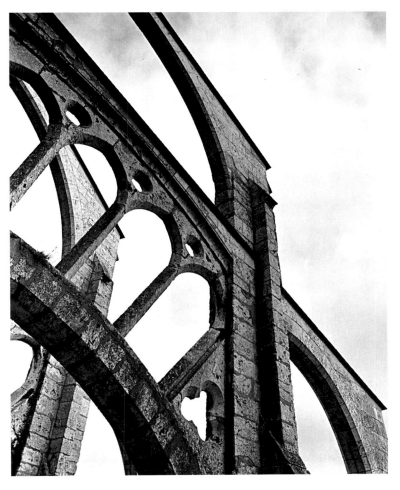

Fig. 9 Flying buttresses of the choir.

Fig. 10 Flying buttresses of the choir showing their 'pendant' character.

Fig. 11 Choir windows.

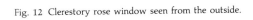

Fig. 12 Clerestory rose window seen from the outside.

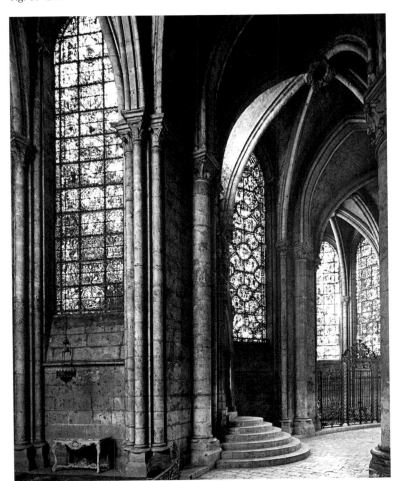

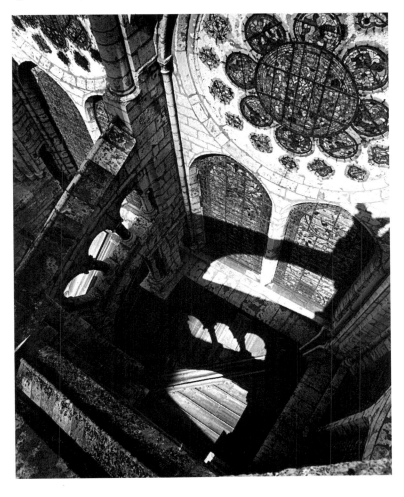

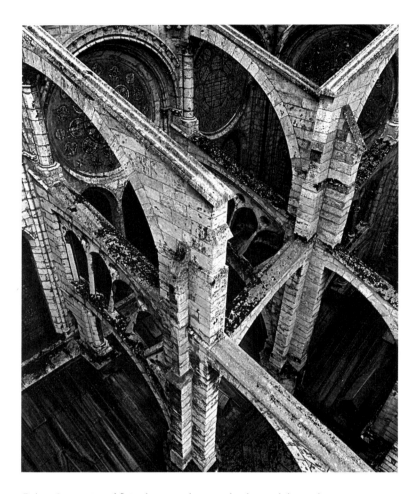

Fig. 13 Intersection of flying buttresses between the choir and the south transept, showing the principle of the axes.

Fig. 14 Evolution of the column bases between 1140 and c. 1240. Progressive pressure on the hollow scotia, until the 'squeezing' made it disappear.

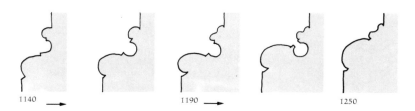

1140 ⟶ 1190 ⟶ 1250

constantly modified, and at times totally changed, throughout the work.

The first scheme for Chartres prepared after the fire probably had allowed for single windows in the clerestory. In 1211 there may have been a competition to update the design to the present window-wall with twin lancets stretching between the shafts. There were many other major changes during the course of construction: for example, in 1215 the first master Scarlet returned to the site after many years away, and laid the lower stones of the western rose with a diameter that presaged vaults almost two meters higher than they are now. The vault height was reduced by Bronze when he placed circular windows over the clerestories. This difference can still be seen in the western bays of the nave where the crowns of the vaults step downwards from the highest point over the rose.[29] Thus, in just six years, the design had been changed from single windows to double, from a height of 35.4 meters at the apex of the doubleau to the present much lower 33.8 meters found in the rest of the cathedral, and possibly from small clerestory roses to today's very large ones.

Scholars have wondered at the incongruous combination of Romanesque and Gothic motifs at Chartres, such as the circular arches over the clerestory being placed next to the highest vaults ever built, the massive shafts in the nave flyers compared to the refined and steeply pointed arches in the choir flyers, and the alternation in the piers against the closely unified interior (Fig. 13).

Stone as energy

It was certainly a time of change. In fact, the creation of Gothic was one of the most outstanding transformations in human culture known to us. Apart from the ancient Greeks and the people who created the modern world, no other civilization has so transformed its architecture. In all previous times, and afterwards in the classical revival, architecture was a wall-based affair in which all stability and lateral thrusts from vaults and roofs were taken within the thickness of the walls. But in Gothic, for the first time in masonry architecture, the wall was eliminated, as in the Chartres clerestory, and the thrusts taken by open arches set *at right angles* to these walls.

It is a truism to say that Gothic is a skeletal architecture, but underneath this phrase lies a most important and novel fact. In other periods, as evinced in the geometric methods used to calculate structural sizes, structure was visualized as the thickness between the inner and outer faces. All the loads and oblique thrusts were to be absorbed into the mass of the wall. Thickness was the first consideration. But in Gothic, the architects' methods show that they designed from the centres of the walls, from what we call an axis.[30] This axis is a line, without thickness, lying *within* the masonry. It is an abstraction. But around it the master 'saw' all the masses needed for the building. The axis, abstract and immaterial, generated the built forms. The plan of the entire building came to be represented by a grid of axes instead of by the actual thickness of the walls and piers. The stonework could be said to be clothing a Divine concept, and became something divine in the process. Thus the building was the substance, and the axis its essence and its immanental form.

The spirituality of the building

The process is the same as God's in creating the universe. First He had an idea – the Word, or Essence, from which He extrapolated the substance. Similarly the building was designed out of the Essence, which lay in the primal act of setting out its axes, and represents the way in which cosmic space was originally derived from the Cosmic Centre. Therefore it could rightly become the Spirit's building on consecration. The Heavenly City could exist in it because, in a sense, the master had approached the design with the correct rituals. As Dionysius the Areopagite said, 'the mason looks at the archetypes, grasps the divine model, and makes an impression of it in real material.'[31]

But structurally the consequence was momentous. The loads of the building, and the diagonal thrusts from the vaults and from wind loads, act on the building along these axes. To visualize one was to imply the other, clearly demonstrated in the intersecting flyers of Chartres. Since the axis was the Essence, the loads and dynamic axial thrusts came to be visualized as part of the spirituality of the building. In some cases the loads were conceived as

pure energy *rising* within the buttresses as well as descending to the ground. The thin shafts on the inside joining the piers to the vaults seem to hang suspended from them.

As the energy was thought to ascend and descend simultaneously, the masonry came to reflect this inner movement, as can be seen clearly in the bases of the columns. They are like miniature windows into the period, demonstrating the growth of this concept up to 1200, and thereafter its decline and final extinction.

Bases are usually made up of two projecting rings set around the bottom of the shaft, called tori, and an indent between them called a scotia, which was carved to the same depth as the column, no deeper (Fig. 14). The Romanesque torus, to the left of the drawing, looked like two ropes tightened around the column, as if they were holding a piece of wood from splitting.

Starting in the 1130s in the Chartres western doors, the scotia was bent downwards, and twisted a little so that it would hold water if it rained. A few decades later the lower torus also began to move to bulge up and out so that it was no longer a half-round, but elliptical. By the 1180s the upper torus mold began to change too, but rather than turning, it buckled in the middle. The sequence can be followed in the drawing from left to right.

The bases look as if they were being *squeezed* by the tremendous loads above, as if made of plasticine rather than stone. To have shown this gradual deformation under pressure, the masters must have perceived the energy within the stone, which must have come alive to express the forces within it, more like some organic material than rock.

The last stage is equally significant. The scotia kept on turning under 'pressure', and the opening into it continued to get smaller, as if one more excruciating weight was imposed upon the pier. Then, some time in the 1240s the scotia snapped shut, and disappeared. The recess between the tori had been squeezed out of existence, and the base was reduced to a simple cushion. The bases had returned to stone, and the inner energy had evaporated.

Through the use of the axis the masters' thought processes led them to conceive of omitting the wall and replacing it with glass. It was thus that they rotated the walls, replaced them with open arched flying buttresses, disguised the structure and in all ways replaced traditional architectural forms with an utterly new aesthetic. In this the masters of 1200 were the forbears of ourselves. At Chartres, the modern steel skeleton building with its glass infill panels and clear structural logic was exemplified in all its clarity, seven hundred years before it was reinvented in the modern skyscraper.

At the same time the windows were widened until all vestiges of the wall had been eliminated between the buttresses, probably first used in the Chartres choir aisles just after 1200, and then applied to the clerestory in Orbais about 1205. By stretching the window the full width between the buttresses, nothing of the wall was left. It was a momentous concept, inaugurating the dynasty of great glazed windows that stretched across three centuries from the great north rose to the end of the Middle Ages (Figs. 15 and 16).

A time of change

The concept developed out of the use of axes, for if the building could be conceived as a grid of abstract lines, it would in time be obvious that if all the loads descended where the line through the wall met another across the bay, then all that was needed was a pier-sized buttress at the intersection. The wall was no longer required. From inside, the stonework was reduced to the shafts themselves, and the material edifice dissolved into the glass. The walls had become truly diaphanous.

Similar changes were occurring above the main vaults. Chartres was initially designed to support nine towers with spires, the central one higher than any of the others, thrusting and sawing heavenwards to a size and scale never attempted before. The cathedral of Laon gives some idea how this may have looked, though only four were completed. Set around an enormous spire in the middle — which was also the *axis mundi* connecting earth with heaven — they would have electrified the silhouette like a ring of thrusting fingers. They suggest a stupendous effort was being made to reach into the sky, like a giant socket preparing to plug into the celestial current.

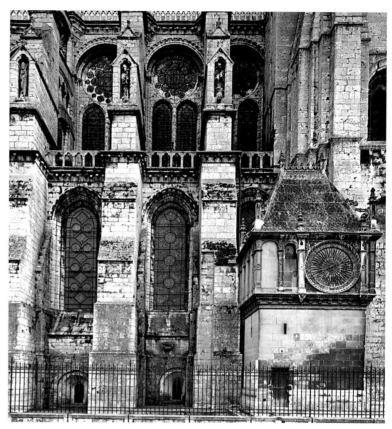

Fig. 15 Plain windows in the aisle of the nave.

Fig. 16 Double windows of great size in the choir.

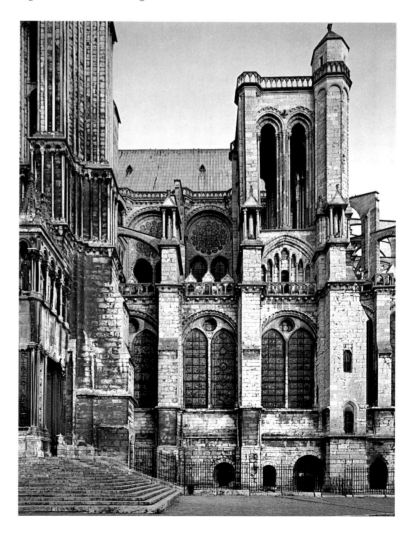

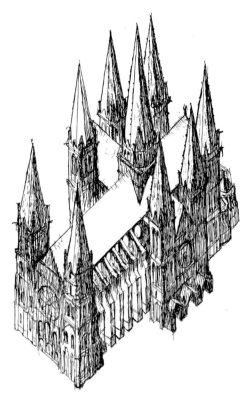

Fig. 17 Isometric drawing of Chartres with nine towers. (From *Richesses de France, Eure-et-Loir*, p. 37, éditions Delmas, 1973)

Fig. 18 The south-west tower that was never completed.

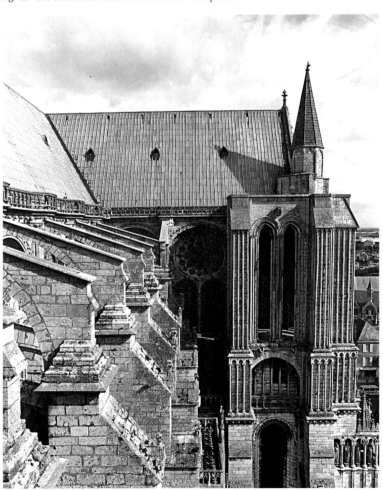

The 1220s saw the decision to scrap the towers and replace them with tall and simple roofs. Chartres and Rheims were both begun before then, and the latter was intended to have seven towers, while Chartres would have had nine (Fig. 17). When it was important to emphasize the verticality of the towers, the roof had been kept low, but it was with an almost audible sigh of relief that the pitch of the roof was increased when the lantern was eliminated (Fig. 18). At Chartres the clergy were even prepared to pay huge sums for additional flying buttresses to stabilize the new roof. A recent Church Council had insisted that the clergy should be less close to the people. Was this simplified roof and towerless silhouette part of a new detachment?

Times of change are by their nature transitional. Works will contain some elements which are old-fashioned, and others which are innovative. Not only that, some masters will hold tenaciously onto some ideas they were taught, while being tremendously inventive in others. As many masters worked on every building we should expect to find the old-fashioned adjoining the new. Thus round arches were used by Bronze over the clerestory roses and were also used by Scarlet in the adjacent flyers, while Ruby and Cobalt only a few years later were using pointed arches in the choir. One should not think from this that the nave was in its entirety more traditional than the choir, for in the ground floor the nave has pointed arches over the windows while the choir has round. This is why some scholars have misunderstood the cathedral's history. Believing that people's stylistic ideas followed a linear progression, they hoped that each work could be dated by placing it appropriately along this presumed evolutionary process.

Their method of analysis was based on the simple paradigm that style gradually evolved from the primitive and abstract to the more complex and realistic. On this basis the thick walls, small windows and round arches were naturally earlier than vast windows, skeletal frame and pointed arches. As a method for separating the work of one century from another it worked well, but when applied to the creations of one generation it produced such contradictions that this paradigm is now being abandoned, though slowly.

Difficulties in analysing the cathedral's history

There have been two main arguments about the constructional order that have occupied most research this century: which end was built first, the nave or the choir, and were the porches and even the transepts added after the rest had been completed.

On the first, expert opinion was neatly divided so that half of those who wrote on the subject claimed that the nave was built before the choir, while the other half put it the other way round.[32] In fact, the evidence in the stonework has shown that both were built together, but that the nave was at all times a meter or so in advance of the apse. The reason for this was that the foundation on which the cathedral sat was lower in the east than in the west, and as both ends of the cathedral were begun together, the deeper trenches and footings at one end always ensured that work in the choir would be somewhat lower than any contemporary work in the west.

The second great issue has been that of the north and south transept porches. It was argued at great length that they had been added, and even that some of the lateral doorways had been cut into the walls and their sculpture inserted after the central doors.[33] The style of the sculpture was the nub of the problem. From the paradigm of linear stylistic progression some of the sculpture should have been dated to the 1190s, and other to the 1250s or thereabouts. It was largely for this reason that it was assumed that the porches were added. I say assumed, because rarely was firm archaeological evidence provided to back up these assertions. When this evidence was provided it became clear that the porches were not added, but had been built with the walls of the transepts (Figs. 19, 20, 21).

The conclusion from this new evidence was twofold. Firstly, traditional sculpture could be carved at the same time as the most advanced and *à la mode* work, so that sculpture was in this no different from architecture at a time of rapid change. Secondly, that as the sculpture in the transepts is among the greatest in France, the Golden Age of French medieval carving had to be dated to the generation that worked around the year 1200, and to the reign of Philip Auguste rather than to Saint Louis. These thoughts may not seem momentous now, but at the time they were propounded in 1972 they drew considerable criticism that is only now beginning to die away.[34]

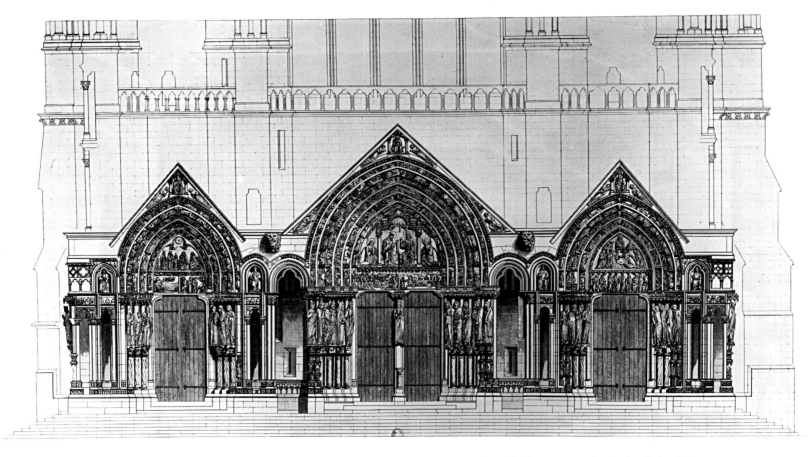

Fig. 20 Porch and south portal.

Fig. 19–21 North portal. *Above*: engraving by Gaucheval after Adams. (From *La Monographie de la cathédrale de Chartres*, by Lassus, Bibliothèque nationale, Paris). *Below*: view of the porch.

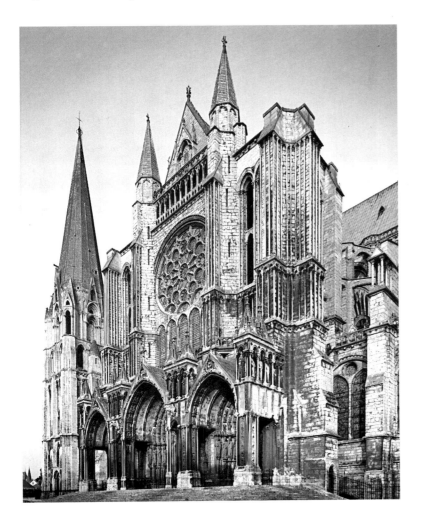

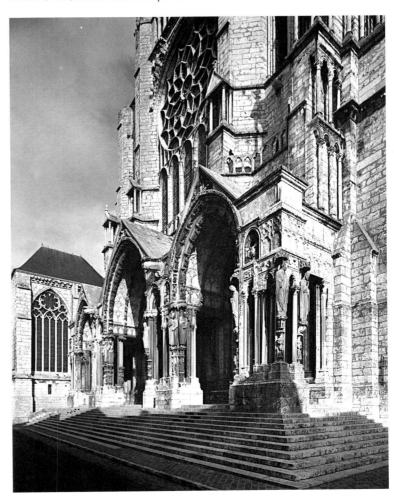

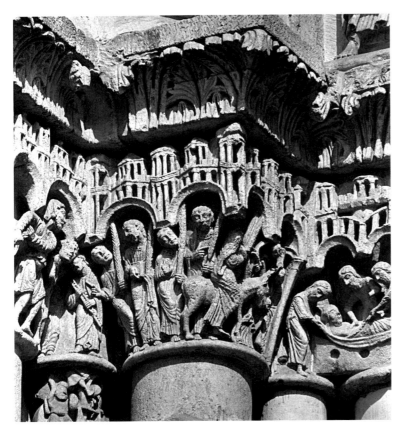

Fig. 22 Portal of the Incarnation of the Royal Portal, showing the repairs in the lintels, which leads to the idea that they were moved.

Fig. 23 Isometric drawing of a side aisle showing that the size (**W**) of the pillars is equal to the opening of the adjacent windows. The space between the pillars is in the relationship of 1.618 to 2 with the space measured between the pillar and the wall. Measuring the height of the pillar as 2, the Golden Mean proportion obtains in the aisle.

A similar situation existed with the building of the Royal Portal fifty years earlier. Excavations made before the First World War disclosed old foundations some meters to the east of the doors. As some of the sculpture had been remade before being assembled it was assumed that some of the sculpture had been carved for another place and moved into its present location at a later date (Fig. 22). The discovery of these footings seemed to provide that location.[35]

However, recent archaeological analysis has shown that some of these adjusted sculptures had been recut a number of times, and that some had not been carved until much of the portals had been already erected.[36] This showed that the design had been changed while the sculpture was being erected. Also, the stonework over the south door is tied into the walls of the adjacent tower, showing that portals and tower were being erected together.[37]

It has also been recently argued that not only were there a number of individuals at work on the sculpture, but that they were in different teams as well, from which we conclude that the Royal Portal and its flanking towers were built in the same way as the rest of the cathedral: by many teams of builders and/or sculptors, each working for short periods.[38] We can see that each team worked independently, and that the master in charge altered or modified the work of his predecessors, and that it was these alterations which made it necessary to recut the sculpture. The small discrepancies in the Portal were not therefore the outcome of having moved the doors from some other location, but were the result of medieval building methods.

Unity and the use of geometry

Yet, in spite of the way they worked, and the coming and going of the masters, there is an overall sense of oneness about Chartres. It seems, to our eyes, a unified work in spite of the discrepancies. The reason for this lies in their design methods.

The design of the elements, like the piers and windows, were all determined from the first parts laid out. The width of the window openings, which also determined the width of the column of light that floods into each bay of the aisles, was made the same as the thickness of the piers. It was as if the master measured the overall pier size, and used that to fix the glass width. The result was quite extraordinary: the solids which support the vaults alternate with the luminous openings, forming a contrapuntal harmony down the length of the nave. Mass and void have been placed in a sublime artistic balance (Fig. 23). The thickness of the pier from which the width of the windows was determined was itself evolved from the dimensions of the bay and span, so that the distances between the axes both down the aisle and across the space of the nave were used, albeit in a somewhat complex way, to create the pier placed on the intersection of these axes.[39]

In a similar way every element in the elevation was derived, or 'extracted' in medieval parlance, from the plan. The width of the windows was one felicitous example of this. Another is the spaces in the aisle, rather than in the masses. The voids of the aisle, measured between the piers on one side, and between pier and wall shafts on the other, relate in the proportion of the Golden Mean, that ancient ratio which is said to underlie the proportions of most growing things. If the openings into the nave measured the Golden Mean number 1.618, then the space of the aisle measured two.

Now, when the work had progressed to the height of the capitals, the master took a rod of wood and cut it so that it exactly fitted between the piers. It therefore represented the Golden Mean ratio itself. He then used two of these rods, placed end on end, to locate the tops of the capitals. Thus, automatically the Golden Mean proportion used in the plan came to be repeated in the elevation. Chartres is recognized as a beautiful building not only because this proportion occurs in the public spaces, but also because later masters continued to use dimensions found in the aisles at all levels of the building, including the overall height of the main vaults.

So today, when we walk down the aisles of the nave, we experience these perfect proportions. It may be bizarre, but the master who located the capitals need not have known that he was thereby producing this classic proportion. It is the beautiful consequence of this method that, by determining the parts of the elevation from lengths derived from elements in the plan, the proportions used in the plan will automatically occur in the

façade. No further calculation would be necessary, and though the masters did continue to calculate proportions for the vertical dimensions, there was no need for them to do so as long as they followed the method.

In nearly all these churches we need to use our imagination if we are to have much feeling for what they were like a thousand years ago. We see them bare, the plain stone walls and piers occasionally retaining a scrap of paintwork. In the north side of the choir at Chartres the altar of the Virgin may give some idea of what they were like. It is surrounded by candles, often hundreds of them, as every chapel and every altar would have been in the Middle Ages. The gold on the altars and precious stones mounted on the reliquaries shone with an eerie iridescence, the copper and bronze of the giant candelabras reflected the candles, and over all hung the lazy plumes of incense. The interiors were like jewels themselves, reflecting the words of Saint John that the Heavenly Jerusalem 'was of jasper: and the City was of pure gold, like unto clear glass. And the foundations were garnished with all manner of precious stones.'

The effect is peaceful and nurturing. We are at rest, without being immobilized or being driven dramatically into the air. We are left to wander or meditate in tranquility. These delicate structures exemplify the very essence of the period, mystic and immanental, secure in the knowledge that God is very near. The buildings levitate just a little so that for one short magical moment the tabernacle seems to occupy the entire material edifice. It is like a temple hanging within the walls of the fortress.

The walls were hung with tapestries, carpets and rushes covered the paving, and of course the disarming glow of the stained glass suffused everything. There was always music. Large choirs and musicians were constantly employed, not only for the masses themselves, but for processions to the relics. Important visitors would be heralded by fanfares, and shouts of welcome. The church was alive and the focus of all activity.

One feels so secure here that the verticality combines with the sense that this is Paradise itself to suggest that the barrier between us and it, between the human and the material, has disappeared. The impact of Chartres on people at the time was enormous. More than any other building, it represented an ideal. It reached the status of an icon. It partook of the divine.

FOOTNOTES

1. Identified in J. James, *Chartres, les constructeurs*, Chartres, iii vols. 1977–82: to be referred to hereafter as *Les constructeurs*. His other work at Longpont is identified in J. James, 'The canopy of paradise', *Studies in cistercian art and architecture*, lxix 1984, 115–129, and at Mantes-la-Jolie in J. James, *The pioneers of the Gothic Movement: interim report*, Wyong, 1980.
2. Discussed in J. James, *Chartres: the masons who built a legend*, London, 1982.
3. In *Les constructeurs* all the masters were colour-coded to give them some identity. An alpha-numeric notation for unnamed masters, such as 'Ml', has been suggested: J. James, 'The pioneers of the gothic movement', *Architectural history papers*, Adelaide, 1984, 24–44.
4. In 'The canopy' (as in note 1), 118–119, this date is postulated from the style of the capitals and details. See alternative dating in C. A. Bruzelius, 'Cistercian High Gothic', *Analecta Cisterciensia*, xxxvv 1979.
5. For a similar, if slightly later, Cistercian ambulatory see T. N. Kinder, *Architecture of the cistercian abbey of Pontigny, the twelfth century church*, Dissertation Indiana University, 1982.
6. Other recent studies of multiple campaigns of construction: C. E. Armi, *Masons and sculptors in Romanesque Burgundy*, Philadelphia, 1983; S. Gardner, 'Two campaigns in Suger's western block at St.-Denis', *The Art Bulletin*, lxvi 1984, 574–587; J. James, 'The rib vaults of Durham cathedral', *Gesta*, xxii/2 1984, 135–145; J.-P. Ravaux, 'Les campagnes de construction de la cathédrale de Reims au XIIIe siècle,' *Bulletin Monumental*, cxxxvii 1979, 7–66; S. Murray, 'Bluet and Anthoine Colas, master masons of Troyes cathedral. Artistic personality in Late Gothic design', *Journal of the Society of Architectural Historians*, xli 1982, 7–14, and 'Master Jehancon Garnache (1485–1505) and the construction of the high vaults and flying buttresses of the nave of Troyes cathedral,' *Gesta*, xix 1980, 37–50, and 'The completion of the nave of Troyes cathedral,' *Journal of the Society of Architectural Historians*, xxxiv 1975, 121–139; D. Vermand, *La cathédrale Notre-Dame de Senlis au XIe siècle: étude historique et monumentale*, Paris 1987. With these new approaches, we should consider the thesis in Belting H., *The end of the history of art?*, Chicago, 1987.
7. See recent work by H. Kraus, *Gold was the mortar*, London, 1979, and M. Snape, 'Documentary evidence for the building of Durham cathedral and its monastic buildings', *British Archeological Association*, 1980, 20–36; also R. A. Goldthwaite, *The building of Renaissance Florence*, Baltimore, 1980.
8. Team composition and working methods discussed in the Rennes Conference, 1983, and also: F. Bucher, *Architector. The lodge books and sketchbooks of medieval architects*, New York, 1979, and 'The Dresden sketch-book of vault projection', *Acts of the 22nd International Congress of Art History*, Budapest, 1972, 527–537, and with H. Koepf, *Die baumeisterfamilie Boblinger*, Esslinger, 1982; J. James, 'Gothic pinnacles', *The Architectural Association Quarterly*, xi 1979, 55–59; D. Kimpel, 'La sociogenèse de l'architecte moderne', *Artistes, Artisans et production artistique au moyen âge. Actes du colloque*, i, 1983, 135–149; Murray (as in note 6); Shelby L., 'Medieval Mason's Templets,' *Journal of the Society of Architectural Historians*, xxx 1971, 140–152, and 'Medieval masons' tools. II. compass and square', *Technology and Culture*, vi 1965, 236–248, and 'Monastic patrons and their architects: a case study of the contract for the monk's dormitory at Durham', *Gesta*, xv 1976, 91–96.
9. Evidence was presented by the author at the Medieval Conference, Canberra, in 1982 in a paper entitled 'Medieval mortar and the building campaigns of the Sainte-Chapelle'. It will be published shortly in *The stones will speak*, referred to hereafter as *The stones*. See recent research on lime mortars in J. Ashurst, *Mortar, plasters and renders in conservation*, London, 1983.
10. J. James, 'An investigation into the uneven distribution of churches in the Paris Basin, 1140–1240', *The Art Bulletin*, March 1984, 13–46.
11. The results of the survey, as in note 10, have been computerized, and some of the results will be published in *The stones*. The techniques were presented at the Kalamazoo Conference in 1986 entitled 'Computer programmes for the Gothic churches in the Paris Basin', and aspects were published in *The pioneers* (as in note 3).
12. The evidence will be published by the author and Professor Ane Prache, and was presented by him at the Medieval Academy Conference in Toronto in 1987 as 'The origin of the flying buttress in the 1160s'. See A. Prache, 'Les arc-boutants au douzime siècle', *Gesta*, xxv 1976, 31–42, and 'Les arc-boutants du chevet de Saint-Rémi de Reims', *Bulletin de la Société nationale des Antiquaires de France*, 1973, 41–3; and S. Gardner, 'The nave galleries of Durham cathedral', *The Art Bulletin*, lxiv 1982, 564–579. See differing views in W. W. Clark and R. Mark, 'First flying buttresses: a new reconstruction of the nave of Notre Dame de Paris', *Art Bulletin*, lxvi 1984. 47–64.
13. These are the sanctuary aisle windows designed by Bronze c. 1201; see *Les constructeurs*, 242–243.
14. Discussed in *The stones* and part of the paper presented at Kalamazoo in 1983 entitled 'Ml, and the invention of tracery'. Professor Carl Barnes, in a paper delivered at Kalamazoo in 1987, provided documentary evidence that suggested that the clerestory of Soissons cathedral may have been contemporary with Orbais, and certainly antedated Chartres. J. Ancien, *Contribution à l'étude archéologique: architecture de la cathédrale de Soissons*, Soissons, 1984.; C. Barnes Jr., *The architecture of Soissons cathedral: sources and influences in the twelfth and thirteenth centuries*, Dissertation Columbia University 1967, and 'The cathedral of Chartres and the Architect of Soissons', *Journal of the Society of Architectural Historians*, xxii 1963, 63–74.
15. In the paper presented at Kalamazoo in 1983 (as in previous note) it was suggested that the stages in the invention of tracery may be followed in the work of one master from the clerestory at Orbais, to the transept chapels at Essomes, and then to its final form in the aisle windows of Rheims cathedral. To be published in *The stones*. For bar tracery see R. Branner, 'Paris and the origins of Rayonnant gothic architecture down to 1240', *The Art Bulletin*, xliv 1962, 39–51.
16. Braine was dated after Chartres, but recent discoveries suggest a date a generation earlier. M. Caviness, 'St. Yved of Braine: primary sources for dating the gothic church', *Speculum*, xix 1984, 524–548, and 'The canopy' (as in note 1), 126 n.37.
17. The relationship between these buildings was discussed in my paper at Kalamazoo in 1987, 'The decision-making process at Soissons cathedrals', to be published in *The stones*.
18. For this date of Soissons, see Barnes's paper, as in note 14.
19. Discussed in J. James, *The traveller's key to the sacred architecture of medieval France*, New York, 1986, 116–118. For fresh appraisals of Gothic spatial intentions W. Clark, 'Cistercian influences on premonstatensian church planning: Saint-Martin at Laon', *Studies in cistercian art and architecture*, ii 1984, and 'Spatial innovations in the chevet of Saint-Germain-des-Prés', *Journal of the Society of Architectural Historians*, xxxviii 1979, 348–365.
20. See note 14 for these dates. Some scholars date these buildings later, on the questionable grounds that the innovations in their style must have derived from the larger cathedral workshops: see A Villes, 'L'ancienne abbatiale St-Pierre d'Orbais', *Congrès archéologique*, cxxxv 1980, 549–589 and P. Héliot', *Deux églises champinoises méconnues: les abbatiales d'Orbais et d'Essómes*, *Mémoires de la Société d'Agriculture, Commerce, Science et Arts du Département de la Marne*, lxxx 1965, 87–112.
21. Soissons about 1205, and Chartres in 1211 – Barnes as in note 14, and *Les constructeurs*, 464–465.
22. J. Bony, *French Gothic Architecture of the 12th and 13th centuries*, Berkeley, 1983. Evidence from the survey (as in note 10) shows that of 47 buildings begun in the Parisian area between 1200 and 1240, 68 percent are squat, often with circular oculi: compare this to only 7 percent such buildings in the Soissonais region.
23. Not as claimed in J. Bony, 'The resistance to Chartres in early thirteenth century architecture', *British archeological journal*, xx–xxi 1957–58, 35–52. Chartres is the form chosen by the northern builders; many of the other types mentioned were derived from other areas, particularly Paris. For his recent opinions, see J. Bony, 'The genesis of gothic: accident or necessity?', *Australian journal of art*, ii 1980, 17–31. For actual function of these vaults: K. D. Alexander, R. Mark and J. F. Abel, 'The structural behaviour of medieval ribbed vaulting', *Journal of the Society of Architectural Historians*, xxxvl 1977, 241–251.
24. See *The key* (as in note 19), 78–80, 87–89 and 108–110. For comparison with symbolism of domes, see E. Smith, *The dome*, Princeton, 1978.
25. The survey (as in note 10) shows that drum piers remained the most popular Ile-de-France form through to the 1230s, despite Branner's argument (as in note 15).
26. R. Mark, 'The structural analysis of Gothic cathedrals, a comparison of Chartres and Bourges', *Scientific American*, 1972, 90–99.
27. See *The key* (as in note 19), 112–114.
28. Identifications made during the survey: see *Interim report* (as in note 1), 9.
29. Discussed in *Les constructeurs*, 504–505.
30. See *Chartres* (as in note 2), 175–176.
31. *De Ecclesiastica* IV.3
32. Listed in *Les constructeurs*, 27 n.14.
33. L. Grodecki, 'The transept portals of Chartres cathedral', *The Art Bulletin*, 1951, 156–164; and 'Chronologie de la cathédrale de Chartres', *Bulletin Monumental*, 1958, 91–119. See evidence in *Les constructeurs*, 41–56.
34. J. James, 'The Contractors of Chartres', *The Architectural Association Quarterly*, iv 1972, 42–53.
35. E. Fels, 'Die Grabung an der Fassade der Kathedral von Chartres', *Kunst Chronik*, 1955; E. Lefèvre-Pontalis, 'Les façades successives de la cathédrale de Chartres au XIe et XIIe siècles', *Congrès Archéologique*, 1900, 256–303.
36. J. James, 'An examination of some anomalies in the ascension and incarnation portals of Chartres Cathedral', *Gesta*, xxv 1986, 101–108.
37. *Les constructeurs*, 261 n.2. See a similar story in the western porch of Senlis: J. James, 'La construction de la façade occidentale de la cathédrale de Senlis', *La Cathédrale Notre-Dame de Senlis au XIIe Siècle*, Paris 1987, 109–118.
38. C. Watson, *The structural principles of the Head Master of Chartres Cathedral*, dissertation University of North Carolina, Chapel Hill, 1986; W. S. Stoddard, *Sculptors of the west portals of Chartres cathedral: their origins in Romanesque and their role in Chartrain sculpture*, New York, 1987. Similar concepts elsewhere are discussed in Armi (as in note 6); A. C. Doherty, *Burgundian sculpture in the middle of the twelfth century: its relationship to sculpture in the Ile-de-France and neighbouring provinces*, dissertation University of Wisconsin, Madison, 1980; W. W. Clark and Ludden M. F., 'Notes on the archivolts of the Saint-Anne portal of Notre-Dame de Paris', *Gesta*, xxv 1986, 109–118. M. Schmitt, 'Travelling carvers in the romanesque: the case history of Saint-Benôit-sur-Loire, Selles-sur-Cher, Meobecq', *The Art Bulletin*, cxiii 1981, 6–31.
39. This is explained in detail in *Les constructeurs*, 94–95.

Archaeological research and conservation work

The accidental fire in 1836 was regarded as a real disaster at the time. It totally destroyed the roof timbers and leads of the upper church; all the bells and their belfries perished except for the 'fixed bell' on the upper level of Jean de Beauce's belltower. The vaults resisted the fire, although the upper area had to be reinforced by a cope of limestone masonry. It was decided to construct a metal roof, and a competition was held for the project. The winning solution chosen among the four that were presented was constructed between 1838 and 1840. What the tourists disappointed at the sight of scaffolding do not always understand is that France's great monuments have only survived thanks to successive restoration campaigns to repair the destruction caused by wars, accidents of various kinds or simply the wear and tear of the materials; erosion of the stone, leaks from snow or heavy rain and many other circumstances eventually cause deterioration. So restoration work has to be carried out periodically. In addition to these major reasons for intervention, excavations and diggings may be carried out for the purposes of archaeological research side by side with other, necessary work; or the building may need to be converted because of liturgical changes or technical advances in heating or lighting systems. Like most of the cathedrals of France since the suppression of the concordat system and the law of separation of 1905, Chartres has become State property and is designated as a place of Catholic worship. Since that time, any necessary work has been entrusted to architects from the Historical Monuments department instead of to diocesan architects.

Archaeological excavations

Search for the Saints-Forts well in the crypt. Several digs were undertaken by Lassus and Durand in 1843, again in 1849 and then from 1855 to 1860, on the basis of the erroneous plan of Félibien, to find the well which the canons of the 17th century had deliberately concealed. It was not until 1901 that the archaeologist René Merlet discovered it, together with vestiges of earlier buildings.

Excavations in the centre of the labyrinth. During a dig in the centre of the labyrinth in 1849 Lassus discovered a small-bonded wall with string courses of bricks, the steps of a small stairway, Campan marble plaques, flanged tiles and flagstones measuring 0.50cm a side. In his view, this suggested that the 11th-century façade was tangential to the labyrinth.

Borings prior to installing a heating system. The site chosen was the north transept. When the flagstones were raised, this uncovered the north façade of Fulbert's crypt, with its windows in their original state, together with even older walls.

Digs to find the foundations and discover the earlier state of the west façade. Publications by various learned societies in the first decade of the 20th century highlight the different ways archaeologists and art historians (Mayeux and Lefèbvre-Pontalis) have interpreted the façades and porches that were planned, begun or completed on the existing foundations, set back from the present façade and on several other sites — such as behind and between the towers — and uncovered by digs. These theories are also based on the profile of the cornices of the towers and the presence of bays which are now hidden. The sides of the two towers facing the interior of the nave also show traces of an earlier porch and signs of changes made in preparation for the construction of a Renaissance tribune that was never built. In 1938 Etienne Fels excavated to the right of the former narthex.

Restoration work

The south porch. Restoration work was carried out on the south porch at the end of the last century after structural weaknesses were found to the right of the heavily loaded lintels.

The spire of the old tower. The old tower had already been restored once in the 14th century. Further work was carried out in 1680 and again in 1753–54. In 1903–04 the top of the spire was restored in Saint-Maximin stone, which is very similar to the original material used. The ground plan drawn up in the course of the work shows that the octagon of the pyramid is not entirely regular.

Protective measures during the two world wars. During each of the wars the stained glass was taken down, crated and transported to a secure place. The statues on the portals were protected by sandbags. The cathedral survived the two wars virtually intact. In 1944 a shell damaged a statue of an Apostle on the new tower, and all the towers, suspected of harbouring lookouts, narrowly missed being hit by artillery fire.

Recent work

Cleaning the nave and transept crossing vaults. The replastering of the surfaces of the nave and transept crossing vaults to a height of about 36 meters was completed in 1970–71.

Checking the condition of the stained glass. When it was found that the glass was becoming increasingly opaque and slowly deteriorating, it was decided to examine it carefully, using the most up-to-date techniques of laboratory analysis. In 1972 a 12th-century panel from the Tree of Jesse window on the western façade, the most exposed one, was chosen as a test piece.

Repairs to the organ. The great organ, still with a good tone but becoming very worn, needed repairing. Under an ambitious programme the stops were modernized and their number increased by means of a low-voltage electric transmission. The number of stops was increased from 39 to 67 on four keyboards and one pedal-board, the latter equipped with a 32-foot principal situated in the side turrets. It was inaugurated in 1971 in the presence of the President of the Republic.

Statue-columns of the Royal Portal. Since the stone of several of the Royal Portal statues was seriously deteriorating, four statues had to be taken down, and then another two, including the Angel with the Dial, all by the same hand. As in the case of *La Danse* by Carpeaux in the Paris Opéra, it was decided to replace them not by casts but by new statues made of a stone as similar as possible to the original. Stone from Ténac in the Dordogne was used and the work was entrusted to two sculptors, who finished the new statues with several coats of patina to ensure that they did not stand out among the old ones. The work was completed in 1977.

Protection against fire. The fire extinguishers installed at several points were the first protective measure. After a fire nearly broke out on a large piece of timber in the belfry of the new tower during the dry hot summer of 1976, it was decided to equip the building with dry risers because fire extinguishers were not effective for long enough. These risers, made of copper for reasons of appearance and because of its resistance to corrosion, were fitted at three points so that rapid and effective action could be taken throughout the building.

Restoration of the new tower (1978–84). In 1977, after the spectacular break-off of one of the main gargoyles of the new tower, at a point inaccessible without scaffolding, it was decided to embark on a campaign to restore this tower. The very heavy stone had first struck the balustrade of the balcony, damaging it in its fall but luckily itself breaking up into three pieces which then pierced the copper roofing and finally came to rest on top of the vaults. The repair work took seven years. Not only was the gargoyle replaced by an entirely newly sculpted one, but apart from the spire itself, which was in good repair, the entire upper part of Jean de Beauce's tower was examined and checked; stone damaged by erosion and frost and by the long-term effects of the fire in 1836 was replaced, including some important sculpted stonework. The Apostle St Andrew, who had unfortunately been hit by a shell in 1944, was restored to his place, and the angel supported by the little cupola at the top of the stairway was replaced and its base made squatter. All the bells were tested by ringing a full peal, and the condition of the various belfries and frameworks on which the bells were suspended was also checked *in situ*, for any movement transmitted to the masonry by the movement of the bells would act like a battering ram and could cause damage. No defects were found.

Restoration of the upper balustrades. For many years now the public has had access to the cathedral towers; ascending by a stairway in the north transept, the visitor then follows the gallery along the roof to the new tower which he can ascend as far as the balcony. The balustrade, restored in soft stone after the fire, had not withstood the rigours of time well and was restored again in 1976–77, this time in Berchères stone, which could be used because of the simple design of the balustrade. The arcature spaces were closed in by copper grating, invisible from the ground, for the safety of children.

Lead roofing (1975–78). The worn condition of the roofing of the stairway of the Saint-Piat chapel and several apse chapels called for total restoration. It was decided to follow tradition and re-roof these areas in lead. Although difficult, this option was chosen for reasons of quality and durability. Instead of laminated lead, lead cast on sand was used; this produces thicker plates and soon acquires a wonderful patina, in spite of the difficulties of manufacture. This procedure of casting on sand needs a special knack and the right climatic conditions; the operation would not work on a foggy day, for instance. The roofing of other chapels is still pending.

Restoration of the sanctuary of Notre-Dame-sous-terre. Looking ahead to 1976, the date of the eleventh centenary of the return of the Veil of the Virgin to Chartres by Charles the Bald, the clergy decided to rejuvenate the appearance of the sanctuary of the crypt. The altar against the wall and its altarpiece, dating from the 19th century, were replaced by a massive central altar in Berchères stone, soberly proportioned. The groined vault and its springings, which had been transformed into a simple barrel vault in this bay, were restored. The restoration of the paved floor was accompanied by several surveys which confirmed the continuity of the architectural elements discovered early this century. A wooden screen, with glass panes and areas that could be opened to allow for processions, was positioned behind the altar; in front of the fixed central part, against the background of a Gobelin tapestry predominantly in blue, a new statue of the Virgin in Majesty was set up, carved in pearwood on the model of

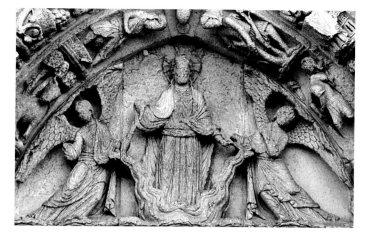

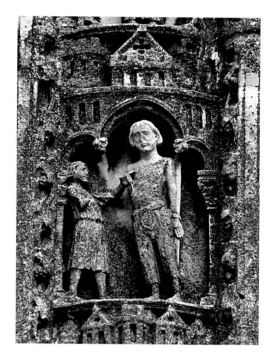

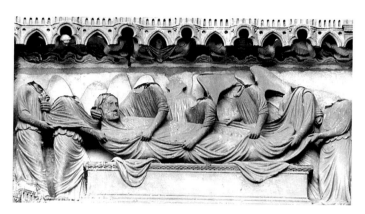

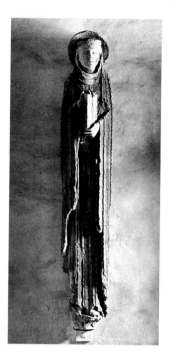

the original statue preserved by the Carmelites, although on a slighty smaller scale. When the plaster which had been darkened by the smoke of an accumulation of candles over many years was cleaned, the 17th-century panel paintings reappeared. The cleaning also led to the happy discovery, in the forward bay of the right aisle, of a wall painting probably dating from the early 13th if not late 12th century. It represents a Virgin in Majesty, a theme found again and again in the cathedral sculptures and stained glass.

The windows. Following tests carried out in 1972 on a panel taken from the Tree of Jesse window dating from the 12th century, it was decided that it was vital to carry out rapid restoration work on the glass of the three western windows above the Royal Portal, if they were not to be lost. A combination of physical, chemical and biological factors had damaged the glass, which had become more opaque and eroded in many places, producing little craters. This magnificent stained glass was cleaned, treated and protected according to the instructions given by the research laboratory of the Historical Monuments department under the supervision of the Corpus Vitrearum Medii Aevi, an international organization of highly skilled specialists. Without disputing the aesthetically attractive effect of the more or less opaque areas of glass, the blue being spared, however, this restoration work, which had to be carried out to save the glass, had the advantage of achieving just what the medieval clergy and builders had wanted: to let in the light, to create a balance of colour, to make legible the scenes they depicted. A long programme of treatment of the 13th-century windows is now under way.

The Royal Portal statues. Replacing the most exposed statue-columns with copies was the most urgent task, but at the same time research was undertaken to try to avoid this solution for the other, less damaged Royal Portal statues. A process developed by the Italian Nonfarmale was tested on small, west-facing bas-reliefs of the south porch. This process involved cleaning the stone and strengthening it by a very painstaking method which produces results re-

garded as quite effective. After local tests proved satisfactory, it was decided to treat the three bays of the Royal Portal, and from 1981 to 1983 all the statues there were treated every year, at the most appropriate season.

Other work. Although several methods were tested, no satisfactory or safe way was found to rid the building of pigeons, whose droppings are unaesthetic and damage the stone. Two maintenance campaigns are undertaken every year, in spring and autumn; but the moment of greatest danger is when the snow falls and care must be taken to ensure that no powdery snow enters or accumulates in places where it could cause serious damage if it melted and penetrated the stonework.

Future work. Once all the locks have been changed according to a schedule which divides the building up into sectors depending on use, further work is envisaged or planned, including, but not in chronological order, the following: restoring the masonry of the old tower; restoring the balustrades running from the sector accessible to visitors; restoring the lead roofing of several apse chapels, a gutter-tile of the north transept and a number of gutter and roof areas; completely rewiring the old electrical system; restoring all the stained glass, cleaning the north and south porches and treating their statues; further restoration of the crypt; improving the design of the main site of worship at the transept crossing; installing a more economical heating system, etc.

This brief and incomplete overview of the life of Chartres cathedral is evidence, if any were needed, of the variety and continuity of the work that has to be done on the basis of the large number of reports drawn up by authors who go all the way back to the medieval builders. Everyone feels a legitimate sense of pride, and of great humility too, the more he learns about the work of the architects and builders of the time of the great cathedrals, among which Chartres occupies a prime place.

Yves Flamand

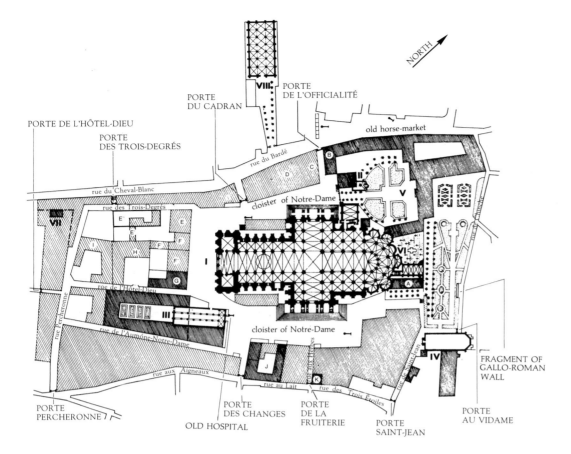

PORTE DE L'HÔTEL-DIEU

PORTE
DES TROIS-DEGRÉS

PORTE
DU CADRAN

PORTE
DE L'OFFICIALITÉ

NORTH

old horse-market

rue du Bardé

rue du Cheval-Blanc

rue des Trois-Degrés

cloister of Notre-Dame

rue de l'Hôtel-Dieu

rue de l'Aumône-Notre-Dame

cloister of Notre-Dame

rue de la Percheronne

rue aux Aigneaux

rue au Lait

rue des Trois Étoiles

FRAGMENT OF
GALLO-ROMAN
WALL

PORTE
PERCHERONNE

OLD HOSPITAL

PORTE
DES CHANGES

PORTE
DE LA
FRUITERIE

PORTE
SAINT-JEAN

PORTE
AU VIDAME

SITE PLAN
I Church of Notre-Dame of Chartres
II Church of Saint-Nicolas-du-Cloître, formerly SS. Sergius
 and Bacchus
III Former hospital of Notre-Dame
IV Chapel of Saint-Etienne-du-Cloître
V Bishop's Palace
VI Cemetery and Chapel of Saint-Jerôme
VII Former Chapel of Saint-Même
VIII Wall of Loëns

A Chapter library
B Bishop's offices (now a house)
C Notary secretaries of the chapter (Aulbe children's
 home)
D Haberdashers' Hall
E House dating from 1600 (now Chamber of Commerce)
E' House dating from 1626, now demolished
E'' Building constructed in 1954
F 1286, canons' house (now Tourist Office)
G 1374, house demolished in 1868–69
H 1484, house, now demolished
I 14th century, house of Canon Pierre Plumé (demolished
 in 1905)
J 14th century, house of Erard de Diey
K 13th-century house
 (The first date quoted is the earliest recorded one.)

SITE PLAN
(Extract from the 1730 plan)

Several different factors show that the site of the present cathedral was occupied from antiquity by a succession of buildings, probably of a religious nature, which certainly played their part in the defence of the town: the topography of this elevated site, the information, imperfect as it still is, provided by examination of the subsoil, the documents, history and tradition, the latter often embellished by legend. The temples of antiquity were traditionally sited in well-defined positions, generally facing the point on the horizon where the sun rose at a precise date of the year, whose significance bore some relation to that of the building. The term 'orientation', which refers to the eastward direction, is still with us. In the Christian churches of the West, the chevet generally faced east. However, the orientation also depended on the site itself, especially if it sloped, and on the road network which was generally based, since the Roman conquest, on the two orthogonal directions of the *cardo* and the *decumanus*. The orientation of the old walls rediscovered in the course of various projects is consistent with that of the present cathedral walls, which suggests that the early building followed the same layout and its orientation was perpetuated.

We know that in the early centuries of Christianization, the bishop's see was not a great cathedral but a 'cathedral complex', generally made up of two churches fairly close to one another, one dedicated to the Virgin, and a baptistery. Near the Carolingian building at Chartres there existed another church, now disappeared, dedicated to SS Sergius and Bacchus, before becoming Saint-Nicolas-du-Cloître, north of the sacristy and right of the entrance to the present museum; the site of the baptistery at that time, sometimes identified as an ancient glacier, could be east of the sacristy, at the edge of the present lawn which marks the old cemetery of Saint-Jerome north of the chapel of Saint-Piat. We must also remember the major reforms carried out at the end of the 8th century by Chrodegang, Bishop of Metz, who required the clergy of his cathedral to live and pray communally, which is somewhat reminiscent of the monastic rule, in a slightly less severe form, and marks the beginnings of the organization of chapters of canons. This reform spread in the next century, leading to the construction of the buildings needed for communal life: the oratory, the chapters' room, the cellar, the dormitory and other dwellings, all enclosed by a wall. The cloister of Notre-Dame still shows traces of this very ancient organization, first in its name, which it has retained, then in the vestiges of its gates, on rue Saint-Yves, rue de l'Horloge and rue Fulbert, among the dozen or so roads that controlled all access to the area under the jurisdiction of the cathedral chapter.

North of the cloister we still see the enclosing wall of Loëns, which comprises a large granary with three timbered aisles above a magnificent vaulted room with three bays on intermediary columns used as a cellar. This structure, which can be dated to the early 13th century, would be contemporary with the large Gothic cathedral. The fact that the clergy controlled the land within the perimeter of the cloister from the late Middle Ages on was probably one of the chief factors leading to the enlargement of the subsequent buildings, until we get to the large Gothic cathedrals erected in towns enclosed within their ramparts and fortifications and therefore with little free land. That was also the reason why shops and houses adjoined the cathedral on each side. Within the cloister, to the south-east of the cathedral, was the hospital with the well-proportioned Saint-Côme room dating from the 11th century and demolished at the end of the last century. At the southern extremity of the terraces of the bishop's palace, the remains of the former chapel of Saint-Stephen, destroyed in 1568 during the wars of religion, are still preserved. The chapter library was housed in a building parallel to the south side of the chapel of Saint-Piat. On the north side, after the cemetery of Saint-Jerome, a reversed wing of the bishop's palace connected the palace with the cathedral. An isolated row of arcades shows the site in the museum gardens.

Careful examination of the architecture of the former bishop's palace shows the various transformations that occurred in the course of the centuries. The most important ones include the Italian room and the alterations to the chapel at the end of the 18th century. Under the embankments of the terraced gardens it is still possible to find ancient drains and underground systems which may have been overground at the time and accessible from the museum cellar. Several cloister houses can still be distinguished today by features which recall their past use, for instance as an ecclesiastical court, to accommodate the chapter notaries or to receive dignitaries of the church. The opening up of the cathedral square, carried out mainly at the end of the last century, which allows most of the building to be seen from the west façade, distorts the scale and separates the cathedral too much from its traditional urban environment.

Yves Flamand

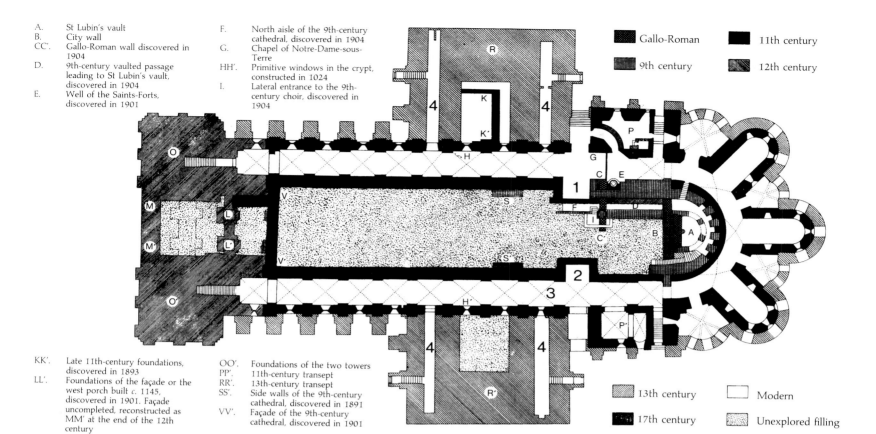

A. St Lubin's vault
B. City wall
CC'. Gallo-Roman wall discovered in 1904
D. 9th-century vaulted passage leading to St Lubin's vault, discovered in 1904
E. Well of the Saints-Forts, discovered in 1901
F. North aisle of the 9th-century cathedral, discovered in 1904
G. Chapel of Notre-Dame-sous-Terre
HH'. Primitive windows in the crypt, constructed in 1024
I. Lateral entrance to the 9th-century choir, discovered in 1904

Gallo-Roman
9th century
11th century
12th century

KK'. Late 11th-century foundations, discovered in 1893
LL'. Foundations of the façade or the west porch built c. 1145, discovered in 1901. Façade uncompleted, reconstructed as MM' at the end of the 12th century
OO'. Foundations of the two towers
PP'. 11th-century transept
RR'. 13th-century transept
SS'. Side walls of the 9th-century cathedral, discovered in 1891
VV'. Façade of the 9th-century cathedral, discovered in 1901

13th century
17th century
Modern
Unexplored filling

PLAN OF THE CRYPT

This plan shows the known changes over the centuries. The subsoil underneath the nave, most of the transepts and the choir has not yet been explored. It is likely, on the basis of information obtained from other buildings of the same period and from research carried out on the cathedral, that vestiges remain of several earlier structures on this site, including from the Gallo-Roman period, and probably even earlier.

Before the year 1000. A Gallo-Roman wall (B) with courses of brick alternating with stone, visible in the crypt of Saint-Lubin (A), must certainly form part of an old rampart or public structure of that period, judging by its thickness. Digs directed by the archaeologist Merlet in around 1900 brought to light a wall of the same structure (C) parallel to B. A well (E), square in section for part of its height starting from the base, descends some 30 meters to the groundwater, at the level of the river Eure. Presumably it was used to supply water to those using the antique building, whose public function at the time was as much military and civilian as religious, the two being indissociable. This well, rich in history and legend, is called the well of the Saints-Forts. Ceremonies regarded as pagan still took place there in the 17th century, which led the canons to conceal the top of the well in the masonry of the north aisle of the crypt. The well was rediscovered only at the beginning of the 20th century. It looks as though the desire to wipe out anything relating to this object of pagan devotion led the clergy of the 17th century to remain vague in their descriptions of the well. At the beginning of the 20th century, the search for the well was one of the arguments used to justify the excavations in the floor of the choir when the small organ was installed. This led to the discovery, through the passage (D and F), of a door and its doorstep near the base of a cruciform pillar forming part of an earlier church. The semicircular area situated below the choir, called the vault or crypt of Saint-Lubin (A), was originally accessible only from a stairway descending from the choir by a trapdoor. It was used on several occasions to hide precious cult objects in times of unrest, and especially during the fire of 1194 to save the very prestigious relic of the Veil of the Virgin which Charles the Bald donated to Chartres in 876. The original level of the crypt corresponds to that of the rectangular excavation carried out round the central engaged column and which shows its base. The vaults of this crypt were reinforced in the 18th century because of the great extra load resulting from the alterations to the choir at that period and due mainly to the very heavy group of the *Assumption* by Bridan. The five niches of the curving wall are in fact the windows of the 9th-century cathedral which only look low because the floor has been raised. The existing access stairway to this vault, north of the ambulatory of the crypt, was opened at a later date and its masonry-work is recent. Excavations carried out at various points (S,S') in the transept, when the paving was renewed, uncovered the longitudinal extensions of that same building.

Bishop Fulbert's crypt, begun in 1020, corresponds to the substructures of the great Romanesque cathedral Bishop Fulbert decided to erect, on a wider and longer scale than the earlier churches, the vestiges of which it encompassed. The plan clearly shows the three radiating apse chapels and the transepts, which echo the transepts of the upper church of that period. The straight stairways on the southern side of these transepts still survive, leading outside, as do those of the northern side which lead to the sacristy of the present cathedral. On the west side, traces remain of alterations made to the last bays, probably when the towers were built and again later when the stairs leading to the lower tower rooms were constructed. This crypt, surmounted by groined vaults, had windows that opened, as attested by the rear voussoir which leaves the upper right side of each window free.

The foundations of the towers and the west façade. Construction of the west towers began before the middle of the 12th century, starting with the one on the north side (O and O'). Between them, foundations have been discovered of various structures that existed earlier or were perhaps planned and begun, only to be altered subsequently: porches, a narthex which preceded the actual façade aligned with the western exterior face of the towers. The exact details and chronology of these structural elements are not yet known.

The infrastructures of the Gothic cathedral, begun in 1194. The new architectural concept of a large and high cathedral with its entire main body vaulted in stone – formerly it was covered only in timber – meant that the lower church had to be greatly reinforced. New masonry-work now enveloped Fulbert's crypt: the buttresses and foundations of the new transepts, together with reinforcement work and the construction of new chapels, making seven in all. It is worth noting that the foundations of the earlier transepts were used to support the towers which take the thrust of the choir vaults.

Later uses and changes of use. The south crypt (H) contains the baptismal fonts, which are situated in the third bay from the west. The north crypt has been used as a sanctuary dedicated to Notre-Dame-sous-terre (G) for several centuries. Although the positioning of the altar and its altarpiece closed off the sanctuary area, the procession of pilgrims could continue uninterrupted thanks to the creation of a circular passage within the confines of the old transept (P). The area of the chapel of Saint-Savinien and Saint-Potentien (1), near the altar on the north side, is echoed on the south side by the chapel of Saint-Clement (2), decorated with a Romanesque wall painting. A lovely 17th-century wooden gate (3) closes the passage of the south crypt. Below the new transepts and their steps are vaulted passages (4), running north-south and accessible from outside by stairs in the base of the buttresses. Two of these passages connect with the crypt, the other two stop to the right of the old windows. A boiler room, first planned under the south transept, has now been installed under the north transept (K, K').

Y.F.

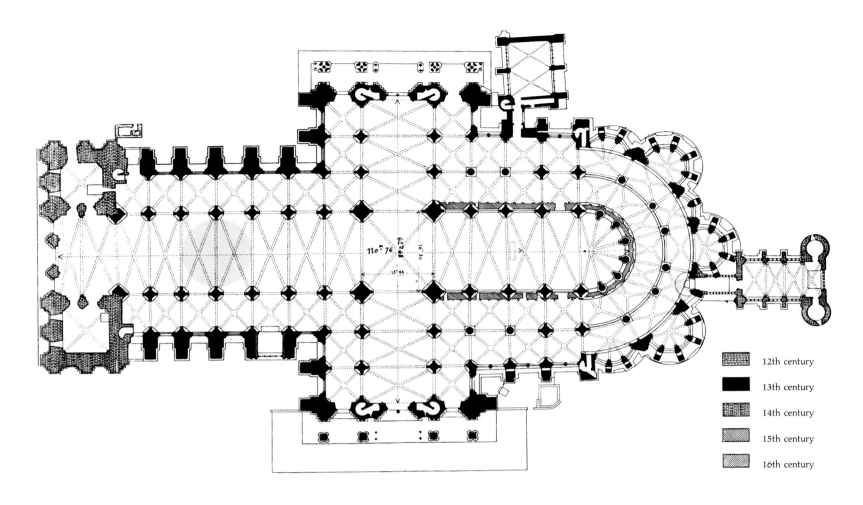

GENERAL FLOOR PLAN

Even at first glance, the plan shows the unity and harmony of this magnificent structure, whose brilliant architect managed to create a synthesis on the basis of a geometric scheme which had to take account of the constraints of the pre-existing infrastructures. For instance, he had to build on Fulbert's crypt, retain the very wide nave but vault it in stone instead of the earlier timber roof, and integrate the existing west towers.

The nave has nine bays, two of them between the towers; the three portals open into the nave. The choir has four bays preceding the apse with its seven radiating bays. The transept, slightly narrower than the nave, has three bays on each arm. The nave and the two arms of the transept are framed by a single aisle, while there are two aisles round the choir, including the curved part of the ambulatory, onto which open the chapels of varying depths. Originally there were seven chapels, but one of them was altered during the construction of the Saint-Piat chapel stairs. The aisles are rib-vaulted, on an almost square plan except in the curved parts of the ambulatory and the chapels, where several different systems were adopted: not only are the rib-vaults adapted to the irregular quadrilaterals defined by the points of support, they also integrate the vaulting of the four least projecting chapels by the use of five-ribbed vaults, whereas the three larger, more projecting chapels each has its own vault. In the main body of the cathedral, the transept crossing is supported and defined by four imposing pillars, while the four arms of the cross are covered by quadripartite ribbed vaults, except for the semicircular apse whose judiciously positioned keystone made it possible to balance the thrust of the vaults on their radiating ribs.

In quadripartite vaults, unlike the sexpartite ones whose points of support are alternately more or less heavily loaded, each support receives the same vertical load in a standard bay. However, Chartres returned to the idea of alternating stronger and weaker supports, carrying a greater or lesser load, in the profile of the

mouldings of the pillars, by alternating cylindrical shafts with four prismatic colonettes attached, with prismatic shafts with cylindrical colonettes. This principle is echoed in the intermediate supports of the double aisle of the choir which has to bear the load of the towers, while the other pillars take the form of simple cylindrical columns. The eight stairways leading to the upper church each rise from a corner of the towers framing each of the arms of the cross.

The thickness of the masonry shows how robust this building is: we need only look at the thickness of the walls and buttresses of the west towers, vaulted on the ground floor, of the standard-size buttresses, and of the crossing pillars. The north and south portals, whose doorways each open on to a transept bay, are preceded by a porch richly decorated with statuary. By the north transept, the sacristy is linked to the cathedral by a passage barrel-vaulted in wood panelling. The sacristy itself, built at the end of the 13th century, consisting of two bays covered by rib-vaults and lit by high grisaille windows, contains splendid wooden furniture, including a magnificent cope chest with revolving drawers supported by a moveable stand when they are pulled out. A little to the south of the axis, near the chevet, the chapel of Saint-Piat, accessible from the cathedral by a stairway, now houses the cathedral treasury. The Vendôme chapel, alongside the south aisle, was inserted between two buttresses in the 15th century. North of the nave, near the new tower, a small rectangular tent-roofed structure contains a clock whose outer face is divided into twenty-four rather than twelve hours. Although it dates from the time of Jean de Beauce, i.e. from the 16th century, its lower part looks earlier. It still contains vestiges of an old mechanism and the deep well into which the clock's weights descended is still there. The very beautiful rood-screen in sculpted stone, with small arcatures, originally placed before the transept pillars in front of the choir, was destroyed in the 18th century because it was in danger of falling apart. Some vestiges were given to the Treasury.

The cathedral has retained its authentic, circular labyrinth halfway down the nave; its diameter extends

almost across the entire width of the nave. Made up of 365 white stones alternating with black stones, it symbolizes man's journey towards the celestial Jerusalem. Centred on the transverse axis of the pillars, its distance from the Royal Portal is calculated in proportion to the height of the centre of the rose in relation to the floor. This detail would suffice to prove, if proof were necessary, that the masters of the period drew diagrams, applied the mathematical laws of ratios and proportions, and referred to models or to the basic site in order to define the sections and elevations or draw up the ground plan. A few figures will give an idea of the main dimensions of the cathedral. Total length of the building, without Saint-Piat's chapel, 130m; length of north-south transept, without porches, 64m; width of transept, without aisles, 13.50m (from axis to axis); width of nave, without aisles, 16.50m (axis to axis); length of nave 59m; of choir, 37m; total width of nave, 33m; of transept, 28m; of choir, 46m; height of internal vaults, from 35m to 36m (variable); total height of old tower, 104m; of new tower, 115m; diameter of roses, more than 13m.

Y.F.

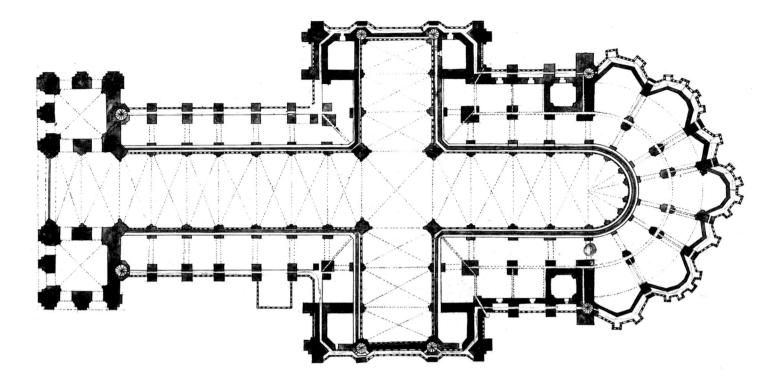

PLAN OF UPPER LEVELS

The plan drawn up at the level of the first internal and external galleries shows the general layout of the structures designed to buttress the thrust of the high vaults over the central cross: the network of flyers, doubled for the choir, resting on buttresses, and the eight towers (the two choir towers situated further apart) which absorb the thrust through single flyers. The roofs of the aisles are articulated by buttress walls whose openings are designed merely for access. The roofs of the chapels and outer aisles of the choir are totally isolated and accessible only from the external gallery, except for one on the south-east. The triforium opens onto the nave in the interior, the choir is reached directly from the transept stairs and gives access to the roofs. The internal balconies at the base of the large transept bays and between these stairs allow for continuous passage round the church at this level, except on the west side where the triforium abuts the towers. The external gallery of this intermediate level is directly accessible via the stairs of the west towers and choir towers, but visitors have to go via the triforium and the roofs in order to reach it from the transept stairways. The passages that run through the stonework of the towers provide a continuous and convenient passage along these galleries, as far as the gutters between the roofs of the choir chapels and the encircling double aisle. Like the first aisle of the choir, the nave and transept aisles have lead roofs. The roofs of the second choir aisle are covered with stone cupolas, slate or lead. The passage of time and the lovely patina of the plates of sand-cast lead seem almost to plead for the gradual replacement of the slate roofs with lead, and this has already been done for one of the chapels and for the concealed stairway leading to the chapel of Saint-Piat. The west tower under the old spire can be reached via the roofs of the south aisle, but the equivalent communicating bay on the north side by the new tower has been walled up.

The water drainage system was correctly designed from the outset with stone or lead gutters attached to gargoyles. To prevent the water splashing down from the gargoyles' outlets, downflow pipes were installed in the 19th century, which did not always prove very successful when they become blocked. One of the changes made was to collect the water in cisterns as a protection against fires, but this turned out to be a bad idea because the resulting humidity damaged the stonework, so they were removed. All the eight stairways lead to the level of the main roof via the gallery which runs round it; the two choir towers, which are separate from it, are linked to it by passages supported by flyers. *Plan of 18 July 1829.*

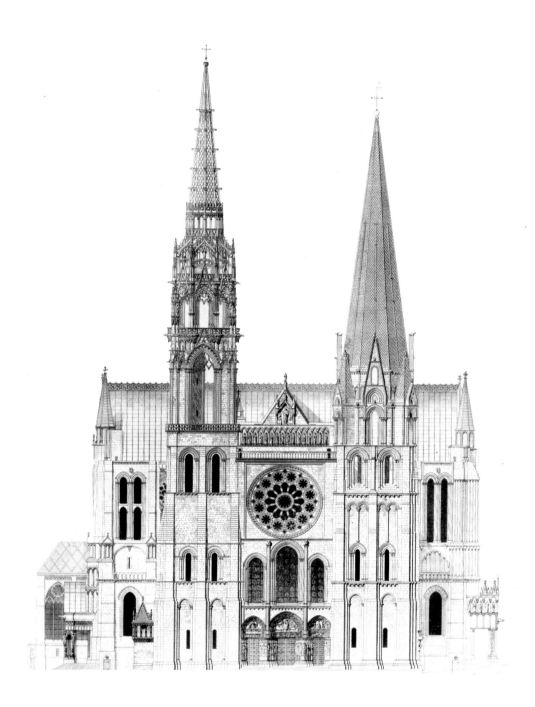

THE WEST FAÇADE

In spite of the marked difference between the new tower on the left, dating from the Renaissance, and the old tower on the right, which is Romanesque, the façade gives an effect of great balance. Careful examination shows considerable variations in the profiles of the moulding of the towers, the left one being a few years older, but in both cases the decorative effect is enhanced as the eye moves upward. Encased between them, the west façade of the nave can be broken down into several registers, the divisions between them underlined by horizontals. The three bays of the Royal Portal, richly carved with statue-columns, the tympana, the voussoirs and the capitals are separated by piers which give way to pilasters rising between the three large windows and supporting the figures of the ox and the lion, symbolizing physical and moral strength respectively.

The structure of the drainage arch originally surmounting the three bays seems to have been modified when the rose window set within the square of the third register was constructed; the remarkable design of the many-petalled rosettes surrounding the vigorous structure radiating from the central oculus produces an impressive effect. Above, a narrow gallery is supported by the projecting cornice above which, on a horizontal aligned with the joints of the towers, a row of sixteen statues of kings of France stands under a series of

arcades, partly concealing the nave gable, before which stands a figure of the Virgin. A statue of Christ crowns the whole structure. At floor level on each side we see, to the left, the clock house and to the right, on the corner of the tower, the angel with the dial which is probably simply a statue-column that has been moved and reused. Behind, we see the transept towers, then the side views of the transepts themselves and their roofs, and the projecting porches with their sculpture. A comparison between these porches on the basis of the profiles of their moulding shows the fertile invention of the medieval artists, who managed to create two different structures that were virtually identical from the point of view of function. Even further along on the left is the outer end of the sacristy. *Drawing by Lassus engraved by E. Ollivier.*

Y.F.

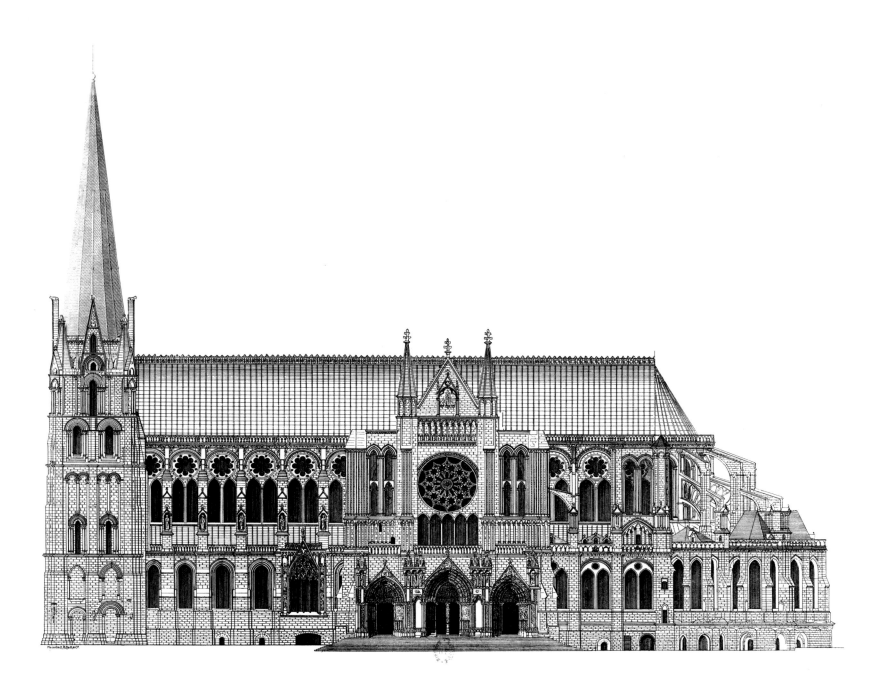

THE SOUTH FAÇADE

The old tower. On a square plan throughout its entire elevation, this tower, solidly based and buttressed, shows an admirable harmony of composition. The profile of the superimposed blind arches, the gradual lightening of the buttresses, the succession of horizontals marking the different levels give it a great elegance, underlined by the projecting gables and pinnacles which herald and announce the slender octagonal stone spire. The successive courses of this hollow pyramid are horizontal and not perpendicular on the surface, to avoid any outward thrust, while the thickness decreases as it rises, from 80cm to 30cm approximately. Since the 1836 fire, which destroyed all the timbers of the upper levels, this tower no longer contains either a belfry or a bell. The top of the spire, which had been weakened and damaged by the accumulation of very hot gases from the fire, had to be rebuilt at the beginning of the 20th century. The room on the ground floor, a few steps lower than the floor level of the cathedral onto which it opens, leads down to the crypt. The first floor room, which is open and well lit, is supposed to have been used by the master masons for many years as a workshop. On the corner by the nave side, the helix form of the stairway partly conceals the first bay.

The nave and the aisles. The narrowing of the intermediate axes between the buttresses towards the old tower led the builder to increase the height of the lancets of the nave. In the niche of each buttress stands an early bishop. The Vendôme chapel, added in the 15th century, is supported by reinforced masonry, which made it possible to continue using the crypt window. The two centuries of architectural development are very legible here in the sculpted decoration and in the treatment of the stained glass.

The porch and façade of the south transept. On the south side we see the main steps leading up to the level of the cathedral from the cloister of Notre-Dame. Behind the three bays of the porch, richly decorated with sculptures, even in the voussoirs, based on a well-defined iconographical programme, the two flat-fronted towers, crowned by the high turrets of their stairwells, shoulder the transept gable. A number of delicate colonettes flank the arcatures and the upper part of the bays, framing the rose which, from outside, and even forgetting the colourful splendour of its stained glass, attracts the eye by its perfect design.

The choir and its aisles. The south tower, like its symmetrical counterpart to the north, which helps to balance the chevet, is treated more soberly than the transept towers, as is its stairway whose roof barely rises above the level of the terrace. The choir bays with two lancet windows surmounted by a rose on the right-hand side become plain windows in the radiating apse. The aisle bays, which had single windows facing the nave, here have twin lancets surmounted by a little oculus. The balustrade follows the contour of the series of chapels. Great care was taken to preserve the light through the crypt windows when the masonry around the anterior chapels was reinforced. The first external bays of the aisles are surmounted by fairly flat, polygonal stone cupolas, which stand out in silhouette against the lead roofing of the internal bays. Subsequently, the chapels were given tent roofs. Round the chevet, the double flying buttresses took the thrust of the high vaults.

The great roof. Ever since the disappearance of what was called the 'forest' of timber supporting the lead roof, this great roof has been covered in copper, whose verdigris patina is as characteristic a feature as the tall spires of this cathedral in the Beauce country. The angel at the summit of the chevet revolves, acting as a weathercock. *Engraving from* Die Kirchliche Baukunst des Abendlands *by G. Dehis and G. V. Bezold, 1881–1901.*

Y.F.

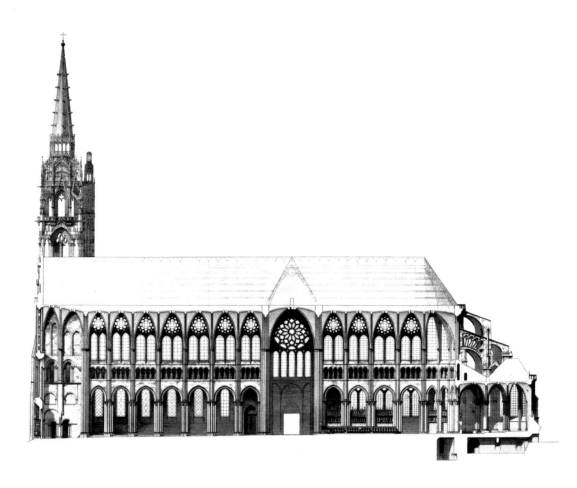

LONGITUDINAL SECTION ALONG THE AXIS

St Lubin's vault. At the lowest point of the section we see 'St Lubin's vault', a vestige from the pre-Romanesque era: the foot of the column partly engaged in the Gallo-Roman wall, on the left, shows the original level; the top of this column was reinforced in the 18th century to carry the load of the major sculptural work of the *Assumption of the Virgin* by Bridan, positioned in the choir.

Crypt. At a slightly higher level, below the ambulatory which connects the aisles, lies the curved area of the existing crypt, extended eastward, on the right, by a chapel.

The main body. The general westward slope of the ground, on the left, proved very useful for discharging washing water at the time when most of the building, except for the choir and chapels, was used as a kind of 'caravanserai'. In the centre, the impressive pillars that frame the transept crossing suggest that a counterpart had been planned above, no doubt in the form of a lantern tower. The main body of the cathedral has three superimposed registers: a first level of arcades opening onto the aisles; then the triforium gallery behind which is the sloping roof of the aisles; then the clerestory with twin windows surmounted by a rose in each bay, except in the radiating part of the choir where there is only one window between each support. It is possible to walk all round the triforium thanks to a balcony at the base of the five lancet windows under each transept rose leading, to the west, to the tower rooms. However, it is not possible to cross from one tower to another across the nave on the other side of the façade of the Royal Portal to the right of the three great Romanesque windows. The masons had considered it essential to leave these three bays totally open, as well as the great rose whose cumulative height, like that of the sculpted portal, left no room even for a small gallery, since it was already higher than the gallery of the nave; the upper part of the vaults gradually joins the west wall above the rose. The face of the tower abutting the nave still shows traces of an ancient porch, or narthex, which occupied the lower part of the (originally shorter) nave, and the preparatory work for the construction of a tribune at the foot of the windows which would have been supported by a very flat vault; this project was not carried out, presumably because it was too daring. The fact that the towers predate the Gothic cathedral is demonstrated by the gradual narrowing of the last two bays before the towers, reflected by the change in the rhythm and number of triforium arcades and the change in proportion of the upper windows. The drawing does not show the medieval rood-screen which closed the choir; regarded as dated by the 18th-century canons, it was demolished and replaced by a solid wall on each side of a very lovely gate. The illustration shows the choir stalls but not the 18th-century stucco-work, in order to reveal the position of the sculpted choir wall more clearly – a wall which in fact continues to the right of the arcade, shown quite empty here so that the foot of the windows of the choir aisle can be seen.

Exterior of the chevet. After the lean-to roof, the apse was covered by a tent roof, around which runs the external gallery and its balustrade. The upper flyers are supported only by the first row of buttresses. Although site studies have shown that these buttresses were placed a little too high, their presence proved very useful in limiting the damage at the top of the guttered walls during the 1836 fire which totally destroyed the timber roof and its lead covering. At the end of the chevet we see the balustrade of the external gallery running round the main roof.

The main roof. Two years after the 1836 fire, a competition was held to choose a new roof and the winning project was a roof of iron and cast iron, which is both light and solid and provides a very interesting example of the work of a period which saw the construction, among others, of the Pont des Arts bridge in Paris. This roof used to have two spires: the first, above the transept crossing, contained a small hoist for bringing materials up to the roof through the eye of the fairly large ring-shaped keystone; the second, above the choir, contained small 'babbling' bells, operated from inside, which signalled to the ringers of the large bells when it was their turn to ring out during the ceremonies.

The Renaissance spire. In 1506 another fire, caused by a storm, again destroyed the lead and slate-covered roof of the tower supporting the magnificent Romanesque spire. The master mason Jean de Beauce, building upon and strengthening the Romanesque tower, crowned it with the Renaissance spire, which is about 10 meters taller than its neighbour, from 1507 to 1513. This ornate structure is based on a quadrangular plan up to the first level, crowned by a gallery, and then narrows into an octagonal plan whose frame is buttressed by two levels of flyers which create a balance by a clever system of triangles. A second gallery can also be reached by the spiral stairs. The interior contains several rows of bells in superimposed belfries. A room, with a hearth, once occupied by lookouts and bell-ringers, is situated at the level of the upper gallery. Today a mechanical clock with weights, wound up every fortnight, still tells the time as it has done regularly for a hundred years and more. From this room, an internal corbelled stone stairway, becoming steeper as it rises higher, leads to the upper lantern turret containing the very large bell which sounds the hours. This is the base of the octagonal spire, decorated with crockets and reinforced inside by a metallic frame, whose summit, surmounted with the emblem of a sun on a cross, rises some 115 meters above the ground. *Drawing by Lassus engraved by A. Guillaumet.*

Y.F.

Eudes and related to the Merovingians, he refused to acknowledge himself a vassal of Charles Martel but when he was defeated by Carloman and Pepin in 742 and 745, he abdicated in favour of his son Waifre and retired to the monastery of Rhé (745). He came out twenty-three years later, when Waifre was murdered on Pepin's instructions, and organized an uprising in Aquitaine, but was killed by Charlemaagne soon after.

Isaiah. The first of the four major Hebrew prophets. He prophesied for Kings Uzziah, Ahaz, Jotham and Hezekiah (7th century BC) and was sawn between two boards by order of King Manasseh. Legend has it that one day when he was praying in the Temple, an angel took a piece of burning charcoal from the altar and touched Isaiah's lips with it to purify them. He is considered the most eloquent of the prophets.

J

James, St, called the Just or the Less (died 62). Apostle, cousin of Jesus by his mother Mary Cleophas, brother of Simon and Jude. After the Resurrection he was chosen to preside over the Church of Jerusalem, which he did for nine years. The Grand Priest Ananus wanted him condemned. He was thrown from the pinnacle of the Temple and his head was smashed by a stone as he lay there.

John, St. Born in Bethsaide, son of Zebedee and Salome, brother of St James the Greater, he worked as a fisherman. In the context of the apostles, John is often mentioned together with Peter (Luke 22, 8). Tradition has it that he went to Ephesus where he governed the Churches of Asia Minor, probably towards 62. Then he is said to have been exiled to Patmos, where he recorded the vision of the *Apocalypse*. He is said to have died at Ephesus at the beginning of the reign of Trajan (98–117). He is the author of the Fourth Gospel and the *Apocalypse*.

John of Salisbury (c. 1115–80). A pupil of Abelard in Paris, he also studied at Chartres. When he returned to England (1150) he became secretary to the Archbishop of Canterbury and remained in the service of his successors. He left England in 1164 when Henry II turned against him, but returned with Thomas Becket in 1170 and witnessed Becket's murder. Bishop of Chartres (1176–80), he wrote a *Life* of Thomas Becket and a *Life* of St Anselm. His main work, the *Policraticus*, is at the same time an encyclopedia of medieval knowledge and thought and a satire of contemporary customs. He is the author of the *Metalogicon*, the *Entheticon*, a satire on false philosophers, and a *Historia pontificalis* (1148–52).

Jeremiah (c. 627–c. 587 BC). One of the four major prophets of Israel. After prophesying the fall of Jerusalem, which was destroyed by Nebuchadnezzar, he was apparently put to death by the Jews who were angered by his reproaches. The *Lamentations*, songs of mourning about the ruin of Jerusalem which foretell the punishment of Israel, are traditionally attributed to him.

Jerome, St (c. 345–419). Born in Strido (Dalmatia) of a well-to-do family, Jerome first studied in London. After a stay in Trèves and in Gaul, he went to Syria where he became a hermit. Summoned to Constantinople, he translated the *Homilies* of Origen and the *Chronicle* of Eusebius of Caesarea. Secretary to Pope Damasus in Rome, he revised the Latin version of the New Testament. St Jerome spent the last years of his life in Bethlehem. His considerable literary *oeuvre* is dominated by his Latin translation of the Scriptures (the Vulgate). As a historian, he wrote a Life of St Paul of Thebes and of St Hilarion. He also wrote an important collection of letters.

Jesse. One of the Latin forms of the name Isaiah. The Tree of Jesse is the iconographic representation of the prophesy of Isaiah. Christian art adopted this symbol in the 12th century. Jesse lies asleep, a stem springing from his loins. The Messiah can be seen at the summit of the branches, which represent the human lineage of Christ.

Job. Biblical figure famous for his misfortunes and hs resignation (1500 BC). Jealous of Job's virtue and happiness, Satan persuaded God to give him permission to test Job. Job lost his wealth and his sons and was afflicted by a terrible illness. Living on a dunghill, mocked by his family, he still continued to praise the Lord, who returned to him half his possessions.

Judas. One of the twelve Apostles. According to the Gospel, Judas, who looked after the small purse of money needed to feed the Master and his Apostles, was above all the traitor who delivered Jesus to his enemies. Accompanied by armed soldiers, he went to the Garden of Gethsemane on Maundy Thursday night and kissed Jesus. That was the agreed signal: Jesus was immediately seized and bound. Judas, full of remorse, is supposed to have hung himself after throwing his traitor's ransom into the Temple.

L

Leviathan. The term used in the Old Testament to describe a wide range of fabulous animals. The word is said to derive from *liwyâthan*, which means crown or garland; by extension it acquires the meaning of a sinuous animal that coils itself into a spiral like the dragon, snake or even crocodile (*Job 41*). It is the symbol of the devil.

Lubin, St (died 587). Bishop of Chartres from 552 to 587. A Life, certainly legendary, tells of his many miracles. The crypt housing his vault is on a second level below the cathedral. St Lubin gave his name to several villages around Chartres.

Luke, St (died c. 80). Born in Antioch, traditionally said to be a painter, St Luke was Paul's disciple and accompanied him on his travels. Before 70, he wrote the Third Gospel, intended for the Gentiles, which was followed by The *Acts of the Apostles*. St Luke is said to have preached the Gospel in Dalmatia, Gaul and Macedonia before dying in Bithynia.

M–N

Mark, St. One of the four Evangelists, martyred in Alexandria (Egypt) in 68. A disciple of St Paul and then St Peter, Mark wrote his Gospel for the Christians of the Church of Rome in 63; it describes the life and person of Christ in a very lively and colourful fashion. In it he repeats the catechism of the Apostle Peter.

Martin, St (316–97). Son of a soldier, he enrolled in the army at the age of fifteen. He was baptized at Amiens where, according to tradition, he gave half his cloak to a beggar. After acting as an exorcist at Poitiers, he withdrew to Ligugé where some of his disciples joined him. His fame spread throughout Gaul. He was elected Bishop of Tours in 371. His episcopate marked the triumph of Christianity west of Gaul; his missionary travels led to the organization of the first rural parishes and the creation of monasteries (Marmoutier near Tours).

Matthew, St. Apostle and Evangelist, probably born in Galilee at the beginning of the Christian era, martyred in Ethiopia in 70. According to Eusebius and St Jerome, he wrote his Gospel c. 60, in Aramaic. The original is lost, but a Greek translation by Matthew himself remains. He attempts to show, in this Gospel addressed to the Jews,

that Jesus really is the Messiah.

Melchizedek. 'King of Justice' in Hebrew. Priest of the Almighty, king of Jerusalem and its dependent territory. The most famous event connected with him is his meeting with Abraham on his return from defeating the Elamites in 1912 BC (*Genesis 14:18*). Melchizedek offered him holy wine and bread. In return Abraham gave him one-tenth of his booty.

Nicholas, St, known as Nicholas of Myra or of Bari (4th century). Born in Patara in Asia Minor, he became Bishop of Myra, the capital of the province, before being imprisoned during Diocletian's persecutions. He died at Myra and his relics were brought back to Bari, safe from the Muslim threat. St Nicholas is one of the most venerated and popular saints of the Church in Russia, Greece, Sicily and Lorraine.

P

Peter the Hermit (1050–1115). A hermit from the Amiens area, he embarked on a crusade to the Holy Land followed by a crowd of the poor. The expedition, which went on its way without waiting for the armed troops, ended in disaster. Peter the Hermit reflected the mood of uncontrolled religious fervour of the first crusade.

Pait, St (c. 200–86). After preaching in the Chartres region, he went to the Tournai area to pursue his evangelical work. He was martyred in Seclin (north).

Potentien, St. In 847 the remains of SS Potentien and Savinien were exhumed at the abbey of Saint-Pierre-le-Vif near Sens. According to legend, they were the first two bishops of that town. In 1045, a long time after their discovery, the monk Odoranne wrote a Life of the two saints. According to him Potentien and Savinien were two of the seventy-two first disciples of Christ whom St Peter sent, with Altin, to evangelize Gaul. These three saints are credited with founding the church of Chartres. The monk Odoranne's story reflects the desire at that time to make the church of Chartres seem older than it was.

Priscian (5th–6th century). Born in Caesarea in Mauritania, he moved to Constantinople to teach Latin there. He wrote many works, the most important of which is the 18-volume *Instutio de arte grammatica*. It is the most complete Latin grammar treatise we have from the Middle Ages and was even used to help compile the first modern Latin grammars.

Ptolemy (2nd century AD). The most famous of the astronomers of antiquity. He is said to have been born in Ptolemais (Egypt). He wrote a treatise on astronomy in which he set out his theory of the earth and of planetary motion. In the Middle Ages his theories of astronomy were unquestioned.

Puiset (Sire du). The domain of Puiset is situated near Chartres, between Paris and Orléans, the vital axis of the monarchy. For many years continuous quarrels arose between the lords of Puiset and the counts of Chartres or kings of France. Hugh of Puiset is the most famous, because he sacked the cathedral. But he repented and returned the stolen goods.

Pythagoras (6th century BC). Born in Samos, he soon emigrated to Sicily. Pythagorean theory centres on the metempsychosis and purification of the soul through knowledge. Pythagoras' moral teaching and all the (mathematical and astronomical) discoveries attributed to his school form the basis of Western rationalism.

R

Remi, St (died 530). St Remi's popularity has nothing to do with his writings but rests on the fact that he baptized

Ground plan

The numbers refer to the pages
illustrating sculptures in the place
indicated on the ground plan

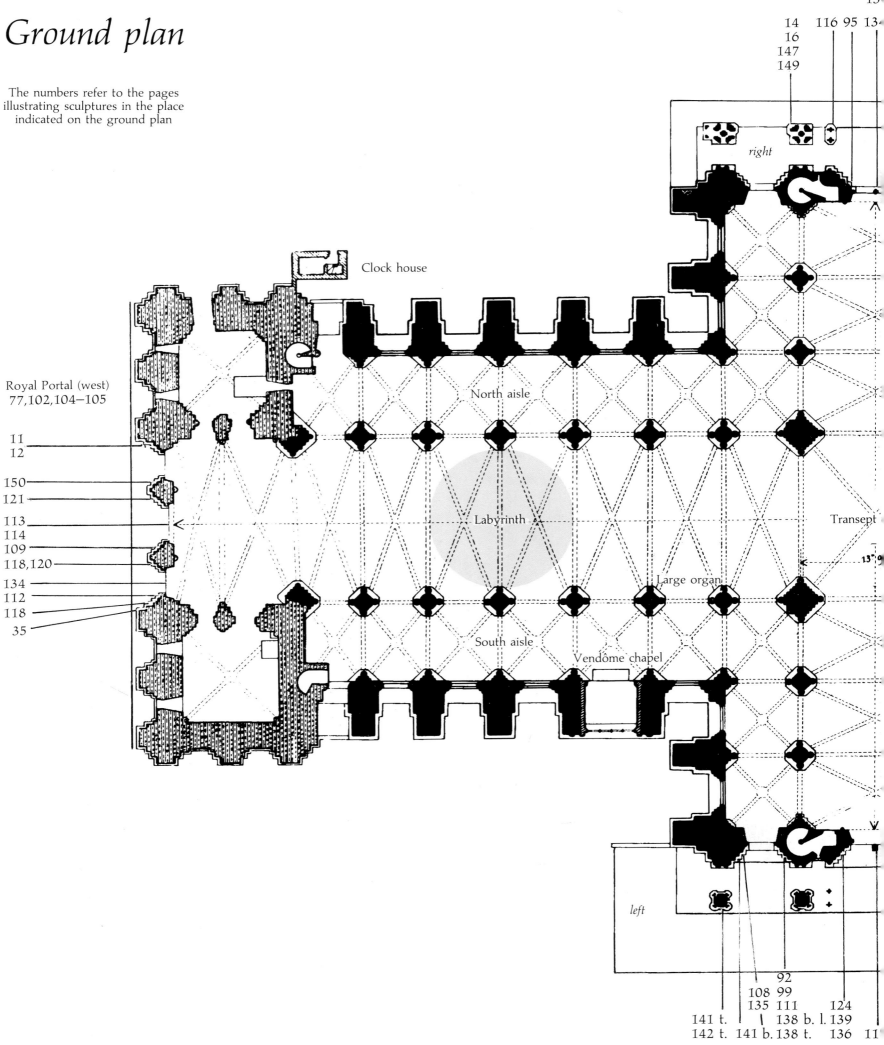

North
13

14 116 95 13

16
147
149

right

Clock house

North aisle

Royal Portal (west)
77, 102, 104–105

11
12

150
121

113
114
109
118, 120

134
112
118
35

Labyrinth

Transept

13 9

Large organ

South aisle

Vendôme chapel

left

92
108 99
135 111 124
141 t. 138 b. l. 139
142 t. 141 b. 138 t. 136 11

South
103, 128

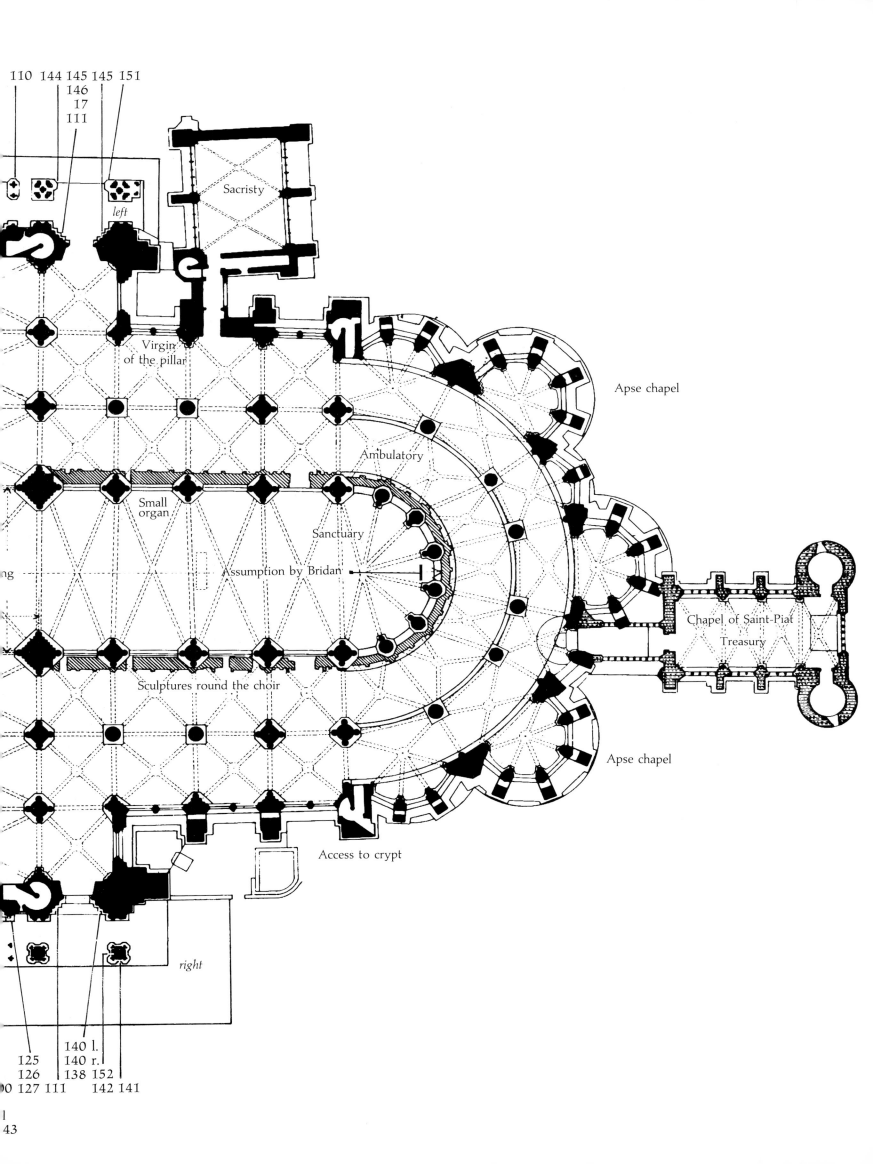

110 144 145 145 151
146
17
111

left

Sacristy

Virgin
of the pillar

Apse chapel

Ambulatory

Small
organ

Sanctuary

Assumption by Bridan

Chapel of Saint-Piat
Treasury

Sculptures round the choir

Apse chapel

Access to crypt

right

125 140 l.
126 140 r.
00 127 111 138 152
 142 141

GLOSSARY

A

Abraham. Biblical patriarch, born in the 19th century BC in Ur, Chaldea (western Sumeria). He had a child by Hagar whom he named Ishmael and who, according to the Bible, was the father of the Arabian tribes, and a son by Sarah called Isaac, from whom the Hebrews are descended. At God's instruction, Abraham went to the land of Canaan. To test him, God ordered him to sacrifice his son Isaac. He was about to obey when an angel stopped him.

Albertus Magnus (c. 1193–1280). German theologian and philosopher. After studying in Bologna and Padua, he became a Dominican in Padua (1223). Albertus taught theology at Paris from 1240 to 1242 (Thomas Aquinas was one of his students) before ending his career as Bishop of Ratisbon (1260–62). He wrote many works and seems to have been the first to conceive the idea of 'revising Aristotle for Latin use'. In science, he supplemented his readings with personal observations and experiments. A collection of magic remedies is also attributed to him.

Antoine Brumel (c. 1460–1510). Chapel master at Chartres, Paris and Lyon, he is regarded as one of the greatest composers of his time. His work includes several masses and motets.

Apocalypse. The last book of the New Testament, attributed to St John the Evangelist. The writer describes the seven visions of the end of the world he had at Patmos, a small island in Asia Minor. Originally meant as a poem on the triumph of Christ and the heavenly city of Jerusalem, this narrative impressed medieval man by its depiction of disasters and prophesies of the end of time.

Aristotle (384–322 BC). Greek philosopher who went to Athens to be taught by Plato, then became tutor to Alexander the Great and founded the Peripatetic School at Athens. His work covered many fields, ranging from anatomy and comparative physiology to logic, history and philosophy. The scale of his work and research gave the Middle Ages much matter for commentary and reflection. Albertus Magnus and Thomas Aquinas followed his line of thought when they formulated the philosophy and theology of Christian rationalism.

Avit, St (c. 547). The origins of St Avit are uncertain. He is supposed to have been the son of a labourer and after becoming abbot of Mixi (Milly) apparently decided to live a hermit's life in the Perche area. He is famous for his many miracles and for words of advice to St Lubin.

B

Balaam. The hero of a number of stories connected with old Israelite tradition about the entry into Canaan and found in the Book of *Numbers* (22–24), Balaam is seen both as a diviner and as a prophet. The episode involving the ass is the most popular story. Balaam went to see Balak, king of Moab, who felt threatened by the sight of the Israelites who had left Egypt camping in his country. Balak wanted Balaam to curse Israel and summoned him. But God sent down an angel who stood in the way of Balaam's ass three times. Balaam did not see the angel and beat his ass, which turned aside and finally refused to go on. At last Balaam saw the angel, who reminded him that he must scrupulously obey God's orders.

Bernard, St (1090–1153). The son of a noble family from Burgundy, Bernard entered Cîteaux monastery in 1112 and then, at the request of Abbot Stephen Harding, founded a monastery at Clairvaux in Champagne in 1115. His ascetic life-style, spiritual influence and writings gave him enormous authority throughout the Christian world. He preached the need to humiliate the body and the spirit in order to find God. This was also an attack on the Cluniac monks, whom he castigated for their wealth and the lack of austerity in their art, and on the philosopher Abelard, whom he had condemned.

Bernard of Chartres (died 1126). Schoolmaster of Chartres from 1114 to 1119, he became its chancellor from 1119 to his death. He based his teachings on grammar and his works on his excellent knowledge of Plato. He affirmed the value of the legacy of antiquity, while also believing in the possibility of indefinite intellectual progress.

Béthaire. Known for a Life whose historical bases look solid enough, he was elected Bishop of Chartres in 585 with the support of Clotaire II, whose chaplain he had been. When Clotaire was defeated by the sons of Childebert, one of them, Thierry, took over Chartres and sent the bishop to Burgundy in exile.

Boethius (480–525). Latin philosopher and statesman. The son of an old Roman aristocratic family, he entered the service of the barbarian king Theodoric. He was subsequently implicated in a pro-Byzantine conspiracy and died in prison. His literary *oeuvre* is composed of translations and commentaries of the Greek philosophers. He popularized (in Latin) the neo-Platonic and Aristotelian doctrines which the Middle Ages were only to know through his work for a long time to come. At the time he was therefore considered a storehouse of the wisdom of antiquity, the very embodiment of philosophy.

C

Cheron, St. From the sixth century on, the tomb of this saint on the right bank of the river Eure became a place of pilgrimage. According to his *Life* as told by a monk, Cheron was of Roman origin and after studying with St Denis was, like him, sent by Pope Clement I as a missionary to Gaul in the 3rd century. His travels apparently took him to Chartres where he is said to have been killed by robbers.

Cicero (106–43 BC). Born into a little-known equestrian family, he received a solid and wide-ranging education in Rome in the art of oratory and in poetry, law and philosophy. After several years of political exile he returned to Rome where he embarked on a brilliant political career. Thanks to his oratory and works of philosophy, Cicero is known as one of the most remarkable figures of Latin antiquity.

Clement, St. Third successor of St Peter of Rome from 88 to 97. St Irenaeus and St Jerome affirm that Clement was ordained priest by the Prince of the Apostles. A series of texts entitled the *Clementine Apocrypha* is attributed to St Clement. A letter he sent in the name of the Church of Rome to the Church of Corinth reveals his thorough knowledge of the Bible, his familiarity with the philosophy of the Stoics and his desire for a unified church.

D

David. Born in Bethlehem, he succeeded Saul as king of Israel in 1055 BC and played a vital role in the history of the Hebrew people. His life, told in the two Books of *Samuel* and the first Book of *Kings*, contains many famous episodes, the best known being his victory over Goliath. He conquered Jerusalem, which he made his capital, and had the Holy Ark brought there. God punished him for carrying off Bathsheba, the wife of one of his officers. His later years were saddened by the rebellion of his son Absalom. He was also a poet and has left us some lyrical *Psalms*.

Daniel. Hebrew prophet of the 7th century BC. Taken to Babylon as a captive, he was able to interpret King Nebuchadnezzar's dreams and saved Susanna from punishment when the old men who surprised her at her bath and whose advances she had repelled accused her of adultery. Thrown into the den of lions when he refused to honour Darius the Median as a god, he emerged untouched. He persuaded Cyrus to send the Jews back to Palestine and reestablish the Temple.

Donatus (4th century AD). St Jerome's teacher, he wrote a commentary on Terence and a treatise on Virgil. His *Ars Grammatica*, one of the most complete grammars of the kind, was long used as a work of reference.

E–F

Euclid (3rd century BC). Greek mathematician. In about 300 he taught mathematics at Alexandria, where he founded a school. He is the author of a book on geometry, the *Elements*, and of various treatises on optics.

Ezekiel. Hebrew prophet of the 5th century BC. He is said to have prophesied on the banks of the river Chebar, a tributary of the Euphrates. His prophesies consist mainly of accusations, at times vehement: the prophet declared that the disasters striking his fellow citizens and the even worse catastrophes that loomed ahead were simply the just punishment for their crimes, especially idolatry. He described numerous symbolic events and visions.

Flavius (died 484). Successor of Arbogast at the bishopric of Chartres under the reign of Childeric, bishop from 470 until his death.

G

Germanus of Auxerre, St (c. 389–448). Born in Auxerre, after studying law at Rome he returned to his native town. Elected bishop in 418, he is said to have led a life of prayer and austerity, giving away all he had to help the poor. He died at Ravenna and was buried at Auxerre, where his tomb was greatly venerated.

Gilbert de la Porrée (1080–1154). Chancellor of Chartres church from 1126 to 1154, then Bishop of Poitiers. A philosopher as much as a theologian, his work helped make the reputation of the school of Chartres. He incurred the wrath of the Church for devoting himself mainly to authors from antiquity such as Aristotle and Plato.

Godfrey of Bouillon (c. 1060–1110). Duke of Lower Lorraine (1089–95), and one of the first crusaders to leave for the Holy Land; to pay for the expedition he sold his duchy and his possessions. In the first crusade, he played an important diplomatic role between the crusaders and Constantinople. He took the title 'Advocate of the Holy Sepulchre' (1095–99). After his death in Jerusalem he soon entered legend.

Gregory the Great, St (c. 540–604). Gregory, who came of a patrician family, rose to the highest administrative offices in Rome at a very early age. In 579 he became *aprocrisarius* (papal agent) of Pope Pelagius II in Constantinople. Gregory spent six years in Constantinople and was then elected to the see of Rome. He was pope from 590 to 604. Known also for his reforms in education, welfare and religious teaching, he is most famous for his important liturgical decisions. He is wrongly regarded as the father of the 'Gregorian' chant.

H–I

Hunald, Duke of Aquitaine (died 768). Son of Duke

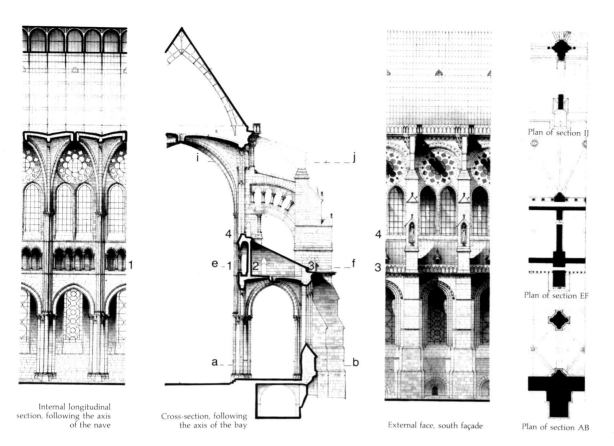

Internal longitudinal
section, following the axis
of the nave

Cross-section, following
the axis of the bay

External face, south façade

Plan of section IJ

Plan of section EF

Plan of section AB

DETAIL OF A BAY

In the three drawings shown above, the cross-section through the axis of a bay shown in the centre is completed on the right by the external view of the bay and on the left by the internal view. The lightness of the stonework between the buttresses contrasts with the robust supports. The projections of the external buttresses absorb the oblique thrust of the upper nave vaults, a thrust transmitted though the three levels of flyers and the thin wall at the level of the aisle roofs. A masonry revetment, decorated with a colonette, supports the top of the lower flying buttress. Each rib, echoed by its capital, is extended down to the base by colonettes or bundles of colonettes which absorb the load in an aesthetically satisfying manner.

This section clearly shows that it is possible to walk along the continuous gallery of the triforium (1), opening on to the internal nave; along the passage at roof level in each bay (2) of the aisles; along the external galleries (3); and along the continuous passage at the foot of the high windows (4). On the external façade we can see the gradual thinning of the buttresses and of the drainage arch protecting the rose window above the twin windows of the clerestory. The corbels of the cornerstones periodically help to take the load created by the widening of the gallery at the foot of the main roof. At the lower level, a wide embrasure allows maximum light to enter the narrow crypt windows. Unlike the clever network of leading which defines the stained-glass medallions of the aisle windows, the upper windows have simple right-angled bars, excepting the stone tracery of the roses. The iron and cast iron roof shown replaced the oak-timbered one after the 1836 fire. The perspective drawing clarifies the three-dimensional details in the upper level. *Two studies of a nave bay, 1904 and 1905.*

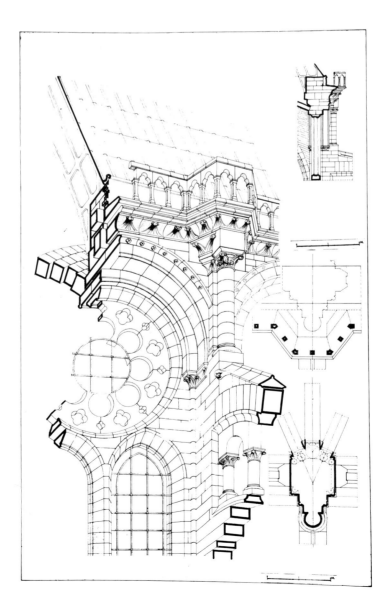

Y.F.

Clovis after the battle of Tolbiac, thereby bringing the Frankish nation into the Catholic Church and dissociating it from the German 'barbarians' who were adherents of Arianism. Nothing else is known of his life. However, Gregory of Tours tells of his long reign as bishop of Rheims (seventy years).

Renaud de Mouçon (1182–1217). A native of Lorraine, he became Bishop of Chartres from 1210 to 1217 and initiated a project to reconstruct the cathedral.

Richard I of Normandy, aka Richard the Fearless (942–96). Duke of Normandy. Son of William I, he was only ten when his father died and the Carolingian Louis IV tried to seize this opportunity to take away his duchy. He was only saved by Harald, king of Denmark. He was in favour of Hugh Capet being crowned king of France and was married to his sister Emma.

Richer. Chronicler (late 10th century). Monk of Saint-Remi of Rheims, between 991 and 995 he wrote the *Histoires* which continue the *Annales* of Hincmar, no doubt at the request of Archbishop Gerbert. The work, which still exists in manuscript, is most valuable for the details the author gives about his period.

Rollo (died 927). Duke of Normandy. A Norseman, he headed a band of Norman pirates. After leaving England he attacked Paris and established himself in Rouen. Charles the Simple defeated him near Chartres and negotiated the treaty of Saint-Clair-sur-Epte with him. A figure shrouded in legend, Rollo has given rise to great differences of opinion.

S

'Saints forts'. When SS Altin, Potentien and Savinien set out to convert Gaul, they found a church had already been founded at Chartres, which they consecrated. By so doing, they incurred the anger of the Roman governor Quirinus, who had had a number of Christians massacred, including his own daughter Modesta. Their bodies are supposed to have been thrown into a well near the church, known as the 'Saints forts' well, i.e. the well of the courageous saints.

Solomon. Son and successor of David, king of Israel from 970 to 931 BC. He was responsible for the construction of the Temple of Jerusalem. The Bible praises his wisdom, legendary throughout the East. His ostentatiousness and tendency towards idolatory were to encourage decadence and, after his death, led to the partition of his kingdom (Roboam and Jeroboam). He composed poetry and some of the Old Testament books bear his name.

Siger of Brabant (c. 1235–c. 1281?). Master of Arts at the University of Paris, Siger de Brabant was the main supporter of Averroism, which looked at Aristotle through the interpretations of the 12th-century Cordovan Arab commentator Averroes. Three of these doctrines created a scandal: the eternal nature of the world, which denies the Creation; the double truth, according to which revelation and reason can be apparently incompatible and yet wholly true; the unity of the intellect, which denies the individual soul. These theories were slightly adapted by Thomas Aquinas and in the eyes of the Augustinians and Platonians they compromised his thought.

Solenne, St. Elected to the bishopric of Chartres in 484, he is known for his charitable works. Tradition has it that St Solenne played a part in the conversion of Clovis, but there is no historical proof one way or the other.

Suger (1081–1151). Suger studied at Saint-Denis and Saint-Benoît-sur-Loire. When he returned to Saint-Denis in 1106 he soon joined the administration of the abbey and made his name in many of the councils. A friend of Louis VI, he was entrusted with diplomatic missions to the papacy. In 1135 he persuaded the King

to crown his second son. He then became regent of the kingdom during Louis VII's crusade. He wrote a *History of Louis VI*, an essential source book for the history of the period 1093–1137, and began a *Life of Louis VII*. Some twenty-six letters and various treatises by him survive.

T

Teinturier or Tinctoris, Jean (c. 1435–1511). Theorist and musician from Brabant. He was master of the childrens' choir at Chartres for a few years and ended his career at the court of King Ferdinand I of Naples. He wrote masses, motets and a few French and Italian songs.

Texier, Jean, aka Jean de Beauce (died 1529). A master mason, he played an important part in the completion of Chartres Cathedral, adding the openwork spire of the north tower (1507–13). He also built the small clock house at the foot of the north tower (1520) and began the choir wall. He enlarged the Church of Saint-André of Chartres by spanning an arch (since destroyed) over the Eure. He also worked on the choir and the ambulatory of the Church of Notre-Dame des Marais at La Ferté-Bernard and the flamboyant façade of the Trinité Church in Vendôme.

Theodore, St, of Heracleum or Amasea (died 319). Today it is thought that this saint is identical with Theodore Tyro, a young recruit of the Roman army of Licinius who was martyred at Amasea for courageously upholding his faith.

Theophilus, deacon (c. 538). Treasurer of the church of Adana, he was dismissed by the bishop. In his resentment, he sold his soul to the devil but then, overcome by remorse, persuaded the Virgin to revoke the deed. This legend was popularized by the poet Rutebeuf in the *Miracle of Theophilus*.

Thibaud le Tricheur (c. 908–78). The son of a viscount of Tours, faithful vassal of the Robertians in their fights against the Carolingian dynasty, Thibaut 'the Trickster' was rewarded by being appointed count of Chartres. His authority extended to Blois, Tours and Saumur. Feared for his trickery, he spent his life fighting his neighbours, the kings of France, the dukes of Normandy and the Church of Rheims.

Thierry of Chartres (died 1155). He taught in Paris at the beginning of his career, then succeeded Gilbert de la Porrée as chancellor of the church of Chartres from 1142 to 1150. All his works showed his keen interest in the sciences, Plato and Pythagorean theories.

Thomas Becket (1117–70). Born in London, he studied at Oxford, Paris and Bologna. He was appointed Chancellor of England, then Archbishop of Canterbury in 1162; he came into conflict with Henry II who wanted to restrict the jurisdiction of the Church. After a period of exile in France he returned to England. Four knights keen to please Henry II murdered him at the foot of the altar of his cathedral. The clergy was to develop a cult around his name, aimed at promoting the material and spiritual interests of the Church against the temporal rule of the kings.

Thomas, St. His name, which means 'twin', appears in its Greek translation, Didymos, in the Gospel of St John. One of the Apostles, Thomas' main claim to fame is that he doubted the Resurrection of Christ. Tradition has it that he preached in India. An apocryphal Gospel is also attributed to him.

V–Y

Vincent, St (died 304). After being instructed in the profane and sacred sciences by Bishop Valerius of

Saragossa, Vincent was ordained deacon. At the beginning of Maximian's reign, the Roman governor Dacian summoned Valerius and Vincent to Valencia. The bishop, who was very old, was banished, but Vincent was tortured horribly. His cult is very ancient and spread beyond Spain to France in the 6th century.

Walter the Penniless. One of the leaders of the People's Crusade (1096). He accompanied Peter the Hermit as far as Cologne and soon reached Constantinople. The pilgrims caused such disturbances that the sultan of Nicaea set his soldiers on them and the expedition ended there. Walter never reached Jerusalem.

William V of Aquitaine, called the Great (c. 960–1030). Duke of Aquitaine (994–1030), he tried to make himself independent of the king, refused the imperial crown offered to him in 1024 and proved an active patron of the arts and literature. He retired to the abbey of Maillezais (Vendée) where he took monastic orders.

William of Conches (1080–1154). Born in Conches in Normandy, he was a pupil of Bernard of Chartres and then taught grammar and philosophy at Paris. John of Salisbury was a disciple of his and towards the end of his life Henry II Plantagenet came to hear him. He wrote several works inspired by Platonism and commentaries on Priscian.

Yves of Chartres. St (c. 1040–1116). A pupil of Lanfranc at the abbey of Bec, he became provost of the canons regular of Saint-Quentin in Beauvais (c. 1075) before being elected Bishop of Chartres in 1090. The surviving letters and sermons by him prove him a keen defender of the Holy See, faithful servant of the Capetian monarchy and zealous pastor. He is also known as a canonist through his *Tripartite Collection*, *Decree* and *Panormia* (1092–1095).

Acknowledgments and Photo credits

Thanks are due to Yves Flamand for his instructions in connection with the drawings and diagrams executed by the architect Didier Leneveu, and also with the identification of plans.

Fanny Bernard was responsible for the identification of the statues and stained glass windows in Chartres, and Anne Delille assembled the Glossary.

The photographer Jean Bernard worked with the following cameras: Nikon 24 × 36 cm, Pentax 6 × 7 cm and Cambo 13 × 18 cm. He wishes to express his gratitude to the Nikon company for lending him telephoto lenses of 300 and 600 mm IF-ED.

The plans and drawings on pp. 177, 178, 179, 182 and 183 are reproduced by courtesy of the Bibliothèque de la Direction du Patrimoine, Paris. (*Photos* © *Photeb.*)

The drawings on pp. 171 (top), 180 and 181 and photographs pp. 23, 25 and 76 are reproduced by courtesy of the Bibliothèque nationale, Paris (*Photos* © Archives *Photeb.*)

The scene from the Bayeux Tapestry (p. 15) is reproduced by special permission of the town of Bayeux.

The drawings on pp. 63 and 70 are by Didier Leneveu.

© Arch Phot. Paris/SPADEM/Photeb.: pp. 32 (top), 60 (Bourges), 162
© Bibliothèque nationale, Paris – Arch. Photeb.: pp. 32 (below)
Centre Guillaume-le-Conquérant, Bayeux: p. 15
J. Feuillie © C.N.M.H.S./SPADEM/Photeb. pp. 56, 60
 (Laon, Paris, Soissons), 125
© Giraudon/Photeb.: p. 77
© E. Houvet: p. 27
Jeanbor © Photeb.: pp. 13, 14, 22, 30, 37, 38, 47
© Yan: p. 56

Bibliography

History of Chartres

Billot, C. *Chartres à la fin du Moyen Age*, Paris 1987
Brooke, Christopher *The Twelfth Century Renaissance*, London/New York 1969
Chedeville, A. *Chartres et ses campagnes, XIe–XIIIe siècles*, Paris 1973
Evans, Joan, ed. *The Flowering of the Middle Ages*, London/New York 1966 and 1985
Lepinois, E. de *Histoire de Chartres*, Paris 1854–58
Pare, G., Brunet, A. and Tremblay, P. *La Renaissance du XIIe siècle, les Ecoles et l'Enseignement*, Paris/ Ottowa 1933
Southern, R. W., *Medieval Humanism and Other Studies*, Oxford 1970

The Cathedral

Aubert, M. *La Cathédral de Chartres*, Paris 1952
Branner, R. *Chartres Cathedral*, New York 1969
Bulteau, Abbé, *Monographie de la cathédrale de Chartres*, Paris 1887–1901
Delaporte, Y. *Les Trois Notre-Dame de la cathédrale de Chartres*, Paris 1965
Delaporte, Y, and Houvet, E. *Les Vitraux de la cathédrale de Chartres*, Chartres 1926
Erlande-Brandenburg, A. *Chartres*, Paris 1986
Grodecki, L. 'Chartres', *Verve*, 1963
Houvet, E. *Cathédrale de Chartres*, Chelles 1919–21
Katzenellenbogen, A. *The Sculptural Program of Chartres Cathedral*, New York 1964
Lévis-Godechot, N. *Chartres*, Paris 1987
Male, E. *La Cathédrale de Chartres*, Paris 1948
Mallion, J. *Le Jubé de la Cathédrale de Chartres*, Chartres 1964
Poole, R.L. *Studies in Chronology and History*, Oxford 1934
Popesco, P. *La Cathédrale de Chartres, Chefs-d'oeuvre du vitrail européen*, Paris 1970
Sauerländer, W. *Gothic Sculpture in France, 1140–1270*, London/New York 1972
——Das *Königsportal in Chartres*, Frankfurt 1984
Simson, O. von *The Cathedral of Chartres*, New York 1956
Stoddard, W. *The West Portals of Saint-Denis and Chartres*, Cambridge 1952
Van der Meulen, J. *Notre-Dame de Chartres. Die vorromanische Ostlange*, Berlin 1965
Van der Meulen, J, and Hohmeyer, J. *Chartres, Biographie der Kathedrale*, Cologne 1984
Villette, J. *Les Vitraux de Chartres*, Rennes 1979

Selected Works by Jean Favier

Les Archives (1949, 4th ed. 1985)
Un conseiller de Phillippe le Bel: Enguerran de Marigny (1963)
Cartulaire et actes d'Enguerran de Marigny (1965)
Les Finances pontificales à l'époque du Grand Schisme d'Occident (1966)
De Marco Polo à Christophe Colombe (1968)
Les Contribuables parisiens à la fin de la guerre de Cent Ans (1970)
Finances et fiscalité au Bas Moyen Age (1971)
Paris au XVe siècle (1974)
Philippe le Bel (1978)
La guerre de Cent Ans (1980)
François Villon (1982)
Le Temps des principautés (1984)
De l'or et des épices (1987)

Works of John James

Chartres, les Constructeurs (1977–82, 3 vols)
The Pioneers of the Gothic Movement (1980)
Chartres: the Masons Who Built a Legend (1982)
The Traveler's Key to the Sacred Architecture of Medieval France (1986)

Index

A

Abraham 95–96, 108, 115, 120
Adelman of Liège 38
aisles 164, 178–79, 181–82
Aix-la-Chapelle 55
Albertus Magnus 41
Altin, St 30
Amiens 26, 63, 80, 116, 143
Apocalypse 105, 115, 122–23
apse 63, 174–75, 178
Aquinas, Thomas 38, 40
arches 55, 56, 63, 70, 164
Aristotle 40–42
Aubry Clément 151
Augustines 25, 37
Aulnay-de-Saintonge 61
Autun 61, 119, 124
Auxerre 37
Avit, St 138

B

Balaam 108
bays 168, 172, 178, 180, 183
Beatitudes 142–43, 145, 150
Beauce 14, 15, 18, 37, 156
Beauvais 21
Bec-Hellouin 37
Becket, Thomas 152
Benedictines 37, 152, 162, 164–65
Berenger (mason) 47
Berenger of Tours 38
Bernard, St 31–32, 97–98, 101, 108
Bernard of Chartres 39, 112
Berzé-la-Ville 76
Béthaire, Master 37
Blanche of Castile 76, 153
Blois 14, 18, 21, 29–30
Boethius 40
Bourges 60, 80, 166
Bruges 22
Brumel, Antoine 87
buttresses 50, 55; flying 63, 70, 80, 164

C

Capetians 18, 21, 23, 30, 38, 152, 156
Carmelites 37
Carnutes 29–30
Carolingians 30, 33, 37–38
Cathars 143
Charlemagne 45, 55, 95, 107–08, 152
Charles the Bald 29, 31, 160, 174, 177
Charles of Valois 22
Charles V 32
'Chartres blue' 76f.
Châteaudun 21, 29–30
Chermir 37
Cheron, St 30, 32–33, 138, 150
choir wall 106, 122, 170, 178, 182
Cicero 39
Cistercians 37, 101, 152, 162
Cîteaux 23
Clement, St 138
clerestory 164, 166, 168
Cliquot, François-Henri 88–89
Clodomir 29
Clotaire 150
cloth-making 21
Clovis 29, 37, 39, 95
Cluny 23, 164
Conques 23, 56, 124
Constantine, Emperor 30, 45

Corbie 37
Council of Trent 107
crusades 32, 145, 151f.

D

Dagobert 37
Daniel 40, 119–20
David, King 95
Dominicans 25, 37, 145
Donatus 39, 41
Dourdan 29
Dreux 29; family 76
Drouaise gate 16

E

Enocq, Etienne 88
Epars gate 16
Etampes 29
Euclid 39
Ezekiel 40

F

Filleul (organ builder) 88
Firmin-Didot, Pierre 90
Flavius, Bishop 37
Fleury-sur-Loire 37
Fontevrault 23
Francis I 30
Franciscans 25, 37, 145
Franks 29
Fulbert, Bishop 16, 38, 45–47, 55, 70, 160, 174, 177–78

G

Gadault (organ builder) 88
Gaston of Orléans 30
Gerbert of Aurillac 38
Germanus of Auxerre, St 151
Gethsemane 105
Godfrey of Bouillon 145
Gombault Rougerie 85
Gonzalès (organ builder) 89
Gothic style 164f., 166ff.
Gregory, St 116, 138
Guschenritter (organ builder) 90

H

Henry I, King 38
Hunald, Duke of Aquitaine 45

I

Isaiah 40, 94, 119, 120, 187

J

James, St 32
Jean de Beauce, see Texier
Jeremiah 40
Jerome, St 138
Jesse, Tree of 32, 93, 95, 120, 122, 174–75
Job 95–96
John, St 40, 115
John of Salisbury, Bishop 38, 42, 160
jubé 33, 105, 160
Judas 104

L

Laon 26, 58, 61, 169
Last Judgment 123–28

Lawrence, St 141, 142
Lesclop, Henri 88
Liège 38
Limoges 37
Louis I, Count of Blois and Chartres 21–22
Louis VI 153
Louis VII 50, 153
Louis IX (Saint) 22, 30, 32, 76–77, 128, 152, 153, 156, 170
Louis XIII 30
Louis XIV 30

M

Mantes 22
Mark, St 40, 115
Martin, St 141, 150
Matthew, St 40, 115, 143
Melchizedek 41, 95–96, 108
Merovingians 29
Mont-Saint-Michel 23, 32

N

nave 50, 58, 60, 70, 170, 177–78, 180–82
Nicholas, St (archbishop) 22, 150
Nogent-le-Rotrou 29
Normans 29, 30, 45
Notre Dame (Paris) 18, 60, 104, 153, 156
Notre-Dame (Chartres) 45
Noyon 21, 58, 80

O

organs of Chartres 85–90
Orléans 29, 37

P

Paris 14, 18, 22, 29, 30, 37, 41, 58, 61, 80, 152–3
Passion of Christ 13, 104–05
Péguy, Charles 34
Peter, St 30, 104, 117

Peter the Hermit 145
Philip I 13, 21, 152
Philip II Augustus 18, 21, 50, 152–53, 170
Philip IV the Fair 22, 30
Philip of Valois 30
Piat, St 30, 32–33, 138, 160, 174, 176, 178–79
Porrée, Gilbert de la 40
Potentien, St 30
Priscian 39
Ptolemy 39
Puiset, Sire du 16
Pythagoras 39, 41

R

Rambouillet 14
Remi, St (Rheims) 151, 152
Renaud de Mouçon 50
Rheims 37, 63, 152, 170
ribs, diagonal 56, 61, 164, 178; formeret 70; transverse 56, 165
Richard I, Duke of Normandy 30
Richer 38
Robert II the Pious 13, 152
Rollo 29

Royal Portal 7, 13, 40, 50, 104ff., 108, 112, 115ff., 119, 149, 160, 172, 174, 175

S

Saint-Aignan (church) 16
Saint-André (church) 16, 22
Saint-Denis Abbey 23, 150, 152–53, 154, 156
Sainte-Chapelle (Paris) 80, 156, 162, 165
Sainte-Foy (Conques) 56, 101
Sainte-Geneviève Abbey 23, 37
Saint-Germain-des-Prés Abbey 23
Saint-Hilaire (church) 16
Saint-Jean gate 16
'St Lubin's vault' 45, 177
Saint-Michel (church) 16
Saint-Père (church) 16, 22
saints 137–46
Saint-Savin-sur-Gartempe 76
Saints-Forts well 33, 50, 174, 177
Saint-Victor Abbey 37
Saulieu 61, 119
Savinien, St 30
scotia 169
Senlis Cathedral 32, 104, 132
Senonches, forest of 21
Sergius and Bacchus, SS. (church) 45
Sheba, Queen of 119
Siger of Brabant 40
Soissons Cathedral 26, 58, 60
Solenne, Bishop 37
Solomon, King 119, 132
spandrels 76
Stephen, St 138
Suger 97–98, 101, 108

T

Teinturier, Jean, aka Johannes Tinctoris 85
Texier, Jean, aka Jean de Beauce 26, 106, 160, 174, 182
Theodore, St 108
Thibaut le Tricheur, Count of Blois 30
Thierry of Chartres 39–41, 160
Thomas, St 42, 151
torus 169
Tournus 56
Tours 37
transept crossing 59, 70, 175, 178, 181
triforium 58, 70, 164, 166, 179, 182–83

V

vault, groined 56, 63; ribbed 61, 164, 178; sexpartite 61
Vendôme 29
Vézelay 23, 32, 56, 61, 119, 124
Vicq-en-Berry 76
Virgin 30–33, 130–34
'Virgin's veil' (or 'tunic') 29, 31, 33, 50, 138, 160, 177

W

Walter the Penniless 145
William V of Aquitaine 38
William the Conqueror 13
windows 70, 71–83, 132, 165, 166ff.

Y

Yves of Chartres 38